HOW TO READ
NANCY

The Elements of Comics in Three Easy Panels

Conceived and written by: Paul Karasik and Mark Newgarden
Senior Editor: J. Michael Catron
Designer: Keeli McCarthy
Copy Editor: Beth Pearson
Design Consultant to the Authors: Megan Montague Cash
Image Restoration: Nathan Bulmer, Emily Elizabeth Garrett, Ben Juers, Paul Karasik, John Keen,
Brendan Leach, Yue Li, K. J. Martinet, Chandler Moses, Mark Newgarden, and Carolyn Presti.
Associate Publisher: Eric Reynolds
Publisher: Gary Groth

Fantagraphics Books, Inc.
7563 Lake City Way NE
Seattle, WA 98115
Fantagraphics.com • Twitter: @fantagraphics • Facebook.com/fantagraphics

First Fantagraphics Books edition: December 2017
ISBN 978-1-60699-361-3
Printed in China

Opposite: Ernie Bushmiller reads Nancy, *1959.*

HOW TO READ
NANCY

The Elements of Comics in Three Easy Panels

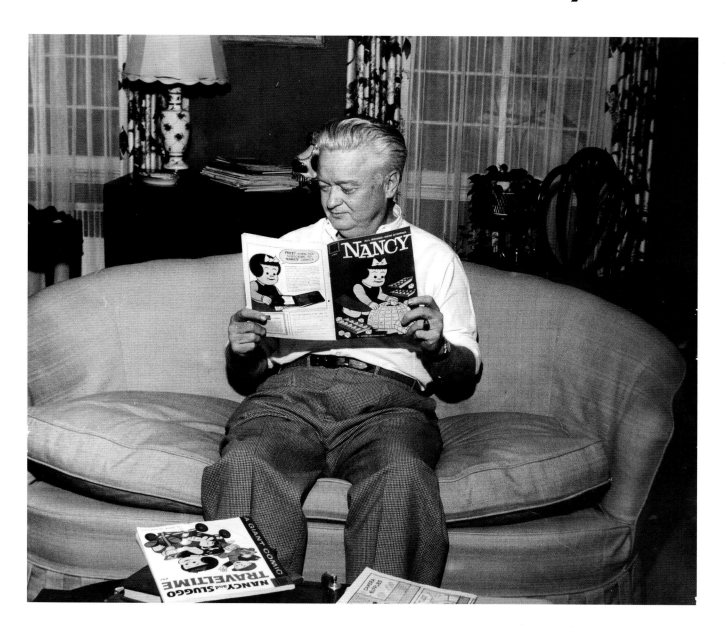

Paul Karasik • **Mark Newgarden**

FANTAGRAPHICS BOOKS

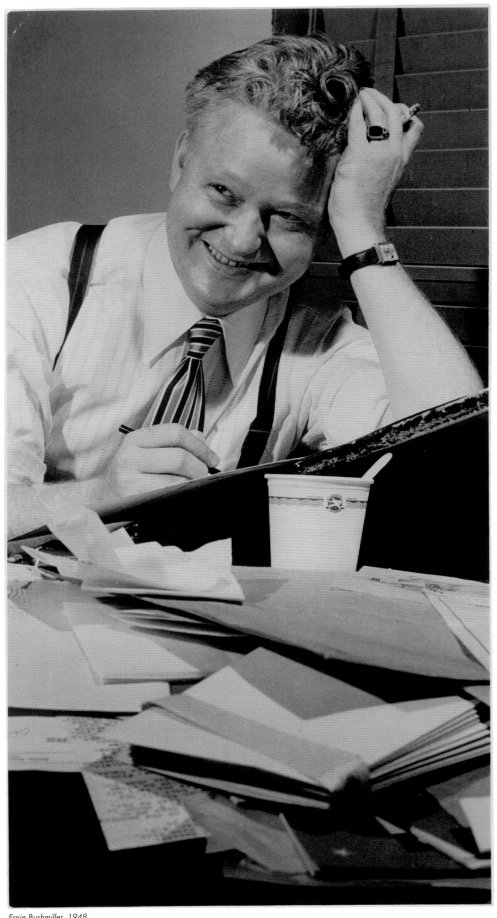

Ernie Bushmiller, 1948.

4

It is the pervading law of all things organic and inorganic,
Of all things physical and metaphysical,
Of all things human and all things super-human,
Of all true manifestations of the head,
Of the heart, of the soul,
That the life is recognizable in its expression,
That form ever follows function.
This is the law.

— Louis Sullivan, architect, 1896

What poem ever ceased to be good because someone analyzed it badly? The purpose of analysis is not to destroy beauty but to identify its sources. There is no such thing as a beautiful object without characteristics. If one cares about the nature of the beautiful object, he is well occupied in studying what makes it beautiful, and that study necessarily demands a look at the artist's management of his art.

— John Ciardi, poet, 1975

I would have written a shorter letter, but I did not have the time.

— Blaise Pascal, mathematician, 1656

CONTENTS

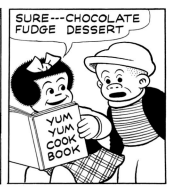

Nancy, August 13, 1948.

ACKNOWLEDGMENTS

LIKE THE COMIC STRIP ITSELF, *How to Read Nancy* may appear to be simple in concept and execution. But we know otherwise. The essay on which this book is based originally appeared twenty-five years ago, and since then, try as we might, we have never completely stopped looking at the August 8, 1959, episode of *Nancy*. Along the way, many people have stopped and taken a look with us and contributed to our understanding of this strip. We are grateful to them all.

Two men have gone above and beyond to share their knowledge of Ernie Bushmiller, memories of Ernie Bushmiller, Ernie Bushmiller archives, and consistent, indispensable support. When ground is finally broken for the Secret Bushmiller Society Fence of Fame, we hereby propose that the first two solid-gold slats erected shall honor charter members James T. Carlsson and Brian Walker.

During his lifetime there was relatively little of note written about Ernie Bushmiller, and there were very few who paid close attention to his work. As the scope of this project developed, questions arose that could only be answered by those with a firsthand knowledge of the subject. For sharing their experiences, information, and unique expertise we thank Orlando Busino, Bill Crouch Jr., Roy Doty, Jerry Dumas, Georgia Lee Ford, Ron Goulart, Irwin Hasen, David Hendin, Dick Hodgins, Mell Lazarus, Bobbie Miller, David Papenfuss, Al Plastino, Ruth Alice Reinhardt, Mort Walker, and Morris Weiss.

On many occasions during our research we simply did not know which way to turn for essential information. Fortunately we received invaluable tips, advice, introductions, sleuthing services, and the solid goods from Bill Alger, Jimmy Alley, Jerry Bail's Who's Who of American Comic Books database, Michael Barrier, Alberto Becattini, Jerry Beck, Jordan Bochanis, Luca Boschi, Serge Bromberg, Henry Callegary-Karasik, Alfredo Castelli, Laura Coit of the West Tisbury Free Public Library, Patrick Cooper, Stephen DeStefano, Eric Fettmann of the *New York Post*, Drew Friedman, Ken Garland, David Gerstein, Glen David Gold, Paul Gravett, Karen Green of the Columbia University Libraries, Bill Griffith, George Hagenauer, Willy Hartland, R.C. Harvey, Jeet Heer, Steve Heller, Alan Holtz, Bill Janocha, Mark Johnson, Charlie Judkins, Bill Kartalopoulos, Michel Kempeneers, Paul Leiffer, Paul Levitz, Kerby Lovallo, Ulli Lust, Frank Martinez, Michael Maslin, Ever Meulen, Jerry Moriarty, Dean Mullaney, Bruce Mutard, Dan Nadel, Sean Noel and Laura Russo of the Howard Gotlieb Archival Research Center at Boston University, Jessica Palmieri, Robert Peterson, Kai Pfeiffer, Jesse Poimboeuf, Jeff Roth, Susanne Rudloff, Tom Schiller, Bruce Simon, Joel Smith, Thierry Smolderen, Thomas Stein, Tom Sullivan, Michael Tisserand, Jack Turnbull, Huib Van Opstal, Diane Wanek, Joanne Weber, Sarah Weeks (assistant to Agnes Gund), Jerry Weiss, Chris Wheeler, Artemis Willis, and Frank Young.

Others provided no less critical information on an intimidating range of topics — some decidedly un-*Nancy*-like — and their understanding became unexpectedly crucial to this study. We are deeply appreciative to Sandy Bernat, Neil Cohn, Joe D'Angelo, Fae Kontje, Nikki Matheson, Jason Reiss, Frank Romano, Akira Satake, Bob Taubin, and Paul and Susan Vogel for their knowledge and generosity.

As we piled up early drafts of our manuscript, Judy Karasik consistently offered practical guidance and keen editorial insight. Upon completion of the first full draft we sought a reader who could evaluate this work on multiple levels — someone who was a discerning reader, a thoughtful practitioner, and an experienced teacher. Fortunately, we found David Mazzucchelli. Coming in for a landing, the manuscript was well served by a final assessment by three wise men: Richard Bruno, Philip Nel, and Thierry Smolderen. And finally, for her game nature and grammar smarts, we are deeply grateful to Beth Pearson.

The contrasting experience and knowledge that our two distinguished contributors brought to this book's Foreword and Introduction speak to both the wide appeal and the depth of Ernie Bushmiller's work. We are doubly honored and greatly appreciative that Jerry Lewis and James Elkins took the time from their busy schedules to frame *How to Read Nancy* for our readers so meaningfully.

Old newsprint has become difficult to find . . . in some cases, impossible. One of our most difficult tasks in the making of this book has been the assemblage of an intimidating variety of quality images for reproduction, from crumbling newspaper pages to rare original artwork. For their generous loan of invaluable materials and resources, we salute Dr. Steve Barghusen; Warren Bernard; Antoine Bonfait and Armand Colin of the Estate of Georges Columb (Christophe); Ariel Bordeaux of the Rhode Island School of Design Fleet Library; Charles Brown of the St. Louis Mercantile Library; Lucy Shelton Caswell, Jared Gardner, Susan Liberator, Caitlin McGurk, Jenny Robb, and Marilyn Scott of the Billy Ireland Cartoon Library & Museum at Ohio State University; Vicki Catozza of the Research Center Reference Division, Western Reserve Historical Society Library; Mike Caveney; Pierre Chemartin; Dan Clowes; Rebecca Crowther and Patricia J. Johnson of the Center for Sacramento History; Nicole C. Dittrich of the Special Collections Research Center, the Syracuse University Library; Sara W. Duke of the Library of Congress; Ingeborg Eggink of the KIT Tropenmuseum, Amsterdam; Catherine Ferreyrolle and Jean-Pierre Mercier of La Cité Internationale de la Bande Dessinée et de l'Image; Yves Fremion; Samo Gale and Michael Hermann of the Andy Warhol Foundation for the Visual Arts, Inc.; Tom Gammill; Joost Gielen; Eddie and Coco Goredetsky; Leonardo Gori; Ward Harkavy; Tom Heintjes; the Hershenson/Allen Archives; Peter Huestis; Cole Johnson; Dave Johnson; Denis Kitchen; Andy Konkykru; Alan Kupperberg, Anita Lane, and Steve Butman of the Taylor County, Texas, Historical Commission; Angela Mace of the Duke University Rare Book, Manuscript, and Special Collections Library; Andy Madura; Peter Maresca; Richard Marschall; Aimee L. Marshall of the Art Institute of Chicago; Gretchen Martin of the Phillips Collection, Washington, D.C.; Patrick McDonnell and Karen O'Connell; Andrei Molotiu; Mary Frances O'Brien and Henry Scannell of the Boston Public Library; Ron Padgett and the Estate of Joe Brainard; Aliénor Pauly of Novanima Productions; Lisa Pearson of Siglio Press; Ken Rightnour of Bailey & Co. Antiques and Collectables; Lance Rickman; Peter Rohowsky at Art Resource; Antoine Sausverd; Eckart Sackmann; Tammy Schrecengost of the Heritage Museum, Big Spring, Texas; Matthew Seiden; Will Shortz; Anthony F. Smith; Rob Stolzer; James Sturm and the Center for Cartoon Studies; Diana Thompson and Bruce Weber of the National Academy Museum & School; Sarah Traugott of the University of Texas at Austin's Dolph Briscoe Center for American History;

Paul Tumey; Richard Michael Tususian; Mikael Vuorinen; Wayno; Jim Woodring; and Dan Zettwoch. (And for the off-site scanning and photography of some of these treasures, a tip of the lens cap to Randi Baird, Walker Blackwell, Ric Blanc, Eli Dagostino, Sam Hiser, Kristine Larsen, Sean Visintainer, Marian Winsryg; and Mark Witz!)

It is our good luck that Fantagraphics Books is run by two individuals who are so well versed in the history of comics: Gary Groth and Eric Reynolds. And for his unerring vision and years of support we honor the memory of Kim Thompson, the late co-publisher of Fantagraphics Books, whose love of *Nancy* was crucial to the publication of this volume.

Not only does Fantagraphics care about publishing great books, they care about publishing great books that also look great. It helps that they work with a great designer: Keeli McCarthy.

Late in the game we realized that if we were going to reprint close to 200 vintage *Nancy* strips as pure line art in the back of this book, they had better look as good as Ernie Bushmiller drew them. For their dedication, hard labor, and ace digital restoration skills, we are beholden to: Nathan Bulmer, Emily Elizabeth Garrett, Ben Juers, John Keen, Brendan Leach, Yue Li, K. J. Martinet, Chandler Moses, and Carolyn Presti. Ancillary hands-on assistance from Sonia Eklund, Owen Kline, Dennis Pacheco, and Kevin Uehlein was also greatly appreciated.

In a series of 1983 lectures deconstructing Frank Capra's *Meet John Doe* frame by frame, Ken Jacobs demonstrated the benefits of depth over breadth that helped inspire our original "How to Read Nancy" essay. Thanks, Ken.

Since we have both been thinking and lecturing about *Nancy* for so many years, this book was supposed to take a couple of months to finish. It didn't. For their understanding, tolerance, and in-house support on innumerable levels we are deeply indebted to Megan Montague Cash and Marsha Winsryg.

And finally, a special "like" to the Shop Teachers of Plonsky who helped keep the authors reasonably entertained during the proceedings.

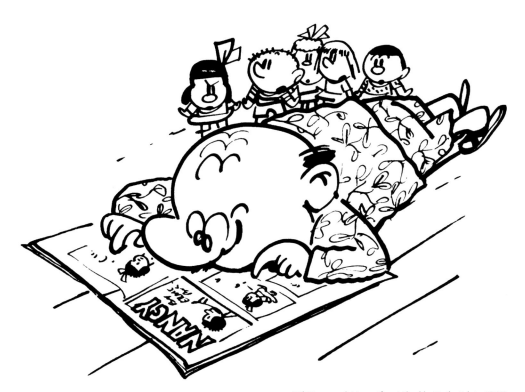

Milt Gross reads Nancy *(from* I Shoulda Ate the Eclair, *1948).*

AUTHORS' NOTE

Ernie Bushmiller was a man of few words. For such a prominent contributor to his field (and to the broader popular culture), this cartoonist left behind remarkably few interviews, press items, and written works. In this book there are instances where the authors have connected some of Ernie's often disconnected quotes from these sources in order to achieve a smoother narrative flow and allow fuller clarity on a given subject.

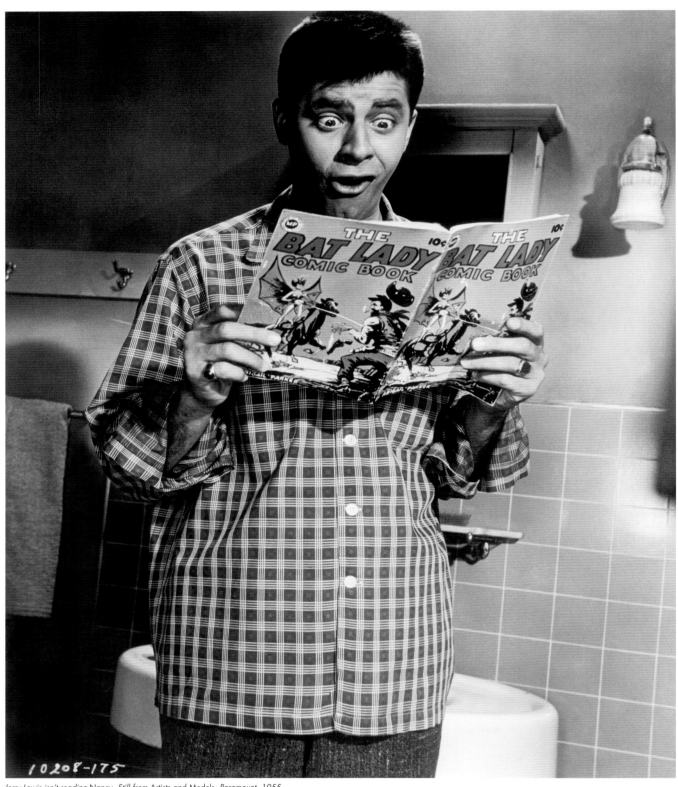

Jerry Lewis isn't reading Nancy. *Still from* Artists and Models, *Paramount, 1955.*

FOREWORD

I've written forewords before, but never for a book like this. *How to Read Nancy* is a book that was written with an infinite care rarely seen in today's world. As an avid reader of the *Nancy* cartoon strip for years, I thoroughly enjoyed Paul and Mark's insights about humor. *Nancy* is a national treasure and no fan can be without this book as a companion.

— Jerry Lewis
 Las Vegas

AN INTRODUCTION

BY JAMES ELKINS

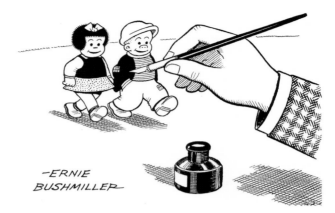

Washington and Lee University yearbook, 1949 (detail).

WHAT IS GENUINELY WONDERFUL, and also creepy, about *Nancy* is that it is about what happens when the visual world becomes so simple that if you take away just one line, it all completely collapses. Few artists or critics go near that limit, and that is what is spectacular about this book. (The closest parallel I know to *How to Read Nancy* in the world of comics is the early *Felix the Cat*, where Felix acts as both his own artist and his own critic, drawing and undrawing himself.)

I am absolutely delighted to write an introduction to *How to Read Nancy*. I am, in one sense, the worst possible person because I know next to nothing about comics. What's worse, when I do read comics, I am an awful, irresponsible reader. The problem is I can't stand to look at pictures that are carelessly drawn. My iPad has shown me universes of comics I had never known about: not just Marvel and DC and Dark Horse but dozens of indie companies — not to mention the apparently endless world of manga.

There are at least a dozen iPad apps for manga, and some of them offer long scrolling menus of all kinds of manga in Japanese. But for me, those unexplored worlds are hardly worth looking at, because the images are so quickly and poorly drawn. The visual is straitjacketed in formulas: you can go to an art supply store and buy books on how to construct anime figures, or how to make DC-style superheroes, bulging with stereotypical muscles. I used to teach anatomy for artists, and I know those muscles were codified in the 1960s by artists like Jack Kirby. They aren't even 1930s muscles, not to mention 1530s muscles. The apparently endless thousands of comics produced each year are, for me, an endless ocean of mediocre drawing. (I don't even get as far as the plots.)

I understand that comics, graphic novels, and *bandes dessinées* use the visual in a different way from fine art, and that I shouldn't expect the same focused attention to detail that attracts me in paintings, drawings, and prints. But that's not a reason to accept the miles of poor drawing. After all, I only admire a dozen artists from the High Renaissance and a half-dozen artists from the 1950s. Why should I spend time with a thousand indifferently skilled comics artists from the 2010s?

So I am a perverse reader of comics. But when a comic strip is drawn and designed well I am mesmerized. Above all other comics, *Nancy* is really just about one thing: seeing. It isn't very witty, even for children, unless they're very, very small children. It is anodyne, asexual, and intentionally simple, and that has been part of its attraction for artists from Warhol to Joe Brainard's *The Nancy Book* and the current internet proliferation of "kinkiest *Nancy* strips," *Nancy* remixes, and *Nancy* parodies.[1]

I have some things to say about the idea of making the visual world into a clattering skeleton, edging closer and closer to the single line on the white page . . . but before I do, I want to say some academic things about what is at stake in this book's approach to *Nancy*.

There is a serious reason why it is inappropriate to say that most comics are drawn poorly or that it matters exactly how they're drawn. That serious reason has to do with how comics create meaning, and the literature on that subject intersects at several points with existing literature on semiotics, pictorial sense, and pictorial logic.

Charles Hatfield, who wrote a very good book called *Alternative Comics*, quotes the psychiatrist Fredric Wertham, famous in comics circles for having written, in 1954, *Seduction of the Innocent*, a book that helped spur the Comics Code.[2] Wertham thought comics exacerbate a "reading disorder," because comics readers don't read but engage in "picture reading," which Wertham defined as "gazing at successive pictures of the comic book with a minimal reading of the printed letters." (*Alternative Comics*, page 34) As little as anyone in comics likes Wertham — and the major recent theorists of comics are miles away from Wertham's polemics — that is exactly the kind of explanation that fits with contemporary visual theory, art history, art criticism, and the academic literature on comics, because it proposes that reading comics is something different from either looking at pictures or reading texts, and because it focuses on the overall experience of "reading" comics, rather than the bits and pieces that are the subject of this book. (Although it's interesting to read about Wertham's change of heart later in life, studied in Bart Beaty's *Fredric Wertham and the Critique of Mass Culture*.)

But the recent theorists of comics share the idea that it is necessary to rethink what "reading" and "looking" mean, and to come up with accounts that are specific to comics. Hatfield himself offers a number of incisive readings, and there are also excellent books by the poet and scholar Jan Baetens, the scholar Pascal Lefèvre, and the philosopher and critic David Carrier, and there are anthologies such as *A Comics Studies Reader* that cover some of the same ground.[3] In their different ways, they are concerned with larger-scale structures of meaning: panels, pages, layout, structure, narrative, politics, art, literature, and identity. This book is concerned with the fact that you probably

read the dialogue in *Nancy* after you have looked at the pictures, but it is also concerned with such things as periods, commas, little wavy lines, fence slats, and leaky spigots. It's even concerned with the ever-so-slightly upward-curling flourish at the end of Ernie Bushmiller's signature.

This idea — that the most interesting, plausible, and meaningful ways of looking involve a moving eye that does not settle on bits of images but focuses on larger structures of meaning — has a very strong pedigree in art theory on both sides of the Atlantic.

A branch of scholarship more in line with the approach in this book is Anglo-American, and it includes theorists from Wittgenstein and Nelson Goodman to W.J.T. (Tom) Mitchell. For the purposes of understanding *Nancy*, I'll divide these thinkers into two groups. The early Wittgenstein and a book by Nelson Goodman, *Languages of Art,* exemplify the first group — they are about the logical structure of images.[4] Goodman would have loved this book, because he was fascinated by the way that images can seem to be structured like writing or like logical notations. Goodman knew that the most interesting fine-art images (paintings, for example) can never be analyzed down into their component signs, but he certainly tried. From Goodman's point of view, this book is a valiant attempt to show how sense is made, piece by piece, in a comic strip, the way you make sense in writing, letter by letter or word by word. The difference, he would say, is that pictures are ultimately composed of "dense" or "nondisjoint" marks and signs, so they just don't behave like writing, or like numbers. *Nancy* comes close! — but it is visual precisely because it cannot be completely reduced to a system. (My *Domain of Images* has lots more on Goodman, Wittgenstein, and their hopes.[5])

The second group of Anglo-American scholars includes a more recent generation of "word and image" students: people interested in the relation of text and pictures in all fields. Currently, by far the most influential is Tom Mitchell. Hatfield's book makes use of Mitchell's work, and so does the anthology *The Language of Comics: Word and Image*, which also includes a text by Mitchell.[6] In his work, what matters is not how an image might actually be structured, but how it is understood to be structured. Mitchell is interested in how people think images work, and in what they seem to want from images. (He has famously put it the other way around, asking what images want from us.) *The Language of Comics* excerpts one of his books that argues pictures and words cannot be dissociated. (For a book I edited called *Visual Literacy*, Mitchell contributed an essay called "Visual Literacy or Literary Visualcy?"[7]) Hatfield knows the literature on pictorial semiotics, but he isn't necessarily interested in the details of the theories of images — he wants to say that comics blend words and images, and that's what Mitchell's text in *The Language of Comics* is enlisted to do.

The other community that has studied these themes is mostly French-speaking, although it also includes Scandinavian and German scholars. Its orientation is determinedly semiotic: writers are interested in the structure of images, and how language-like they are. Thierry Groensteen, author of *The System of Comics*, comes out of this tradition.[8] He cites French semiotic theory (the mysterious-sounding Belgian "Groupe μ"), people who are known for investigations of linguistic signs (Émile Benveniste[9]), and people who are influential in contemporary Francophone art theory (Louis Marin, Hubert Damisch[10]). Damisch in particular pursued a fascinating idiosyncratic path, writing about the kinds of "thought" that inhere in lines and in paint itself.

These are all authors I've studied, and it was gratifying to find them here and there in the comics literature, like thin rope bridges leading from familiar territory to the world of comics. Groensteen identifies himself with Damisch's approach (but says it's "marred by a certain ambiguity"), and Hatfield and others make use of Mitchell — and as different as Mitchell and Damisch are, they share something in common: a mistrust of exactly the sort of thing that Karasik and Newgarden do in this book, which is to search for the "minimal units" of pictures, the smallest parts of their "system of signs." (That's Groensteen, quoting Damisch, who is disparaging semiotics because it tends to think it can find just those minuscule building blocks.) Mitchell, too, has criticized Continental-style semiotics (especially the sort practiced by the Swedish scholar Göran Sonesson[11]) because it is a sterile redescription of something that's already known, and because it hopes to dismantle images, in particular, into parts, Lego-fashion. Images, Damisch and Mitchell would agree, are a different kind of creature that cannot be dissected into neat parts the way that written texts can be divided into paragraphs, sentences, words, and letters. Comics, Groensteen and Hatfield would agree, are a strange mixture of words and images, and therefore even less likely to be a form that can be neatly parsed.

Both Groensteen and Hatfield are interested in the larger structures that comics build, and not in their microscopic parts. Groensteen says, "The comics panel is fragmentary and caught in a system of proliferation. . . . It can and must be understood as a component in a larger apparatus." (*The System of Comics*, page 5)

I could go on and on. If you are interested in walking across these rope bridges that connect contemporary visual theory to comics, you might try Mitchell's *Picture Theory*, or Hubert Damisch's *A Theory of /Cloud/*, or my own edited book *What Is an Image?*[12] The salient point here is that the mass consensus of writing on images, both in English and in other languages, is that what this book does is misguided. It doesn't matter that most comics are drawn indifferently, unskillfully, or just plain badly, because comics are something different from fine-art pictures. The parts and pieces of comics — the fence slats and hose spigots — are not objects of delectation but false friends, things that need to be read in their wider social contexts.

There are many reasons to agree with that, but I choose to disagree, because there are also good reasons to consider the kind of microscopic looking Karasik and Newgarden do here. *How to Read Nancy* is primarily interested in the details of Bushmiller, as they help us understand how the whole works so faultlessly as transmitted visual information. The general strategy this book adopts would be known in art history as formal analysis, and in literary theory as close looking. Both have long histories, reaching back into early modernism. (That is, into the years Ernie Bushmiller was learning to draw.) I am myself very interested in both formal analysis and close looking, even though they are considered philosophically and ideologically dubious. It is philosophically suspect to look at the tiny details of a picture because that assumes a picture divides into tiny details, and that those details are the image's building blocks. It is ideologically suspect to look at little parts of pictures because close looking, in literary criticism, was practiced by formalist critics,

who tried to look as closely as they could, partly to shut out the racial, social, gender, and identity issues that were pressing in on their pure art. It is also ideologically suspect because formal analysis, in art history, was once the province of connoisseurs, who purported to understand images in a deep nonverbal way, but who were often more in the business of cultural aggrandizement (not to mention monetary aggrandizement). Art history likes to think of itself as the surviving descendent of connoisseurship and formal analysis: the smarter offspring who sees the errors of its parents' ways. (If this is something of interest, the best book is Whitney Davis's *General Theory of Visual Culture*.[13])

But there are some holdouts in art history — people for whom details have a compelling interest. Art historians might name the French scholar Daniel Arasse, whose book *Le Détail* is a compendium of examples — or Georges Didi-Huberman, who sees details as little portals into the fuller world of representation, outside the constraints of naturalism and other habits — or Friedrich Teja Bach, who has written a number of essays on the forgotten details of

pictures and what they might mean. I confess I am largely in their camp.[14]

So much for theory. Here are a couple of examples of very, very close looking, like the looking in this book — the kind that isolates tiny parts of the image and thereby deepens our understanding of the whole. Both examples seem to have to do with the stripped-down linear style of *Nancy*. The first, Piet Mondrian, turns out not to be related to *Nancy*: it calls for a different kind of close looking. The second, a book on the famous map of the London Underground, turns out to be very close to *Nancy*: the same family, if not the same genus or species.

From a distance, Mondrian's bare-bones paintings and Bushmiller's skeletal cartoons are not entirely dissimilar. They're both relentlessly flat, largely unshaded, and dependent on large areas of color, and, most intriguingly, they're both articulated by thick black lines of uniform width.

You can look very closely at a Mondrian, as I learned when I tried to help students copy one of the Mondrians in the collection of the Art Institute of Chicago, where I work.[15]

Piet Mondrian, Dutch, 1872–1944, Lozenge Composition with Yellow, Black, Blue, Red, and Gray, 1921, Oil on canvas, 23 5/8 x 23 5/8 in. (60 x 60 cm), Gift of Edgar Kaufmann, Jr., 1957.307, The Art Institute of Chicago. Photography © The Art Institute of Chicago. Opposite page: Top left: Student copying Lozenge Composition with Yellow, Black, Blue, Red, and Gray (detail). Top right: Piet Mondrian, Lozenge Composition with Yellow, Black, Blue, Red, and Gray, 1921, Oil on canvas (detail). Bottom left: Student copy of Lozenge Composition with Yellow, Black, Blue, Red, and Gray (detail). Bottom right: Piet Mondrian, Lozenge Composition with Yellow, Black, Blue, Red, and Gray, 1921, Oil on canvas (detail).

This is the kind of picture that has had people since the early twentieth century complaining that their six-year-old could do it (or five-year-old, and I've even heard four-year-old). But what seems simple and *Nancy*-like from a distance is actually complex from up close. Here is my student's hand, copying one of Mondrian's strokes.

And here's Mondrian's original. The original line and its white border are crusty and impacted, and not at all the simple black and white they appear to be at a distance.

Here is my student's copy of the part just to the right of that.

And here's the original.

My student's copy is flat and flaccid. Mondrian's blue looks like it was painted with a wire. Mondrian's painting turns out to be what we might call fractal: its apparently simple geometry turns fiercely complex when it is seen close up.

This is what I mean by saying Mondrian seems like *Nancy* but is not. I don't mean that these painterly textures are signs that Mondrian is better than *Nancy*. They are signs that Mondrian is fine art, just because fine art painting in the West tends to have these endlessly fine details.

But that does not mean that Mondrian is more interesting, or more serious. The authors of this book note that Bushmiller used medium size brushes dipped in Higgins ink, and in their reduced reproductions, as they were originally printed, Bushmiller's strips are ultra-clean. Ultimately, both Mondrian and Bushmiller created work that appears to be clear-cut and apparently easy to replicate but upon close inspection is fraught with hidden subtleties that are not immediately obvious.

My second example is the work discussed in the strange book *Mr. Beck's Underground Map*, by Ken Garland.[16] It's the story of the man who invented the famous London Underground map, which launched a style that became ubiquitous in bus, train, and tram schedules around the world. A reviewer on the internet calls the book "brief and insanely detailed," and it really is. Garland looks at the way Henry C. Beck, inventor of the map, brought order into the chaos of the existing maps, and how he tinkered with it into the 1960s. Beck's innovation was to take the spaghetti curls of the naturalistic maps (this is one from 1932, showing central London) —

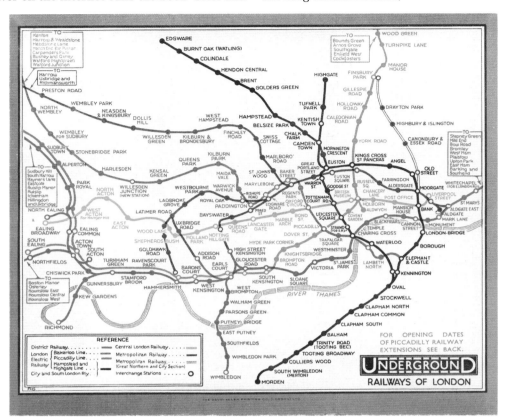

— and turn them into orderly verticals, horizontals, and diagonals.

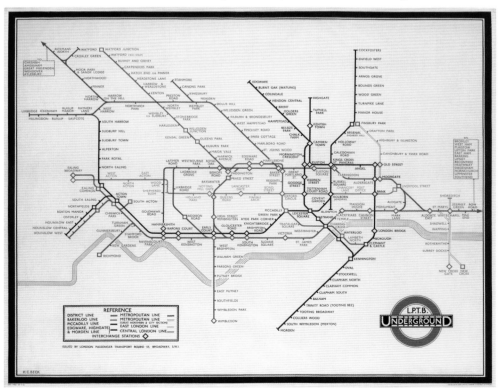

Top: *Underground Railways of London, London Passenger Transport Board*, pocket map designed by F.H. Stingemore, 1932. Bottom: *L.P.T.B. Underground, London Passenger Transport Board*, designed by Henry C. Beck, 1933. Opposite: Top: *Henry C. Beck, sketch for underground map design*, 1931. Bottom: *Underground, London Transport*, designed by Henry C. Beck, 1959.

Beck was the same generation as Bushmiller (Beck was born in 1902), and like Bushmiller, he couldn't abide sloppy graphics. He didn't just design the Diagram (as Garland likes to call it, with a capital "D"), but he kept designing it, clarifying and streamlining, his entire life. Even his initial sketch from 1931 is uncluttered and nicely spaced.

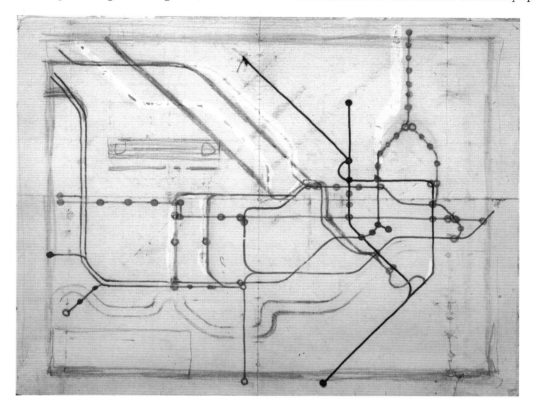

Like Bushmiller, Beck had to deal to some extent with the real world, because London's Underground lines twist and curl around one another in messy three-dimensional knots.

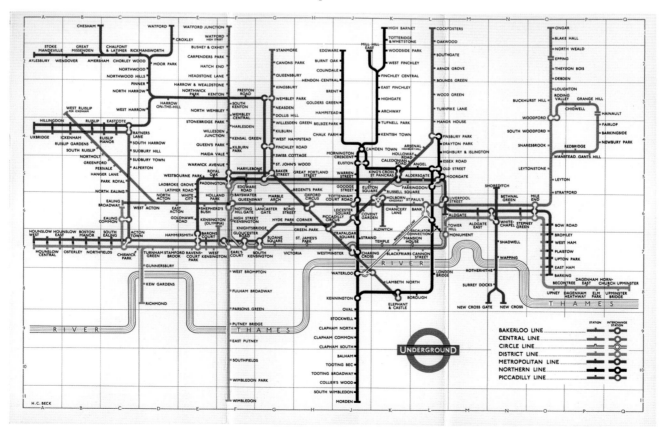

The central part of the map, with the yellow Circle Line loop, was the most difficult part. Here it is in a 1959 version — Piccadilly Circus is inside the loop, in the middle, on the blue line.

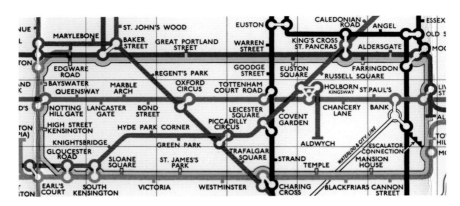

And here is one of Beck's later experiments, after 1964, in which he tried to rethink it as an ellipse. Piccadilly Circus is in the bottom left quarter of the ellipse:

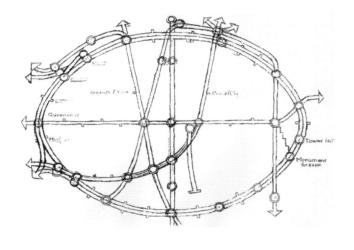

And here another experiment, in which he permitted himself two other diagonal lines: one more vertical, and another more horizontal. Piccadilly Circus is labeled "PICCAD":

Garland marvels at this last experiment, saying it "would have defeated anyone with a less ingenious mind than Mr. Beck's." Neither of these sketches was ever adopted, because his original was already the simplest solution. Nothing simpler could even count as a map. Garland, who has studied the Diagram in excruciating detail, thinks that Mr. Beck's map, as it's always called, isn't really a map at all. It distorts and simplifies so much that it's really a diagram (or even a Diagram). The same could be said of *Nancy*: it's so thoroughly thought through, so precise in its unnatural conventions, so stringent with what it permits on the page, that it's less a cartoon than a diagram.

I can't resist mentioning here that the Diagram is often said to be influenced by modernist painting, and Mondrian in particular. Art historians say this without actually concerning themselves with whether or not it's true, and it turns out it isn't true. Beck was influenced by early twentieth-century electric schematics. It is much more likely Mondrian was influenced by Beck than the other way around, and that means Mondrian's paintings are descendants of electrical schematics. When I first

looked at *Nancy* as an adult — as an art historian — I thought it fitted well with abstraction, Suprematism, and Constructivism. That is, I thought it was a popular version of avant-garde movements. Now I wouldn't say that: *Nancy* is a world unto itself, but it has satellite worlds, and they include Mondrian, the London Underground map, and electrical schematics. Very good company.

In this book you will learn, in "insane" detail, how Ernie Bushmiller attended to the exactness of his art, its visual properties. The kind of close reading you will learn from *How to Read Nancy* is different from the kind you'd learn studying Mondrian's paintings, and it is even different from Beck's Diagram. It is also different from what you'd learn in the books by Arasse, Didi-Huberman, and others that I cited. The moral is very simple, even if academics sometimes resist it: seeing is various, multiple, and extremely exacting. Visual things are particular: they are particular about how they're seen, and particular in the sense that they are often unique.

And now: here's the book that will change the way you look at comics, and many other things besides.

NOTES

1. Joe Brainard, *The Nancy Book* (Los Angeles: Siglio, 2008).

2. Charles Hatfield, *Alternative Comics: An Emerging Literature* (Jackson: University Press of Mississippi, 2005); Fredric Wertham, *Seduction of the Innocent* (New York: Rinehart, 1954).

3. Jan Baetens, *Formes et Politique de la Bande Dessinée* (Paris: Vrin, 1998); David Carrier, *The Aesthetics of Comics* (University Park, PA: Pennsylvania State University Press, 2000). Anthologies include *A Comics Studies Reader*, edited by Jeet Heer and Kent Worcester (Jackson: University Press of Mississippi, 2008), especially Pascal Lefèvre's chapter, "The Construction of Space in Comics"; *Comics and Culture: Analytical and Theoretical Approaches to Comics*, edited by Anne Magnussen and Hans-Christian Christiansen (Copenhagen: Museum Tusculanum, 2000); and *The Language of Comics: Word and Image,* edited by Robin Varnum and Christina Gibbons (Jackson: University Press of Mississippi, 2001). My own favorite in the culture-studies field is Hiroki Azuma's literate and eloquent *Otaku: Japan's Database Animals*, translated by Jonathan Abel and Shion Kono (Minneapolis: University of Minnesota Press, 2009).

4. Nelson Goodman, *Languages of Art: An Approach to a Theory of Symbols* (Indianapolis: Hackett, 1976).

5. James Elkins, *The Domain of Images*, On the Historical Study of Visual Artifacts (Ithaca, NY: Cornell University Press, 1999).

6. *The Language of Comics*, op. cit.

7. James Elkins ed., *Visual Literacy* (New York: Routledge, 2008).

8. Thierry Groensteen, *The System of Comics*, trans. by Bart Beaty and Nick Nguyen (Jackson: University Press of Mississippi, 2007).

9. Émile Benveniste, *Problems in General Linguistics,* trans. by Mary Elizabeth Meek (Coral Gables, FL: University of Miami Press, 1971).

10. Louis Marin, *To Destroy Painting*, trans. by Mette Hjort (Chicago: University of Chicago Press, 1995); Hubert Damisch, *The Origin of Perspective*, trans. by John Goodman (Cambridge, MA: MIT Press, 1994).

11. Göran Sonesson, *Pictorial Concepts: Inquiries into the Semiotic Heritage and Its Relevance to the Interpretation of the Visual World* (Lund, Sweden: Lund University Press, 1989).

12. W.J.T. Mitchell, *Picture Theory: Essays on Verbal and Visual Representation* (Chicago: University of Chicago Press, 1994); Hubert Damisch, *A Theory of /Cloud/: Toward a History of Painting*, trans. by Janet Lloyd (Stanford, CA: Stanford University Press, 2002); and *What Is an Image?, The Stone Art Theory Institute, Vol. 2,* ed. James Elkins and Maja Naef, with contributions by W.J.T. Mitchell, Gottfried Boehm, and forty others. (University Park: Pennsylvania State University Press, 2012).

13. Whitney Davis, *A General Theory of Visual Culture* (Princeton, NJ: Princeton University Press, 2010).

14. Here the best book is in German: *Was aus dem Bild Fällt: Figuren des Details in Kunst und Literatur*, [Festschrift fur] Friedrich Teja Bach zum 60. Geburtstag, ed. by Edith Futcher, Stefan Neuner, Wolfram Pichler, and Ralph Ubl (Munich: Wilhelm Fink, 2007). See also Arasse, *Le Détail: Pour une Histoire Rapprochée de la Peinture* (Paris: Flammarion, 1992), and Didi Huberman, *Confronting Images: Questioning the Ends of a Certain History of Art*, trans. by John Goodman (University Park: Pennsylvania State University Press, 2007).

15. More on this at huffingtonpost.com/james-elkins/post_1036_b_756669.html.

16. Ken Garland, *Mr. Beck's Underground Map* (London: Capital Transport, 2003 [1994]). The diagram is also discussed in my *Visual Studies: A Skeptical Introduction* (New York: Routledge, 2003).

Opposite: Top: *Underground, London Transport, designed by Henry C. Beck, 1959 (detail).* Bottom left: *Henry C. Beck, sketch for underground map design, post-1964.* Bottom right: *Henry C. Beck, sketch for underground map design, post-1964.*

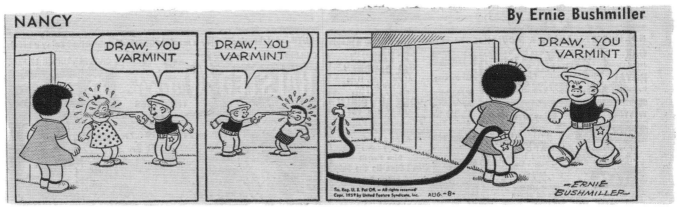

Nancy, *August 8, 1959.*

PREAMBLE

Put it before them briefly so they will read it, clearly so they will appreciate it, picturesquely so they will remember it and, above all, accurately so they will be guided by its light. — Joseph Pulitzer, 1911

A cartoon is seen at exactly the level at which it is drawn. — Rudolf Arnheim, 1969

You'll come to learn a great deal if you study the Insignificant in depth. — Odysseus Elytis, 1959

JUST ABOUT EVERYTHING that you really need to know about comics — reading comics, making comics, and understanding comics — can be found within the ruled borders of three panels published on August 8, 1959, and drawn by Ernie Bushmiller.

While it is common for a monograph to cover discrete aspects or phases of an artist's oeuvre (Monet's Water Lilies, Picasso's Blue Period), comparatively few volumes explore a single work of any artist (let alone a cartoonist). These bodies within greater bodies of work are elucidating as studies in comparison and contrast. Our strategy is the direct opposite. *How to Read Nancy* is the first book to focus primarily on the analysis of a single comic strip.

In *How to Read a Book* (1940), Mortimer Adler and Charles Van Doren's "classic guide to intelligent reading," the authors enumerate three basic levels of reading (elementary, inspectional, and analytical) as they pertain to a wide variety of written materials. *How to Read a Book,* however, explicitly does not concern itself with "reading for entertainment" (let alone reading a comic strip). The authors maintain that this is the least demanding kind of reading and requires the least effort. In *How to Read Nancy* we have undertaken an analytical approach to what was, above all, created to entertain with the least amount of effort.

Medical students peel back the muscles of cadavers to understand how the human body works. English majors diagram plots and track recurring symbols to understand how fiction works. Aspiring composers run the scales. Film pupils rewind. And now the student of comics — or any interested reader — can better understand the medium by examining forty-two aspects of this single strip in naked isolation.

Only recently has the serious field of comics studies crashed the university press with numerous volumes collecting works by single or multiple academics addressing single or multiple academic themes. Also, more popular and prevalent than ever are historical collections of comics by a single creator, often reprinted with modest biographical and critical assessment regarding the subject's work, leaving most of the appraisal up to the reader through osmosis. Yet others have addressed the innards of this medium with varying mixtures of utopian zeal and cloudy snake oil.

Although it may share some of these traits, *How to Read Nancy* is neither academic essay nor coffee table compilation nor one-stop manifesto. In an attempt to get to the essentials about the nature of comics, we have adopted a vertical approach to drill straight through to the heart of matter. What you see is what you get. And with *Nancy* that's plenty.

Taking a lead from contemporary findings in education, our approach favors "depth over breadth." Recent indicators have shown that in the classroom, covering fewer topics in greater depth is more beneficial on several counts. A study in the September 2009 issue of *Science Education* ("Depth Versus Breadth: How Content Coverage in High School Courses Relates to Later Success in College Science Coursework") noted that, in addition to achieving higher grades and being better prepared for college, high school students who studied fewer science concepts in more detail appeared to have a better comprehension of the overall subject itself. With *Nancy,* "the gag is the thing," yet by simply broadening the notion of "gag" to one of "content," we believe that the clearly discernible lessons of August 8, 1959's three panels can rapidly awaken a greater awareness of the workings of an entire medium.

Which, incidentally, covers a lot of territory — as the venerable debate rages on as to what, precisely, is meant by "comics" in the first place. Scholars have scrutinized a wide range of material over the decades with partisans wielding both exclusive as well as inclusive axes. The battle lines of classification and taxonomic rank have been drawn and redrawn in the sand, with still no Comics Canon yet in sight as the medium itself continues to mutate and adapt, progress and regress.

What is not in dispute, however, is that comics come in different forms and genres and originate from different cultures in different eras for different reasons. Due to this scope and complexity, most hard and fast definitions inevitably fall short, e.g., "If comics only combine words and pictures, what about wordless strips? If comics are only sequential, what about self-contained single panels? If comics are only comical, what about . . . ?"

comen or *cumen* (infinitive), *com* or *cam* (past singular), *comen* or *camen* (past plural), *comen* or *cumen* (past participle), Old English *cuman, cōm, c(w)ōmon, cumen.* See **gwā-** in Appendix.*]
Usage: Come in the subjunctive form occurs in constructions such as these: *Come what will* (or *may), I propose to remain here. Our plans will be settled come Friday.*

come back. 1. To return. 2. To retort.

come·back (kŭm'băk') *n.* 1. A return to former prosperity or status. 2. A retort; repartee. 3. A recourse.

co·me·di·an (kə-mē'dē-ən) *n.* 1. A professional entertainer who tells jokes or does impersonations or performs various other comic acts. 2. An actor in comedy. 3. A comedy writer. 4. A person who amuses or tries to be amusing; clown.

co·me·dic (kə-mē'dĭk) *adj.* Of or relating to comedy.

co·me·di·enne (kə-mē'dē-ĕn') *n.* A female comedian.

com·e·do (kŏm'ə-dō') *n., pl.* **-dos** or **comedones** (kŏm'ə-dō'-nēz). A **blackhead** *(see).* [New Latin, from Latin *comedo,* glutton, from *comedere,* to eat up : *com-* (intensive) + *edere,* to eat (see **ed-** in Appendix*).]

come down. 1. To lose status or wealth. 2. To become ill. Used with *with: come down with the measles.*

come·down (kŭm'doun') *n.* A decline or drop to a lower status or level.

com·e·dy (kŏm'ə-dē) *n., pl.* **-dies.** *Abbr.* **com.** 1. A play, motion picture, or other work that is humorous in its treatment of theme and character and has a happy ending. 2. Any literary composition with a theme appropriate to comedy or using the methods of comedy. 3. The branch of literature dealing with comedies. 4. The art or technique of composing comedy. 5. A comic element of literature or life. 6. A comic occurrence. [Middle English *comedie,* from Old French, from Latin *cōmoedia,* from Greek *kōmōidia,* originally "a singer in the revels" : *kōmos†,* revel + *ōidos, aoidēs,* singer, from *aeidein,* to sing (see **wed-²** in Appendix*).]

comedy of manners. A comedy satirizing fashionable society.

come-hith·er (kŭm'hĭth'ər) *adj.* Seductive; alluring.

come·ly (kŭm'lē) *adj.* **-lier, -liest.** 1. Having a pleasing appearance; attractive; handsome; graceful. 2. Suitable; proper; seemly. —See Synonyms at **beautiful.** [Middle English *comli, comeli(ch),* Old English *cȳmlic,* lovely, splendid, from *cȳme†,* beautiful.] —**come'li·ness** *n.*

Co·me·ni·us (kə-mē'nē-əs), **John Amos.** Czech *Jan Ko·men·sky* (kō'mən-skē). 1592–1670. Czech theologian and educator.

come on. 1. To meet by surprise; to find. 2. To make progress; improve; develop. 3. To enter, as on a theater stage.

come-on (kŭm'ŏn', -ôn') *n.* Something offered to allure or attract; an inducement.

com·er (kŭm'ər) *n.* 1. One that arrives or comes. 2. *Informal.* One showing great promise.

co·mes·ti·ble (kə-mĕs'tə-bəl) *adj.* Edible. —*n.* Anything edible. [Old French, from Medieval Latin *comestibilis,* from Latin *comedere* (past participle *comestus*), to eat up : *com-* (intensive) + *edere,* eat (see **ed-** in Appendix*).]

com·et (kŏm'ĭt) *n. Astronomy.* A celestial body, observed only in that part of its orbit that is relatively close to the sun, having a head consisting of a solid nucleus surrounded by a nebulous coma up to 1.5 million miles in diameter, an elongated curved vapor tail arising from the coma when sufficiently close to the sun, and thought to consist chiefly of ammonia, methane, carbon dioxide, and water. [Middle English *comete,* Old English *cometa,* from Latin *comēta, comētēs,* from Greek *(astēr) komētēs,* "long-haired (star)," from *koman,* to wear long hair, from *komē†,* hair.] —**com'et·ar·y** (kŏm'ə-tĕr'ē), **co·met'ic** (kə-mĕt'ĭk) *adj.*

come-up·pance (kŭm'ŭp'əns) *n.* Also **come-up·ance.** *Informal.* Punishment or retribution that one deserves; one's just deserts. [From phrase *come up,* sense development obscured.]

com·fit (kŭm'fĭt, kŏm'-) *n.* A candy; confection; sweetmeat. [Middle English *confit,* from Old French *confectum,* "preparation," from Latin *conficere,* to prepare : *com-* (intensive) + *facere,* to make (see **dhē-¹** in Appendix*).]

com·fort (kŭm'fərt) *tr.v.* **-forted, -forting, -forts.** 1. To soothe in time of grief or fear; to console. 2. To ease physically; relieve, as of pain. 3. *Law.* To aid. —See Synonyms at **relieve.** —*n.* 1. A state of ease or well-being. 2. Relief; consolation; solace. 3. Help; assistance. 4. One that brings ease. 5. Capacity to give physical ease and well-being: *enjoying the comfort of his favorite chair.* —See Synonyms at **rest.** [Middle English *comforten,* from Old French *conforter,* from Late Latin *confortāre,* to strengthen : Latin *com-* (intensive) + *fortis,* strong (see **bhergh-²** in Appendix*).] —**com'fort·ing·ly** *adv.*

com·fort·a·ble (kŭm'fər-tə-bəl, kŭm'ftər-bəl) *adj.* 1. Providing or giving comfort. 2. Being in a state of comfort; at ease. 3. *Informal.* Sufficient; adequate: *comfortable earnings.* —**com'fort·a·ble·ness** *n.* —**com'fort·a·bly** *adv.*

Synonyms: comfortable, cozy, snug, restful. These words mean affording pleasurable ease. *Comfortable* implies the deliberate removal of sources of pain or distress. *Cozy* evokes the image of a warm room in winter and suggests cheerful or reassuring closeness. *Snug* is even closer; the image is of a warm bed. *Restful* suggests a seclusion and quiet conducive to ease. Metaphorically, the terms may acquire ironic overtones. Thus, *comfortable* may suggest lethargy or complacency, and *cozy,* a self-serving closeness of relationship.

com·fort·er (kŭm'fər-tər) *n.* 1. One that comforts. 2. *Capital* C. The Holy Spirit. 3. A quilted bedcover. 4. *Chiefly British.* A woolen neck scarf.

comfort station. A public toilet or rest room.

com·frey (kŭm'frē) *n., pl.* **-freys.** Any of several usually hairy or bristly plants of the genus *Symphytum,* native to the Old World, having clusters of variously colored flowers. [Middle English *conferie,* from Old French *cumfirie, confire,* from Latin *conferva,* a water plant, "healer," from *confervēre,* to boil together, heal : *com-,* together + *fervēre,* to boil (see **bhreu-²** in Appendix*).]

com·fy (kŭm'fē) *adj.* **-fier, -fiest.** *Informal.* Comfortable.

com·ic (kŏm'ĭk) *adj. Abbr.* **com.** 1. Of, characteristic of, or pertaining to comedy. 2. Of or pertaining to comic strips. 3. Amusing; humorous. —*n. Abbr.* **com.** 1. A person who is comical. 2. *Plural. Informal.* Comic strips. 3. *Informal.* A comic book. 4. Anything that provokes humor in art or life. [Latin *cōmicus,* from Greek *kōmikos,* from *kōmos,* revel, merry-making. See **comedy.**]

com·i·cal (kŏm'ĭ-kəl) *adj.* 1. Provoking mirth; funny; amusing. 2. Of or pertaining to comedy. —**com'i·cal'i·ty** (-kăl'ə-tē), **com'i·cal·ness** *n.* —**com'i·cal·ly** *adv.*

comic book. A booklet of comic strips, sometimes violent or sensational rather than humorous.

comic opera. An opera or operetta with a humorous plot, spoken dialogue, and, usually, a happy ending.

comic strip. A narrative series of cartoons.

Co·mines (kô-mēn'), **Philippe de.** Also **Com·mines.** 1447?–1509? French diplomat and historian; served Louis XI and Charles VIII.

com·ing (kŭm'ĭng) *adj.* 1. Approaching; next. 2. *Informal.* Showing promise of fame or success. —*n.* Arrival; advent.

com·ing-out (kŭm'ĭng-out') *n. Informal.* A social debut.

Com·in·tern (kŏm'ĭn-tûrn) *n.* The Third **International** *(see)* or, especially, its executive committee in Moscow. [**Com**(**munist**) **Intern**(**ational**).]

co·mi·ti·a (kə-mĭsh'ē-ə, -mĭsh'ə) *n., pl.* **comitia.** A popular assembly in ancient Rome having legislative or electoral duties. [Latin, plural of *comitium,* meeting place : *com-,* together + *ire* (past participle *itus*), to go (see **ei-¹** in Appendix*).] —**co·mi'tial** (kə-mĭsh'əl) *adj.*

com·i·ty (kŏm'ə-tē) *n., pl.* **-ties.** Civility; courtesy. [Latin *cōmitās,* from *cōmis,* courteous. See **smei-** in Appendix.*]

comity of nations. 1. Courteous recognition accorded by one nation to the laws and institutions of another. 2. The nations observing such courtesy.

comm. 1. commerce. 2. commission; commissioner. 3. commonwealth. 4. communication.

com·ma (kŏm'ə) *n.* 1. *Abbr.* **com.** A punctuation mark (,) used to indicate a separation of ideas or of elements within the structure of a sentence. See Usage note below. 2. Any pause or separation; a caesura. 3. Any of several butterflies of the genus *Polygonia,* having wings with brownish coloring and irregularly notched edges. [Latin, from Greek *komma,* a cut, section, clause, from *koptein,* to cut. See **skep-** in Appendix.*]

Usage: A comma cannot be used to separate independent clauses not connected by a conjunction, unless they are short and closely related: *I came, I saw, I conquered. It was not only false, it was libelous.* Otherwise, a semicolon or period must be used. When independent clauses are joined by a conjunction, a comma usually precedes the conjunction if the clauses are lengthy, and especially if they have different subjects or if confusion might result from omission of the comma: *It snowed yesterday, and today the road is closed. He was eager to set out, for the woods are splendid in October.* Dependent restrictive, or defining, clauses are never set off by commas: *The book that he requested is still missing.* Nonrestrictive clauses are generally set off: *The book, which was a gift from his teacher, is no longer in print.* Similarly, terms in apposition preceded by the nondefining *a* are separated by a comma: *a Whitman poem, "Song of Myself";* those preceded by defining terms are often not separated: *the poem "Maud Muller"; my son Joe.* Two adjectives in succession are not separated by commas when the second precedes a noun with which it forms a sort of compound (in which case no pause is felt): *a rare second chance; an ugly old man.* In formal usage, the elements are separated by commas: *colored red, white, and blue.* In less formal contexts, the comma may be omitted before *and* if there is no possibility of resultant confusion. When commas are employed to set off a parenthetical passage, two are necessary: *Mr. Hay, of Montana, is the next speaker.* (Often, in such examples, both commas can be dropped, but not merely one.) Normally a single comma does not appear between the subject and its verb, though subject and verb may be separated by a passage set off by two commas: *The air, heavy with moisture, was like a warm blanket.*

comma bacillus. A bacillus, *Vibrio comma,* that causes Asiatic cholera. [From its commalike shape.]

comma fault. *Grammar.* Improper use of a comma between independent clauses not joined by a conjunction. See Usage note at **comma.**

Com·ma·ger (kŏm'ə-jər), **Henry Steele.** Born 1902. American historian and educator.

com·mand (kə-mănd', -mänd') *v.* **-manded, -manding, -mands.** —*tr.* 1. To direct with authority; give orders to. 2. To have control or authority over; rule. 3. To have at one's disposal: *He commands seven languages.* 4. To deserve and receive as due; require: *His bravery commanded respect.* 5. To dominate by position; overlook. —*intr.* 1. To give commands. 2. To exercise authority as a commander; be in control. —*n.* 1. The act of commanding or giving orders. 2. An order so given. 3. The authority to command. 4. The possession and exercising of authority to command. 5. Ability to control; mastery. 6. Dominance by location; extent of view. 7. *Abbr.* **comd. a.** The jurisdiction of a commander. **b.** *Military.* A unit, post, district, or

comic strip

comet
Comet Alcock, photographed
September 1, 1959

On the other hand, a definition that attempts a broad inclusion can be so vague as to be meaningless. Cartoonist Will Eisner once wrote, "Comics are essentially a visual medium composed of images. While words are a vital component, the major dependence for description and narration is on universally understood images, crafted with the intention of imitating or exaggerating reality." Does this mean that a United States one-dollar bill is comics? It speaks to the true complexity of this ancient yet evolving form that a working definition is so difficult to nail down without a host of riders and provisos. As with "Art," "Music," "Poetry," and "Pornography," what, precisely, is meant by "Comics" *depends.*

How to Read Nancy puts forward no Grand Unified Theory of Comics. We leave that bit of heavy lifting to others. Our goal is no less grandiose; it's perhaps just a bit more practical. We are not concerned with classifying the infinite systems of text and image interconnectivity and delineating their relative attributes. Our concern is with the Bushmiller system and its universal applicability. We are opinionated. We like *Nancy.* A lot.

But there are plenty of comics that we do not care for. A substantial strain persists made by those who are seemingly unaware of silent structures that have long been in practice and that make comic strips and comic books functionally readable. Besides time, aptitude, and something to communicate, making comics requires a rigorous commitment to the disciplines of its own peculiar craft. This is not the craft of illustration and this is not the craft of literature — it is the craft of comics.

A crucial aspect of Bushmiller's work is his concise vigor, which we believe all makers of comics can take a lesson from. It could be argued that William Strunk Jr. and E.B. White, writing in *The Elements of Style* (1959), were overly severe when they ruled: "Vigorous writing is concise. A sentence should contain no unnecessary words, a paragraph no unnecessary sentences, for the same reason that a drawing should have no unnecessary lines and a machine no unnecessary parts." Faulkner's prose is usually full of vigor but not necessarily concise. Rembrandt's most vigorous drawings often contain numerous "unnecessary" lines. But when it comes to comics, Strunk and White were right on the money.

Comics are primarily *neither* drawing nor writing, but they are, in some respects, like simple machines, designed to communicate swiftly and efficiently and with all working parts laid bare. They contain so many variables (as enumerated in this book) that they must be engineered with utmost care for a reader to divine even primary meaning. In film, such mechanics are myriad and traditionally well hidden from an audience's surveillance. But something as simple as a repair splice can easily jolt a movie viewer from his or her diegetic torpor. Similarly, in comics a misplaced balloon, an overly rendered fence, or a questionable question mark can derail the entire enterprise.

Comics are one of the great balancing acts of all media. They unfold in an intricately interdependent order of operation — yet always in plain sight. When clarity of concept, form, and execution are precisely aligned, a successful, *functional* comic strip instantly clicks into place like the squares of a Rubik's Cube and its content rises to the fore as the nuts and bolts in turn seemingly recede, but never quite vanish, from our scrutiny.

The man behind the subject of this study first saw print at the age of fifteen in the New York *World* and for the next sixty-two years produced artwork for the printed page on a continuous basis. Just as a podiatrist is primarily a physician, Ernie Bushmiller the gagmeister was first and foremost an artist. Despite their machinelike rigors, comics are an art and, like all arts, have malleable rules based on medium, culture, and epoch. Thus *How to Read Nancy* is intended not as a rulebook, but more as a playbook; not as a set of commandments, but more as a set of commendations. Functional and perhaps truly innovative comics could be made while overruling Bushmiller's methods — but they cannot be made by ignoring them.

We have read a great deal of *Nancy,* tracked down virtually every recorded word that Bushmiller left about his work, and spoken at length to his surviving colleagues and friends. We feel we have come to know this man, and we admire not only his comics but his conviction. *How to Read Nancy* is a tribute to a hardworking precisionist who rarely missed his target, never missed his deadline, and could seemingly concoct the perfect gag out of next to nothing: a few kids, a water pistol, a fence, and a garden hose. Though Bushmiller's *Nancy* may at times seem simple, obvious, or perhaps even "dumb," it is never less than masterful.

While Bushmiller was an exemplary practitioner of his medium whose work was read by millions, he was routinely dismissed in his lifetime — even by the few who were thinking seriously about the funnies and preserving their heritage. The late Bill Blackbeard of the San Francisco Academy of Comic Art (his archive now resides at Ohio State University) was a true patron saint of comics history who literally rescued tons of rare hard-copy newsprint from certain oblivion — yet failed to assemble a run of *Nancy,* which he dismissed as "infuriatingly naïve."

During its heyday *Nancy* was both beloved and reviled by its own readership: often simultaneously. Typical "Letters to the Editor" debated the strip's humor quotient, took issue with a particular stunt performed by the characters, or simply questioned the publication of *Nancy* in the first place. One 1974 reader of the *Idaho State Journal* pinpointed the precise day that *Nancy* ceased to be funny (May 15, 1955) and then poignantly grieved the strip's impending cancellation in that publication's pages. David Hendin, former senior vice president at United Feature Syndicate and a longtime Bushmiller fan, concluded: "It was the comic strip that everybody loved to hate." (In addition to exploring the lexicon of all comics, we hope to also answer the eternal question: *Nancy?!*)

Certain discerning readers, however, have long understood that something unique was at work in the strip. *Nancy* found an early admirer in art and film maven Manny Farber, who noted in the 1944 pages of *The New Republic*: "It is possible that *Nancy* is the best comic today, principally because it combines a very strong, independent imagination with simplification of the best tradition of comic drawing." His later thoughts on "Termite vs. White Elephant Art" (1962) seem spot-on in the case of Bushmiller: "Good work usually arises where the creators [here he cites Laurel and Hardy and Howard Hawks] seem to have no ambitions towards gilt culture but are involved in a kind of squandering-beaverish endeavor that isn't anywhere or for anything. A peculiar fact about termite-tapeworm-fungus-moss art is that it goes always forward eating its own boundaries, and, likely as not, leaves nothing in its path other than the signs of eager, industrious, unkempt activity."

Farber's thoughtful critique was followed over a decade later by a backhanded *Mad* magazine homage ("Nansy") lovingly illuminated by Wally Wood (who once pointed out that it is harder to *not* read *Nancy* than to

read it). The 1960s ushered in a large-scale *Nancy* portrait by Andy Warhol, as well as Joe Brainard's flurry of eccentric pastiches. Since then the strip has been increasingly adopted (and appropriated) by an escalating body of artists, critics, writers, copyright infringers, and fans. *Nancy* is a true American icon, simultaneously down to earth and ethereal.

Indeed, by 1973 *Nancy* had become so iconic that *The American Heritage Dictionary of the English Language* illustrated the entry for "comic strip" ("a narrative series of cartoons") with a tiny example of a *Nancy* strip in the margin. *Nancy* EQUALS comics.

Even as postage-stamp size marginalia, *Nancy* communicates. *How to Read Nancy* attempts to explain *why*.

To best glean this explanation, it is recommended that one begin this volume at the beginning and read straight through. Just as Bushmiller rigorously slaved under the Western convention that a comic strip is read from left to right, we have constructed our deconstruction to be read the same way. Each aspect of our chosen strip is first given a background check (what we refer to as the "Context"), augmented, whenever possible, by the artist's own words, before being placed in isolation (what we refer as the "Text"). To the comic strip makers in the house, pithy "Morals" are offered in summation here as well. A supplementary appendix and a "Do It Yourself" zone (for the reader to apply these concepts to a selection of *Nancy* dailies) follows this section of explicated spreads. These exercises, in turn, are followed by a comprehensive bibliography.

Discovering the complexities embedded in such a deceptively simple specimen as this strip is an exercise in optical perception. Although this book is aimed primarily at students of comics, *How to Read Nancy* can also be read as a meditation on the nature of visual communication for the general reader as well as the practicing visual communicator. We have analyzed this example of *Nancy* in numerous college-level art classes and found it effective in rapidly improving student work and overall visual acuity, a truly useful skill for any sighted citizen in a culture teeming with so much visual fakery and hucksterism. Critical Thinking is taught at the college level, but Critical Perceiving must come first.

Noam Chomsky has asserted that the study of linguistic syntax is primarily one of biology. This notion is also applicable when discussing comics syntax, ostensibly a visual "language" and certainly dependent on visual perception. Thus we have endeavored to follow the same analytical restriction in our "Text" that we place on our students: *Stick with the observable.* We trust that maintaining a straight and deliberate course while steering clear of foggy conjecture and abstract extrapolation can allow for revelations.

Our first draft of this dissection saw light in a short essay included in comics historian Brian Walker's indispensable *The Best of Ernie Bushmiller's Nancy* (1988 BP — Before Photoshop). That little essay has been reprinted many times since and used in countless classrooms, and it has seemingly informed new generations of comics forensics. In the intervening years we have continued to return to this strip, scrutinizing it down to the tips of the blades of grass under Nancy's feet to fully understand what makes it run with such clocklike precision. This book has been over twenty-five years in the making, yet we still continue to discover new gears in that clock.

Back in 1988 we singled out this particular strip for autopsy almost by accident. But as Picasso once said, "There are no accidents." We found that the *Nancy* of August 8, 1959, is like a Zen onion: simple at first glance but infinitely layered. And there is no doubt that a great deal of the other 16,000-odd *Nancy* strips that Bushmiller produced in his lifetime are too.

Bushmiller might have been amused by an analysis like ours, but he probably would not have been completely surprised. The cartoonist was routinely besieged with correspondence from his readers who searched for significance in his strip and found it: everything from tips on the ponies and lucky numbers for policy players to the theory of tectonic isostasy and the perfect names for their newborns. And while he may not have especially cared to belabor the contents of these three particular panels, the demand he placed on himself and his colleagues' work was loud and clear: "Remember . . . ya gotta DO THE JOB RIGHT!"

We take this directive to heart and challenge our readers to do the same. Ernie Bushmiller's *Nancy* deserves to be seen (and understood) at exactly the level at which it was drawn — if only for this one time.

(And as for us cartoonists, we may be able to draw like Leonardo, write like Twain, and construct three acts like Shakespeare, but if we are making comics and cannot *think* like Bushmiller, there is little hope.)

Paul Karasik, West Tisbury, Massachusetts
Mark Newgarden, Brooklyn, New York

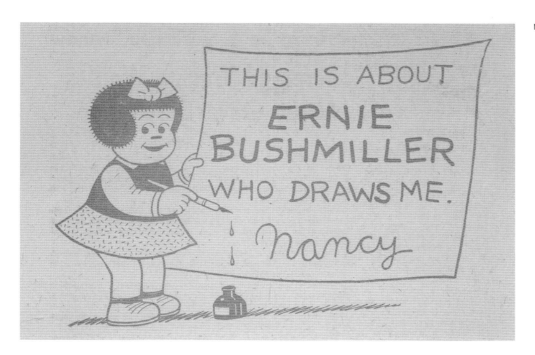

New Haven Register, *January 18, 1959.*

Not magnitude, not lavishness,
But Form — the Site;
Not innovating wilfulness,
But reverence for the Archetype.
— Herman Melville, 1891

"I never did anything interesting."
— Ernie Bushmiller, 1945

"HOW TO READ NANCY?"

you might ask. "You might as well explain how to read a stop sign!"

You'd be right, perhaps, or at least in part, but there's a lot more to Ernie Bushmiller's comic strip than meets the eye. Because, like a traffic signal, meeting the eye is precisely what *Nancy* was designed to do. Before your inner traffic cop can step in and holler "STOP!" the optic nerve has thoroughly transmitted the essence of *Nancy* to your frontal lobes, and chances are that you have either smiled, frowned, moved along to the next strip, or doubled over in arch hysterics. Few other cartoonists have ever met their readers with such systematic economy.

To dismiss *Nancy* as a simple strip about a simple-minded slot-nosed kid is to miss the gag completely. *Nancy* appears to be simple only at a simple glance. Like the modernist architecture of Mies ("Less is more") van der Rohe, *Nancy*'s deceptive simplicity is a deliberate function of a complex amalgam of formal rules laid out by a master of design. To consider Bushmiller as an architect is entirely appropriate, for *Nancy* is, in a sense, a blueprint of a comic strip. Walls, floors, rocks, trees, ice cream cones, motion lines, and midgets are clearly demarcated and carefully positioned with no need for further embellishment. And they are laid out with one purpose in mind: to put the gag across.

"Clarity is more important than an artistic effect," Bushmiller bluntly declared. "I try to focus attention on the item or object that tells the story. I leave out all extraneous detail that may detract from the main point."

Minimalist? Formalist? Structuralist?

CARTOONIST!

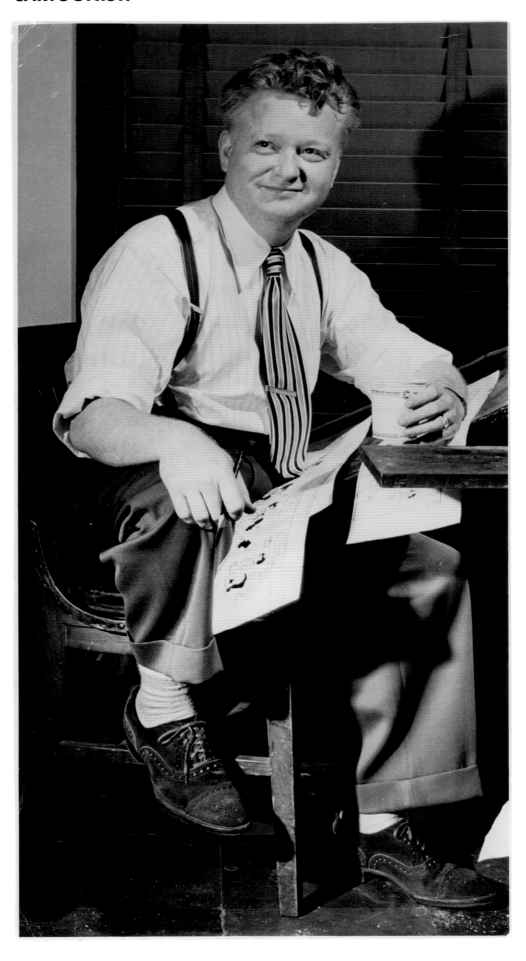

Right: *Ernest Bushmiller Jr., 1948.*

Ernest Paul Bushmiller Jr. entered life on August 23, 1905, in the Twenty-third Ward of New York City (633 East 137th Street, borough of the Bronx). He was the middle child of two young immigrants (he German, she Irish) who had landed at Ellis Island in the final decade of the nineteenth century and met on the streets of New York.

"I have a very vivid memory of my childhood," he confided seventy years later with little elaboration. "I was a very screwy little kid."

Ernest and Elizabeth Hall Bushmiller brought up Junior along with his sisters, Vera and Florence, in a series of gas-lit coldwater flats in the grim and largely industrial southwest Bronx neighborhoods known as Port Morris and Melrose. These he later nostalgically assessed as "rough — but normal for the time." "On my street there were about three hundred kids — all from similar backgrounds — but none of us ever got into any trouble. They all turned out to be cops, firemen, plumbers, etc.," Bushmiller recalled. "I was one of those unusual kids who looked forward to rainy days so I could stay indoors and draw. . . . I was a sort of Casper Milquetoast. . . . [I] never caricatured the teacher."

"Lizzie" Hall was born in 1876, the daughter of Episcopalian farmers of English extraction, and grew up with three strapping bothers in a thatched-roof cottage in Northern Ireland. She arrived in America in 1894, while her brothers (all measuring in at precisely six feet four inches) remained and signed on with the Belfast police force. Her son remembered her mainly as a "gentle and kind" woman with "the most wonderful sense of humor I have ever known" and wrote, "Although we were poor, we ate well and were always secure in the knowledge that our parents loved us and we loved them."

The Senior Bushmiller, a frustrated artist and voracious reader who struggled to support his young family, was born in 1874 to a literary-minded couple in Elberfeld, Germany. His father, Johann Heinrich Buchmüller, taught high school there and in 1869 founded the newspaper *Mettmanner Kreisblatt* in the small neighboring village of Mettmann in the North Rhine–Westphalia region. His mother served as a journalist for the family business and apparently wrote novels under a nom de plume as a sideline. Both were dead before Ernest, the youngest of six, had reached his second birthday. After spending the balance of his childhood with an impoverished and nearly senile grandmother, he set sail upon her death for the New World at age fifteen with nothing more than ten dollars in his pocket — and hope.

But the American dream eluded Ernest Bushmiller Sr. Initially impeded by the language barrier, he failed to rise above a scrappy, meager livelihood tending bar and peddling life insurance. Even though self-improvement remained a steadfast priority, "he never found his niche," his son wrote many years later. "Despite his omnivorous intellectual bent, he never made it. His knowledge of literature and history was enormous." No garden-variety bookworm, Ernest had also been a self-styled vaudeville chalk-talker in his youth, hustling laughs with his onstage doodles at Tony Pastor's on 14th Street, and he encouraged his son's creative bent. Like his old man, Ernest Jr. wanted to be an artist — and an entertainer.

Fortunately those combined ambitions converged with the first comics boom. Although both narrative sequential art and caricature had been around for centuries, in the mid-1800s an eccentric Swiss boarding school teacher and amateur painter named Rodolphe Töpffer arguably became the first comics creator by combining words and pictures with a new kind of intent (linear, direct, easily read) in a novel series of self-published volumes, single-handedly forging a medium in the process. Several decades of experimentation (and

Ernest Bushmiller the elder, circa 1904.

piracy) followed, with proto-comics popping up in various forms around the world, incubating and cross-pollinating until they finally found a place to take solid economic root: the American newspaper.

This was due, in part, to a series of revolutionary developments in the mass reproduction of images and the responses to these changes by the artists who created them. Cartoonist Frederick Burr Opper reminisced about the shifts his profession underwent in an unpublished memoir entitled "Comics and Cartoons of Earlier Days," written in 1933, near the end of his long career. He explained that when his earliest work was published in 1876, "drawings were made on blocks of boxwood and engraved by wood engravers, a slow and expensive method of production. Wood engraving was a well-paid and lucrative profession. Engravers had to serve an apprenticeship of three years before they could set up for themselves. Suddenly, almost overnight, the photo-engraving process of reproducing pictures made its appearance. It was much cheaper and much quicker than wood engraving. Publishers at once saw its advantages and adopted it — and the use for wood engravers ceased almost entirely."

Opper's drawings, through the intermediate hands of engravers and lithographers, were consumed by the public for years before a direct reproduction of his own pen lines ever saw print.

By the end of the nineteenth century the daily press had become the central locus through which Americans received the vast bulk of their news, data, and entertainment. With Joseph Pulitzer's introduction of high-speed color printing added into the equation at the New York *World* in 1893, proto-comics, pseudo-comics, and, soon, honest-to-God *comics* suddenly became a viable commodity, narrowly winning one early public trial over an alternate four-color weekly supplement depicting lady's dresses.

The New York World*'s wondrous Hoe four-color rotary press, able to produce upward of 20,000 color supplements per hour, March 27, 1898.*

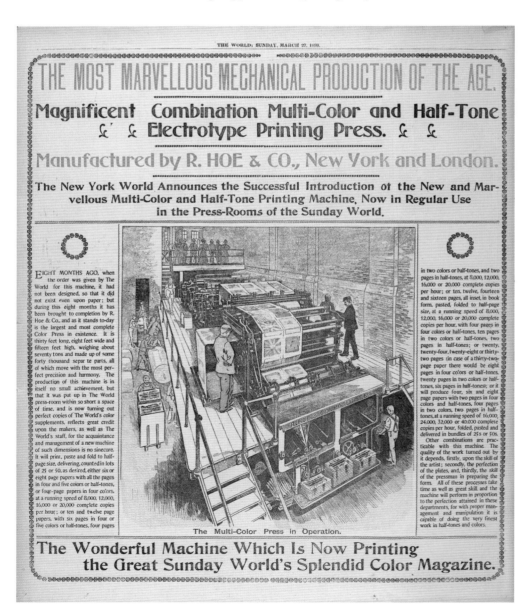

The great popularity of these new color strips was one of the more felicitous and enduring outcomes of the newspaper wars of this "Yellow Press" era, largely fought between news barons Pulitzer and his bitter rival, William Randolph Hearst. Insider Moses Koenigsberg took pains, however, to note in his autobiography, *King News* (1941), that the form of newspaper comics simply followed the function of graphic suitability for an early, imperfect Hoe four-color rotary press. "Contrary to a general notion, the colored comic did not issue from a genius for humor," he asserted. "It was born, not in a flash of afflatus, but in the travail of editorial minds trying to solve a problem. It was the answer to a mechanical conundrum."

These garish, eye-catching, quickly digestible supplements, all kids and beasts and tramps and tricks, proved to be demonstrable circulation boosters (50,000 additional readers per paper on Sundays by one 1900 estimate) and multiplied rapidly, yet for all intents and purposes they were still essentially novelties. From the very start it became part and parcel of the newspaper strip cartoonist's job to keep a wide readership actively engaged in his drawings and ideas and coming back for more — or there just might not be any more.

The working methods of American newspaper cartoonists and comic art itself underwent a halting transformation at this time, in large part to serve the demands of this emerging medium. Such polished draftsmen as Opper (who in the weekly humor magazine *Puck* had generally worked in the dense and detailed manner of nineteenth-century political cartoonist Thomas Nast) began to systematically rethink his entire approach to drawing — and how his drawings would be read.

In numerous Sunday comic strips, including the seminal *Happy Hooligan* (a childhood favorite of Bushmiller's, which began in Hearst's *New York Journal* in 1900), Opper jettisoned the printed caption and embraced the word balloon while he increasingly simplified, exaggerated, and abstracted his imagery to meet the rigors of direct and effective newsprint narrative — as well as a broader (and less reliably literate) readership. In virtual lockstep with several other concurrently emerging media (most significantly the motion picture), newspaper comics would become a staple of America's new fast-acting multimedia narrative diet.

Critics of the day, at least those few who cared to acknowledge such things, invariably took harsh note. Frank Weitenkampf, in his *American Graphic Art* (1912, revised 1924), praised Opper's earlier work at *Puck* for "the element of caricature [entering] into

his drawings with just enough force to accentuate the point of the joke he is illustrating" but found his subsequent newspaper drawings "subordinated to an almost elementary simplicity." ("To-day the idea is apparently everything to him.") "The comic strip," he went on, "with its daily record of the doings of stenciled personages has in more than one case descended to an expression of unlettered vulgarity. And it is not art but literature with rubber-stamp illustrations. The eternal ebullition of the all-dominating 'kid,' to the discomfiture of its elders, is not exactly a pleasing subject in the gaudy 'Supplement' for which our children can hardly wait on Sunday." However, those "kids" (as well as those immigrants, those women, and those working stiffs), whom these strips simultaneously caricatured and were geared toward, avidly devoured them by the million.

Opper reflected of this era, "In the days I speak of there was a great deal of crudeness in the public taste regarding comic pictures. Acrobats, physical violence and painful mishaps were the stock subjects for the comic artists. People falling down stairs, slipping on banana skins, being thrown out of buildings and chased by dogs were staple subjects. In fact public taste was crude in many other respects. It was a period when prize fighters had not-yet adopted boxing gloves but were pummeling each other with bare fists. It was the time when Henry Berg the kindly man who founded the Society For The Prevention of Cruelty to Animals was hooted with shouts because he wanted to lighten the sufferings of dumb creatures. It was a time when an unbalanced man dubbing himself 'Count Johannes' appeared as Hamlet in a Broadway theater before a howling mob. It was the time of the 'Amateur Nights' at a Bowery theater when any fortunate novices who wanted to become actors were 'tried out' and many of them were violently yanked off the stage by a large hook, manipulated from the wings. It was a time when a popular comedian made an enormous hit by giving a realistic portrayal of an epileptic fit. Small wonder then that the comic pictures and cartoons of those days reflected the prevalent coarseness of public taste."

Scores of other strip creators, including such younger artists as Rudolph Dirks, James Swinnerton, F.M. Howarth, "TAD" (Thomas A. Dorgan) and "TEP" (Thomas E. Powers — one of Hearst's personal favorites), often pushed the envelope further with intentionally simplified (and sometimes intentionally crude) yet highly effective comic techniques. Emboldened by one another's weekly revelations and informed by a generation of such widely imported Europeans as children's author Wilhelm Busch (who in turn had been directly influenced by Töpffer), this new, blunt, and vital kind of drawing — engineered to embody the slapstick it usually delivered — marked the birth of modern cartooning in the United States.

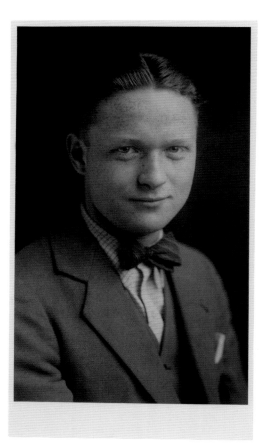

I was a teenage Bushmiller.

Powerful full-service syndicates soon arose from the press magnate's extensive newspaper chains, beginning with Hearst's Newspaper Feature Service (later called King Features Syndicate) in 1913. While press syndicates had operated on a modest scale for decades and generally focused on hard news, now hundreds of smaller newspapers throughout the country would amplify their pages with a complete seven-day-a-week menu of the same bylines and entertainment features that had proven popular in big-city editions. Comics in particular generated readers, and those readers generated advertisers. Both generated income. Color supplements, once buried in the back of Sunday newspapers, soon became their point-of-purchase display. Thanks to the viability and low cost of the new lightweight stereotype "mat," such hit strips as Bud Fisher's *Mutt and Jeff* (one of the first to score on a daily basis) could now simultaneously amuse both their New York *World* and Cleveland *Plain Dealer* readership with the same punch line, brickbat, and out-the-back-panel "Plop!" In turn, the savvy creators of such sensations could enjoy princely incomes and international celebrity. It was a very good time to become a cartoonist.

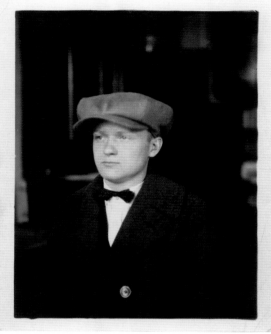

Ernie Bushmiller launched his sixty-three-year newspaper career in 1919 at age fourteen with a self-described "lucky break": convincing his parents to allow him to quit Theodore Roosevelt High School on East Fordham Road after a scant six months of attendance to fill a vacant copy boy post at the New York *World.* There is little doubt much convincing was ever necessary; the struggling Bushmillers, like many in their circumstances, simply needed the income more than any sheepskin prestige. "On my entire street only two kids went to high school," he later reminisced. "By today's standards they were Phi Beta Kappa." Had a coin toss gone the other way, Bushmiller maintained, he would have signed on as a cabin boy with the Cunard steamship line instead. ("Thank God! Otherwise I'd probably be a steward on the *Queen Mary*!")

Headquartered in what had once been the tallest building in the world — an eighteen-story golden-domed skyscraper alongside City Hall on Manhattan's famed Park Row — the populist, picture-packed New York *World* was a landmark publication in the history of the American newspaper, the first to hit the one-million mark in its daily circulation. Perhaps past its groundbreaking prime, this institution was still, at the time that Ernie Bushmiller first walked through its marble foyers, just as its name advertised: one of the largest and most influential broadsheets on earth.

Although the *World*'s crusading founder, Joseph Pulitzer, had been dead for nearly a decade, the early 1920s were to become a time of rebirth for this newspaper. As James R. Boylan explained in *The World and the Twenties* (1973), "Pulitzer probably would have shown scant patience with the sober, temperate editorials; nor would he have responded to the light note of chic, centering in the famous op. ed. page, across the editorial page where pranced the literati of the Algonquin Round Table, the relatively fashionable radicalism of Heywood Broun and the reviewers of books, plays, films and music. This *World* displayed a new temper, no longer fervent but cool, skeptical, playful although still aroused to heat by such issues as political violence, racism or repression. Possibly it was no longer a newspaper for every New Yorker but rather for those New Yorkers who read, went to plays and parties, took an interest in issues and 'kept up' — in other words, a kind of elite."

Landing this job was considered quite a coup for a creatively inclined youngster from a working-class immigrant background, and while it netted him only nine dollars

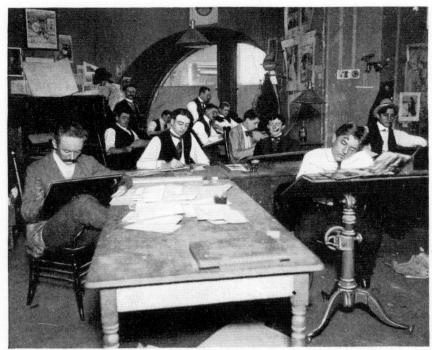

THE ART DEPARTMENT OF THE "SUNDAY WORLD," SHOWING THE MAKERS OF ITS WONDROUS ILLUS-TRATIONS AT WORK.

Top left: *The* World *art department of a generation earlier. Munsey's Magazine, November 1900.*
Bottom right: *Herb Roth remembers his former office boy, 1952 (original artwork).*

a week, Bushmiller later claimed he would have paid the *World* that nine dollars himself "if I'd had it, just to let me hang around."

Early each weekday morning, Ernie left his family's small apartment at 288 156th Street in the Bronx, paid his nickel fare, and rode nearly an hour downtown on the Lexington Avenue IRT line. Exiting with the crowds at the Brooklyn Bridge–City Hall station, he crossed the green to 63 Park Row — and another universe. There he and six or seven other boys sat on a hard wooden bench in the vast, loud city room of the *World* waiting for one of the scores of reporters or feature writers to finish his piece and bellow with the call of *"Copee-ee-e!"* The next available copy boy would then rapidly collect and relay the precious typewritten sheets to the appropriate editor in the labyrinthine World Building. The industrious teenager dutifully gathered raw copy from such cultural luminaries as Alexander Woollcott, F.P.A. (Franklin Pierce Adams), Frank Sullivan, Heywood Broun, Walter Lippmann, and Deems Taylor. But he wasted no time in making his way to the inner sanctum of the *World*'s art room.

Ernie's inherent sense of humor and raw ability with a pencil caught the attention of his own personal luminaries: the newspaper's comic strip artists. "I was usually over in the art department when the news editors called me. Spent all my time hanging around . . . watching the cartoonists work. Got the biggest thrill of my life talking to such big-timers as H.T. Webster, Milt Gross, Herb Roth, Rudy Dirks, etc." He soon found himself promoted, running their personal errands and sweeping their personal cigar butts, and from these illustrious mentors young Ernie Bushmiller, self-described "mental blotter," absorbed some rudiments of their craft.

The copy-boy-to-art-room track seems to have been something of an institution at the *World*. Harry Haenigsen, who later created the popular teenage comic strip *Penny,* arrived at the *World*'s doorstep only a scant week before Ernie and had just made this transition ("He was kind of an older office boy. I think he had long pants and I had short pants."), while future *Streaky* cartoonist Loy Byrnes followed directly on their shirttails. (A few years later Ernie lorded over his own office boy, future Academy Award–winning screenwriter and director Norman Krasna.) In a 1947 piece on obtaining work in the field of newspaper graphics, John Wolter, who ran the King Features editorial art department, outlined an apprenticeship system structured along a very similar line. He bluntly described the qualifications needed to take the next step up this particular job ladder: "A man must produce or he's worthless to us; in fact the character of the newspaper and syndicate business can be summed up in one word: production."

With fewer than a dozen regular strips and panels (published weekdays, as well as in the four-color "Funny Side" supplement on Sunday), the *World*'s cartoonist bullpen of this era was compact compared to the Hearst paper's expansive lineups — but competitive. Such major-league features of the day as *Mutt and Jeff* and *The Captain and the Kids* called the New York *World* home. Angles ranged from the giddy slapstick and

loopy penwork of strips like these to the sly satire of H.T. Webster's *Life's Darkest Moment* and Harry Haenigsen's stylish travesties of the day's headlines. Milt Gross's cynical *Banana Oil* gave Broadway wise guys their latest catchphrase, while R.M. Brinkerhoff's *Little Mary Mixup* kept their nieces and nephews back home on the edge of their seats until tomorrow's edition.

Another very young man with a passion, broadcasting pioneer Himan Brown, recounted his own youthful entree to that insider's enclave on the eleventh floor: "For me to describe the place these cartoonists worked in, in the old *World* building down on Park Row in Lower Manhattan, is really a nightmare in itself. These were tough hard-bitten men, an elite unto themselves. They sat side by side, doing the cartoons and comic strips that were so familiar, in this one smoke-ridden room, with spittoons and filthy dirty pictures on the wall. Pornography was invented by these guys. And here I come, with my schoolbooks under my arm, knocking on the door."

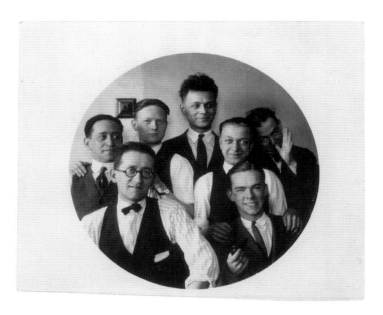

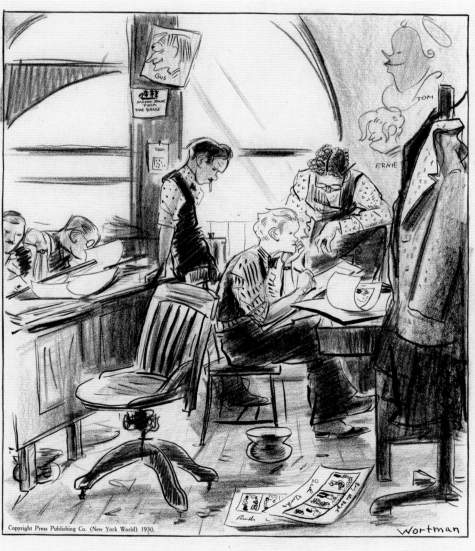

Above: *A few of the World art department inmates in the early 1920s. Top left to right: Maurice Ketten, Ernie Bushmiller, Fred Locher, Gus Jud, unidentified. Bottom: unidentified, unidentified.*
Left: *The World art room in its latter days, as depicted in Denys Wortman's daily panel, Metropolitan Movies, March 3, 1930. Pictured left to right: Clyde "Vic" Forsythe (Joe's Car), unknown, Harry Haenigsen (News and Views), Ernie Bushmiller, Milt Gross (Nize Baby). On wall: Gus Jud (Little Dave), Ernie Bushmiller (again) and Tom Johnstone (manager of the World's syndication arm, Press Publishing, Inc., and brother of topical cartoonist Will B. Johnstone) (original artwork).*

Shortly before his death in 1931, the noted Sunday *World Magazine* illustrator Leo Kober channeled the departed spirits of this same room in his meditation on the *World*'s collapse, "Portrait of the Artist as a Corpse." "What a joke it sounds like! And yet the holy flame of true enthusiasm, the eternal light of big doings, here in this room it was kept going and burning. How they looked in print! ... Who cares? Daily hackwork and ... beating, throbbing, struggling hearts of artists with the everlasting, never-ceasing side glance for the great and beautiful ... Art enchained into two columns and three columns, veloxes and silverprints, comics, pretty girls and cartoons ... done by men devoted to a great and wonderful passion. Passion transposed into jobs, holy struggle into daily routine, but passion and struggling still. The great desire of creation, cut into pieces, for Sunday morning use, as accompaniment of the breakfast coffee and pancakes." This was, above all, a place where laughter met a daily deadline.

"Cross-Word Puzzle Corner" ("Ingenuities"), Sunday New York World Magazine, February 6, 1921.

Ernie swapped his knickers and push broom for a button-down vest and the stray board assignment tossed his way, such as brushing in solid blacks, lettering word balloons, and (significantly) laying out the newspaper's weekly crossword puzzles — originally invented at the *World* in 1913 by Arthur Wynne. Gradually the green kid from the South Bronx learned the demanding ropes of newspaper graphics and ripened into an able hand. "I became their expert crossword puzzle line drawer," he proudly recalled. "This job did nothing for my sense of perspective but it gave me a lasting familiarity with the T-square."

Left: "Knight's Square" ("Ingenuities"), Sunday New York World Magazine, January 2, 1921. Below: "How to Walk Five Miles in Five Minutes" ("Ingenuities"), Sunday New York World Magazine, March 4, 1921.

By December 1920 Ernie was among the principal illustrators of "Ingenuities — Are Your Wits Equal to Them? (If Not Turn to Page Thirteen)," the Sunday *World Magazine's* weekly puzzle and brainteaser page. His first signed work appeared there on January 2, 1921, the initials "E" and "B" bookending a small word puzzle depicting a crude pair of chess knights. E.B. carried a clipping in his pocket for weeks.

By March 4 he had published his first comic strip. Ernie Bushmiller was fifteen years old.

If one were looking very closely, a dedicated *World* puzzle fan might have detected larger, bolder, and more numerous images, variously signed "E.B.," "E. Bushmiller," or even (for a short stretch) "Bush-Miller," decorating the Sunday magazine's penultimate page each week. This was a period of experimentation. New tools and new techniques were enlisted or discarded and the printed results dutifully scrutinized. One week Ernie reached for a "ye olde" woodcut look, another week a halftone ink wash followed by an encore with a calligraphic nib. Pen lines waxed and waned. Even the dark squares of his crosswords shifted unpredictably from solid to striped to speckled. By the fall of 1922 the page's very young lead illustrator was considered adept enough to handle the design of an extravagant double-page four-color edition of "Ingenuities" whose jazzy borders he executed as an epic rebus.

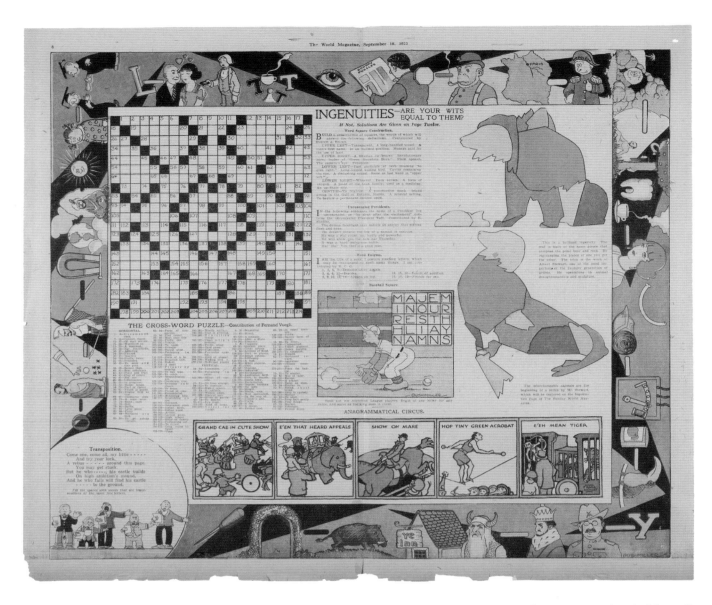

Bushmiller's first color page ("Ingenuities"), Sunday New York World Magazine, September 10, 1922.

This teenager's graphic design showed promise, yet there was an inevitable pull toward the comic. On some early pages he simply snuck sketchy facsimiles of his favorite "big time" characters (such as Gus Mager's *Hawkshaw the Detective* and George Herriman's *Krazy Kat*) into the proceedings. But increasingly Bushmiller's puzzle assignments took the form of the comic strip, and his editors apparently gave him his head. Recurring characters would soon come and go, including the riddle-happy comedy team of *Jibes of Jib and Jab*, the clownish duet of *Ditties of Dee and Dumb,* and the sassy bob-haired starlet of *Trixie's Tricks* — who perhaps served as a primordial prototype for Bushmiller's most famous creation nearly a decade later.

However heady it may have been for this teenager to see his work in print every week, illustrating comic strip puzzles was still not creating comic strips — and Ernie was determined to join the staff cartoonists on Mount Olympus. After a hard day at the *World*'s drawing boards, Bushmiller continued to draw. "While doing the puzzles I submitted many cartoon strips. I read humor strips and traced and swiped and developed my artwork," he later confessed. "I looked over shoulders in the art department and as fast as I developed anything I showed it around for advice." And he received it, forging lifelong friendships with many of the *World*'s cartoonists as fellow Bronx boy Milt Gross stepped into the role of Ernie's mentor.

"Special Rates for Actors," perhaps Bushmiller's first solo completely puzzle-free attempt at a comic strip of his own, ran (rather out of context) on the January 29, 1922, "Ingenuities" page. Another early effort went to print nearly a month later on the amateur page of the venerable national weekly humor magazine *Judge*. Their wispy, delicate linework immediately recalls such fashionable contemporary stylists as John Held Jr. and Ralph Barton — but the characters (and humor) were pure vaudeville sledgehammer.

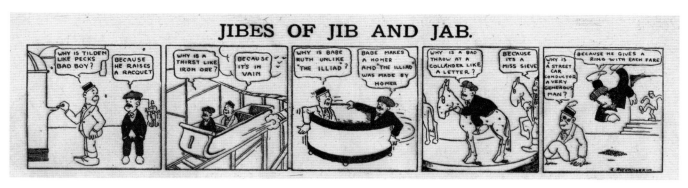

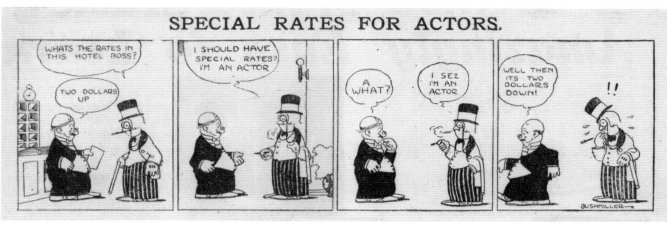

Amateur Knights of the Pencil

Drawn by ERNEST BUSHMILLER, New York *World* Sunday Art Department, 63 Park Row, N. Y.

Knuttley— Would you like to come to a lecture on the heart and lungs tonight?

Sappley — I'm sorry, but I don't care for organ recitals.

Jibes of Jib and Jab ("Ingenuities"), Sunday New York World Magazine, July 31, 1921.
"Special Rates for Actors" ("Ingenuities"), Sunday New York World Magazine, January 29, 1922.
"Amateur Knights of the Pencil," Judge magazine, February, 25, 1922.
Trixie's Tricks ("Ingenuities"), Sunday New York World Magazine, July 30, 1922.

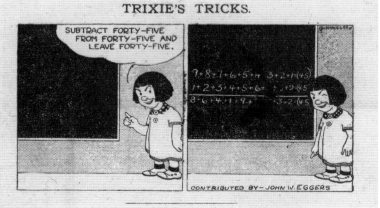

Remarkably, by the fall of 1924, Bushmiller had already sold his first continuing comic strip: *Mac the Manager,* about the daily doings of a hungry boxing promoter and his thick-witted meal ticket. However, *Mac* did not premiere in the glorious pages of Joseph Pulitzer's New York *World*. It launched instead in ex-strongman Bernarr "Body Love" Macfadden's new uptown scandal sheet, the *New York Evening Graphic* (a.k.a. "The Porno-Graphic"), home to cash prize contests, lonely hearts clubs, and the absurdly faked "composograph" photos (and historically esteemed as one of the sleaziest — if not silliest — ventures in American journalism). *Mac* fit the template for other *Graphic* strips (including *Ozzie and His Gym* and *Little Samson*), which directly reflected Macfadden's well-known mania for physical culture. Jumping ship for a better berth may have been a routine method for getting ahead in the newspaper game, but from the very start the *Graphic* was a shaky vessel for cartoonists. No comic strip was ever to develop a solid footing there in its brief eight-year run. Bushmiller was lured onto the tabloid's staff along with his sports cartoonist friend Gus Edson and dutifully hacked it out for nearly three months (Edson lasted three years). But while *Mac* went down for the count after a few brief rounds in the *Graphic*'s back pages, his energetic creator's extracurricular activities did not go unnoticed over at the *World*.

Mac the Manager, New York Evening Graphic, *September 7, 1924.*
Mac the Manager, New York Evening Graphic, *September 22, 1924.*
Mac the Manager, New York Evening Graphic, *September 23, 1924.*
Mac the Manager, New York Evening Graphic, *September 30, 1924.*

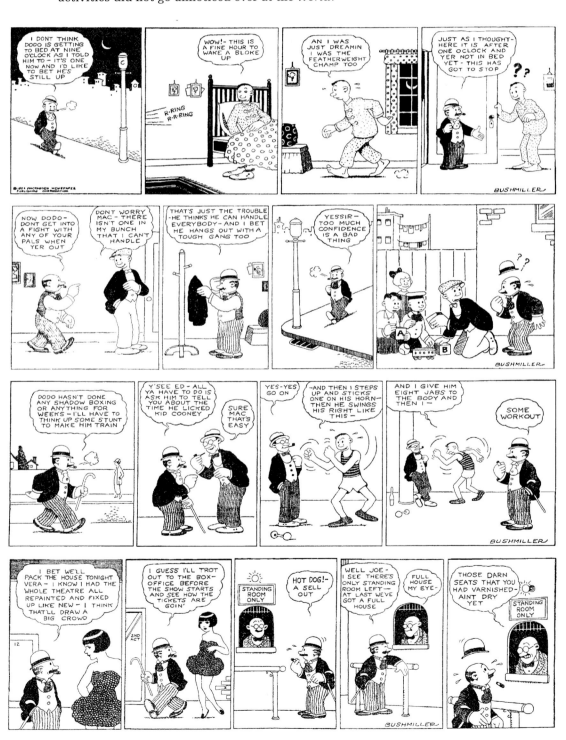

HELP HOUDINI OUT OF THE HANDCUFFS

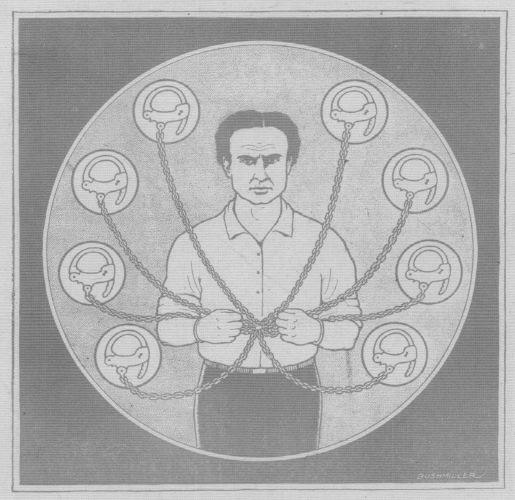

Harry Houdini can escape from real handcuffs, straitjackets or prison cells as easily as you or I would walk out of the room; but we have put him in paper handcuffs here so tight that he can't get away. You can help him escape by following directions:

As many as you please can play the game. Hang this page on the wall, at about the height of your eyes. Then stand about ten feet away from the picture with a pencil in your hand; take a good look at it, close your eyes and walk toward it; when you have reached it without opening your eyes make three marks in where you think three of the handcuffs are. Then let some one else try. You had better each decide on a special mark—say, one a cross, another a circle, a third a triangle, and so on. The first to get his mark in three of the handcuffs sets Houdini free and wins the game.

Copyright: 1924

SAVE YOUR MAGIC SECTIONS EACH WEEK
ANSWERS NEXT SUNDAY

*Harry Houdini by Ernie Bushmiller,
"Red Magic," Sunday New York World,
December 12, 1924. (Syndicated to the
Philadelphia Inquirer, December 21, 1924.)*

Bushmiller's increasing facility and puzzle savvy led him to a plum assignment on the Sunday *World*'s new "Red Magic" supplement, which launched on November 16, 1924, replacing the old "Ingenuities" page (which had been immodestly retitled "Best Puzzle Page in New York" that April). Ostensibly edited by renowned escape artist Harry Houdini and printed in blood-red ink, this syndicated eight-page tabloid insert promised "EDUCATION as well as ENTERTAINMENT" in the form of illustrated puzzles, games, and tricks, plus exposés of popular stage illusions (which eventually landed the magician in hot water with some of his peers). But for this ambitious young draftsman "Red Magic" was a golden opportunity, and there, in the company of such dependable yeomen as Herb Roth and Art W. Nugent, he honed his already considerable cartooning, graphic design, and storytelling skills further.

Over the course of his six-and-a-half-month stint with Houdini, Bushmiller continued to rule the squares and brush in the blacks of his crossword puzzle grind (which had gone daily at the *World* in 1924), but he soared on Sunday, furnishing "Red Magic" with numerous striking illustrated covers and elaborate full-page cartoon puzzles. Some of these featured his own recurring character Enigmatic Edgar (often accompanied by Anagram Ann or Cryptic Clarence). His drawing had ripened into a pleasing workmanlike cartoon style that would be more at home on the newspaper's comics page than ever before. Itching for another crack at a strip of his own, in his final months there he somehow managed to slip one into the mix, appropriately entitled *Cross Word Cal*.

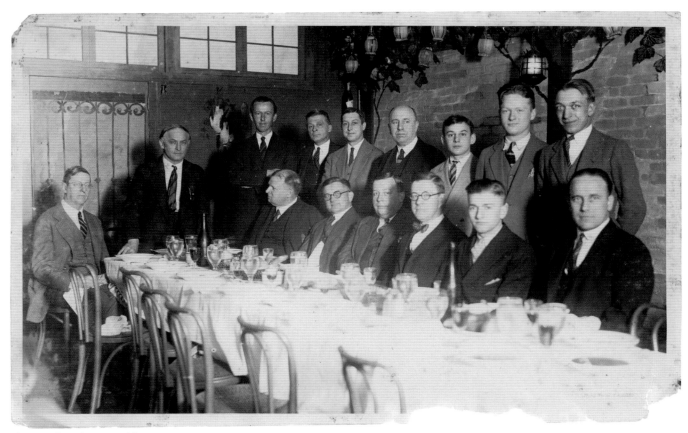

Above: Houdini and company celebrate the launch of the New York World's "Red Magic," November 1924. Left to right, standing: Harry Houdini, F. Gregory Hartswick (crossword puzzle editor), Herbert Bayard Swope (executive editor, New York World), unidentified, Karl K. Kitchen (writer), Norman Krasna (office boy and future Academy Award-winning screenwriter and director), Ernie Bushmiller, Gus Jud (illustrator). Seated: John O'Hara Cosgrave (Sunday New York World editor), William Andrew Johnston (writer), unidentified, unidentified, Charles Merz (writer), Loy Byrnes (illustrator, identification unconfirmed), and Art W. Nugent (illustrator).

A HAPPY NEW YEAR TO THE PUZZLERS

The annual swearing off takes a cryptic guise. First of all we observe the insignia of the New Year. The old year has an anagram embroidered on his nightgown. Rearrange the letters to form an appropriate phrase. He cries out in the form of a spell-out square. Move as the king in chess and spell out consecutively the words of a six-word phrase. The legend on the chimney is in the form of a number cryptogram. Each letter represents a number in accordance with the succession of letters in a ten-letter expression. The calculation will give you the clues. The New Year exclaims in an enigma. Guess the words defined and distribute their letters in accordance with the number given.

The cake eater leaning against the fireplace speaks his vacant patter in the form of a transposition. Fill the blanks with words made of the same letters. The solemn guy looking down at the table makes his vow in a cryptic phrase. The man next to him talks in hidden words, as "good" is hidden in "years ago, oddly." The third at the table speaks an anagram. On the clock is a rebus, of which every picture represents a syllable of a phrase. The cat declaims in an anagram. The small spell-out square in the corner comments upon the contents of the big square next to it. The big square contains seven bad habits,

SAVE YOUR MAGIC SECTION EACH WEEK AND YOU WILL HAVE A UNIQUE COLLECTION OF TRICKS, GAMES, PUZZLES AND INGENUITIES OF ALL SORTS

"A Happy New Year to the Puzzlers"
("Red Magic"), Sunday New York World,
January 4, 1925.

THE ONE-HORSE TOWN

This thriving community has taken to puzzling as a means of self-expression. The sign-painter in the lower left-hand corner has put the name of the village in a number cryptogram. The letters represent the figures in a sum in long division. When solved and the letters arranged according to their respective figures, they will spell the name of a small town.

The young married couple crossing the street speak in an enigma. Guess the words defined and arrange their letters according to the numbers given to spell a sentence expressive of many married folks' resolve.

The various emporia of the village carry their names in anagrams, as do the sandwich man and the leisurely-proceeding horse-'n'-wagon. Rearrange the letters to form appropriate words and phrases.

The smart-aleck talking to his friend leaning against the lamp-post speaks of his firm resolve to seek his fortune in the great and wicked city, using a transposition to convey his thoughts. Fill the blanks with different arrangements of the same five letters.

SAVE YOUR RED MAGIC—ANSWERS NEXT SUNDAY

"The One-Horse Town" ("Red Magic"),
Sunday New York World, March 8, 1925.

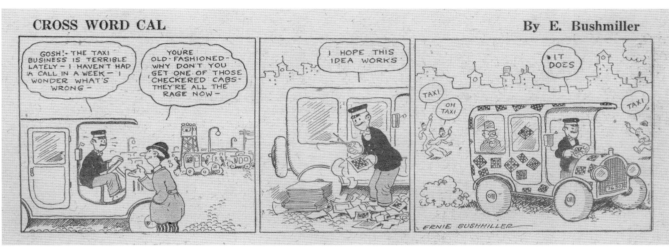

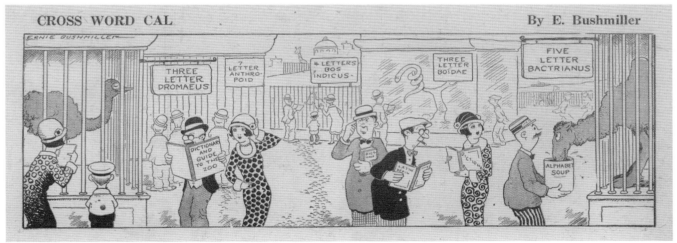

Cross Word Cal ("Red Magic"), Sunday New York World, April 12, 1925.
Cross Word Cal ("Red Magic"), Sunday New York World, April 19, 1925.
Cross Word Cal ("Red Magic"), Sunday New York World, May 3, 1925.

Although a popular exclusive at the New York *World* for many years (as well as Ernie Bushmiller's primary source of income), the crossword puzzle would suddenly become the proverbial "overnight sensation" in this era of manufactured fads and weekly seven-day wonders. As the legend goes, an enterprising pair of Columbia University graduates named Richard L. Simon and M. Lincoln Schuster took shrewd notice of an Aunt Wixie's hankering for a book of the *World*'s puzzles to sate her crossword-addicted daughter. They quickly cut a deal and commissioned the *World*'s three crossword editors (the intimidating-sounding trio of Prosper Buranelli, F. Gregory Hartswick, and Margaret Petherbridge) to compile such a collection from their "slush pile" of unpublished manuscripts, reportedly paying twenty-five dollars per. "And they asked me to do the squares, numbering and lettering," revealed Bushmiller.

The prototypical "non-book," *The Cross Word Puzzle Book* was released on April 12, 1924. Complete with detachable Venus pencil (plus eraser) and a stamped serial number, this apparently irresistible package (which retailed for $1.35) went through three editions and sold almost half a million copies that year alone — at a time when the New York *World*'s circulation was less than 300,000 and it sold for 2 cents. Originally published under the Plaza Publishing imprint, *The Cross Word Puzzle Book* was, by its second edition, proudly proclaimed a Simon and Schuster publication, and a publishing empire was born.

The Cross Word Puzzle Book, First Series,
Simon and Schuster, 1924.

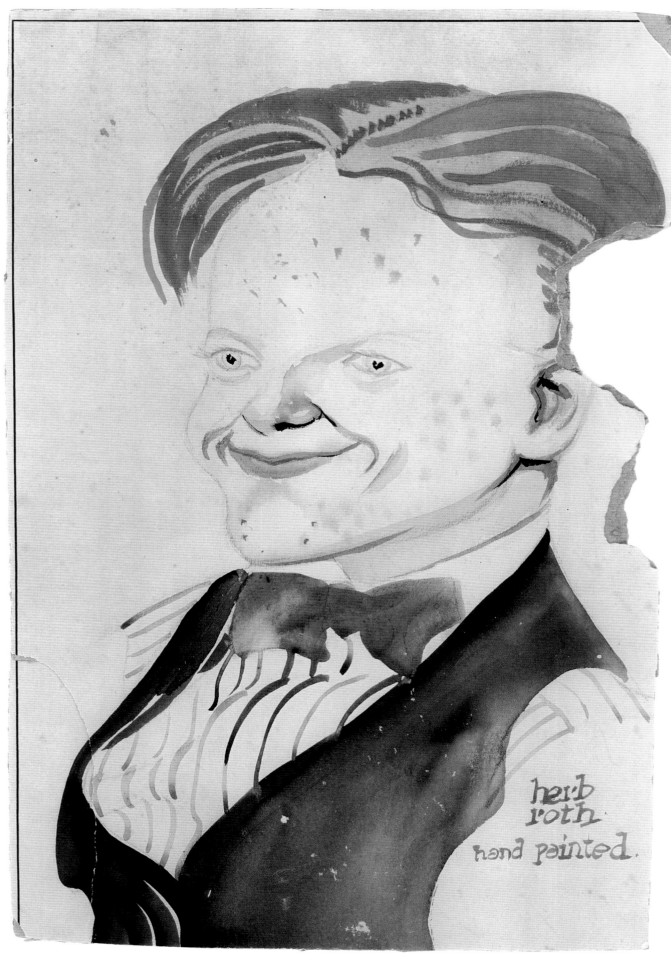

*Young Bushmiller, "hand painted" by
Herb Roth, 1920s (original artwork).*

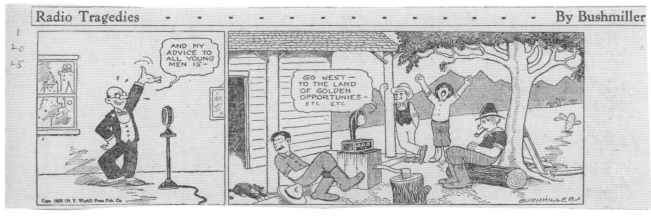

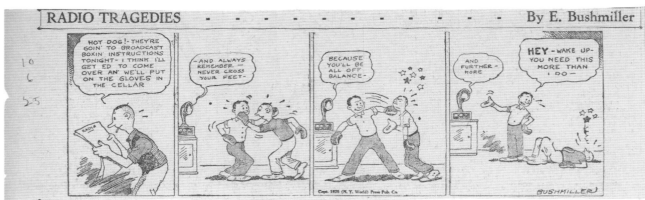

Radio Tragedies, *San Francisco Chronicle*, *January 20, 1925.*
Radio Tragedies, *San Francisco Chronicle*, *October 7, 1925.*
Bottom: *Fritzi Ritz, June 30, 1925 (original artwork).*

Bushmiller went back to the drawing board once again, all the more determined to make his bones in the *World*'s comic strip department. Like the contemporaneous *Cross Word Cal*, his next published strip was a topical one that exploited a red-hot fad of the day. And like *Mac the Manager*, the resulting strip never saw print in the New York *World*. *Radio Tragedies* appeared only twice during 1925 in the pages of the *San Francisco Chronicle* (although possibly elsewhere) via the *World*'s Daily Feature Service syndicate (a.k.a. Press Publishing Company). While a nominal step up from the puzzle-page ghetto, the strip was essentially procured and peddled as "filler" material by the good graces of syndicate manager Tom Johnstone, and was undoubtedly culled from Ernie's growing backlog of unsuccessful *World* pitches. This ironic look at "the unseen audience" lacked a continuing character and was presumably conceived as a series of recurring variations on a single gag theme — for perhaps the first, but certainly not the last, time in this cartoonist's career.

Ernie's next lucky break broke that May, when without apparent warning *World* comics staffer Larry Whittington abandoned his fledgling "flapper" strip, *Fritzi Ritz*, for an even ritzier deal drawing *Mazie the Model* for the rival Hearst syndicate. Fritzi, christened three years earlier by the *World*'s comics editor Myer Marcus, was a typically liberated (yet scatterbrained) career girl of the era, a leggy model, romantic adventuress, aspiring movie starlet, serial dater, and cigarette fiend. She was also a blatant clone of Russ Westover's Tillie the Toiler, who had famously been all of the above for the Hearst papers' comics readers since 1921 (and was hardly the first in a long line of similar heroines).

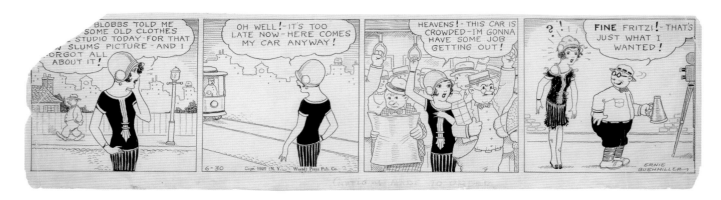

Ernie effortlessly slid behind Whittington's (still warm) drafting table and furnished the next *Fritzi* daily, seemingly without missing a beat — and it was soon his own. (Whittington had in fact tipped off the young cartoonist to his exit plans well in advance and generously coached him on the ins and the outs of producing the feature). Ernie's first *Fritzi Ritz* ran on the fourteenth of that month. Four days later he was signing the strip, and by May 25, 1925, at the age of nineteen, Ernie "Boy Cartoonist" Bushmiller was receiving a daily byline in hot type. He became the youngest artist ever to author a nationally syndicated comic strip, a record he proudly held for many decades.

Ernie Bushmiller had arrived.

As it had under Whittington's tenure, *Fritzi Ritz* sold gags — but *Fritzi Ritz* also sold sex. Assessing a need for improvement in his figure-drawing skills, Ernie had previously enrolled in classes at the prestigious National Academy of Design, beginning his studies there on September 20, 1920. The school was located, at that time, on Manhattan's Upper West Side at 109th Street and Amsterdam Avenue and numbered among its instructors such prominent illustrators as the printmaker Joseph Pennell and caricaturist William Auerbach-Levy.

Originally founded in 1825 by a group of dissenting students of the American Academy of Fine Arts, including Samuel F.B. Morse, Asher B. Durand, and Thomas Cole, this new and improved, artist-run academy had a fitting goal: "to promote the fine arts in America through instruction and exhibition." The academy's alumni roll included such American creative heavyweights as George Catlin, Winslow Homer, Albert Bierstadt, Thomas Eakins, Louis Comfort Tiffany, and Frank Lloyd Wright.

For Ernie, this was a long way from the New York *World* art room, in more ways than one. He studied under the portrait, landscape, and floral painter George Laurence Nelson (who in turn had studied under James McNeill Whistler and John Singer Sargent) and labored through such mandatory and rigorous

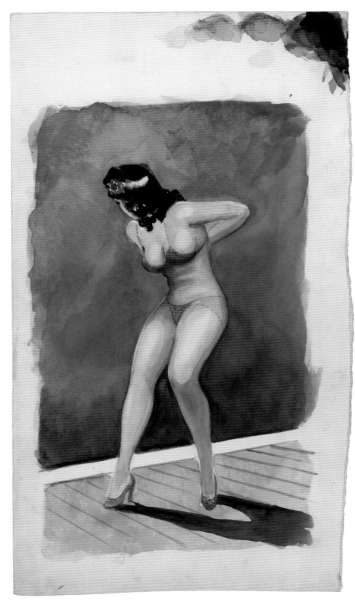

Top: *Burlesque show. Watercolor by Ernie Bushmiller, National Academy of Design, 1920s (original artwork).*
Left: *Nude and mirror. Watercolor by Ernie Bushmiller, National Academy of Design, 1920s (original artwork).*

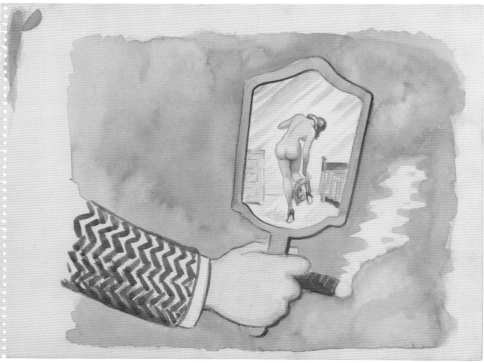

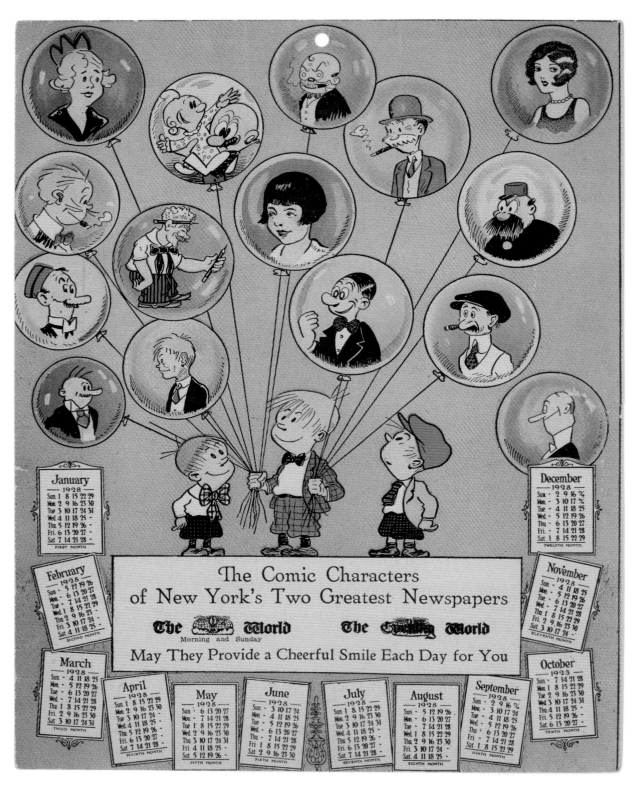

courses as Antiques in Profile and Antiques in Full. Unbeknownst to his coworkers (and even his family), Bushmiller spent his evenings at the academy for the next two and a half years sketching nudes and scumbling still lifes alongside the likes of Paul Cadmus and Reginald Marsh. He suspended this formal art education on January 20, 1923, definitively deciding that he'd "rather be drawing comics." ("All I ever learned to draw there was a plaster bust of Dante," the cartoonist later grumbled.)

Ernie Bushmiller now settled into the notoriously difficult task of generating a fresh (and more important) *funny* comic strip 365 times a year. His *Fritzi Ritz* swiftly eclipsed the work of Whittington (who, on occasion, was known to tap his successor for payback in the form of gag input on his new — and competing — feature). Visually the strip became more polished and easier on the eye, the humor less dialogue-bound and more robust — and the heroine more anatomically fetching. Notably, Bushmiller's *Fritzi* transcended a genre that was already wearing thin with some readers. As Clare Briggs warned aspiring

cartoonists in his *How to Draw Cartoons* (1926), "There is a superabundance of the Giddy Gertie and Bessie Bonehead type of cartoon. The public has enough of the insanely silly stuff without newcomers seeking to add to it. There is a difference between silliness and humor, between crude slapstick buffoonery and comedy."

Ernie seemed to inherently understand this distinction as well. His gags variously revolved around Fritzi's home life, her rising film career at the Star Studio (where she apparently filled every station from leading lady to factotum), her seemingly endless string of suitors and aspiring sugar daddies, and her Teflon courtship with the faithful and long-suffering clod Wally. Charming, capricious, fickle, confusing, confused, and reliably self-involved, Fritzi came into harder comedic focus in Bushmiller's hands, and he made the most of her.

While yoked to a conventional "dizzy dame" persona and solidly rooted in the "big foot" school of cartooning, as the twenties progressed *Fritzi* fell under the subtle influence of another type of *World* strip. Those were the topical, scattershot features of cartoonists like Harry Haenigsen, Maurice Ketten, and the moonlighting caricaturist Al Frueh.

SUMMER TIME IS LAUGH TIME!

IN THE HOT WEATHER YOUR READERS WANT TO LAUGH PUT THESE NEW YORK WORLD STARS ON YOUR STAFF NOW

FRED LOCHER
Creator of
Cicero Sapp

BUD COUNIHAN
Little Napoleon's
Artist

R. M. BRINKERHOFF
Who Draws
Little Mary Mixup

HARRY HAENIGSEN
Famous
Daily Cartoonist

ERNIE BUSHMILLER
Fritzi Ritz's
Boy Friend

NEAL O'HARA
Who Writes That Column
"Telling the World"

MAURICE KETTEN
Internationally Famous
Cartoonist

VIC FORSYTHE
of Joe's Car
Fame

A. W. NUGENT
Puzzles for Kids

OVER

$100,000

WORTH OF COMIC IDEAS PER YEAR IN SALARIES ARE REPRESENTED BY THIS GROUP OF ARTISTS

THE NEW YORK WORLD uses the work of all the above artists every day and they are proven circulation getters and holders. You can add them to your staff by using the DAILY FEATURE SERVICE.
Write us for terms in your city.

NEW YORK

𝔚orld

DAILY FEATURE SERVICE

NEW YORK WORLD SYNDICATE

63 PARK ROW, NEW YORK CITY

Some of the faces behind the World's comics, circa late 1920s.

Solidly slanting their work toward the *World*'s adult readership and working under such generalized titles as *News and Views, Such Is Life*, and *Can You Beat It?*, these men practiced a clean, frugal, deliberately paced multipanel technique in the manner of the renowned British *Punch* and *Tatler* cartoonist H.M. Bateman. (Bateman himself followed a European tradition that included the Frenchman Caran d'Ache and German Wilhelm Busch.) With character design and gestures winnowed to an elegant essence and background detail often eliminated completely, their work evoked a composed, "modernist" sophistication that would seem right at home on the early pages of *The New Yorker* magazine (to which Haenigsen and Freuh would, in fact, soon become contributors). In this respect Bushmiller invites the most direct comparison to his mentor Milt Gross (Ernie considered himself a "fervent satellite of the glorious man"), whose unrelentingly gag-driven strips similarly straddled such seemingly irreconcilable poles. (Although with their perpetually cockeyed casts and anarchic linework Gross's comics skirted closer to the spirit of Dada than the Bauhaus — and came down even more decisively in the school of American Wacky.)

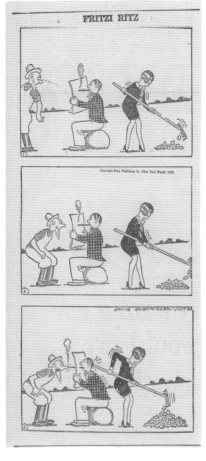

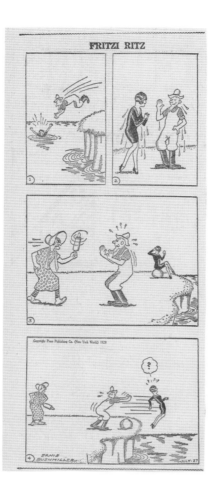

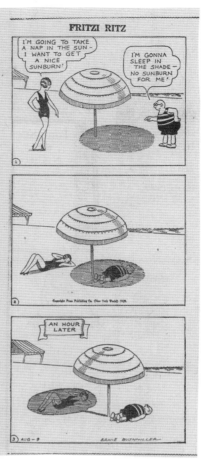

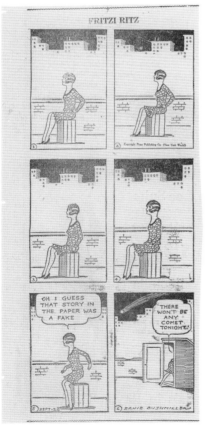

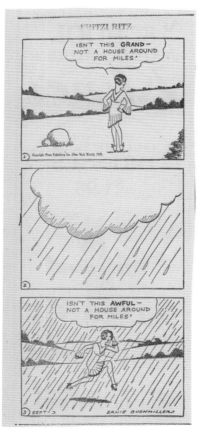

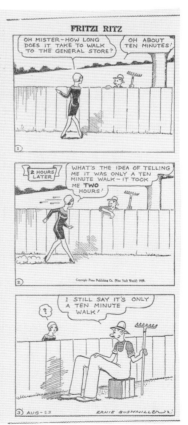

Clockwise: Fritzi Ritz, July 24, 1929.
Fritzi Ritz, July 27, 1929.
Fritzi Ritz, August 9, 1929.
Fritzi Ritz August 23, 1929.
Fritzi Ritz, September 3, 1929.
Fritzi Ritz, September 26, 1929.

Above: *The End of* The World, *G.F. Murray, 1931 (original artwork from Bushmiller's scrapbook).*
Below: *Ernie Bushmiller courts Abby Bohnet, 1920s.*

As the Jazz Age drew to a close, *Fritzi* and Ernie continued to prosper. Together they launched a Sunday color page on October 6, 1929, only weeks before the stock market crashed. Most critically, both survived the failing New York *World*'s sale to the Scripps-Howard chain and its ultimate collapse on February 27, 1931, when the majority of the paper's 2,800 employees lost their jobs overnight. Ernie, who had just married his sweetheart (and occasional *Fritzi* model) Abby Bohnet, the slender, stylish daughter of a Bronx El train conductor, counted himself lucky when *Fritzi* was among the strips chosen to be continued under the auspices of Scripps's United Feature Syndicate.

Like her husband, Abby Bohnet Bushmiller was born (in 1906) to German and Irish parents in the Bronx. She was in many respects a muse as well as a literal prototype for Ernie's Fritzi — a charismatic, vivacious beauty with a distinct sense of humor, making her way in a man's world (although Abby's position at the Metropolitan Life Insurance Company was presumably more stable than Fritzi's ups and downs at the Star Studio). The couple met at a local party in the mid-1920s and dated throughout the decade. They were married on July 9, 1930, at the 13th Street Presbyterian Church in Greenwich Village in a ceremony attended only by Ernie's fellow *World* cartoonist Harry Haenigsen, who stood up as best man, and Harry's vaudevillian wife, Bobby, who served as matron of honor. The cozy wedding party retreated a few blocks away to celebrate at Lüchow's afterward.

Even in their later years Ernie described his bride as "a very beautiful lady who looks twenty years younger than her age." "She is so thoughtful about everything alive," he continued. "She feeds her birds and animals and worries about them."

"That was beyond my comprehension," reminisced her niece Ruth Alice Reinhardt, "because you couldn't kill a fly or a mosquito or anything in her house! She didn't want them killed." Ruth remembered her aunt as beautiful, fashionable, loving, and in some respects "very eccentric." She vividly recalled, when visiting the couple as a young child, Ernie's confidential coaching in the art of Abby-wrangling, a scenario straight out of a *Fritzi Ritz* Sunday page: "Now, we've got to get Abby started early. . . . She won't be able to figure out what she's gonna wear and then she'll have everything out of the closet and then she'll finally end up putting on the outfit that she first pulled out."

Best friends as well as partners, the Bushmillers enjoyed a marriage that worked for over half a century. "Abby always had his back," according to James Carlsson, a young neighbor who aided Ernie with his office chores and came to know the couple intimately in their last decades. "She was the ideal cartoonist's wife, attuned to the rhythm and heartbeat of his work. They literally finished one another's sentences — but she also knew when to give him space." (As such, Ernie usually had the last word — which was invariably "Priorities!") Harry Haenigsen framed this generational dynamic in blunter terms: "He never had children. . . . I've been thinking about cartoonists, and I know there are a few exceptions to this . . . but they had either very, very small families — or no families. It was almost a characteristic of the business. Either the woman becomes part of the operation or it falls apart."

"She was a great asset to him," Reinhardt believed. "They rolled in high society. . . . They were photographed with Eleanor Roosevelt. . . . I always thought that he was Phil Fumble and my aunt was Fritzi Ritz."

In 1931 the couple ventured west as Ernie "crashed the movies" with an offer from Harold Lloyd to create gags for his forthcoming Paramount feature *Movie Crazy*. Lloyd, a major comedy star of the silent era and among the medium's shrewdest judges of visual humor, approached Bushmiller on the strength of *Fritzi Ritz*'s impressive gag power. Morris Weiss, then a Bronx neighbor and an aspiring cartoonist, recalled of Ernie, "He was not one to go to shows, but the movies. He was a movie nut. . . . One day Ernie was sitting in the [United Feature Syndicate] bullpen working and Dottie, the receptionist, came and told him that he had a phone call. When the voice on the other end said, 'This is Harold Lloyd,' Ernie hung up . . . twice, convinced that it was somebody playing a prank. Finally Lloyd convinced him that he was a fan and would like to hire him as a writer."

Weiss asked Bushmiller how he felt about picking up and moving to Hollywood. Bushmiller replied, "I was scared!"

Other newspaper cartoonists had attempted similar transitions with varying results. Will B. Johnstone, an ex–New York *World* editorial cartoonist, was already in Los Angeles, profitably embarking upon *Horse Feathers*, his second screenplay for the Marx Brothers written with his collaborator (and fellow ex-cartoonist) S.J. Perelman. (Both were soon joined by J. Carver Pusey, creator of *Benny* and yet another ex-*World* cartoonist). Milt Gross, who was Bushmiller's closest confidant at the *World,* had left for Los Angeles in the spring of 1926 to write gags for Charlie Chaplin's *The Circus*. But by 1928, when the film was released, Gross had long since been dropped by Chaplin.

That year an MGM all-talking feature based on Gross's wildly popular, syntax-twisting *Nize Baby* Jewish-dialect columns and strips went into production. Written, cast, and nominally "supervised" by Gross himself, the project ran into trouble once the cameras began rolling in September. After much hoopla, and $52,000 in the hole with only a few brief weeks of shooting to show for it, MGM brass reportedly saw fit to switch the entire approach from "a straight comedy to a farce" and then from "a dramatic love story to a slapstick comedy." Cast members were swapped out, a new director and new writers sent in, and Gross packed his bags and headed back east. Two weeks later, *Nize Baby* was unceremoniously (and permanently) "postponed." Gross would later move to Hollywood and try to catch the brass ring there again for the rest of his career.

Movie Crazy as it was presented at the Rialto Theatre in Times Square (corner of Broadway and 42nd Street), September 19, 1932.

These events must have still been fresh in Ernie's mind. Lloyd, however, was persuasive. The cartoonist refused to fly ("If I'm up in an airplane and they run out of gas, where are they gonna go to get gas?"), so the Bushmillers ultimately made the trek by rail. They arrived in Los Angeles by the end of August for preliminary story conferences with Lloyd, scenarist Agnes Christine Johnston, and others. Ernie and Abby were given a grand tour of the studio and shown the star's personal *Fritzi Ritz* collection, systematically clipped from a local newspaper and filed into impressive scrapbooks. A lavish welcome party was thrown in the Bushmillers' honor and, according to Weiss, "You name any important silent screen star — they were there!"

Ernie overcame his understandable reluctance and joined *Movie Crazy*'s stable of seven other contributing writers, continuing to produce seven *Fritzi* strips a week while punching the Harold Lloyd Corporation's time clock. The couple continued to be feted in Hollywood style and lived as Lloyd's houseguests at his forty-four-room Greenacres mansion in Beverly Hills for "a very delightful year." "We used to have dinner at the Brown Derby at least once a week with Groucho Marx," Bushmiller later marveled.

Movie Crazy, Lloyd's fourteenth feature (and third with sound), was co-directed (with Lloyd) by comedy veteran Clyde Bruckman, who worked with some of the greatest screen comedians in the business (including Buster Keaton, W.C. Fields, Laurel and Hardy, and the Three Stooges) on some of their greatest films. The plotline was a simple Hollywood Cinderella story, not unlike *Fritzi Ritz*. Lloyd plays Harold Hall of Little Town, Kansas, who dreams of a career as a leading man on the silver screen. Through a series of improbable mix-ups he heads west for a screen test at Planet Studios. Once on the lot he manages to create havoc at every turn, but when things seem darkest Harold is "discovered" and hailed as a natural comedian — and naturally gets the girl (in this case Constance Cummings) before the final fade-out.

While not as exhilarating as his silent masterpieces, *Movie Crazy* is perhaps Lloyd's sturdiest sound feature. There are no records of Bushmiller's specific contributions, but a number of gags seem likely candidates, including the opening shot, where Harold is first seen cruising along in an aristocratic limousine but is soon revealed to be pedaling alongside on a humble bicycle, and an early bit where he produces a lost duckling, seemingly from thin air, by applying a garden hose to a posthole in his front yard. The film is filled with the kind of visual conceits that fed both silent comedies and Bushmiller's comic strips, and Lloyd reportedly previewed it to "an audience of deaf-mutes" (to test a possible European silent release), who were able to follow ninety percent of the plot without the benefit of dialogue.

Perhaps the film's best-known gag sequence is the formal dance, where Harold unwittingly exchanges tuxedoes with a stage magician. Bruckman's recycling of that gag over a decade later, first for a Three Stooges short at Columbia Pictures and then for a Universal B-musical, resulted in a pair of successful lawsuits from Lloyd. In 1961 Jerry Lewis revisited the premise of *Movie Crazy* in *The Errand Boy*, upping the already considerable gag ratio to unprecedented heights.

In a 1962 CBS television interview Harold Lloyd described how he worked with collaborators like Ernie: "The films that I was making, especially in the silent period, they were so much more visual. . . . Today the dialogue seems to take up so much of the time that they don't have that action and the opportunity for thrills and the surprise business. . . . I know if I were to start today, and dig up what we called gagmen — idea men — it would be quite difficult, there's very few trained for that. You take Bob Hope, for instance, he has a corps of men who work with him on dialogue. They get with him and they throw ideas — verbal, of course — and he chooses and takes out what he wants. Well, I did exactly the same thing. I'd send them off separately, maybe I'd have six or seven, sometimes less, sometimes more. And you'd send them out to work singly or in pairs, or maybe I might work half a day or all day with them. One fellow would throw an idea out, you'd choose that idea or maybe you'd just take the thought he had and then we'd all go to work and put it in. And it was a cooperative idea like that. But those men don't exist anymore."

During the production of *Movie Crazy*, Lloyd, a man of great enthusiasms, reportedly became so fascinated with the comics medium that he'd rush through the day's shoot in order to work as a gagman on his gagman's comic strip. This irony was seemingly not lost on Bushmiller. Although *Movie Crazy* (released on September 23, 1932) was a solid critical and financial success, the collaboration of Lloyd and Bushmiller lasted for one film only. The Bushmillers undoubtedly preferred Bronx comfort to Tinseltown glitz, and although Ernie was generously compensated ($250 a week at the bottom of the Depression, with all expenses paid), his autonomy and national byline easily

Top: *Ernie isn't Movie Crazy (from a 1951 newspaper publicity feature).*
Bottom: *Gagman and star reunited, 1949.*

REUNION—Ernie Bushmiller, creator of the comic strip, NANCY, draws a quick sketch of his friend Harold Lloyd at a comedians' and cartoonists' party welcoming Lloyd's return to the screen in a reissue of "Movie Crazy." Years ago Bushmiller helped to produce this film, which was one of the bespectacled comedian's biggest hits.

outranked his uncredited gagman status with Lloyd. While he maintained a lifelong friendship with the movie legend, Ernie chose to remain a comic strip artist first and foremost.

Back in New York, Bushmiller joined a group of cronies in a freewheeling "office" in the newly completed Chrysler Building at Lexington Avenue and 42nd Street (another one of the world's tallest buildings — for a short time). "Ernie didn't like to be alone," explained Morris Weiss. "He liked working in the office. He liked the camaraderie . . . as in the days of being in the bullpen of the old New York *World*."

In those days "the art department became a hangout," recalled Harry Haenigsen. After the newspaper folded, Fleischer Studios animator Ted Sears "was leaving to go to California and so Milt Gross rented Sears's office in Midtown New York on 45th Street, just east of Broadway. . . . [Gross told Ernie:] 'Don't tell a soul!'" continued Haeningsen. "But he and Ernie were close friends, so Ernie talked Milt into letting him move into the office."

Bushmiller soon joined his ex-mentor in a comfortable two-man studio in room 56 at 160 West 45th Street ("We used to check each other's work and share our erasers," Bushmiller remembered) and they, in short order, were successively reunited with such *World* refugees as Haenigsen, H.T. Webster, Herb Roth, Gus Jud, George Donnan, and studio assistant Dow Walling. "So we all wound up in an office on the forty-fourth floor of the Chrysler Building," bemoaned Haenigsen. "The place was just as crowded [as the *World*] and now we're paying nine million dollars!"

The twenty-four-hour rumpus room, with a sweeping view of Manhattan's Midtown skyline ("We didn't look out after the first day," said Gross) and

Above: *Ernie Bushmiller and Milt Gross share a photo booth, 1920s.*
Below: *Marketing Fritzi, circa early 1930s.*

wall-to-wall (plus ceiling) graffiti murals by some of the world's greatest cartoonists, soon became the stuff of Broadway columnists' legends. However, the all-night poker games, Peeping Tom shifts, practical jokes, and alcohol-drenched gag sessions spelled a predictable demise to this creative sanctuary as the nervous syndicates eventually shut the party down once and for all (coinciding, perhaps, with the repeal of Prohibition).

"We had to give it up," admitted Bushmiller. "It became a Midtown headquarters for everyone who had a date in three hours and wanted to kill time. . . . We were truly sorry to break up the combine but it was all for the best interests of everybody concerned. Our daily luncheon club meetings were something to talk about." ("I couldn't get anything done," Haenigsen lamented.)

Bushmiller continued to produce *Fritzi* at the nearby United Feature Syndicate offices on the eleventh floor of the New York *Daily News* building at 220 East 42nd Street. (He also maintained a small home studio at his Marion Avenue apartment in the Bronx.) During these years he rubbed shoulders daily with Al Capp (*Li'l Abner*), R.M. Brinkerhoff (*Little Mary Mixup*), Bernard Dibble (*Looy Dot Dope, Danny Dingle, The Captain and the Kids*), Rex Maxon (*Tarzan*), sports cartoonist Alan Maver, and the brothers Leff: Sam (*Joe Jinks* writer) and Mo (*Joe Jinks* artist).

Ernie, along with six of his peers, later co-founded the National Cartoonists Society (along with its charitable arm, the Milt Gross Fund), which was perhaps in good measure created to carry on the tradition of such raucous congregations within a nominally more officious setting.

After the mighty New York *World*'s demise, *Fritzi Ritz*'s future could not be taken for granted. The public's ready fascination with flappers had waned, and in an era of failing newspapers and sharply stiffening competition, city comics page editors would have to be sold on giving *Fritzi Ritz* a shot at their readership one tough customer at a time. Bushmiller became understandably nervous during these uncertain Depression years and began to dip his toes into a number of side projects.

Aside from his year in Hollywood on *Movie Crazy*, this era saw him contributing numerous one-shot pantomime gags to *Judge* magazine, the weekly venue on whose amateur page he had broken into national print. At *Judge*, a staple in America's barber shops for decades, Ernie joined such high-caliber contributors of this period as S.J. Perelman, Dr. Seuss, Milt Gross, Otto Soglow, Jefferson Machamer, Bill Holman, Gardner Rea, William Steig, and dozens more.

These little strips often boasted unusually spare graphics (even for Bushmiller) and were in much the same vein as a series he was now producing for the Sunday *World*'s

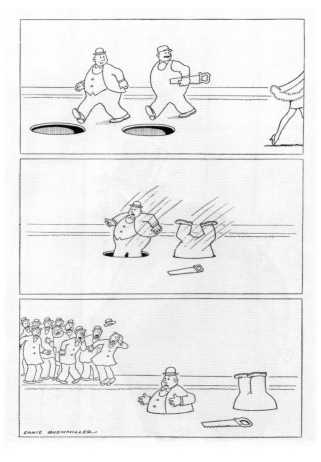
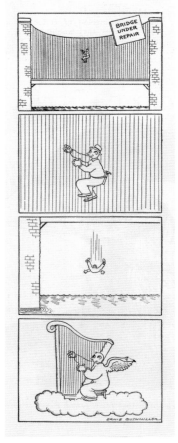

Left: Judge *magazine, March 30, 1929.*
Right: Judge *magazine, April 13, 1929.*

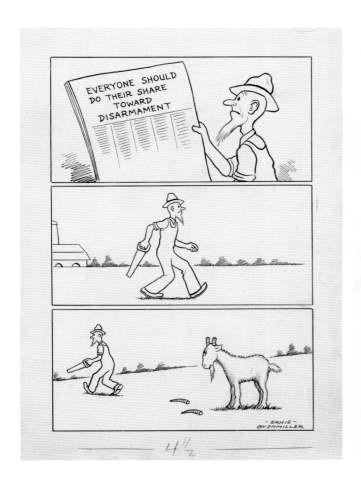

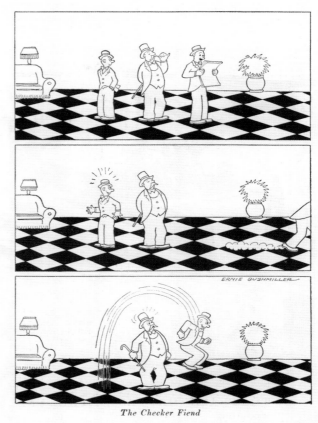

The Checker Fiend

"Metropolitan" section, as well as the brief "toppers" to *Fritzi*'s earliest color Sunday pages. (*Fritzi* became a "two-in-one" feature of equal parts on Sundays when *Phil Fumble* was added to the page on December 20, 1931). Bushmiller's gags had rarely been presented so baldly, and the best of these strips benefit from the rigors of a dry, detached, almost diagrammatic approach to their comedy.

During this period the cartoonist also flirted with the book trade. The Vanguard Press (the imprint of James Henle, one more New York *World* alumnus) had courted Ernie as early as 1929 about a collection of his newspaper work. Managing director Jacob Baker finally found the ideal project in *The Milk and Honey Route: A Handbook for Hobos,* released in 1931. It was written by academic Nels Anderson under the pseudonym "Dean Stiff" (alleged practitioner of the "grand art") as a bum's-eye parody of his own pioneering 1923 sociological study *The Hobo.* This amusing effort included practical tips for aspiring hoboes and an extensive hobo glossary, as well as sixteen tidy hobo drawings by Bushmiller. These received lavish praise from one of Ernie's boyhood idols, illustrator John Held Jr., a pop culture giant of the previous decade who privately commended their creator as "the best comic artist at work today." Although no further collaborations with Vanguard were forthcoming, hoboes would conspicuously loaf on in Ernie's strips long past their presence on the American scene.

As the decade progressed, Bushmiller's graphic style, although exceptionally crisp and well ordered from the start, gradually took a denser, fussier, detail-laden left turn. Perhaps appropriate to the exotica of *Fritzi Ritz*'s Hollywoodland milieu, or perhaps a misplaced by-product of Bushmiller's ambition and work ethic, such superfluous trimmings would linger in his panels for at least another decade. The strip's format, which during its *World* run had routinely been of the gag-a-day variety, evolved as well in the 1930s, venturing into sustained and amusingly woven

Above left: Judge *magazine,*
July 25, 1931 (original artwork).
Above right: Judge *magazine,*
September 21, 1929.
Below: *Dust jacket for* The Milk and Honey
Route: A Handbook for Hobos, *1931.*

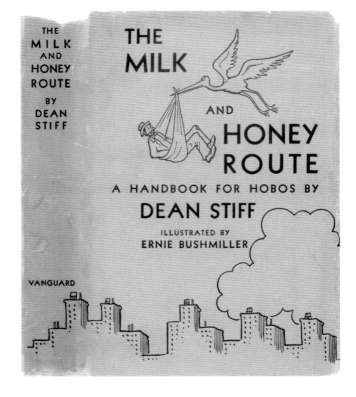

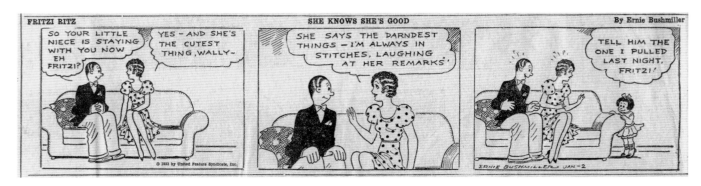

Above: Fritzi Ritz, *January 2, 1933.*
Below left: Editor and Publisher *magazine,*
December 18, 1937.
Below right: Editor and Publisher *magazine,*
June 6, 1938.

MEET

NANCY

She's a new and sparkling starlet in the comic constellation, this chubby, cherubic little ruffian.

Yet she never meant to have a career. She has been content always, as well as proud, just to be the niece of the gorgeous heroine of Ernie Bushmiller's daily strip and color page

FRITZI RITZ

But lately in the feature Nancy's had a lot of things to do. And readers have been clamoring for her to do more. So she's been as busy as Fritzi's been dizzy.

Nancy, of course, isn't quite the glamour-girl that Fritzi is. But she's already got herself a mighty fine collection of hearts, and it's growing faster than her hair.

Above you see Nancy in person. You ought to see her in action—in FRITZI RITZ. We will be glad to send samples.

United
FEATURE
SYNDICATE
220 EAST 42ND STREET
NEW YORK CITY

23

"most popular strip we have"

Nancy

Nancy's the little girl who's such a big hit in the Fritzi Ritz strip—so very big a hit that many subscribers have taken to calling the comic Nancy. And new subscribers are following suit.

Here's what subscribers think:

"We're for Nancy. So is practically everyone we've talked to."—The Buffalo Times.

"The most popular strip we have." — The Janesville Gazette.

"Nancy has universal appeal."—The Elyria Chronicle-Telegram.

"We could no more drop Nancy than page one." — Greenwich Time.

Both The Cleveland Press and The Newark Ledger have just introduced Nancy to their readers with page-one promotion. The Columbus Citizen placed its order this week. Nancy's going places. See Nancy and see why. We will be glad to send proofs.

United
FEATURE
SYNDICATE
220 EAST 42ND STREET
NEW YORK CITY

continuities that occasionally skidded into pure soap opera. (In 1936 we find "Curly," a suitor of Fritzi's, wasting away on his hospital deathbed — or is he?) Now lacking a flagship newspaper, the perpetually antsy Bushmiller was closely eyeing the national comic strip playing field, systematically trying on the latest syndication trends of melodrama, pathos, and even international intrigue for a fit in *Fritzi* — and angling for a bigger share of the market.

On Monday, January 2, 1933, Bushmiller introduced Fritzi's impish niece Nancy to his readers, in order, as he put it, "to pep things up."

"I had been drawing *Fritzi Ritz* since 1925, but nothing much had come of it," he lamented many years later. Although *Fritzi Ritz* was, in fact, appearing in a reasonably healthy 150-odd newspapers, the perennially dissatisfied cartoonist was still actively experimenting, trying to crack the code to something bigger and better. Nancy was "purely an accidental character," he later conceded. "I planned to keep her for about a week and then dump her."

Milt Gross nudged him, remarking, "That's kid's a funny character. Why don't you keep her around?" Gross sagely predicted, "Your future is with that little girl!" Bushmiller took the advice and, in his simple estimation, "she clicked."

Within three days of her cheeky debut, Nancy took her first solo turn. However, the scrawny, newly hatched supporting player did not initially steal any spotlight. *Fritzi Ritz'*s cheesecake, adventure, and breezy melodramas continued for years. Only haltingly did Nancy outgrow her supporting role and venture center stage for more than a quick gag. "She was supposed to visit her beautiful Aunt Fritzi for a day or two, once in a while, to give readers a few laughs by annoying Fritzi's faithful boyfriend," recalled Ernie. "But something happened, and it didn't turn out that way at all!"

Egged on by a deluge of reader mail, Ernie's strip found its true ground. In fact, "that little girl's" grassroots support eventually became so pervasive that some canny editors took to labeling the strip *Nancy* in their own pages. Lawrence W. Hager, publisher of *The Owensboro* (Kentucky) *Messenger-Inquirer,* was among them and a United Feature inter-office memo of October 26, 1937 (from editorial to sales), relayed his experience, which proved to be a tipping point for *Fritzi* and Ernie — and *Nancy*: "As Postmaster of Owensboro [Hager] sometimes drives out to suburban points to check the rural delivery. On numerous occasions, as the children have run down the walk to the Postman's car, Mr. Hager has asked them about the rush for the evening paper. With almost one accord, he explains, they give the funnies as the incentive. Asked further with a lead question whether they liked Orphan Annie, or Popeye, or Dick Tracy most, the boys and girls alike in by far the majority of cases answered, 'Nancy.' This was Mr. Hager's first experience with Nancy, and he would not trade her for any other strip in his paper, he says."

It remains unknown if the syndicate execs decreed that *Fritzi Ritz* was due for a formal sea change, or if Bushmiller instinctively knew this sassy niece was the inevitable vehicle for his strongest suit. But such branding decisions in the comic strip business were never made impulsively. Even Popeye, who had stolen the show from E.C. Segar's *Thimble Theater* ensemble in 1929 and went on to become

one of the most popular comic strip characters of the Depression and World War II, was not definitively awarded that strip's title until 1967. Colin Miller, a Hollywood producer who had worked as a publicist for United Feature in the 1930s, recalled a lunch in Manhattan's Tudor City where he and Bushmiller "talked at great length" about the ramifications of such a change. Whatever the case, by the week of June 11, 1938, following a formal poll of subscribing papers, Ernie Bushmiller's daily strip had decisively been rechristened *Nancy* and came fully equipped with one Aunt Fritzi and one Sluggo Smith (a pug-nosed accomplice from the wrong side of the tracks) and was clearly back in the gag-a-day business. *Nancy* was a syndicated sensation from daily one (more than 100 newspapers jumped on board in 1941 alone), but it wasn't until the years of the postwar baby boom that the strip reached the full measure of its ubiquity (reportedly more than 300 American papers by 1946, 450 by 1949, 530 by 1957, 650 by 1962, and 880 by 1971) as well as its true maturity. *Nancy*'s graphic gestalt began to noticeably crystallize during the dawn of World War II. Eyeing the current success of such strikingly efficient gagcrafters as Otto Soglow (*The Little King*), Crockett Johnson (*The Little Man with the Eyes*), Carl Anderson (*Henry*), Oscar Jacobsson (*Adamson*), and Marge Henderson Buell (*Little Lulu*), Bushmiller surrendered the last vestiges of his florid impulse to a bolder line and a decisive return to a more aggressive economy.

Nancy had arrived.

A hit every day in the week, every week! NANCY is the star performer for MILLIONS of readers everywhere!

Sample strips and page, editors' endorsements inside

Above and below: *Promotional brochure, United Feature Syndicate, 1947.*

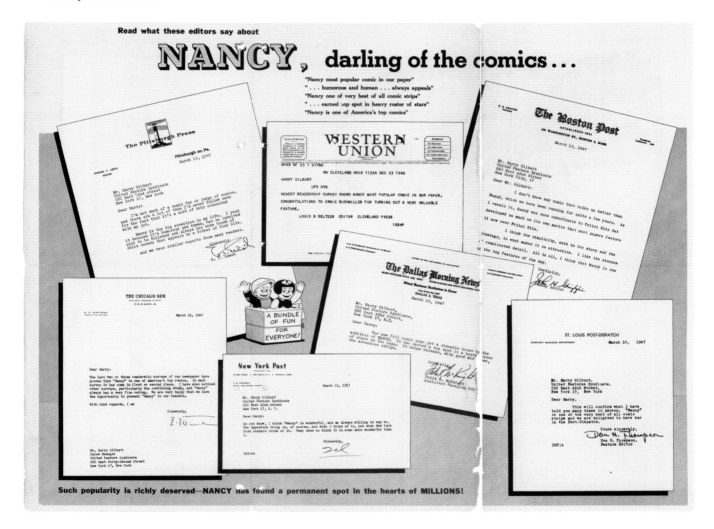

Like most successful comics of its day, *Nancy* was swiftly commodified, her celebrity grafted onto a predictable range of consumer goods. Besides generating revenue for her owners, in theory these ancillary products promoted the strip, and the strip in turn created a further demand for more and more merch. In the process, *Nancy* became an American icon — and soon an international one, reprinted in scores of foreign markets and translated into over a dozen languages from Finnish to Tagalog (by 1959 *Nancy* was said to be running in ten Swedish newspapers alone). Licenses were first granted by United Feature in the early 1940s and brokered by agent Toni Mendez after the war. Product categories eventually came to include Nancy (and Sluggo) toys, games, dolls, books, craft kits, toothbrushes, and even a short-lived series of theatrical animated cartoons produced by Paul

Dolls by S&P Doll & Toy Co., 1954 . Quality control by Bushmiller.

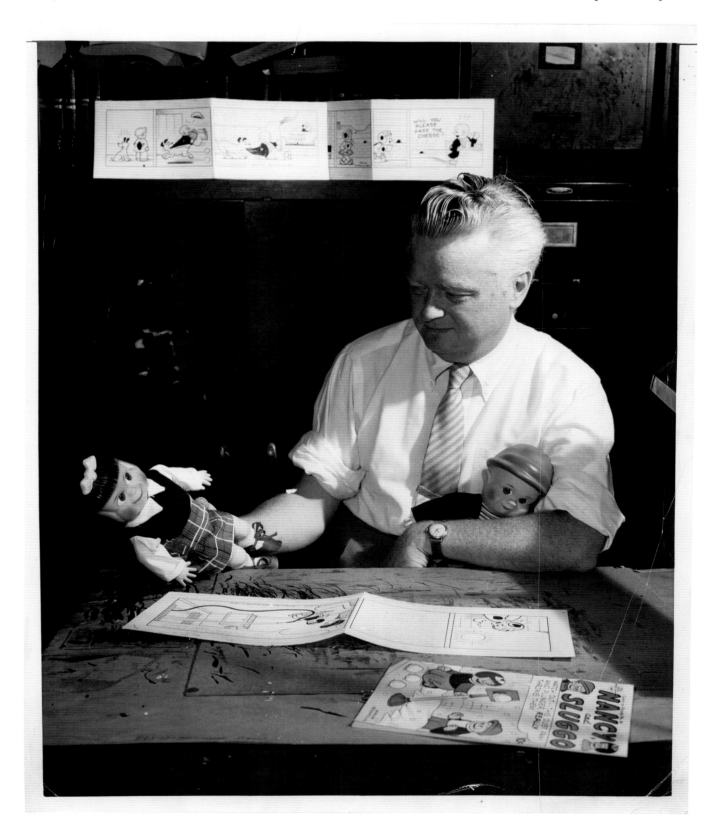

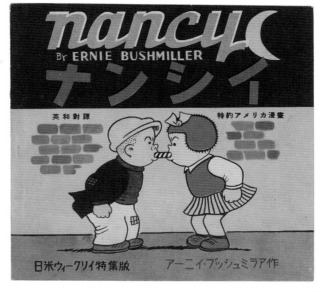

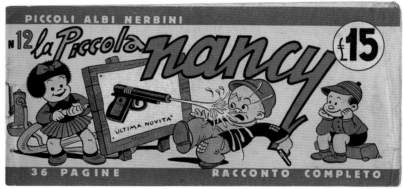

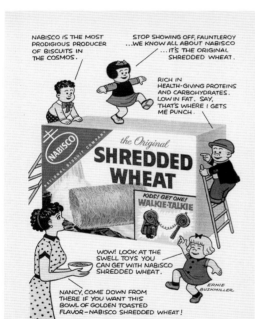

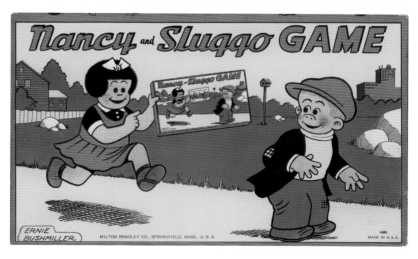

Clockwise from top left: *School Daze, one-sheet movie poster, Twentieth Century–Fox and Terry-Toons, 1942. Comic book, Japan, 1948. Comic book, Italy, 1948. Nancy and Sluggo board game; Milton Bradley, 1944. Shredded Wheat advertisement, Nabisco, 1960.*

Terry. While the strip itself remained top priority at all times, Bushmiller kept a steady hand in the quality control of such endeavors, sealing the deals himself with a handshake (he reportedly preferred Nedick's in Times Square for such financial tête-à-têtes) and often designing the item's packaging (or covers) personally.

As newspaper space and column size first seriously eroded for comic strips in the days of the World War II paper shortages, what would eventually amount to a crisis for much of the industry worked beautifully to *Nancy*'s advantage. Right on track, if not ahead of the curve, the strip's bold graphic austerity functioned superbly on an increasingly dense daily comic page, and it held its shrinking ground with little appreciable loss. It was in this period that Bushmiller began to rigorously distill his decades of hard-earned comic strip experience into a true working aesthetic. Having liberated himself from youthful flirtations with ornate embellishment and protracted narrative, Ernie Bushmiller got back to basics and down to his life's work: his self-proclaimed quest to discover and delineate "the perfect gag."

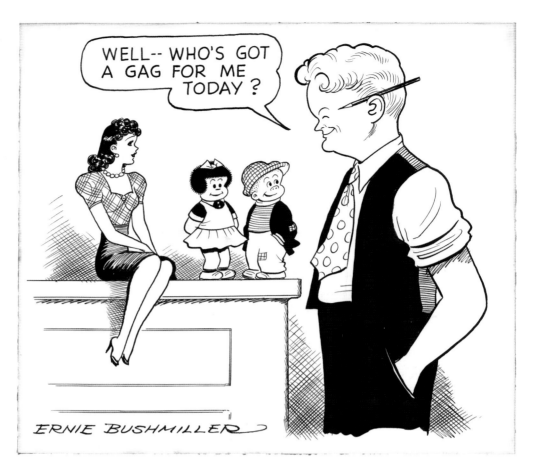

gag[2] *Informal*
n
1. a joke or humorous story, esp one told by a professional comedian
2. a hoax, practical joke, etc. *he did it for a gag*
vb **gags, gagging, gagged**
1. *(intr)* to tell jokes or funny stories, as comedians in nightclubs, etc.
2. (Performing Arts/Theatre) *(often foll by* up) *Theatre*
a. to interpolate lines or business not in the actor's stage part, usually comic and improvised
b. to perform a stage jest, either spoken or based on movement
— *Collins English Dictionary, Complete and Unabridged*

Etymologists note that as early as the mid-nineteenth century "gag" was used as a synonym for "joke" and suggest that it has its theatrical roots in the word's primary meaning "to stuff or to fill" (as in: time onstage, holes in scripts). By Bushmiller's era it had literally become a job description for those who devised the fine-tuned bits of visual business essayed by the stars of movie comedies, as well as for the yards of dialogue burned up nightly by radio and TV scribes. Professional gagmen toiled in gag departments, kept gag files, and held gag sessions to determine gag opportunities as they gagged their sketches and gagged their scripts. Some peddled their gags freelance (in the form of typed index gag cards) on the side — to magazine gag cartoonists. A Gag Writers Protective Association even popped up in the 1940s to sponsor National Laugh Week, commencing every April Fool's Day. (Ernie was duly recognized by that august body in 1946.)

The pursuit of the Perfect Gag ("the one which will knock everybody dead") clearly became the *raison d'être* for *Nancy* — and for Bushmiller himself. "Gag it down" was a mantra among a generation of newspaper cartoonists and one that came to occupy Bushmiller with a vengeance. "Ninety per cent of my strips are just individual gags without any theme tying them together," he once conservatively estimated. "I have never gotten an idea from real life." Emotional depth, social comment, plot, internal consistency, and common sense were all merrily surrendered in Bushmiller's universe to the true function of a comic strip as he now unrelentingly saw it: to quickly and efficiently trip the "gag reflex" of his readership on a daily basis.

Bushmiller's gag laboratory, which he maintained on the first floor of his Stamford, Connecticut, home after finally leaving the Bronx in 1951, was as efficient as his comic strips. He worked a well-oiled, one-man assembly line with four drawing boards set up around his studio to allow himself to multi-gag. Rather than take a coffee break while the ink was drying on one strip, he simply rolled his chair over to the next board and ruled his fence slats or brushed in his night skies. This arrangement, Bushmiller explained, was "to avoid boredom and prevent mental rigor mortis."

With this concentrated economy of effort (and the helpful hands of assistants), he was typically able to generate an entire week's worth of *Nancy* dailies in about four days (or rather, evenings; Bushmiller slept late and worked his twelve-hour day after lunch, preferring the tranquility of the solitary "hoot-owl" shift). This permitted a few days of recovery with his devoted wife, Abby, their ever-changing menagerie, and his ever-present notebooks before he began to stew about the Sunday strip.

Such was this cartoonist's routine for decades. Meanwhile, the world turned. Television had all but completely entranced the wandering eyes of the American newspaper audience. Milt Gross's once-chic immigrant humor was considered completely unpalatable after World War II, and he took to painting ruined landscapes. Harold Lloyd turned to 3-D photography, color theory, and bacteriology while his comedies became museum pieces. And the grand New York *World* building was razed in 1955 by Robert Moses to make room for a new on-ramp to the Brooklyn Bridge. Yet little changed in Ernie Bushmiller's week-to-week production cycle, and, in turn, little changed in the world of *Nancy*.

"Mine is a lonely business - - - I often sit at my drawing board and wonder if my little scribbles are - - - And talk to myself," he once wrote in an unmailed letter to a fan.

"He was always stashed in his room, drawing," recalled Ruth Alice Reinhardt. "They were true loners. . . . My uncle couldn't be happy with children around. . . . It's funny, because his cartoons were about young children. . . . He put his love into the cartoon, so he didn't have to have a real Nancy running around." Harry Haenigsen remembered a man who could not even endure a brief vacation for very long.

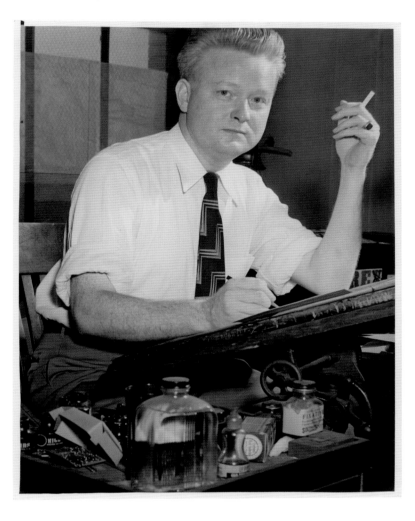

At the drawing board, United Feature Syndicate office, 1940.

"Even after we no longer were on the papers together, he would come down to the [Lambertville, New Jersey] farm once in a while, and went up in the attic where I worked — and Ernie went to work. He was a real pro about work." "Never off task," recalled Morris Weiss. "He knew he could write good gags, but knew what a struggle it was." "God help you if you got in there and disturbed him!" reminisced James Carlsson with a shudder. "The best gag man I ever knew," concluded Milt Gross.

Insular, single-minded, and perfectionist, yet habitually inventive, this was a man with a simple system—and the Bushmiller System simply worked, enabling him to become one of the most successful cartoonists of his generation and *Nancy* to become one of the most successful comic strips of the twentieth century. His goals, however, were always set one strip at a time. "My only aim is to make my feature amusing enough to bring my readers back the next day to see what my characters are doing," Bushmiller matter-of-factly admitted. Few cartoonists ever provided such a dependable public utility for so many years. "I know he was wrapped up in that strip," recalled an associate, cartoonist Al Plastino. "It was his whole life. His whole life."

While Ernie may have found his bliss hunched over a drawing board at 2:00 a.m., he and Abby enjoyed his days off together. Their Stamford home was large and comfortable and decorated with the work of contemporary American illustrators, including Dean Cornwell, J.C. Leyendecker, and maritime watercolorist Gordon Grant. The

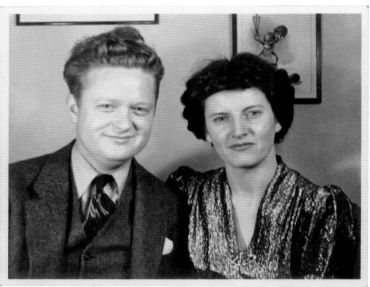

rambling grounds offered ample foliage and wildlife, and a "one-hole golf course" that the non-golfer routinely ignored. A small grouping of rounded white rocks cropped out from the closely trimmed lawn outside his studio window and became part of his strip's iconography. Ernie maintained his ties with metropolitan culture through his longstanding memberships in the Dutch Treat Club and the Society of Illustrators as well as regular weeklong getaways to Manhattan a few times a year with Abby to catch up with old friends and the latest must-sees. While they did not have children ("If I had children I'd probably do a grandpa strip"), various and sundry dogs, cats, and canaries rounded out the Bushmiller family circle. The couple was quietly philanthropic and took their pleasure in providing for a number of organizations that benefited the welfare of animals, children, and cartoonists.

With typical self-deprecation, Ernie Bushmiller summed his career up this way: "Looking back I often wonder how an uneducated oaf could do as well as I did. I'm a very lucky guy — I'm sure if I didn't have a flair for art and humor I would now be a meter reader for the electric company." Yet well into his eighth decade, *Nancy*'s creator was still looking forward, telling an interviewer, "No, I'd never retire. I could never wake up at three in the morning and have nothing to do. I still do all the drawing and the gags. . . . I work seven days a week."

In truth the cartoonist had become increasingly reliant on the steady hands of assistants and ghost artists by the time he was diagnosed with Parkinson's disease in the late 1970s, although he doggedly maintained strict quality control of his strip. "Every week

I feel like a squirrel in a cage," he told *The Vancouver Sun* in 1976, "but it's a nice way to work. . . . I'll keep going until I drop."

In June 1980 Ernie was briefly hospitalized with an apparent heart attack, treated for lung congestion, and placed on the critical list. Shortly afterward, Ruth Alice Rhinehart moved to Stamford and watched over the couple while each underwent major surgery (Abby had a mastectomy and Ernie a prostate operation). "They tried to do them together, and I went to stay with them," Reinhardt remembered. They appreciated her help "in a nurse capacity" but "they always wanted their privacy. That's the type of people they were. Here was an aunt and uncle who had reached out to me when I was five years old . . . and [I tried] to return the love that I had received. At their age [it] was hard. That's just who they were. They were true loners."

Ernie Bushmiller quietly continued to shepherd *Nancy*'s fortunes until his death by cardiac arrest, alone in his studio, on August 15, 1982. He had lived to receive the applause of his peers with the National Cartoonist's Society's Reuben Award in 1961 ("Best Humor Strip") and again in 1976 ("Outstanding Cartoonist of the Year"). *Nancy*, still a valuable property for United Feature Syndicate, endured, after a fashion, continued initially by Will Johnson (dailies) and Al Plastino (Sundays), who had both worked under Bushmiller, and by a host of successors thereafter. Abby survived her husband by five years.

Nancy and Sluggo were beloved characters of the American comic-strip-reading public for generations, yet as characters proper, *Nancy*'s cast may only marginally exist beyond the iconic pictogram that Bushmiller designed for them. Their vital statistics, in fact, can be reasonably summed up in a word or three: Nancy = cheeky fickle imp, Sluggo = impoverished wise-guy loafer, Aunt Fritzi = biological adult, Spike = bully, Rollo = rich, etc. The common quality that the troupe all share (undoubtedly an insight into Bushmiller's own mindset and background as a puzzle maker) is a keen adeptness at solving problems.

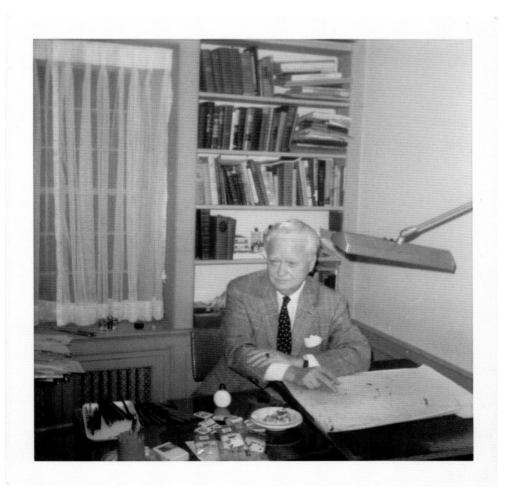

In the studio, 1970.

As with Buster Keaton, Otto Messmer, Jacques Tati, and other master craftsmen of the twentieth century's visual humor, objects were a rich source of gags for Ernie Bushmiller (he routinely claimed the Sears, Roebuck catalog as a major inspiration). Various objects are often introduced into *Nancy* for the express purpose of creating or solving a state of imbalance. The characters' ingenuity (and unpredictability) in transforming these intrusions and restoring balance spelled the gag, sold the strip, and paid off the mortgage in one year on his seven-and-a-half-acre Stamford homestead.

Just what is *Nancy*'s world without these imbalances and intrusions? Nonexistent perhaps. Like case histories out of an Oliver Sacks memoir, the lives of Bushmiller's cast are lived only in the eternal now of ruled panel borders and unpunctuated single-sentence dialogue. There are no inner voices, no outward direction, no hopes for the future or regrets of the past. Whether Zen or autistic, Nancy's existence consists of little more than thousands of isolated, odd (yet oddly inevitable) incidents cropping up daily, and miraculously overcome by Nancy, one of her cast mates, or the cartoonist himself.

Ernie Bushmiller had the hand of an architect, the mind of a silent film comedian, and the soul of an accountant. His formulaic approach to visual humor beautifully revealed the essence of what a Perfect Gag is all about: economy, symmetry, payoff, equilibrium. His gags often have the abstract feel of math, and *Nancy* was, in some respects, a mini algebra equation masquerading as a comic strip for close to fifty years. Bushmiller rarely spoke of his working process, but he often went on record as to how he balanced his gag ledger: "I draw the last panel first and work back toward the beginning, which is the opposite of the way you read it (I hope)."

In the following strips a common household plunger is introduced as a problem-solving tool. These are but a few of the infinite ways (and rest assured there are hundreds more to be found in the *Nancy* canon) a single prop could be exploited for a gag.

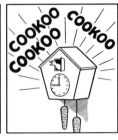

Nancy, July 8, 1958.

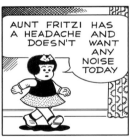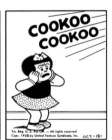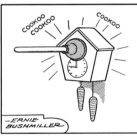

Nancy, October 18, 1958.

Nancy, November 5, 1959.

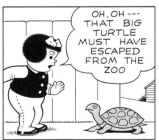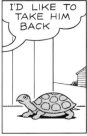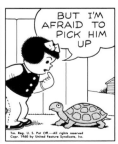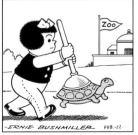

Nancy, February 22, 1960.

The last panel — or as he put it, "the snapper" — was the visual conceit that substantiated the sum of the whole and became of utmost importance to his work. Bushmiller kept notebooks, made lists, and wracked his brain daily for such propitious visions. "I am a very slow worker and a slow thinker," he once explained to a newspaper reporter. "Humor doesn't come in sudden inspirational flashes for me. . . . Stalking the funny idea is long, tedious, sweaty work." Of his innate ability to transform a promising pebble into comedic concrete, he only allowed, "I deliberately make it good."

"Dumb it down" was another oft-quoted Bushmiller credo; indeed, a kind of sublime dumbness became his personal territory, and he mined it brilliantly. Although Bushmiller's true audience was composed of anyone within reach of a newspaper, he came to slant *Nancy*, he once said, "for the gum chewers." Bushmiller was pragmatic about his goals: "In a comic department where I used to work, if the gag was a little too sophisticated, my colleagues would say 'Dumb it down!' And I do dumb it down. I don't get too esoteric in my gags."

Indeed, there is, at times, seemingly little that is beneath Bushmiller in his quest for the Perfect Gag. Along with such twentieth-century visionary humorists as Mack Sennett, Jules White, Tex Avery, Frank Tashlin, and Jerry Lewis, Bushmiller realized that the funny bone recognizes no IQ and that the success or failure of a given gag relies more upon its broad strokes and exacting inner mechanizations than on the sophistication of its premise.

This emphasis on the raw power of pure images and nonstop action was, of course, in the great tradition of all early narrative popular culture, from the stage melodrama to the

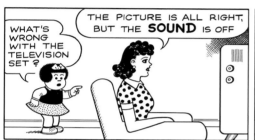
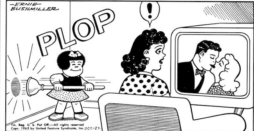

Nancy, October 27, 1962.

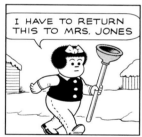
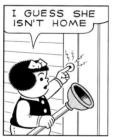
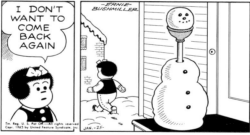

Nancy, January 25, 1963.

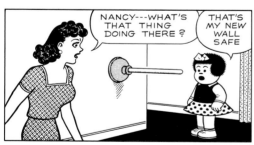
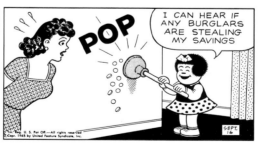

Nancy, September 16, 1963.

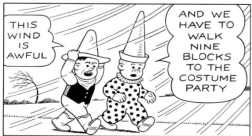
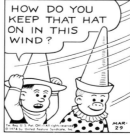
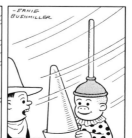

Nancy, March 29, 1974.

dime novel to the photoplay, although that culture had grown dramatically more nuanced by Bushmiller's era. As John L. Fell noted in regard to the original (circa 1886) Nick Carter series of detective stories in his *Film and the Narrative Tradition* (1974), "Introspection among pulp heroes is nonexistent. However they are constantly required to make professional decisions about what to do next." (Fittingly enough, Carter's creator, John Coryell, also crafted his hero's narratives backward from the climax.)

For Bushmiller, a newspaperman to his core, "dumbing it down" meant the rejection of *all* unnecessary baggage — visual, verbal, cerebral, or otherwise — that might impede his information's trajectory. "If I have to point an arrow to the gag," he once groused to a fellow cartoonist, "I'll point an arrow to the gag. . . . I want the stupidest guy in the world to get the gag!"

In statements like these the cartoonist revealed a supreme confidence in his material. Bushmiller understood as certainly as any high modernist (or highway-traffic-line painter) architect Louis Sullivan's edict that "form ever follows function" and literally embodied the conceptual artist Sol LeWitt's observation that "the idea becomes the machine that makes the art." He could be critical of such fellow gagsmiths as Clifford McBride, whose *Napoleon and Uncle Elby* strip was illustrated with an impressive abundance of pen and ink panache. "He didn't care for the work. He thought that the drawing outdrew the gag," testified Morris Weiss. "This is what Ernie told me. He wasn't selling a drawing. He was selling a *gag*."

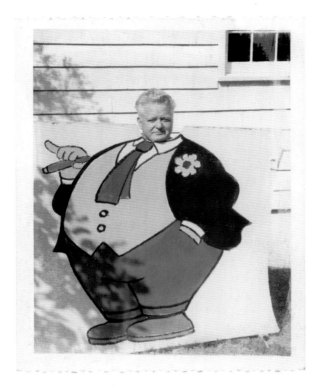

Anything for a laugh, 1960s.

And so, for forty-four years, *Nancy* served up such fresh, easily digestible daily gags, which Bushmiller dished out democratically. "There are more people who eat cornflakes than caviar," he contended. His recipes demanded only humor's most basic ingredients, and they rarely failed him. The following examples demonstrate some common Bushmiller staples:

INCONGRUITY
(The building block of humor. An unexpected juxtaposition demands a mental refocus.)

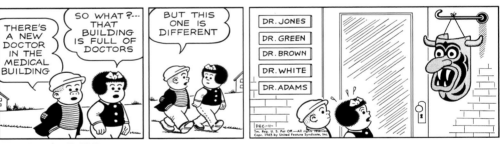

Nancy, December 11, 1963.

SURPRISE
(A sudden shift in perception violates our habitual boundaries.)

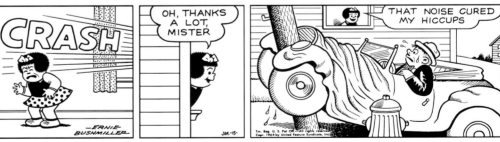

Nancy, January 15, 1964.

SLAPSTICK
(Physical misfortune is tempered by stylized exaggeration.)

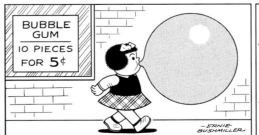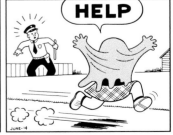

Nancy, June 14, 1963.

EXAGGERATION
(A hyperbolic emphasis simultaneously supports and defies logic.)

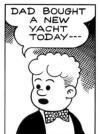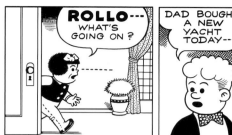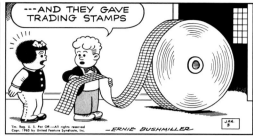

Nancy, January 3, 1963.

MISUNDERSTANDING
(Human error creates palpable consequences.)

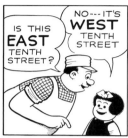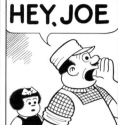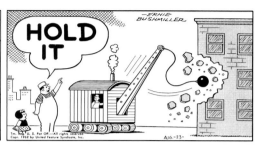

Nancy, August 23, 1962.

IRONY
(A polar reversal is sharpened with poignancy.)

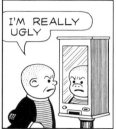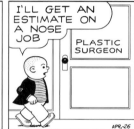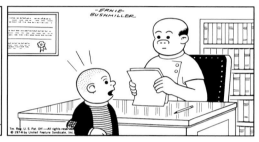

Nancy, April 26, 1974.

PUN
(A double meaning arises from the sound of a single word.)

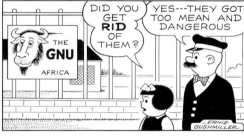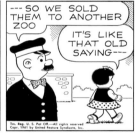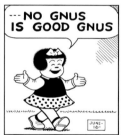

Nancy, June 16, 1961.

VISUAL PUN
(Images do double duty, as both themselves and as unexpected metaphors.)

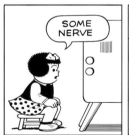

Nancy, December 22, 1962.

ABSURDITY
(Illogic is taken to its own logical conclusion.)

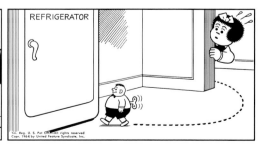

Nancy, July 24, 1964.

The mortar that held these daily gag bricks tight through the decades was basic, iconic, coin-of-the-realm truisms: an ice-cream cone is a kid's best friend, school is a drag, bums are lazy, blondes are cute, bullies are dumb, salesmen travel door-to-door, little green men populate Mars, and modern art is a madman's hoax. No cartoonist more fully exploited these kinds of popular conventions than Bushmiller, and their encyclopedic accumulation, which shaped *Nancy*'s universe, amounts to nothing less than a highly personal vision. Perhaps not since Brueghel were the schemas of an entire culture afforded such a precise and monumental delineation. Functionally, these no-brainers allowed the strips to be rapidly understood and quickly digested; they helped the gag go down faster, cleaner, clearer.

Bushmiller's fundamentalist strategies, once solidly mainstream, had nearly become an anomaly by the end of his long career. Although readership polls had always shown that the strip was enjoyed by all age groups, in the precipitously shifting pop culture of the late twentieth century, where such new and radically unfamiliar sorts of comic strips as *Doonesbury* were now routinely run on the editorial page (and discussed on the floors of Congress), he found himself increasingly referring to *Nancy* and its seemingly out-of-step visual humor as "really, essentially, a strip for kids." "I read the comics for enjoyment," Bushmiller insisted. "*Pogo* is social commentary. Mine isn't. Mine is Lawrence Welk."

Despite such self-deprecation (perhaps verging on defensiveness in his later years), Bushmiller continued to regard his role of public humorist with seriousness and remained a lifelong student of the craft. Reflecting on the necessary qualifications for that role, he advocated an earthy, human-interest approach: "If you want to do a humor cartoon, you must love humor. You must have a good sense of the ridiculous. You must read all the humor you can get your hands on. Mark Twain, Stephen Leacock, Benchley, etc. Get a good background of humor; you'll find that all the greats of humor got their biggest laughs with the most basic human situations." In practice, he simply stuck with what worked.

To question whether *Nancy* is "truly" funny or not may be likened to a Zen koan of the deepest order. No matter how far Bushmiller reached to excite his reader's "gag reflex," he could never possibly gag it down all the way. Humor, despite the staggering mountain of analysis and theory it has aroused, is ultimately an intangible, unquantifiable endeavor: an art (alas) and not a science. We laugh — or do not laugh — at different things than our neighbors do, at different moments of the day, and at different times of our lives. The challenge of all humorists, from Mark Twain to your six-year-old niece, is ultimately to forge a common ground with their audience, joke by calculated joke. In the course of his career Bushmiller conceived and designed upward of 21,000 comic strips — and it is unknown whether any of them ever achieved the creator's (or his audience's) standard of "perfection."

"This is a crazy business," he told a reporter in 1977. "When you finish a strip, you don't know if it's any good or not. You send it in and your toes curl worrying about it. Sure, it still happens. I get a gag I like and figure no one else will like it. You just can't tell." The gag-a-day cartoonist, working in isolation from his audience and months ahead of publication, never hears the laughter. He does not see his work clipped and displayed on refrigerator doors or passed along to a friend. He must rely on instinct, formula, and faith in varying combinations as he moves along to the next strip. The Perfect Gag must, in the last analysis, remain perpetually elusive. "I never quite seem to find it," Bushmiller ruefully conceded. However, on the newspaper pages of any given day in the mid-twentieth century, Ernie Bushmiller came closer than anyone.

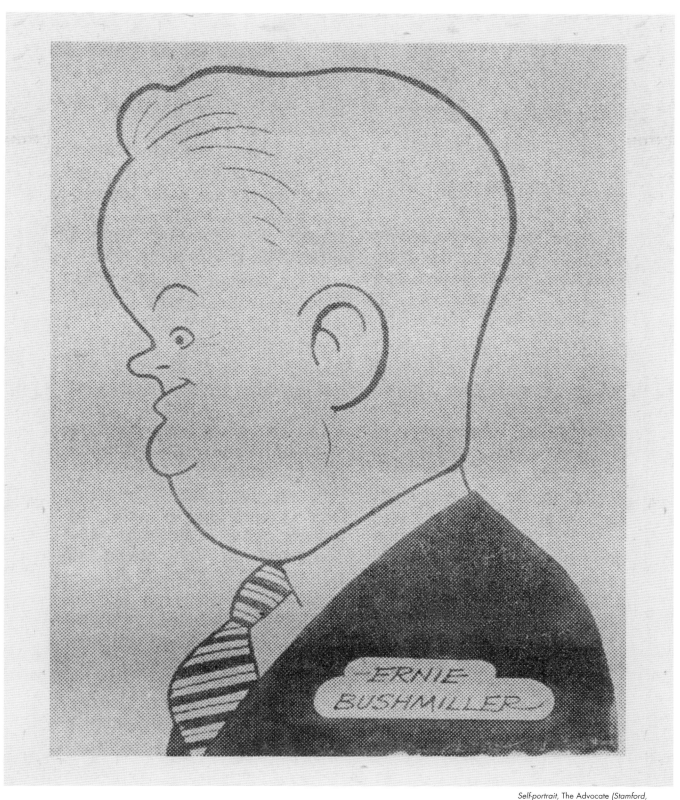

Self-portrait, The Advocate *(Stamford, Connecticut), 1960s.*

NANCY

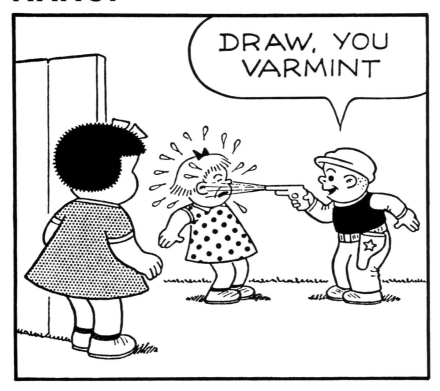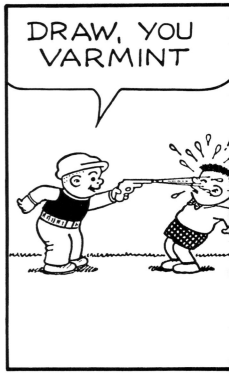

"PHOOEY...I'D RATHER DRAW COMICS." — Ernie Bushmiller, 1948

A. Context

This comic strip was printed in 542 newspapers across the United States (and 102 overseas) on Saturday, August 8, 1959, the last of six *Nancy* dailies published that week. Headlines that day recapped Friday's launch of the *Explorer Six* satellite from Cape Canaveral as well as the floods in Taiwan caused by Typhoon Ellen, which ultimately took the lives of more than two thousand people. On the sports page, former president Herbert Hoover, at age eighty-four, threw out the opening ball at a Yankees "Old Timers Day" exhibition game in the Bronx. Frank R. Kohnstamm, a Cleveland defense contractor, collapsed and died at the home of a friend after making a grand slam at bridge. Strunk and White's *The Elements of Style* returned to the best-seller list for its second week and *Dear Abby* advised a reader signed "Slightly Jealous" that her husband should stop escorting lady wrestlers home at night.

Although this strip was read by millions, in the context of that day's comics page (or of that week's *Nancy*) it would not have been likely that any one of them found this installment especially noteworthy. And it wasn't. The day before, Sluggo had sunk his rowboat fishing for scrap metal. The day after, Nancy one-upped a grumpy neighbor. And the day after that, they both had a close encounter with a lady beatnik. And so it went.

At this stage of his career Ernie Bushmiller, at age fifty-three, had been drawing daily newspaper comics for over thirty-four years and ones featuring Nancy for about twenty-six. As such, this was edging up on Nancy's 10,000th comic strip appearance. Like every last one of them, it was intended to be read once, discarded with the rest of the newspaper at the end of the day, and forgotten.

By Ernie Bushmiller

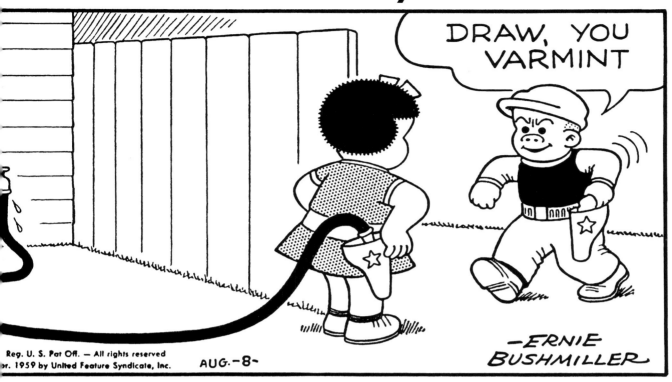

B. Text

"Or, according to others, there is but one point of any object painted on the eye in such a manner as to be perceived at once; but by moving the eye, we gather up with great celerity, the several parts of the object, so as to form one uniform piece." — Edmund Burke, *A Philosophical Enquiry into the Origin of Our Ideas of the Sublime and Beautiful*, Part IV, Section IX, 1757

Black. White. A box. Three boxes. Nancy. Two Nancys. More Sluggos. Words. A hose. A gun. A fence. A house. Two kids. Two squirts. More guns. More fence. Three balloons. Three words. Three guns? Four guns? Hair, eyeballs, pants, nostrils, lines, hats, dots, smiles, frowns, varmints, bows, stars, grass, a spigot, a sky, and . . . "Ernie Bushmiller."

Physically, the act of *seeing* this comic strip (or a bolt of lightning, or a snoring hippo, or anything) is the perception of reflected light meeting the lens of the eye, striking the retina, and shooting along the optic nerve to the brain. But *reading* it is a more complicated matter. To ensure that Burke's "several parts" are *read* — or transmitted effectively to convey intended meaning — the originator of any intentional piece of visual information must have an endgame plan in mind as well.

In spring 2012, Dr. Jason Reiss, assistant professor of psychology at Wheaton College in Norton, Massachusetts, conducted a series of twenty-second eye-tracking tests to begin to determine what happens when thirty-one sets of pupils are confronted with *Nancy* — August 8, 1959 (the first and only study of this kind of which we are aware). While no instrument can yet determine what any eye, when confronted with any image, actually sees *first*, we can assume with some certainty that the process ignited in a flash with the reflexive visual intake of the strip . . . the *whole* strip.

Data from the eye-tracking tests demonstrated that after this initial flash, over the following twenty seconds, all eyes focused on certain areas of *Nancy* more than others. Approximately ten of these "areas of focus" were discerned, and these fixation points were fairly consistent over the course of the tests as eyes darted across the strip, relaying information to the brain as visual judgments were formed.

Some visual judgments may proceed faster than others, but they all follow the same pattern — from seeing to perceiving and ultimately, en masse, to reading. Even though it may have seemed that you "got" this strip virtually upon contact, you went through these stages of translating the bits into a whole as you *read* the strip: words *and* pictures.

The rest of this book chiefly concerns itself with the breaking of this whole back into bits, which we do in an order that may be less than scientific but makes sense to us . . . and making sense of these bits is one of our goals.

But first: take another look at the strip, the whole strip, and nothing but the strip.

2. THE GAG

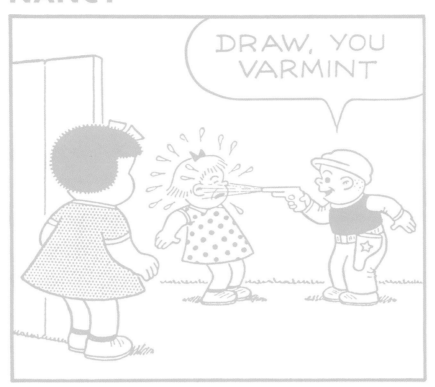

"The gag itself comes first and is more difficult than the drawing part of cartooning."
— Ernie Bushmiller, 1973

A. Context

Before the cartoonist puts pen to board, before the cartoonist puts pencil to notebook, before the cartoonist does anything fruitful with a pulp-based product or any sort of pointed object, the cartoonist first must think. The ability to regularly generate useful concepts is at the core of the creative practice.

In a 1949 essay entitled "The Gag Strip" aimed at aspiring cartoonists, Ernie Bushmiller discussed his process: "It is difficult to explain how an idea is born. . . . I start with a blank piece of drawing paper and I just sweat and stew until I think of a subject that seems likely to produce a ludicrous situation."

Visual stimulation via *Life* magazine ads, the Sears, Roebuck catalog, and other printed ephemera often jump-started the procedure for him. "When I find an item that seems likely, I start to kick it around in my mind to see if I can work out a funny situation. If nothing jells after a reasonable time I discard it and try another item. Sooner or later my mind warms up and I get the nucleus of an idea. . . . I keep a lot of notes on gags that haven't quite materialized; I look these over from time to time and sometimes the solution comes to me and I am able to salvage some of these undeveloped ideas. Also when I am up against the necessity of getting six dailies or a Sunday together, I sit down and try to get the perfect gag out. If it won't come I fish one of these unfinished things from the back of my head or notebook and go to work."

This was hard work. According to Bushmiller confidant and fellow comic strip artist Morris Weiss: "Ernie would go into a trance and he would be completely oblivious to everything around him. . . . He was in a world of his own trying to come up with a gag. If I came into the office and saw him sitting in the office staring into space I wouldn't even say hello to him. . . . Most of his time was consumed with coming up with ideas. . . . His whole life was coming up with gags."

The actual details of how this (or any particular) Bushmiller strip germinated are forever lost to the ages. By 1958 (when this gag was almost certainly conceived) Nancy and Sluggo had engaged in intermittent squirt-gun hostilities for many a summer, a recurring aspect of the pair's sporting rivalry. That year's Sears, Roebuck Fall/Winter catalog featured the traditional pictorial ads for garden hoses, plus "pistol-grip" garden hose nozzles as well as gun and holster sets "for backyard lawmen." It's more than likely that these images passed right under Ernie's nose and smelled ripe for a fresh twist on some reliable themes. (See Appendix 1: Inspiration, page 161.)

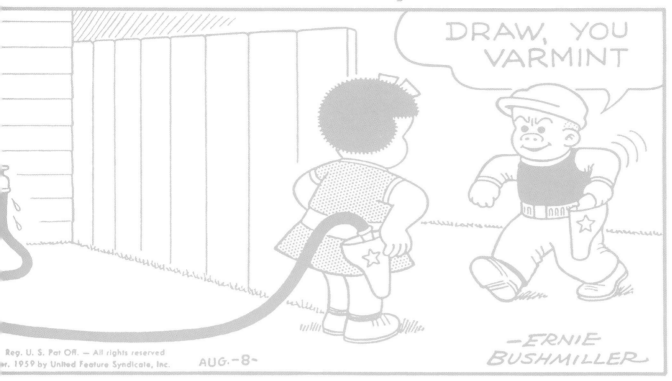

B. Text

In this episode, the gag itself can be broadly categorized as a basic problem-solving type, with Nancy's few outstanding character traits displayed to maximum advantage. The narrative that these three pictures and these three words comprise is manifest, its transmission so efficient as to be absorbed at a glance.

Panel 1: *Nancy sees Sluggo attack.*
Panel 2: *Sluggo strikes again.*
Panel 3: *Nancy returns, prepared with a secret weapon, anticipating Sluggo's next attack.*

Sounds grim, but in fact many of the time-honored comedic tropes are firmly in place here: violence, humiliation, retribution, role reversal, incongruity, deceit, surprise, anticipation — and the repetition of the number three. As a narrative it intentionally lacks closure; rather than concluding with a slapstick payoff, the true climax here is in the implied but nonexistent fourth panel (somewhat atypical of the Bushmiller MO in that it allows the reader a shade more creative participation than usual, but certainly not without precedent).

What makes the combination of these three images funny? Theorists might cite Aristotle on comedy in regard to the triumph of Nancy as plucky underdog. Rival theorists might invoke Thomas Hobbes's "Superiority Theory" of humor in regard to our inside track on Sluggo's incipient dousing (and our own personal dryness). Six-year-olds might tell you they are funny because they are in black and white. At the end of the day, funniness, like all opinions, must remain perplexingly subjective.

But funny or not, this is indisputably a gag. Gags, like jokes of all kinds, are formal, hermetic constructs whose success depends upon (as much as any perceived funniness) the deft arrangement of innumerable interconnecting systems by a discerning engineer. The Bushmiller system for isolating the essence of a gag was unique: he thought backward.

Moral: Content comes first and stays last.

3. THE LAST PANEL

NANCY

"I usually can visualize how the last panel will turn out, so I start to pencil in the finish of the strip very roughly. If it looks okay then I work backward toward the starting panels. I always work in reverse. In this way I can choose the best path leading up to the snapper." — Ernie Bushmiller, 1949

The Script

A. Context

As this statement reveals, Bushmiller was a visionary who birthed his gags in the boldest of strokes: arresting, incongruous, absurd (or in this case portentous) images. It was the only logical way to work for this ex–crossword puzzle designer. "I know a guy who works upside down so I don't worry much about drawing backwards," he joked. A half–century of *Nancy* was retro-engineered around such "snappers."

Once the basic concept had solidified in his mind, Bushmiller understood exactly where he was headed: "You may want to know what the technique is for getting the gag actually down. Some comic artists develop ideas on tracing paper, but I never make preliminary sketches. I start penciling directly on the drawing paper. Then I ink them in."

The peculiar, delirious worlds of these last panels became Bushmiller's trademark, and they served him well for decades. They are at the heart of *Nancy*'s enduring appeal, the strange and wonderful images that fans and poachers most often liberate to their own ends. Surprisingly, during the era of *Nancy*'s greatest success, Bushmiller had little competition among his newspaper strip peers in such graphic flights of fancy. In some respects they were a throwback to an earlier, more pictorial era of comics, as many newer, contemporary strips tended to play up character development and dialogue in response to their rapidly diminishing turf. Some cartoonists (notably his "kid strip" rival at United Feature Syndicate, Charles M. Schulz) did adopt his ass-forward script technique from time to time, but toward a very different brand of gag. "*Nancy* may be considered traditional or even old-fashioned humor by some," Bushmiller reflected later in life, "but to me it's as relevant as *Doonesbury* as it makes you laugh — and that what the funnies are all about."

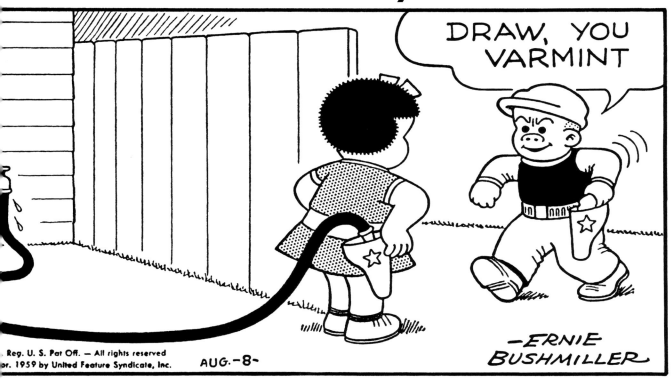

B. Text

Panels 1 and 2 set the stage for the last. It is the largest of the three panels and has been justly allotted maximum available space, comprising exactly one half of the strip's total length. (See Appendix 2: Further Contexts, page 161.) Here Nancy takes a bold stand against Sluggo's advance. He seems to think she will be another pushover. She knows differently. To her left stands the source of that confidence, a concealed strategic defense system significantly more advanced than his (remember, this was the height of the Cold War era). It is in the triangulation of Sluggo's ignorant aggression, Nancy's unexpectedly deeper aggression, and our privileged vantage point that the conceptual crux of this gag lies. Humor is born in the crosshairs.

While the last panel completely houses the cartoonist's "nucleus of an idea," if taken alone it makes a functionally unsatisfactory single-panel cartoon. However, with a little reformatting, the idea fares much better than most of Bushmiller's snappers due to its implicit, unresolved climax. (See Appendix 3: Single-Panel Gag, page 165.)

A solid, reliable graphic concept like this one could easily serve in any visual medium from an oil painting to a silent film comedy to a smartphone app. But Ernie Bushmiller was a twentieth-century newspaper strip cartoonist and this particular image is only a fragment of a larger, custom-designed totality. What alchemy do the two previous panels create in combination with the last to produce a *Nancy* daily? It takes more than a promising final panel to create a functional comic strip.

Moral: Ideas can flow from any direction.

4. DIALOGUE

NANCY

"Most of my gags are visual — that is, the idea depends on what is happening in the picture, rather than what the characters are saying." — Ernie Bushmiller, 1949

A. Context

In 1959 there was scant room for spare gab in a daily newspaper strip (and there is even less in today's diminished format). Fortunately the cartoonist has an advantage over the astrologer one column over: he has pictures to do some of the heavy lifting. More expansive formats of comics may afford increased possibilities, but the inherent wisdom of the daily strip cartoonist's discipline remains: show — don't tell. Or as Bushmiller put it, "If a gag can be set in type it isn't worth drawing."

While *Nancy* was not a pantomime strip, it could often be understood with or without the dialogue. Bushmiller primarily wrote with pictures, and the cartoonist's axiom "Dumb it down," in good part, referred to the primarily visual ("dumb" as in silent and nonverbal) nature of the strip. Yet *Nancy*'s dialogue was never superfluous; its text was routinely scrutinized for the slightest redundancy. The words and pictures in *Nancy* always complement one another, working hand in hand to efficiently deliver the gag.

Bushmiller was still a very young teenager when he first entered the newsroom of the New York *World* in 1919, and he spent the rest of his life in the fraternity of craftsmen known as newspapermen. Newspapermen craft words, and as they craft them, they count them. Ernie Bushmiller was a man driven by such precision. Mell Lazarus remembered his fellow cartoonist as a quiet, reserved man, but "at one [National Cartoonists Society] meeting Ernie asked for the floor and he made an impassioned speech. He was very passionate that there were too many words in comic strips. It

really seemed to upset him. He was an advocate for fewer words. He was moved and sincere, but vehement on the subject. He really believed that the pictures should do most of the talking. In a sense, he was lecturing his colleagues." (See Appendix 4: "Too Many Words," page 166.)

Toward the end of his life, stricken with Parkinson's disease, *Nancy*'s creator required additional help to keep his strip on schedule. Al Plastino, one of the most capable chameleons of the comics, who was hired to execute the Sunday strip, recalls, "Bushmiller would call me up and tell me to take out a word he didn't like. Then he'd call up five minutes later to tell me to put it back in. Then he'd call up again and tell me to replace it with another word. He'd call me ten to twenty times a day!" Bushmiller parsed Nancy's words to the bitter end.

In this strip the pictures do most of the talking and Sluggo does the rest. His phrase "DRAW, YOU VARMINT" is a cocky and confrontational taunt, clearly within Sluggo's wont. Yet it is also an archaic Western cliché and instantly conveys that any armed threat is a mere manifestation of a role-playing game. Of course, the real gunfighters of the Old West did not communicate this way, but generations of dime novelists and screenwriters did — and that was good enough for Ernie Bushmiller.

By 1959 television Westerns were at the height of their ubiquity. During one pistol-packin' week that March eight of the ten top-rated shows were Westerns, with a grand total of twenty-eight Western series running on the three networks

DRAW, YOU
VARMINT

each and every week. On the evening of the particular summer day that this strip appeared, American network television devoted a combined five and a half prime-time hours to the broadcast of Western reruns, more than any other programming genre — and that does not include local stations' round-the-clock transmission of vintage Hollywood oaters. "DRAW, YOU VARMINT" was probably snarled countless times across America's airwaves and, in turn, America's playgrounds. (If not for the enduring growls of Yosemite Sam, how many today could even guess what a varmint is?)

Cartoon children playing at cowboy was in itself a reliable chestnut of ancient standing. Comic strips dating back to the *Buster Brown* era had showcased such pint-sized melodramas, while high-profile animated films from the Walt Disney and UPA studios revived the concept for 1950s theatrical audiences, amid legions of other media incarnations. Bushmiller, always working with the iconic, invoked the precise three words and four syllables that gave him what his gag needed — no more and no less.

B. Text

The dialogue is probably the last thing "read" in scanning this strip, but it holds the key to much of what works here. This strip contains only three words of dialogue (repeated three times in three panels) by a single speaker. Although more economical and direct, Sluggo does not simply say "DRAW." Instead, with these three words, Sociopath Sluggo (arguably the only "varmint" actually depicted here) projects

his own scurrilous varminthood upon his innocent quarry. Such patently unjust behavior is more deserving of the harsh, wet reward that awaits him at the end of the trail. The two extra words also provide amplified motivation for our heroine's brave and resourceful stand, thus giving the reader a bit more reason to root for (and revel in) the true varmint's downfall.

Additionally, the four syllables of "DRAW, YOU VARMINT" help create a specific time frame for the unfolding of the strip's action. A meager "DRAW" would speed up the time elapsed in digesting each panel and contribute to a faster, staccato reading of the whole strip, outrunning much of the deliberately paced visual information in the process. Conversely, a longer line such as "DRAW, YOU ORNERY VARMINT" would do damage in the opposite manner. The specific phonetics of the syllables (though read silently) contribute immeasurably to the desired effect. "DRAW, YOU VILLAIN," for instance, contains nearly the same meaning and the same sounds, yet lacks the hard snap of Sluggo's original line. Mark Twain's oft-cited comment "The difference between the almost-right word & the right word is really a large matter — it's the difference between the lightning-bug & the lightning" could not be more apropos.

Moral: Concise and considered words complement concise and considered images.

5. BALLOON PLACEMENT

NANCY

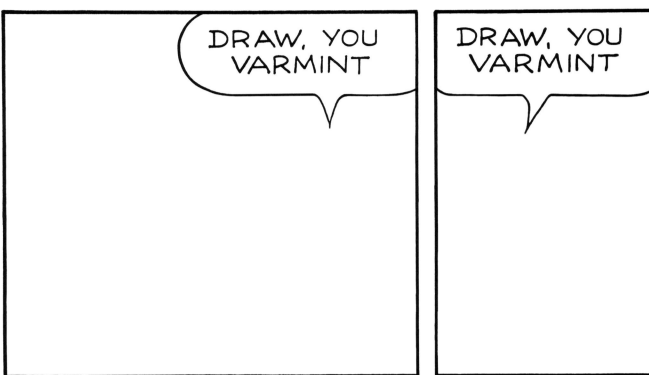

"By composition I mean the intelligent placing of your objects and characters so as to make it as easy as possible for your reader to get what you are driving at." — Ernie Bushmiller, 1949

A. Context

Bushmiller, like all American cartoonists, operated on the fundamental understanding that Westerners read everything, including comics, from left to right. This had long been a precept of both newspaper and graphic design culture. As John E. Allen, editor of *The Linotype News*, noted in his *Newspaper Makeup* (1936), "It is advisable to have the picture face into the story, rather than away from it. This helps focus the reader's attention on the story." In order to control and facilitate the flow of information, the cartoonist strategically arranges his chosen elements — houses, fences, figures, and (especially) word balloons — always keeping this principle in mind.

Unlike houses, fences, and figures, however, in comics, word balloons are simultaneously a part of and apart from the picture plane. They occupy a privileged pictorial status, a semitransparent mediator between author and reader that the players may hear yet do not conventionally see.

In a well-conceived comic strip, the strategic placement of word balloons generally takes graphic precedent. They deliver the strip's soundtrack and, like audio speakers, if installed just so, will clarify and enrich their contents as well as the space they serve. Conversely, if positioned without consideration, they will distort the message and confound the audience.

By Ernie Bushmiller

DRAW, YOU VARMINT

B. Text

Situated in the upper right corner of the first panel, the balloon containing "DRAW, YOU VARMINT" is read *after* the reader has assimilated the visual information. Exiting panel 1 from the upper right via the word balloon, the reader immediately runs headlong into the second. With only the panel gutter separating them, the eye's swift journey from one panel to the next is made directly via balloon. The repeated dialogue becomes a catchphrase, and a verbal rhythm (coupled with its visual counterpart, the squirt) is established.

Entering panel 3 from the left, there is no word balloon and there is no squirt. But there is a drip. Now the reader's glance is diverted straight to the power structure behind Nancy's self-assurance. The rhythm pauses a beat. When the reader and the third balloon finally meet, it is at the outermost extreme, tucked into the upper right-hand corner of panel 3. The payoff comes from reading the same line of dialogue a third and final time *after* encountering a very different image than what we have been conditioned to expect. "DRAW, YOU VARMINT" takes on an extended meaning, inviting further repercussions.

Moral: In the design of comics, situating the text is primary.

6. SLUGGO

NANCY

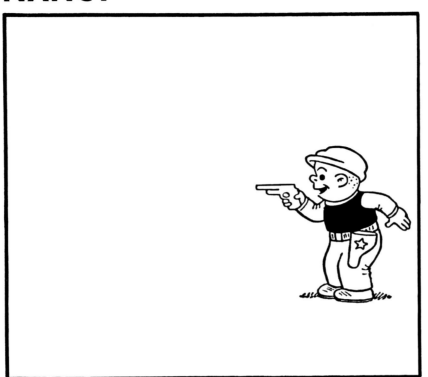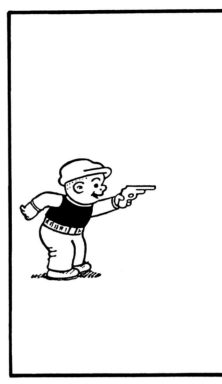

"Most strips reflect the personality of the man who creates them; I think I was pretty much like Sluggo when I was a kid." — Ernie Bushmiller, 1949

A. Context

Sluggo Smith literally slugged his way into Nancy's orbit on January 24, 1938. (Ironically, he was depicted heroically, punishing an anonymous snowball sniper.) Before Sluggo entered the picture, Nancy was occasionally seen in the company of other pint-size suitors, including the mop-headed "Herman" and the nattily appointed "Stewart." But it was Sluggo's macho valor that won Nancy's fair heart from the last panel of their first daily, and the pair have remained inseparable (if not entirely compatible) forever after. (See Appendix 5: Enter Sluggo, page 166.)

Over the years Sluggo evolved . . . slightly. He started out as a streetwise little tough guy from the Bronx via central casting (this was the same year the Dead End Kids began their careers at Warner Bros.). Costumed in patched, over-sized hand-me-downs, Sluggo proved an instant irritant to Aunt Fritzi's glamorous domestic equilibrium (remember, at the time this was still *her* strip he was crashing). His bad manners and rough edges provided class friction gags for months, but Bushmiller soon realized that this gamin had greater potential. A regular sidekick/boyfriend/foil of Nancy's own size and age offered clear and practical benefits for the strip. With Sluggo's inclusion in the cast, the gag premises widened exponentially and the balance of the strip crucially tipped from Nancy's sideline interactions with the adult world of Aunt Fritzi to the world of children's preoccupations.

Sluggo's scope widened a bit as well; he became a versatile, multifaceted, all-purpose little tough guy. By the postwar years Sluggo could be called upon to behave respectably at a birthday party, although if Bushmiller took him to a society ball a bit of the Bronx might still leak out (especially when the gag demanded).

Some aspects of Sluggo have always been kept intentionally murky. He is known to live in a ramshackle home on the other side of the tracks complete with holes, patches, and mice, though with no apparent adult supervision, evidently an orphan on the fringes of society. (A shiftless "Uncle Harry" appeared just once, a week after Sluggo's debut, and vanished without a trace.) Yet Sluggo attends the same school as Nancy and takes part in all the same middle-class social events and activities. (Once, pressed on the point of Sluggo's mysterious finances, Bushmiller uncharacteristically allowed, "I assume he delivers groceries on Saturday or something like that.")

What is kept sketchy in background detail is more than made up for in personality detail: Sluggo, with his innumerable faults and failings, is easily the most consistent, well-delineated character in *Nancy*. Not surprisingly, in some European markets (such as France and Italy) that imported *Nancy* after World War II, Sluggo was given star billing (*Arthur et Zoe, Arturo e Zoe*), with Nancy relegated to second banana.

By Ernie Bushmiller

B. Text

Sluggo's character flaws have often landed him as the butt of a joke. Umpteen gags have been crafted around Sluggo's sluggishness, infidelity, mischievousness, cowardice, and hubris. Here Sluggo is cast in the role of the bullying menace. He is intent on forcing his game on whomever he encounters — ready or not. In one of his rare fashion decisions, Sluggo wears black. Today he is clearly "The Bad Guy."

First Sluggo faces left, then right, and finally he faces left again but now veering forward, toward the reader, in three-quarter view. Remember that his dialogue remains exactly the same, so his movements here produce a visual counterpoint to the text's established rhythm. In the final showdown, as he advances forward he has become twice the size as in the previous panel, twice as threatening. Sluggo gets so aggressive here that he obliterates the bottom part of his own balloon, surging off the newsprint as he moves in for the kill. Notice his expression: at first he is filled with ecstatic glee as he "shoots" the two children. In the last panel this glee is augmented with menace as he confidently stalks his prized victim. But the rules of his game are about to be changed.

Moral: Attractive character traits are often not positive ones.

NANCY

"All of my characters are conceived in desperation." — Ernie Bushmiller, 1948

A. Context

For many decades *Nancy* maintained a stellar position in the syndication rankings of American comic strips, reportedly never dipping below sixth place in overall reader popularity. With an audience in the tens of millions, Nancy became one of the most recognizable cartoon characters of the twentieth century. Yet as a recognizable personality Nancy remains maddeningly hard to sum up.

Nancy is generally mischievous (but kind), bright (but no A student), impudent (but no delinquent), impulsive (but not foolhardy), jealous (but forgiving), and fickle (yet ultimately consistent). She is generally cast as a problem solver, in contrast to Sluggo's role as a problem starter — though both are perpetually open to a complete reversal. She is the de facto daughter of Fritzi Ritz, yet her actual parentage is never addressed. Her most memorable characteristics are her sass, creativity, cunning resourcefulness, and constant physical activity — all of which directly stemmed from her utility as a vehicle for Bushmiller's gags. Perhaps this blank-slate aspect of the Nancy persona holds the key to her overwhelming appeal. Taken with such an active, capable, spunky character, readers from every background on the planet readily identified with this leading lassie.

"You'd be surprised how many letters I get asking me who's Nancy? Where's her mother and father? What's the story on Sluggo?" Bushmiller complained to an interviewer in 1973. "The problem is I don't know."

Who's Nancy? She is *us*.

By Ernie Bushmiller

B. Text

In this strip Bushmiller fortified the reader's identification with Nancy through some shrewd sleight of hand. As one enters the strip, past the ruled, hard-edged panel border, the first figure encountered is Nancy herself — who, in turn, is depicted looking into the space just past the ruled, hard-edged border of the fence. The reader looks in on someone looking in further. She is our surrogate at once. In effect, we *become* Nancy, bearing witness to Sluggo's massacre. By panel 2, we have assumed her point of view entirely.

We do not see Nancy's face in these panels because we do not need to. Even the most casual reader will recognize the featured player without benefit of her particular facial arrangement of dots and lines. By eliminating expression, Bushmiller exploits the technique of the deadpan performer and allows for some reader participation. We deepen our identification with Nancy as we project our own emotions onto her blank slate (or is it vice versa?). Her hidden features likewise keep the reader guessing at her intended thoughts and heighten the surprise of the last panel's payoff.

In the last panel, Nancy responds with intelligence, strength, and compassion — and perhaps just a smidgen of passive-aggressive sadism (small wonder so many grown women remember *Nancy* so fondly). Like generations of fictional Western heroes, she remains stoic and aloof yet bigger than life while assuming command; clearly justice will prevail and the true varmint will get his in the end (or, more likely, the face).

Moral: Engaging characters remind us of ourselves.

NANCY

"Once in a while, in desperation, I'll introduce a character, but if I can't get the gags outta him, the heck with him." — Ernie Bushmiller, 1977

A. Context

In *Nancy,* Bushmiller purposely kept his casting options limited. "I don't believe in too many characters," he asserted. "I, personally, believe in keeping the cast small." George Herriman's extraordinary *Krazy Kat,* often touted as the quintessential three-character comic strip, actually featured a far greater stock company of subsidiary characters than Ernie Bushmiller's *Nancy* ever would. Beyond Nancy, Sluggo, and Aunt Fritzi there were remarkably few recurring characters over the years. Even Fritzi's perennial suitor, Phil Fumble, seems to have never appeared in the *Nancy* strip proper, only in Fritzi's solo escapades on Sunday. (When *Nancy* replaced *Fritzi Ritz* on the Sunday pages on October 30, 1938, *Fritzi* in turn teamed with Phil, who had already occupied the ancillary "topper" strip since 1931.)

Most of the troupe were stock types, obviously concocted for the sake of a running gag (Marmaduke, later Rollo, the rich kid; Spike, the bully; Pee-Wee, the short kid). Nancy's female entourage (Irma, Amy, Annie, etc.) were so lacking in individuality that they were rarely even drawn the same way twice.

Bushmiller discussed his strategy toward *Nancy*'s extended cast: "Another subject which lends itself to new ideas is the injection of a new character. Preferably one who is out of his or her normal environment; such as a hillbilly who is astounded by the sight of modern things such as vacuum cleaners, television, dictaphones, etc., or a little French girl who is visiting relatives in the neighborhood or an Eskimo boy who is playing in a theater around the corner. I find incongruous characters like these very fertile material for gag situations. I also bring in occasional puppy-love triangles; a pretty little girl or a handsome little boy upsets the normal relationship between Nancy and Sluggo." Such characters were generally limited to a few weeks' duration.

"One thing that always worries me is the possibility that I might run the series too long or chop it off too soon. That happened about a year ago [November 1948]. I introduced a new character called Nosey Rosey; she was a snoopy little girl who always pried into other people's business. She was a juicy character for ideas and situations for a couple of weeks. I felt I could have continued this theme for several more weeks, but I didn't want to bore my readers. So I ended the series. A month later, when the strips appeared, I received a great deal of mail asking why I discontinued Rosey."

In the early 1970s the "relevance" of many long-running comic strips such as *Nancy* was being publicly questioned. Bushmiller found himself under increasing editorial pressure from his syndicate to introduce a black youngster into his insular cast. In a widely printed 1973 article on this issue by Associated Press reporter James Carrier, the cartoonist came across as sensitive (yet ambivalent): "My instincts tell me to do it. I'm waiting . . ." His private concerns were, according to Al Plastino, far more characteristic: "Black kid? Where's the gag?"

By keeping his cast small and familiar Bushmiller kept one aspect of his strip absolutely predictable to his daily readers — an important consideration given the often surreal bent of his visual humor. "I think I have an instinct. I can smell and taste the average American," he once said. "They just like to lead nice, gentle lives and read about normal everyday events." At least until the last panel.

B. Text

Just who are these anonymous casualties of Sluggo's wet rampage? They are *not* us! They are merely props, ciphers cast from the Bushmiller forge to be melted down and recast again as playground extras. Yet they are essential to this strip as Victims. Bushmiller provides us with important clues as to *what* they are, even if it is never exactly known *who* they are.

One is a defenseless little girl. (Does Nancy see herself as an inversion of this passive girl with her straight white hair, large-dot-screen dress, and black bow?) The little boy is clearly a *little* boy, with his short checked pants (in contrast to Sluggo's manly trousers) and sissy bowtie (the bow, again, directly signals Nancy's kinship). Neither were formally invited to Sluggo's impromptu game of "squirt-'em-up," and neither will likely be playing again anytime soon.

This sorry, soggy duo are barely given the gratuity of facial features. Bushmiller knew that it would be just plain funnier to have their little mugs obscured by blasts of water, but this choice serves other narrative functions as well. Explicit facial detail might slow the reader down ("Wait a minute — who is that kid anyway?") or evoke distracting empathy. Sluggo is depicted firing point-blank into their unprotected faces, effectively crossing out their physiognomies. Their obscured features provide yet another kindred tie to Nancy, the Faceless Avenger. These are the damned of childhood, eternally roaming the world with arched backs and wet faces.

Moral: Every character is made to order.

NANCY

"I am very fond of Nancy and Sluggo and have genuine feeling for them. I think this is important. You have to believe in your characters or there is no fun in the job." — Ernie Bushmiller, 1949

A. Context

While Bushmiller, the gag-builder, masterfully ordered every micron of his kingdom down to the last dot, Bushmiller, the character-builder, took a kinder, gentler, and far less austere tack with his charges. His paternal fondness for Nancy and Sluggo was reflected in his grounded, respectful, and protective handling of their beings. He refused to reduce Nancy and Sluggo to absolute ciphers, yet he also refused to let them become too "interesting" in and of themselves. "They may be brats, but they're nice brats. They don't play with meat choppers or dangerous weapons. I don't let them get that vicious."

While the pair were clearly no threat to the Katzenjammer Kids, Bushmiller likewise eschewed the inwardly reflective, philosophical approach of cartoonists like Percy Crosby (*Skippy*), Crockett Johnson (*Barnaby*), and Charles Schulz (*Peanuts*). These strips previewed the complexities and contradictions (not to mention the neuroses) of adulthood for young readers as *Nancy* quietly went about its business of "kid stuff" — letting the Sturm und Drang of childhood exteriorize in the topsy-turvy universe of the strip's last panels.

In this episode Nancy and Sluggo are engaged in overt Western role-play. This one-up game of showdown had been a recurring feature in *Nancy* since at least the early 1950s, and regular readers would not be puzzled about yesterday's committed pals behaving as today's committed adversaries.

In this sort of mutability, Nancy and Sluggo embody an authentic aspect of childhood. No matter how unbelievable a given gag might be, Bushmiller never forgot that Nancy and Sluggo were kids first and foremost, and he kept their action and motivation believable.

- Nancy and Sluggo are imaginative, curious, skeptical, readily distracted, and completely self-absorbed. Just like real kids.
- Nancy and Sluggo are enthusiastic about ice cream, bubble gum, comic books, TV, snow, and what's inside the cookie jar. Just like real kids.
- Nancy and Sluggo (though parentless) are at the mercy of the adult world, whose sanity they often question and authority they often subvert. Just like real kids.

Unlike real kids, however, Nancy and Sluggo will never evolve through the stages of human development, but will remain forever frozen at a certain cognitive and physical level: the gag stage. "Older readers love to laugh at Nancy because she's still the same pert, merry little kid they laughed at when they were younger," Bushmiller wrote in 1966. "If she were older, they'd realize they're older too . . . and the laughter would have a touch of sadness in it."

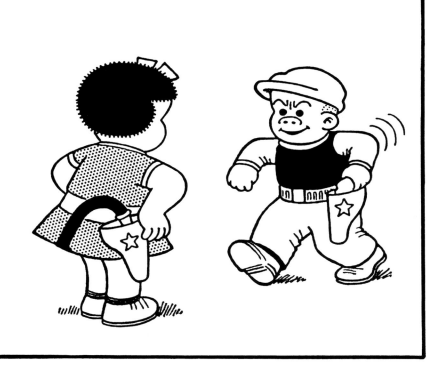

B. Text

Nancy and Sluggo team together to play polar opposites in this symbolic little drama of "Boy Meets Girl." In today's episode:

- Masculine meets feminine.
- "Wrong" meets "right."
- Offensive meets defensive.
- Active meets still.
- Noisy meets silent.
- Distant meets close.
- Playful meets deadly.

Their inevitable attraction can be charted by comparing their physical proximity to each other in the first and last panels. As they inexorably draw nearer, the lights dim, their eyes lock, and the curtains close. Black out.

Moral: In fiction as in life, the closest relationships are often the most complicated.

NANCY

"I WANNA BE A MAN OF DISTINCTION" — Ernie Bushmiller, 1948

A. Context

The final member of the cast (and the most important) is the character who devised the gag, ruled the lines, wrote the dialogue, drew the pictures, brushed in the blacks, packed it all up between cardboard, and mailed it off to the syndicate, along with the five other daily strips that he produced during his Sunday-to-Tuesday production docket sometime in mid-1958.

He loved his work. He loved his wife. He loved Mencken, Twain, Leacock, Benchley, *Happy Hooligan*, small dogs, the borough of the Bronx, and kale. He disliked nightclub humor, early rising, Reginald Marsh, and "messages" in the funnies. He described himself as looking like a honeydew melon and he talked like a movie gangster. He drank cold Heineken from the can, preferred biographies to novels, favored Camembert cheese, bought a brand-new canary-yellow sedan every two years, tuned in to Joe Franklin in the dead of night, and regularly fretted about finding the next gag. He was, in the words of those who knew him, a "real pro": friendly, private, preoccupied, reclusive, shy, fearful, phobic, tolerant, tough, sweet, frugal, philanthropic, youthful, intelligent, and modest. That character is Ernie Bushmiller and his presence is represented here by his signature, made of the same sharp black lines and curves as Nancy, Sluggo, and the rest of their universe.

Many cartoonists of the early twentieth century gussied up their signatures with rococo flourishes — self-impor-tant window dressing that called attention to themselves on a crowded newspaper or magazine page. This may have been savvy self-promotion for an ambitious hustler but was rarely advantageous to the work itself and eventually became the damning hallmark of the amateur. The signature attached to Ernie Bushmiller's teenage *Judge* magazine contribution ("Amateur Knights of the Pencil" for February 25, 1922) was about as ostentatious as this serious young cartoonist ever got. The final R's elongated descender is positively restrained compared to the calligraphic antics of some of his contemporaries (see page 37).

Bushmiller's earliest credits at the New York *World* were the initials that he surreptitiously snuck into the corners of some of his very first puzzles (See page 35). By 1925 (and throughout his long career) Bushmiller styled his name much like his dialogue lettering . . . except in italics. Signature italicization seems to have been a standard convention at the *World* that Herb Roth, Harry Haenigsen, J. Carver Pusey, Al Frueh, Will B. Johnstone, and most other cartoonists in the bullpen conformed to. This was sound policy, as italics allow the artist's signature to be simultaneously visible (floating on the surface) yet invisible (discrete from the depicted space it actually occupies).

Bushmiller was even known to fashion a gag from this odd dichotomy. From time to time Nancy or Sluggo referred directly to the Ernie Bushmiller signature, momentarily flashing the spotlight on the cartoonist's hovering presence. This type of self-referential humor was always a treat in *Nancy*, a holdover from the medium's earliest days (Winsor McCay was a prolific practitioner of such meta-comics) that was rare on the comics pages of the 1950s. Bushmiller had the wit and no compunction in breaking the Fourth Wall (or in this case the Second Wall) to make his gag work.

By Ernie Bushmiller

—ERNIE
BUSHMILLER

B. Text

If the figures, environment, and actions exist on one plane of the picture and the dialogue and balloons on a second, then Bushmiller's signature occupies a third level.

Functionally, of course, a signature verifies any artist's work, provides attribution, brands it, commodifies it, and memorializes it. In our example, Ernie's signature (prefigured by his usual dash) is placed in the lower right (as was common to most dailies), in the tradition of right-handed artists through the centuries. It is signed at about two-thirds of the height of the balloon lettering, another choice that distinguishes it from the remainder of the panel's contents.

As the very last piece of information to be digested, the signature sits snugly in its only logical nesting place while the author signals a modest bow to the reader. There are no more empty squares in this crossword puzzle.

Moral: Pay attention to that man behind the curtain.

NANCY

"I jot down items such as toaster, leaky roof, folding-chair, mail box, windy day, etc., anything that comes into my mind. When I find an item that seems likely, I start to kick it around in my mind to see if I can work out a funny situation." — Ernie Bushmiller, 1949

A. Context

The nucleus of this particular gag probably grew out of the barrel of a water gun.

The earliest patented versions date to the 1890s, and it's more than likely that Ernie the Kid ambushed his friends with a contemporary model outside his apartment building on East 161st Street in the Bronx. By the early 1940s the seeds of Nancy and Sluggo's decades-long water gun, snowball, and peashooter war had been firmly planted. This gag's genesis can be seen in embryonic form in several earlier strips, notably the Nancy Sunday episode for November 11, 1945. (See Appendix 6: "Hey! Where Have I Seen That Gag Before?," page 167.)

Of all the iconic objects in this strip, the gun is probably the smallest. The specimen in panel 2 measured just about three-sixteenths of an inch when it was originally published (a shudder passes to imagine how microscopic it would appear on the reduced space of today's comics page).

Yet despite the size it is immediately discernible for what it is. Remarkable, really, given the fact that the gun is white.

In comics, as in reality, guns are generally black, but had Bushmiller drawn this water gun black (as he did in the 1945 Sunday strip), it might, on first glance, be mistaken for a "real" gun. In the fourteen years that elapsed between his 1945 Sunday and the creation of this strip the relationship between comics, kids, and assault weapons had undergone nothing less than the scrutiny of a widely publicized congressional hearing. Bushmiller did continue to "spot" his toy weapons black on occasion after the 1954 Senate investigation of comics, but perhaps the depiction of a gun repeatedly firing point-blank into children's faces informed his decision in this case. With a white pistol, brandished by a costumed child and squirting a sizable halo of droplets, this cartoonist was on safe footing.

By Ernie Bushmiller

B. Text

Sleazy Sluggo's gun is quick, and he whips it out to violate the innocent. That is, until Sheriff Nancy straps on her equalizer. Can the "money shot" be far behind? At the heart of this gag (so obvious that it almost goes unnoticed) is the inevitable Freudian subtext: big gun on little boy, bigger gun on little girl. Sexual role reversal is always, always good for a laff.

The water gun itself is granted utmost compositional significance here, planted nearly dead center in both panels 1 and 2. This double placement (linked with Sluggo's repeated war cry) creates a very specific set of expectations for panel 3 — which the cartoonist (naturally) proceeds to pull the rug out from under. What becomes most apparent when the gun is graphically isolated is the moment depicted within each panel. The first two are snapshots caught at the split second of impact, while the third panel lags behind, perhaps only another split second — but just enough difference to make things interesting.

Objects propelled Nancy, and Bushmiller's mental prop closet was crammed to the rafters with them. Here the object that kindles the action is the water gun. But a second object was needed to ignite the gag. . . .

Moral: Worlds can revolve around a single object.

NANCY

"I've been drawing since the Stone Age and still, I always worry when I sit down in front of a blank paper. Am I gonna make it so the kids will understand it?" — Ernie Bushmiller, 1977

A. Context

Philosopher Henri Bergson, in his influential "Laughter: An Essay on the Meaning of the Comic" (1900), argued that humor arises from the "mechanical encrusted upon the living" — that is, from the incongruity of our humanity encumbered by unthinking and machinelike behavior. Indeed, from Charlie Chaplin to Homer Simpson, the war of Man vs. Machine became a mainstay of the twentieth century's visual humor. As machine labor replaced human labor each development was tested, evaluated, debated, confirmed, and seamlessly absorbed (as though it had always existed) by a culture that worshipped innovation. Of course, innovation does not necessarily mean progress — and that's where the humor comes in.

The watering can modifies the rain. The garden hose modifies the watering can. The screw nozzle modifies the garden hose. The pistol-grip nozzle modifies the screw nozzle — and Nancy modifies the water gun (a modified hose to begin with). One can imagine Bushmiller cruising by the lush, sprawling lawns and gardens of Stamford, Connecticut, on a sunny summer day as the gag gears began to spin.

As Gunther Kress and Theo van Leeuwen point out in *Reading Images* (2006), "Visual language is not — despite assumptions to the contrary — transparent and universally understood; it is culturally specific." Thus there is a certain tipping point when an invention (or any form of information) fully enters a public's collective unconscious, and at that point, it is probably fair game for a gag. This particular (and, at the time, still comparatively expensive) device became widely available to American home gardeners in the mid- to late 1930s. By 1959, prop master Bushmiller was on safe ground banking on his reader's unthinking familiarity with it. The reader's awareness of the hose's pistol-grip nozzle and an understanding of how it works is imperative to completely parsing this strip's gag — yet it is never actually shown.

Some old habits die hard, however. Although electric washers and dryers entered the décor of Nancy as they became common fixtures in the American home, the old-fashioned clothesline (always good for yet another gag) never quite seemed to disappear.

B. Text

If the water gun is the object that starts Sluggo's fun here, its mutated doppelganger, the pistol-grip nozzle, is the object that will finish it.

While all three panels of this strip are designed to align the reader's interests with Nancy's, it is only upon entering the last panel that a conspiracy has been entered into as well. Here the reader is finally invited into the inner sanctum, made privy not only to Sluggo's disgraceful past but to his hopeless present and soggy future.

Yet in a small but significant tactical decision, the instrument of his undoing is partially hidden from the reader, as it is from Sluggo. Though not depicted, the identity of the weapon that Nancy packs in her holster is never truly in question. It may be deduced empirically through the contours of its container, the length of hose leading to it, and the expectation that Nancy will retaliate reciprocally to Sluggo's own squirt gun attacks (readers familiar with Bushmiller's algebraic gag construction would never expect anything less than the punishment fitting the crime). This small act of deduction is one of the pleasures of reading this strip.

Keeping the pistol-grip nozzle unseen is part of panel 3's delicate balancing act, preparing the reader with enough information to tell Sluggo's fortune accurately — but not too explicitly. As in any good conspiracy, this subtle air of mystery adds a quality of tension to what could easily be made obvious (and unfunny) if baldly displayed. The physical details of what lurks in Nancy's holster rightfully belong to the domain of the fourth panel — and the reader's imagination.

Moral: "Common knowledge" is a calculated risk.

13. THE LEAKY SPIGOT

NANCY

"I love the fact that I don't have to commute anywhere. I look out my window at all the lawyers and executives hurrying to work in New York and laugh." — Ernie Bushmiller, 1974

A. Context

The mere existence of the outdoor spigot points to the suburban environment of this strip. Nancy's world, like Bushmiller's Stamford, Connecticut, home, is one where outdoor access to running water is readily available for lawn and garden. The spigot in panel 3 is the clearest indicator of an actual sociological environment. This was not accidental.

As postwar Americans moved out of the inner city, so did their comic strips. Over the years such persistent (and diverse) features as *Mutt and Jeff*, *Mary Worth*, and *Mickey Mouse* eschewed their urban roots and migrated their players to suburban vistas. By the 1950s it would have been unthinkable to find skyscrapers looming over the horizons of *Hi and Lois* or jabbering immigrants knocking on the back door of Dennis the Menace to borrow a jar of herring.

In 1950, following the lead of *Flash Gordon* creator Alex Raymond, Ernie Bushmiller, along his wife, Abby, and mongrel, Dinky, left his beloved Bronx to join an elite suburban community of artists, writers, and performers who had once helped define Manhattan's Jazz Age. "New York used to be inspiring and a great place to be," Bushmiller lamented in 1974, "but it's gone now." Or, as this Jazz Age copy boy put it in a 1971 letter to the Jazz Age columnist Frank Sullivan, "I am a happy old misanthropic fart and enjoy my cave in Connecticut."

Southern Connecticut in particular became (and remains) a haven for ex-big-city newspaper cartoonists. Today very few syndicated gag strips take place anywhere but the suburbs . . . and you can bet they all have exterior water spigots, many of them leaky.

By Ernie Bushmiller

B. Text

Planted as close to the middle of this strip as possible without landing in the gutter, the leaky spigot acts as a fulcrum, the epicenter from whence the tide turns. Its graphic importance as the narrative's pivot point is emphasized by the way it is carefully framed by an expanse of "dead" space (see Chapter 36: The Modified Silhouette, page 142) and thus made difficult to ignore.

The four tear-shaped droplets leaking from this spigot on the side of Nancy's (?) house are depicted here, hanging ominously in midair. Crucial to understanding the gag, these drops indicate that within the body of this garden hose, invisible to the eye and ear, is a large quantity of water. Precisely four droplets are shown escaping the spigot. Not one. Not two. Not three.

At first the count may appear excessive. It would seem that including two, or certainly three, should suffice. Why four? While fewer droplets would "read" as water within the hose, four droplets convey the impression that this water is under a good deal of pressure. The greater the water pressure, the greater the mounting tension and, in turn, the greater the pleasure to be had in its inevitable release (this particular strip incidentally, virtually diagrams the so-called "Relief Theory" of humor championed by Herbert Spencer in 1860 and later refined by Sigmund Freud*). Adding more droplets, however, would create a red herring, misdirecting the reader to the peripheral issue of faulty hardware.

Graphically these drops simultaneously act as both tiny arrows and motion lines, catching the reader's gaze as the image is scanned and signaling the presence of the open tap and the activity of the water within. They nicely counterbalance the movement lines of Sluggo's arm on the opposite side of an otherwise deathly still expanse of panel.

The discreet addition of a small amount of motion to a foreboding image, like a tiny drip leaping from a large crack in a dam on the verge of collapse, helps us to quickly presage what happens next. When these drips are taken together with the previous panel's shpritzes, a mental image is constructed of Sluggo demolished in a fulsome blast of liquid comeuppance.

Note that the two droplets on the right side of the spigot are drawn slightly smaller and in perspective, aiding in the definition of the corner's space. And last but not least, the spigot itself is a white spigot, echoing the shade of Sluggo's water gun. Bushmiller was nothing if not a scrupulous plumber.

Moral: The placement of the object helps define the place.

*Not to mention Spencer's related "Hydraulic Theory" of nervous energy . . .

NANCY

"There's no Proust or Freud in my strip." — Ernie Bushmiller, 1976

A. Context

Certain objects seem to innately lend themselves to makers of visual humor. The hose is one of them. As effective a weapon as it is a tool, it was probably repurposed for a prehistoric practical joke immediately upon its invention, sometime before 400 B.C. In the modern era it has long served as a traditional slapstick prop for clowns, comedians, bored suburbanites — and, of course, cartoonists. (See Appendix 6: "Hey! Where Have I Seen That Gag Before?," page 167.)

Key to the hose's comic reliability is its flagrant built-in capacity for instantaneous misuse. A connected hose (like a loaded gun) is a dangerous, inherently tension-filled object, a pressurized conduit for mayhem, ready to go off at a moment's touch. And while loaded guns kill, loaded hoses — like loaded seltzer bottles, celluloid carnations, projectile vomiters, and other agents of merriment — spew. No blood is spilled, but dignity

is generally demolished. "By making our enemy small, inferior, despicable, or comic," Freud asserted in his *Jokes and Their Relation to the Unconscious* (1905), "we achieve in a roundabout way the enjoyment of overcoming him."

In the same volume, Freud posited his well-known theory that jokes themselves are formalized mechanisms of tension release. The hose, a most Freudian object on multiple counts, is that concept made corporeal. A hose in the hands of a clown is tension. That hose at full blast is tension released. And any hosed-down fall guy who is not you is funny. According to Freud, "Strictly speaking we do not know what we are laughing at. The technique of such jokes is often quite wretched, but they have immense success in provoking laughter."

By Ernie Bushmiller

B. Text

Here the hose (in concert with its dual attachments) is the prescribed problem-solving tool, a deus ex machina direct from the Sears lawn and garden center. Its most obvious function is routing pressurized water from the leaky spigot to Nancy's itchy trigger finger. But that route has been detoured. Winding and curved like a black cobra in repose, out of the panel and then back in, the hose also diverts and achingly prolongs the proceedings. As the water pressure builds within, the gag's narrative tension mounts. Timing is everything.

Tension, often codified as "suspense," is a common ingredient in all good storytelling. It is the deliberate, judicious extension of a narrative arc to better hold and intensify an audience's attention. If the hose here were short and taut and led directly into Nancy's holster in a straight line, it might be a more efficient attack system for Nancy — but a less satisfying comic strip for us. Why? Too easy. Even the most improbable deus ex machina requires some tension.

In the overall composition of this strip, the hose diagrams and embodies this quickening narrative tension. Functioning something like a dining room table extension leaf, it sustains the tension created by the first two attacks on the left — as well as ensuring the inevitable release on the furthest right. It is the longest and heaviest unbroken line in the entire strip, and the third panel is carefully composed to showcase its gently meandering expanse. In an image that is essentially designed to create and sustain a state of tension, the hose is the linchpin of our uneasiness.

Moral: Tension is a prerequisite of laughter.

NANCY

"NANCY - - - YOUR RIBBON IS ON CROOKED AND YOUR DRESS IS SOILED" — Aunt Fritzi,
October 12, 1958

A. Context

Since the days of the Yellow Kid and his talking nightshirt, newspaper cartoon characters have traditionally dressed for success. In the case of the early comic strip, success depended on a decisive audience reaction — first and foremost on its ability to favorably single out a felicitous hobo or moron on a crowded page of flat feet and big noses. A cartoonist's graphic style and a character's look were crucial factors in winning public recognition. Savvy cartoonists knew from panel 1 that keeping their cast in the public eye meant keeping them branded: engaged in repetitive antics and cloaked in consistent uniforms.

The immediate precedent for this came in large part from the performing arts. From the stock characters of the commedia dell'arte, through circus clowns, vaudeville artists, and (later), film comedians — all depended on specific, identifiable costumes and makeup for their enduring success. (Of course, the history of characterization in the visual arts can be traced back to the uniforms of early

Christian iconography, including Adam and Eve's discreet leaves and branches, the Virgin Mary's blue mantle, and Jesus Christ's crown of thorns — if not further still to the gods of antiquity.)

If we were granted a quick peek into the bedroom closets of Nancy and Sluggo, what deep dark secrets would we discover? Unfortunately, probably none. Each possessed a perfectly consistent ensemble, which (with moderate variation) remained the pair's established standard throughout their long careers. These uniforms were the result of much trial and error on Bushmiller's part, not entirely codified until the postwar era — and never absolute. The influence of his earlier work on Fritzi Ritz, which showcased the leading lady's drop-of-a-hat change of (fashionable, sexy) garments, kept him more flexible in this regard than some of his fellow cartoonists. As with most of the strip's conventions, the uniforms in Nancy were always subject to the demands of efficiently selling the gag.

B. Text

In order to efficiently sell this gag, only a few elements of Nancy and Sluggo's trademark uniforms were retained. Yet even with the main characters obliterated it is obvious who belongs between these tops and bottoms. Nancy's bow and Sluggo's cap are so iconic and integral to their respective designs as to be considered sacrosanct.

Sluggo is rarely depicted lacking his slouchy cap, and Nancy is almost never without her hair bow firmly welded in place (absent, naturally, for the sake of a gag). Conversely, those elements worn below the waist needed to be kept low-profile here. If authentically delineated Western regalia were substituted for these generic shoes and leggings, they would surely create an unwanted diversion from the main event. As with all of this cartoonist's choices, the decisive factors were clarity, moderation, and balance.

Moral: Familiarity breeds content.

NANCY

"Occasionally I strike a theme that lends itself to a series of ideas on the same subject."
— Ernie Bushmiller, 1949

A. Context

In the 1950s, old cowboy movies and new prime-time Westerns (and endless reruns of both) dominated the airwaves. Like TV today, some weren't bad and most were. But the phenomenon provided a field day for satirists, cartoonists — and marketers. Kids followed their favorite TV cowboys — and their favorite TV cowboys beat a hasty trail to the local toy store. Their imprimaturs graced a limitless array of merch, from bubblegum cards to beach balls. And since no one owned a copyright on the Old West, any huckster was free to jump on the chuck wagon. In short, when this strip originally ran, little cowboys and cowgirls (and stuff for little cowboys and cowgirls) were virtually everywhere.

While the universe of *Nancy* was in some respects Twentieth-Century Timeless, Bushmiller frequently introduced fads and current events into the strip, albeit with great care (he was, at very best, 365 episodes ahead on his dailies). During this period Nancy and Sluggo were portrayed in the strip as active, avid TV Western fans, and Bushmiller fashioned numerous gags around watching cowboys, playing cowboys, and talkin' cowboy. In 1959, America's cowboy fixation showed no sign of abating (and neither did Nancy's) for many, many years.

B. Text

In this episode neither Nancy nor Sluggo is depicted in the usual attire. Scurrilous Sluggo, as mentioned, deliberately dresses the villain's part. The perennially patched sleeves on his usual black jacket just won't do for the role of gunslinger. Instead he is depicted here in a black sleeveless vest, perhaps (in keeping with the sex-role-reversal theme) filched from Nancy's dresser. Except for his holster, he does not augment this get-up further; there is no ten-gallon hat, no chaps, no spurs. For one thing, Sluggo could not bankroll those kinds of extravagances. But more important, Sluggo needs to be "read" quickly and clearly by us *as* Sluggo — not Sluggo who, on August 8, 1959, has magically turned into a cowboy.

The holster set that Sluggo sports here is standard commercial issue. The decorative star indicates that it is a model intended for young sheriffs — not young policemen or young Martians (notice how that star's design is cleverly echoed in Sluggo's pose in panel 3). Nancy's holster is identically starred as well (as is her pose, with hose attached) but minus the bullet loops (which, if present, would lessen the clarity of the hose and the hint of any pistol-grip nozzle). This matching set unites the two leads in the classic Western mold of good/evil codependency.

Sheriff Nancy makes a most intelligent fashion statement in her one-piece gray-shaded dress. This choice functions ingeniously in the third panel, where her holster strap effectively splits her upper and lower body. This was the effect usually created by her black vest and white skirt, but because of the cartoonist's need to clearly convey the crucial overlapping white holster and black garden hose at a glance, Nancy's default uniform was out of the question. Instead, a continuous gray background field is substituted, anchoring these disparate elements while allowing them to contrast vividly.

The gray tone is also useful here in allowing Nancy to stand her visual ground, giving her distinction, weight, and density as she bookends Sluggo's mayhem. And perhaps her gray tone can also be read as that proverbial gray moral area of the gunslinger, an angel of justice and likewise an angel of (moist) destruction.

Moral: The concern of pop culture is often pop culture.

NANCY

"I LIKE A CHANGE OF SCENERY ONCE IN A WHILE" — Nancy, August 22, 1951

A. Context

Drawn space is an illusion that artists have wrestled with ever since clever primates began making tricky marks on the walls of caves. Artists from the East have traditionally stacked their space by placing forms that are farther away higher within the picture plane. Artists from the West tend to create space by combining effects of light and dark, with a standardized approach towards perspective and overlapping form.

In the considerably shorter history of tailoring images to the demands of comics, the approaches to space have ranged enormously, depending on many variables, including reproduction size, publication, genre, the goals and abilities of the creator, and the expectations of the readers. On the whole, individual cartoonists tend to maintain a certain consistent approach to the depiction of space in their strips. Consciously or unconsciously, they usually stick with what works. To a reader, this consistency helps to define a particular universe. The treatment of the horizon in such diverse strips as *Little Nemo in Slumberland* (dynamic) or *Garfield* (static) is as important an element as any in defining their individual gestalts.

In his 1944 *New Republic* essay "Comic Strips," critic, painter, and ceaseless champion of "termite art" Manny Farber took note of the characteristic use of space in *Nancy*: "This comic has a remarkable, brave, vital energy that its artist, Ernie Bushmiller, gets partly from seeing landscapes in large clear forms and then walking his kids, who he sees in the same way, with great strength and well-being through them." By the era that this strip was created, those "large clear forms" of Bushmiller's panels had become generally larger and clearer and held their places within more rigorous and sturdy compositions.

The spaces depicted in all three panels of this strip are fairly shallow ones. Bushmiller generally opted for shallow space, as do makers of most gag-based comic strips, where the lead character's interaction with his immediate environment commonly demands close quarters. From day to day, as well as from panel to panel, *Nancy*'s horizon line was deceptively fluid, rarely calling much attention to itself but working behind the scenes as a subtle and effective persuader.

B. Text

When the horizon line of a composition is maintained in every panel of a comic strip (as in a typical *Garfield* daily, for instance), there is no doubt that the same space is being represented serially. But implied as well is that the same, constant amount of time has elapsed between panels. This inertia can be modified — by varying the width of a panel, the information in the foreground, and the length of the dialogue it contains — but a static horizon line is a great leveler of both comic strip space *and* time.

In this example, by slightly raising the horizon line between panels, Bushmiller encouraged the perception that both time has passed and that our view in each panel is from a new, slightly revised location (albeit one in near proximity to the initial space).

The ascending horizon line also serves a compositional function as the strip is read. Like an escalator, this rising ground line lifts the eyes through the strip, going up step by step in panels 1, 2, and 3. Then halfway through panel 3, the diagonal ground line (along the fence's bottom) creates a handy chute, sliding us straight into Nancy's snare. The final horizon line (behind Sluggo) both points toward and helps contain this all-important gag zone.

Precisely *how* a horizon line is rendered also helps delineate the space. These horizon lines were not ruled straight, but were zigzagged to communicate "lawn." Compare the grass that runs horizontally with the diagonal line of grass along the bottom of the fence. The pen lines incrementally lengthen and widen in perspective as they come nearer to the foreground. Even the blades of grass in *Nancy* carry their narrative weight.

Moral: The delineation of space supports the narrative.

NANCY

Production Design

"YES - - - A GOOD BACKGROUND IS IMPORTANT" — Nancy, November 29, 1951

A. Context

Dedicated *Nancy* readers may think they know a few things about Aunt Fritzi's well-appointed suburban residence — but actually, *very* few things are certain. It is apparently close enough to walk to the main drag for an ice cream cone, or to the schoolyard, or to visit Sluggo (who is known to inhabit another, down-on-its-heels neighborhood). But beyond that, the hard specifics about Nancy's place in her own universe were never nailed down. How many windows are in her bedroom? What color is the roof over her head? How far away is the TV from the fridge? How large is her backyard? Such spatial specificities may be of great value to the novelist, illustrator, or real estate agent, but they are generally useless to a cartoonist like Bushmiller, who needs to keep his pictorial options open (and subordinate) at all times.

What Bushmiller provided instead in *Nancy* is an idealized, iconic sense of place, as dreamlike as Coconino County in its day-to-day (if not panel-to-panel) liquidity. White slat fences, brick walls, outcroppings of trees and rocks (occasionally, but never systematically, in the proverbial groups of three), fireplugs, distant towers, and low, open horizons are some of its memorable markers. It is not far from the Mosholu Parkway of Bushmiller's native Bronx and closer still to the suburban vistas of Stamford, Connecticut, where he later made his home. But in its intent, it was at the crossroads of Nowhere and Everywhere, USA.

In *Death in the Afternoon* (1932), Ernest Hemingway delineated what is, in essence, the philosophy of all good cartooning: "If a writer of prose knows enough about what he is writing about he may omit things that he knows and the reader, if the writer is writing truly enough, will have a feeling of those things as strongly as though the writer had stated them. The dignity of movement of an ice-berg is due to only one-eighth of it being above water."

By Ernie Bushmiller

B. Text

Take away the figures and the foreground architecture and what is left? If this were a movie rather than a comic strip, the dearth of background in the first two panels would be immediately questioned. In cinema, as in life, the space beyond a horizon line is rarely pure white. In comic strips, backgrounds are employed (in a number of ways) to give a sense of place — but often only a sense.

In this case, the sense of place is established immediately in panel 1. Here is a yard with a white fence, some grass — and that's enough. There is no need to amplify this landscape with redundancies and details. Against white the figures are instantly recognizable; their gestures are clear and every droplet of spray is present and accounted for. The house conveniently shows up in panel 3 (complete with conveniently positioned spigot), and not a panel too soon. In *Nancy*, Bushmiller created a world where the coordinates of physical reality are always at the mercy of what's clear, what's funny — and what's clearly funny.

Moral: Location can largely be implied with little.

NANCY

"My fence is in awful shape - - - lets fix it"— Sluggo, January 1,1951

A. Context

A house in the suburbs with a white picket fence has long been considered the symbol of the American Dream. And every bit as much as the structure that it encloses, that fence is in itself an icon of "home": safeness, security, comfort, and well-being. It is often associated with family and the culture of childhood, where such fences seem to stripe the imaginary landscapes of so many classics, from *The Tale of Peter Rabbit* to *The Adventures of Tom Sawyer*.

As far back as 1895 and R.F. Outcault's *Hogan's Alley*, fences met children with striking regularity on America's comic pages. Percy Crosby's immensely influential kid strips of the 1920s, *Skippy* and its Sunday topper *Always Belittlin'*, both featured white fences prominently in their landscapes — and logos.

Bushmiller followed Crosby's lead and exploited this icon nearly as extensively, despite its increasing irrelevance. Well into the 1980s Nancy's tidy idyllic universe was crisscrossed by a seemingly endless expanse of charming white wooden fences, while in American suburban reality, strip malls and razor wire encroached.

By Ernie Bushmiller

B. Text

Fences make good neighbors, good wooden things to hide behind, and, in this strip, a good series of vertical lines in rhythmic staccato leading us to Nancy. This rhythm is emphasized by the opposing diagonal lines of the top and the bottom of the fence, which appear to blare outward toward the reader. It is the leading indicator of receding space in this strip.

In real suburban neighborhoods, a fence like this would typically have cross braces facing the inner yard (the side that Nancy is on) with the perfectly aligned vertical slats presenting an aesthetically pleasing exterior to neighbors and street traffic. However, to include the cross braces on the inside of this fence would disrupt the visual flow that Bushmiller establishes here with its linear vertical repetition.

Cross braces or not, there is still no mistaking it: this is a fence. Its fenceness is unquestionable. Its solid pine construction is solidly believable because otherwise the gag would not work — and we have already smiled, long before we have commissioned a structural inspection. In comics, the dictates of logic and verisimilitude are often expendable, with little notice or loss, for greater ease of digestion. In fact, cartoonists make their living betting on it.

Moral: Cartooning is the intentional balance of the observed and the abstract.

NANCY

"THE HOUSES ARE ALL ALIKE" — Nancy's friend, April 21, 1967

A. Context

Ernie Bushmiller might easily have turned his talents to architecture if buildings were meant to be funny. Not that his were. Many cartoonists simply evoke structure with a few casual marks — Bushmiller delineates. To build a real Bushmiller house, a contractor could practically use a handful of select *Nancy* dailies as a guide. Verisimilitude, however, was never the goal of this careful draftsmanship. There is no mistaking the planet *Nancy* for the planet Earth. Rather, it is a replicate world reconstructed object by object, an idealized, archetypal model of our own backyards. (See Appendix 7: Architecture, page 188.)

Bushmiller's strips are charted with the cold precision of a blueprint. Architectural renderings can be quite beautiful in their way: the clean interlocking lines express the precision, forethought, and control of the draftsman who ruled them. This aesthetic is dispassionate and cerebral, a penchant for the inner clockwork and not the gilded casing. An unlikely aesthetic for monkeyshines at first glance, yet as Bushmiller proved again and again, when coupled with an exacting gag structure, this brand of deadpan draftsmanship transcends.

The house depicted here is typically mid-century suburban with its white (aluminum?) clapboards. Such houses appear again and again in *Nancy* (usually capped with a gabled roof), even in miniature when a dollhouse or birdhouse is specified. As with every element in the strip, this house and its heroic spigot are an expression of a unified, uncompromising artistic vision, the World According to Bushmiller.

By Ernie Bushmiller

B. Text

Here, it is worth noting how little is needed to recognize "house," constructed as it is from the same nine pen-and-ink lines as the fence, but ruled horizontally rather than vertically. These equally spaced, nearly parallel horizontal lines are all that is required to delineate clapboard siding. Observe how Bushmiller has subtly but precisely indicated the overlapping ends of the boards. Clapboard or shingles, both spell "house" in the cartoonist's lexicon.

These horizontals directly escort the reader's eye into the third panel. Only the spigot, hose, and water droplets disrupt their uniformity. This break in a predictable pattern of verticality allows those three crucial elements to read clearly, while the house itself appears to recede into its supporting role. That role is (in part) to define the depth of space, the rear flat in this three-panel stage set. Additionally, the house here serves as an icon of security and the power of the adult world (i.e., "home base"). A kid's home was her castle, and that castle needed protection from barbarians at the gate, like Sluggo. The guardian posted here is directly connected to the source of her power.

Until the third panel, it is not apparent that Nancy is anywhere near a house. She is merely behind a white fence, which in this cosmos could mean anywhere. It is something of a revelation to discover that she is right outside this one — a revelation made possible by the elongation of the third panel. This is akin to a visual trick of the cinema known as the "reveal" by the makers of silent comedies (see most anything by Buster Keaton). In this type of gag the viewer is presented with an intentionally limited vantage (by close-up or by iris), and then by extension of the frame (via cut, tilt, pan, dolly, or an expanding iris), a greater, initially unseen environment is revealed, transforming the initial context in a surprising, incongruous fashion. It's an efficient gimmick, and like many such visual tricks, it works its magic with the viewer barely realizing it.

Moral: Solid rendering encourages belief.

NANCY

"NOT A CLOUD IN THE SKY" — Sluggo, March 1, 1953

A. Context

In the first panel, Bushmiller created the heaven and the earth and saw that it was good . . . for a gag. After two days of rest, he stared once again at a blank sheet of Bristol board, sharpened his pencil, and re-created the world of *Nancy* from scratch — one line at a time. Objects were preciously begotten. A living room might contain an easy chair, curtains, and perhaps a divan. A kitchen would display a sink and a refrigerator. A bedroom, a bed. A bathroom, a bath. Sometimes a little more, other times a little less, but usually (like the baby bear's porridge) just right.

When it comes to nature, Bushmiller is equally stingy. Nature is not a force to run rampant over the world of *Nancy*. Unless the gag is dependent on an overgrown lawn that needs mowing, there will be just enough blades of grass to indicate lawn-ness. Likewise the sky is apt to remain a vacuum unless weather is necessary. It is only his celebrated groupings of small white rocks that bear the weight of nature's random disposition. The creator is a force holding nature in check.

By Ernie Bushmiller

B. Text

Each of the elements in this strip carries its precise narrative weight, no more and no less. Water is parceled out in exact droplets. The few grass blades allowed here help to define the environment, the edge of the fence, and the horizon line. The placement of cast shadows gives the strip a specific, meaningful time of day (High Noon!) and grounds the characters to the planet. Even the air itself makes a subtle but significant appearance in the upper left-hand corner of the third panel (storm clouds brewing on the horizon — prepare for a good soaking!).

Water, earth, and air are tamed by Ernie Bushmiller and sprinkled over his strip with judicious care, much as a real estate developer strategically places trees, grass, and fountains around a new luxury high-rise to remind the tenant that as aseptic as this environment may be, it is still located somewhere on the planet Earth.

Moral: Nature is messy, but its depiction is deliberate.

NANCY

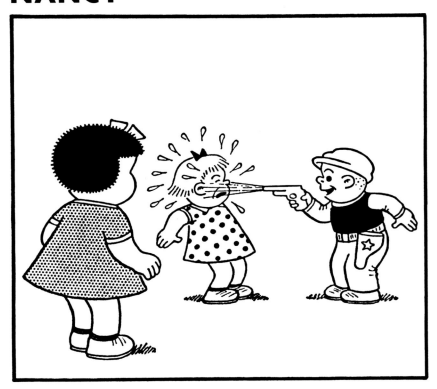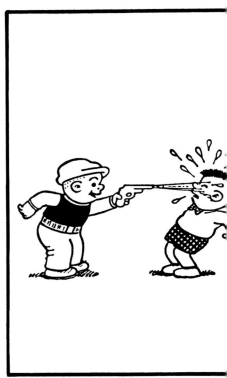

"WHAT A STUPID STATUE" — Nancy, November 11, 1962

A. Context

In the late eighteenth and early nineteenth centuries, *tableau vivant* presentations flash-froze performers on the stage in static poses and depicted, as the curtains opened and closed, implicit (and sometimes explicit) narratives largely conveyed by lifeless gesture alone. A form dating back to liturgical pageants of the middle ages, *tableaux vivants* were a cross-pollination of theatrical, painterly, and sculptural aesthetics. These were fused into a sort of live dramatic snapshot, often intended to display an edifying moment from history, literature, or art. This practice survived, in a limited fashion, well into the twentieth century in incarnations as diverse as religious presentations and vaudeville acts. But more important, its technique informed and cross-pollinated the aesthetics of such diverse popular entertainments as melodrama, waxworks, photography, magic lantern shows, illustration, and cinema and, with the framing device of its proscenium, was also a harbinger of the modern comic strip panel. (See Appendix 8: *Tableaux Vivants*, page 190.)

Paradoxical as it may seem, *tableaux vivants* absolutely captivated contemporary viewers. The polar opposite of the proverbial impending train wreck, what commanded this audience's attention was the complete and utter *lack* of action in these elaborate stagings. Yet actual statues arranged upon a stage, however artfully, would have completely bombed with this ticket-buying public. The allure of these near-statues was precisely because of their living, breathing *near*-stillness. As the medium evolved, clever impresarios discovered that adding elements of direct contrast — such as an offstage wind machine (to gently waft drapery), curling smoke, a gurgling fountain, or real flames — to the tableau boosted box office receipts. But the figures of *tableau vivants* still remained enticingly *almost* still.

The tense, statuesque quality of the figures in *Nancy* often recalls the dynamics inherent in this archaic medium. While Bushmiller regularly employed such cartooning conventions as motion and speed lines (as well as the rare "multiple exposure"), he tended to depict his figures in motion conservatively. Their proportions, symmetrical balance, and line weight were always scrupulously maintained, no matter how extreme the depicted action might be. There is a sense, not of the cartoonist evoking speed, but of carefully delineating it. This tendency in Bushmiller toward regulating the irregular, coupled with his exacting composition, conspired to create a timeless, airless world of near-frozen, yet pregnant, activity.

According to the cartoonist Morris Weiss, Bushmiller deliberately cultivated this diagrammatic quality in his drawings. "Because his work was so stiff and tight, other cartoonists would criticize him. 'Why don't you loosen up, Ernie?' And he said, 'NO!' He wanted to keep it simple. . . . He didn't ever want to outdraw the gag."

By Ernie Bushmiller

B. Text

In the first two panels of this strip, the nameless victims with their mirrored poses, along with Sluggo (who might as well be a statue seen from opposite sides), all appear to be almost stopped in mid-action. Only the water released from Sluggo's gun seems to evoke animation. Nancy is depicted as rigid and still, with the reader left to imagine her frantic dash after panel 1 to hatch her plan, grab her holster, hook up her garden hose, and scurry back in the nick of time to hit her mark in panel 3.

Sluggo enters suddenly in panel 3, stage left. In contrast to the preceding figures, here he is an absolute juggernaut, with one foot in front of the other, head overlapping the balloon, and three crucial motion lines suspended in space behind his flexing elbow. This sudden intrusion of movement is both disturbing and threatening, precisely as intended. The Bad Guy usually draws first, and we suspect that Sluggo, finger on the trigger, may have a split-second advantage on our heroine. But the lively sprays in the first two panels, as well as the dripping spigot in the last, quietly clue us in to Sluggo's next inevitable pose.

Moral: In comics, all action is composition.

NANCY

"My fence is in awful shape - - - lets fix it"— Sluggo, January 1,1951

A. Context

This particular fence would not be much good to shield one's clothesline of wet underwear from the view of the nosy passerby. And it would make a rotten choice if purchased to keep the dog in (or the neighbors out of) the backyard. It is a most curious variety that is exactly nine planks long — and then ends abruptly: a fence that does not fence. The Japanese have a word for such an intriguing yet essentially useless structure or object: a "Thomasson." This was coined by the Neo-Dadaist artist Genpei Akasegawa in honor of American outfielder Gary Thomasson, who in 1981 was awarded the most lucrative contract ever in Japanese baseball history by the Yomiuri Giants — but once he hit the Nippon diamonds he turned out to be . . . essentially useless (nearly setting the league strikeout record and then wrecking his knee).

Of course, this strip takes place not in our world but in the world of *Nancy,* where any seemingly useless structure or object is completely made to order with one use in mind. Here this fence is known as a "Bushmiller."

Staging

B. Text

If Nancy has a pal in this strip, it ain't Sluggo. Nor is it either of the children whose honor she is set on avenging. In this strip, Nancy's best friend (and the reader's) is her fence. They enter together and exit together and they bravely stand together side by side. In fact, they seem to be quite literally attached — at first glance, anyway.

When panels 1 and 3 are compared, the minute but palpable horizontal distance between Nancy's hair bow and the fence becomes apparent. Thanks to that fence it is now clear that Nancy has taken a half-step forward from her former hiding spot. Vertical comparison reveals that Nancy herself has literally increased in stature and, implicitly, in sense of purpose. These are small, nearly subliminal details in her narrative, but intentional ones.

This trusty fence is a true multitasker. In panel 1 it functions as both a shield and a hiding place for Nancy to peer around. In panel 3 the fence next functions as a cache for her arsenal (in fact the fence has traveled upward here to accommodate our own privileged view). Perhaps useless in the real world, in the alternate universe of these three panels this particular fence meritoriously performs its intended job: keeping Nancy safe, keeping us safely in the loop, and keeping Sluggo safely in the dark.

Moral: Where it happens matters as much as what happens.

NANCY

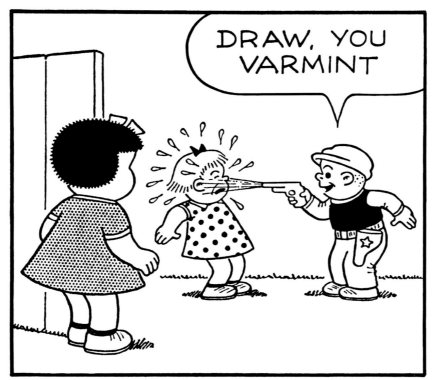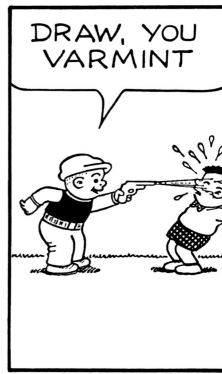

"I think variety in the panels helps the appearance of a strip. Long shots, close-ups and medium shots attract the eye and are useful in putting your idea across." — Ernie Bushmiller, 1949

A. Context

As a broad generality, comic strips from the first half of the twentieth century often tended to be far more mutable in terms of the variation in focal distances they used to tell their stories. There were a number of reasons for this, but it was in good part due to the luxurious amount of newsprint they then commanded. Additionally, as with film, genre came to play a decisive role in this aspect of narrative as well.

Like an action film, an adventure-oriented strip usually leans more toward widely shifting settings and angles to enrich its daily slice of plotline with context and atmosphere. If there is a lot of verbal exposition going on between Buck Rogers and Buddy, it pays for the cartoonist to keep things moving visually. A tight "two-shot" juxtaposed with their rocket spinning through deep space in the next panel creates the impression of activity as the dialogue drones.

In contrast, gag strips generally favor maintaining a more consistent panel-by-panel distance. Character-based gags often need to be seen in fairly consistent shots for the funny business to read clearly. Charlie Chaplin framed his earliest comedy shorts much like the *Mutt and Jeff* dailies

that Bud Fisher had begun to draw only a few years before: with enough space above the head and below the feet to consistently ensure a full-figure view of the intended star(s) as often as absolutely possible.

Nancy was, in some respects, one of the most visually audacious of all gag strips, yet the action rarely strayed more than several feet from the main characters (unless a surprise "jump cut" to Mars was required for the snapper). What separated Bushmiller from so many others in his staging was the subtle, thoughtful, barely perceptible shifts he employed from panel to panel to keep his still characters from becoming static.

By Ernie Bushmiller

B. Text

In comics, an individual panel is read as both a discrete parcel of information as well as a link in a greater chain. Sluggo's change of scale between panel 1 and panel 2 does not mean that he has shrunk. Even junior semioticians grades pre-K and under will instinctively grasp that this panel represents a shift in our perceived distance from the players.

When the staging between two adjacent panels is so similar, a moderate pullback, like the one here, adds a distinctive context of "overview." A broader perspective and an enlarged meaning are both implied. This was a wise decision in this particular case, where dialogue is repeated in both panels (note that the balloon and its contents do *not* change size).

This shift of scale is augmented by another shift, that of Sluggo's right-to-left positioning within the panel. It is not specified whether Sluggo has rotated 180 degrees here — or if the reader's actual point of view has. In the language of cinema this sort of juxtaposition violates some basic principles of film editing. If the panels were viewed as two successive projected shots, the little girl would appear to instantly transform into Sluggo and Sluggo would appear to instantly transform into the little boy. Read contiguously on paper, however, the absence of the so-called "persistence of vision" allows the cartoonist some greater directional latitude. Functionally, both the scale and the positional shift in these panels help clarify what appears at first to be repetitious information for what it is: additional information depicting repetitive behavior.

These shifts also work in tandem with the truncated size of panel 2. Here is the opening of the strip's second act, a half-beat where the reader simultaneously scans the brief panel, gleans its message, and pauses a nanosecond before forging on — the perfect place for getting a little distance. Some comics thrive on monotonous staging in which a fixed point of view is a deliberate component of the stylistic structure. Bushmiller opts for a slightly more lyrical approach, a nuanced push-and-pull for rhythmic effect.

Moral: A shift in viewpoint can redefine a universe.

NANCY

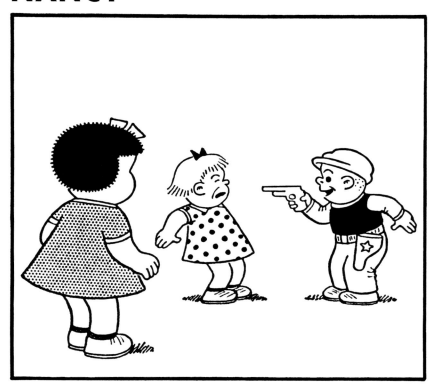

"How do you keep all your characters looking like themselves? You must know them, must feel they are alive and real. Think of them in all kinds of situations, running, standing, sitting, sad or happy. It is like getting to know a person who lives in your house; familiarity will soon do the trick." — Ernie Bushmiller, 1949

A. Context

Distinct from a character's conceptual creation, the cartoonist must also decide how that character will be graphically represented on the page. Even with an "everykid" character like Nancy, the homogenized assemblage of lines, curves, dashes, and dots are not to be confused with the *character* herself. Had the cartoonist opted for a different set of decisions, Nancy could have been angular, blond, clear-eyed, big-nosed — or even a little boy — while preserving every bit of her inherent Nancy-ness.

Prior to her introduction, Bushmiller had, in fact, been experimenting with a succession of similar youngsters in the *Fritzi Ritz* strip: an office boy named "Tommy" followed by a revolving door of sassy cousins and nephews. But would *Tommy* or *Leo* or *Jimmy* or *James* or *Willie* have "clicked"? (See Appendix 9: Aunt Fritzi's Other Relatives, page 191.)

In terms of utility, a successful character design in comics is one that is distinct, concrete, flexible, efficiently configured, feasible to render on a repeated basis, and clearly legible from any angle, in any scale, even fractionally. But in terms of public success, a certain something else is required.

What is the ineffable visual stickiness that separates Nancy from the Priscillas, Cookies, Taffys, Bratinellas, the interminable Littles (Debbie, Lizzie, Iodine, et al.), or any of the scores of other forgotten young ladies of the newsprint who competed with her for a laugh? To be sure, the gags that Bushmiller created for his characters and his expertise in deploying them cannot be underestimated. However, the average reader of newspapers remembers and cherishes characters (and usually in visual terms), not specific gags. Nancy's unique packaging caught the public's eye.

All characters develop and visually evolve over time. When she debuted in January 1933 Nancy appeared lankier,

scrawnier, and sketchier, but with the essentials firmly in place: the bow, the ink-spot pupils, and the frizzy black mop. As an abstract design she matured concurrently with Bushmiller's own visual style, and by the early 1950s Nancy had arrived at her visual prime. "Once you get to know and like your characters, there is no difficulty in getting them to look like themselves," the cartoonist wrote at this time. "You just draw them instinctively. You FEEL that they are right."

Al Plastino, who assisted Bushmiller in his later years, came to understand the power of that design firsthand: "Everything was *exact* — the two eyes . . . the nose . . . the mouth — had to be just perfect. Otherwise it wasn't Nancy! It's the toughest thing to draw."

"Graphically it's very strong," Bushmiller's final editor at United Feature, Bobbie Miller, concurred. "Of all the comic images you can think of, Nancy comes first to mind. . . . That image of Nancy is such a strong one, with the funny hair."

Typical of most widely successful cartoon characters (from Felix the Cat to Bart Simpson), Nancy was cute and short, about three heads high — a ratio unknown even among the cutest and newest humans. Developed during a period when comic strips were shrinking in size, savvy Bushmiller kept Nancy's world close to the ground. As Manny Farber noted in 1944, Nancy and her "group of bright, unsentimental children . . . have fire-plug shapes, two-foot heights and inch-long names." Nancy typically does not have to reach upward to turn a doorknob or switch on the TV, yet she must stand on a bench to boil spaghetti on the stovetop or on tiptoes when approaching the cookie jar. She favors an ottoman or three-legged stool over the divan. And in a full bathtub the water reaches just above her elbows. She is precisely *that* size. The "short & stubby characters" of Nancy and

Sluggo were, according to Bushmiller, "unconscious reproductions of my own well-padded figure."

Fritzi Ritz is not represented in this particular strip, but as the third wheel in the *Nancy* vehicle she is owed a few words. In many respects she remained the same statuesque, raven-haired flapper Bushmiller inherited in 1925, a proto-*Barbie* doll in visual terms, and more closely modeled after Bushmiller's wife, Abby, in subsequent years. Although thoroughly domesticated, Aunt Fritzi retained more than a modicum of her sexual charge, which Bushmiller (and his stable of ghosts) tended to play up in her solo Sunday escapades well into the 1960s. However, her decidedly adult proportions made her a liability in the less generous space allotted the daily strip. In the later years of Bushmiller's *Nancy* she became something of a nagging disembodied presence: a flustered, lipsticked lady-head, leaning into the panels' edges to chastise her niece or register dismay and, for all intents and purposes, nonexistent from the waist down.

B. Text

Like the fireplugs on Manny Farber's block, Nancy is compact, rounded, and slightly chunky, and her reach is about as long. Unlike a fireplug, she has bulbous cheeks, exceedingly thick elbows and ankles, and small, globular hands and feet. Her fingers are fat. Her head is composed of two converging horizontal ovals — the larger on top, until the years following World War II, when their proportions evened out somewhat (she became downright jowly in the Nixon era). Viewed in profile it resembles an inverted number three. She has no ears.

Her facial features (on any *other* day) are deceptively simple, yet as precisely engineered as an atomic clock. Button eyes, slot-nose, half-circle eyebrows and a flexible black mouth: enlarge, reduce, or shift any of them even a micrometer and her essential Nancy-ness is gone. Oddest is her nose, depicted as a thick black en dash in three-quarter view, which improbably shifts to a white V-shape in profile. Her most unmistakable asset is her trademark bang-cut hairdo, which has been described as an afro, a spiked football helmet, a Brillo pad, a sea urchin, and a fuzzy comma and is never complete without a sizable bow anchored low on top — even in the bath, the bed, or her dreams. Whatever her ensemble, she is a carefully balanced proportion of solid black, white, and tidy pattern. The visual distinctiveness and solid black mass of that hair (in combo with her usual black vest) ensure that Nancy, however depicted, is among the first forms to catch the reader's eye in any strip she appears in.

Sluggo's proportions and bodily details differ little from his girlfriend's (were they separated at birth?), and the two could easily swap heads (and did at least once) with little incongruity. Sluggo's design differs most meaningfully from Nancy's in his facial details. As with Nancy, his nose is an odd one, a thick pug with prominent nostrils, which if viewed with just the right conviction reveals itself as the top half of his own head in miniature. Sluggo's flawlessly stippled noggin is meant to be either bald or shaved or both and is usually crowned with the type of floppy cap favored by old men and newsboys. In addition, Sluggo has ears.

Moral: Characters are designed, not born.

NANCY

"If a kid slips on a banana peel in Norway he still falls down." — Ernie Bushmiller, 1977

A. Context

If a three-panel comic strip could be imagined as a filmed performance, then the cartoonist's job would be to decide (via cerebral splicer) which three key frames, when snipped and displayed, will best communicate the narrative's peaks of descriptive action. Nowhere is this peak more decisive than in the gestures of the figures. After the design of the character is determined, a related but entirely separate issue is how the behavior of that character is to be depicted. Gesture is character (and character design) in action.

By the standards of some cartoonists, the gestures that Bushmiller's characters displayed were usually simple and restrained — but undeniably accurate. There is never the slightest question of what a given pose in any panel is meant to communicate. No one in Ernie's little troupe was ever permitted to chew the scenery (as his close friend Milt Gross's creations were more than prone to do) or to play dead (see *Dilbert*). The cartoonist's dedication to a focused presentation of his material as a whole always overrode such temptations. Compared to those of the great silent film comedians, Bushmiller's methods were closest to that of Buster Keaton, who generally kept his trunk stiff and outline crisp even while outrunning cyclones or playing hopscotch with cascading boulders in long-shot.

Bushmiller rarely depicted a figure straight on (unlike Charlie Brown, full frontal views of Nancy are virtually nonexistent). Three-quarter views are far more conducive for action-oriented characters like Nancy. And profiles better yet. Balanced, appropriate, and unambiguous — these figures all successfully communicate their intended meaning when viewed in silhouette: the acid test of a good pose.

By Ernie Bushmiller

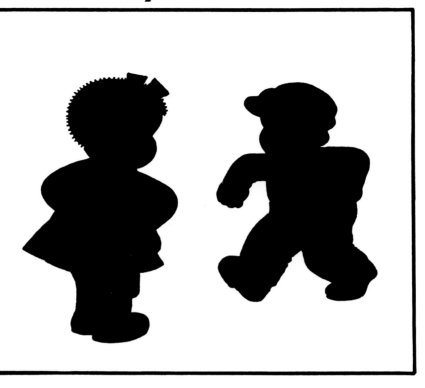

B. Text

When one views this strip minus dialogue, setting, props, and other details, the essential narrative remains apparent largely due to these character's gestures. Acting is storytelling.

The little victims in this strip have only one panel apiece to give their all, and Bushmiller makes the most of their cameos, depicting each at the squirt's apex — just as their squat bodies attain maximum arch, arms thrust backward in shock and awe. This pair seem as though they have just been pushed to the railing at the Grand Canyon.

Sluggo's gesture in panel 1 (and its mirror in panel 2) perfectly captures the bully's mindset. This is no shadowy sniper firing from the rear. Here is a calculated, deliberate stalker approaching his victims head-on with both feet planted squarely on the grassy knoll. He is enjoying his role immensely and has no plans of taking leave anytime in the near future. (The slightly bent knees are common to both Sluggo and Nancy in repose but work here to nicely convey the casual air of his malevolence.)

Sluggo's inactive arm in the first two panels is poised to counterbalance his active arm like the handle on a water pump. In the final showdown, as he advances menacingly, he has become twice his size in the previous panels and twice as threatening. Sluggo reaches to draw with his left hand (converting from righty to lefty somewhere in the gutter of the first two panels) and with his opposite hand he makes a deliberate fist: amplifying his resolve, upping the ante, increasing the tension.

The most iconic pose in this strip can be seen in panel 3, and Nancy is wearing it. However, it does not really belong to her. This particular pose is the trademark of another whom Nancy has apparently channeled for the occasion. Hands on hips, broad-shouldered, looking calmly outward in the face of evil — contemporary readers would recognize this in a heartbeat as none other than Superman himself. (This iconic image was originally conceived by pulp magazine cover artist H.J. Ward in 1940. It opened every one of the Paramount animated cartoons of the World War Two era, which began to play on TV rotation in 1955 and bookended *The Adventures of Superman* live-action program, which first aired in 1952.) And as for panel 1, can Nancy now be seen as anyone else but Clark Kent, meekly peeping through a doorway as trouble (and a plotline) brews?

Moral: Acting is storytelling.

NANCY

"I BET YOU CAN'T MAKE FUNNY FACES LIKE THIS" — Sluggo, March 16, 1952

A. Context

In visual art, the emotional state of a human subject is traditionally communicated, in large part, directly through the combination of gesture and facial expression. In his *Treatise on Painting* (1651), Leonardo da Vinci warned: "The good painter has two principal things to paint: that is, man and the intention of his mind. The first is easy, the second difficult, because it has to be represented by gestures and movements of the parts of the body."

Nearly two hundred years later Rodolphe Töpffer, whose unorthodox combinations of words and pictures earned him international literary attention, deliberately set out to lower Leonardo's bar. In his 1845 *"Essai de Physiognomie"* he expressed the conviction that all facial expressions necessary to communicate an effective narrative could be accomplished with the simplest of forms and the most modest of skills. Today Töpffer is referred to as "the father of the comics."

As humans, when presented with visual representation of humans (or humanoids) we are inherently hardwired to read faces first. We even tend to read them in clouds, trees, rocks, bathtubs, pieces of toast, and plenty of other places that faces generally aren't. Richard Gregory pointed out in his *Eye and Brain* (1997), "If the brain were not continually trying out organizations of data, or searching for objects, such as faces, the cartoonist would have a hard time. In fact all he or she has to do is to present a few well-chosen lines and we see a face, complete with an expression."

There are few cartoon characters who cannot be called to mind without a specific, meaningful facial expression intact. On a well-designed cartoon character (like Nancy or Sluggo), expression can be accomplished economically with the deft redistribution of a few lines and curves. Skilled hands can wring an astonishing gamut of emotion from subtle changes in the spacing and emphasis of a simple character's given attributes. As with every aspect of his work, Ernie Bushmiller took the greatest of care in the facial expressions he gave (or did not give) his creations.

By Ernie Bushmiller

B. Text

Nancy's face, as stated earlier, did not appear in this strip because it was unnecessary. In fact it was better *not* to show it. Keeping her emotions undefined encourages the readers to engage more deeply as they draw their own Nancy faces in their imaginations.

Conversely, the faces of the two neighborhood kids go largely unseen because the cartoonist did not want them identified. Their identities are irrelevant and therefore distracting, so here Bushmiller has effectively crossed out their features with the pen strokes representing the blasts of water. (When those lines are removed it becomes striking how much of their faces were actually drawn — and how closely those faces resemble both Nancy's and Sluggo's. Their pained expressions serve as surrogates for hers and harbingers for his).

Finally, all that remains is the indelible mask of Sluggo, the mouth and the eyebrows curved to express the acme of mischievous glee. (It is perhaps worth noting that Spike, the strip's genuine full-time bully and no player of cowboy games, was routinely depicted wearing a frown.) Hold your bookmark over Sluggo's eyes in panel 3 and the grinning mouth indicates a happy Sluggo. Now cover his mouth and the two extended S-shaped eyebrows reveal an angry or evil Sluggo. By combining these two incongruous aspects together, the reader immediately decodes the essence: a Sluggo happy to do evil.

Moral: Faces communicate.

28. LINES OF VISION

NANCY

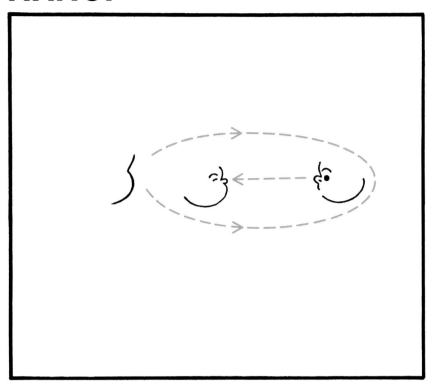

"SLUGGO - - - AM I SEEING THINGS?" — Nancy, April 27, 1953

A. Context

As humans we are programmed to "read" one another through a variety of visual signals, especially the perceived visual signals of the human whom we are reading. Facial expression aside, we learn much about others through what their eyes are doing. Statues, dummies, and corpses may appear entirely lifelike, but without a meaningful subject connected to their fixed gaze their lifelessness becomes apparent at once. Conversely, even the most rudimentary of pictorial icons can seemingly "come to life" by the graphic attribution of an ocular focus.

William Hyde Wollaston, in his "On the Apparent Direction of Eyes in a Portrait" (*Philosophical Transactions of the Royal Society of London*, May 27, 1824), reported on the comparison of facial illustrations in which the portrait's eye positions remained identical but the other features were slightly shifted. Subjects insisted that the eyes had shifted along with the other features, thereby demonstrating that "we do not base our judgment of gaze direction solely on the position of the iris and pupil relative to the whites of the eyes: instead this is combined with information about head direction."

More recently a study conducted by scientists at the University of Cambridge (published in *Current Biology*, June 25, 2009) indicated that following a gaze is far more than merely determining where a person is looking. According to Greg Davis of the research team, "When we look at a face, it is not just a head or eyes pointing in some direction we see. Rather, our brain is coding another person's attention and intentions." Through reading gazes we anticipate the actions of others (*what* they are going to do next) and also their intentions (*why* they are going to do it).

In Pierre-Auguste Renoir's large Impressionist canvas of 1880–1881, *Luncheon of the Boating Party*, fifteen young urbanites commingle around the remains of a midday meal at La Maison Fournaise, against a backdrop of the Seine. Through gesture, expression, and (most tellingly) the strategic alignment of sight lines, Renoir conveys distinct relationships and subtle mental states (longing, jealousy, ennui, irritation) smoldering within this lusty cross section of Parisian society. The viewer can readily track the (unpainted) lines of sight, which zigzag through the scene from figure to figure, as their (implicit) interpersonal narratives accrue. (See Appendix 10: *Luncheon of the Boating Party*, page 196.)

Early comic strip artists, often lacking (or shunning) the subtlety of Renoir by several light-years, were not so certain that their audiences would be able to connect their characters' dots. Bud Fisher (a hugely successful and influential stylist of his generation) routinely employed actual dotted lines that hung in midair like a clothesline to emphasize a critical connection between Mutt or Jeff and the subject of his rapt attention. Although Bushmiller used this quaint crutch himself on many occasions to emphasize a point (and may in fact have been the last major holdout in the medium), by 1959 comics-savvy readers could generally trace their own links via the well-placed eyeball.

By Ernie Bushmiller

B. Text

Panel 1: *Nancy sees Sluggo and the girl. Sluggo looks his first victim directly in the eye. The girl sees nothing.*

Panel 2: *Sluggo stares down victim number two. The boy sees nothing.*

Panel 3: *Nancy and Sluggo's sights are locked in the final confrontation.*

Without the aid of the dotted lines added in this image, we automatically read all of these invisible connections (and disconnects). Behold the power of the well-placed eyeball. The marks that communicate Sluggo's line of sight here are finely tuned and clearly focused. Bushmiller was dead certain of where and how his characters were using their eyes and situated his black dots with surgical precision.

Where a cartoon character's eyes are focused is a critical ingredient of his or her plausibility as an active, thinking entity. A well-connected sight line instantly and meaningfully grounds a character within its depicted space. When this invisible line is unconvincingly delineated, the illusion of presence is greatly minimized.

No less sure is the placement of Nancy's profile in this strip. We cannot see her eyes but we know that they are there. We infer that she sees the ensuing mayhem based on her placement, stance, and history as a sighted character and, ultimately, by her call to action. And, as discussed earlier, her lack of eyes (and affect) invites us, in a way, to join our own along with hers.

Nancy's missing pupils, by the way, are yet another link of affinity to Sluggo's quarry. And with so much observation going on, it's worth noting that the only character depicted with an actual eyeball in this strip is Sluggo. But if Nancy has her way, in the fourth panel nobody (but the reader) will have any eyes left at all.

Moral: Seeing seeing *is* believing.

NANCY

"It is important to make the composition very clear so the reader will not miss the point of the strip." — Ernie Bushmiller, 1949

A. Context

Good composition may be in the eye of the beholder, but it takes effort and deliberation on the part of the artist to get it to the eye in the first place. The "Golden Rectangle" of classical Western art (based on the approximately 1:1.618 "Golden Ratio" of antiquity) has been touted through the centuries as an almost magical formula to conjure pleasing compositional "correctness," but unfortunately there are no such hard and fast rules — except that the goal is intended balance or intended imbalance.

Composition generally refers to the arrangement of line, color, shape, form, texture, and pattern to form a cohesive visual whole within a specific perimeter. But here composition also refers to the overall arrangement of the story itself and how it unfolds. (Remember your "composition book" in grade school for arranging your writing into gradable presentations?) Just as the Golden Rectangle was first promoted as a foolproof artistic device by Luca Pacioli in his *De Divina Proportione* (1509), present-day Hollywood hucksters enjoy lucrative second careers writing books, holding seminars, and peddling software under the pretext that there is a secret, surefire three-act dramatic structure to which all successful screenplays invariably conform.

The compositional structure of the strip itself is really the subject of this entire study that you hold in your hands. Bushmiller was all about gag structure, not dramatic structure — but a gag is still necessarily composed of narrative elements. If we were to retrofit this strip's narrative composition into the standard three-act format it might look like this:

Act I: *Introduction of the characters and situation and central conflict established.*
Curtain: *End of panel 1.*
Act II: *The plot thickens.*
Curtain: *The hose runs along the ground to Nancy on the left side of panel 3.*
Act III: *Confrontation.*
Curtain: *Resolution? (Sluggo to meet his fate in the unseen coda of panel 4.)*

Unfortunately, as you can see, it doesn't quite work so neatly in this case. And that's the point. The bottom line is that there is *no* magic formula for "successful" storytelling *or* gags *or* composition — except to understand that effective communication is always deliberately ordered.

In examining this strip's purely visual composition, however, we must first consider the prescribed format in which Bushmiller was obliged to work. *Nancy,* as well as every comic strip of its day, was created for print at a specific proportional size, the Golden Rectangle notwithstanding. For syndicated strips this was based on the standardized column widths of newspaper pages. In the United States, newspaper columns commonly measure about eleven picas wide (or about 1.83 inches) — although this measurement does vary.

In 1959, the daily *Nancy* strip was made available to United Feature Syndicate's clients in two sizes: three-column (7½ x 2¹⁄₁₆ inches) and five-column (10 x 2½

By Ernie Bushmiller

inches). This did not include the title, which was set in type by the individual papers in keeping with their own formats (and in some cases dropped directly into the upper left-hand corner of the first panel — the covert reason Bushmiller never anchored his initial word balloon in this most obvious of spots). The proportion of the entire strip was thus perpetually fixed at a 3:1 aspect ratio. Additionally, cartoonists of this era were mandated to consider their daily real estate as two equal parcels, allowing for a panel break and gutter at the strip's dead center. This was because some newspapers reformatted their daily strips "boxed": severed into two balanced tiers. (See Appendix 2: Further Contexts, page 161.)

Sunday strips were even more complicated exercises in modular planning, requiring that a given episode be able to function just as hilariously in concurrent one-third-page, one-half-page, and full-page tabloid formats. It's no wonder that visual problem solving figures so prominently in this twentieth-century comic strip artist's aesthetic. (See Appendix 11: Sunday Strategies, page 197.)

B. Text

In Art discourse, forensic composition is often a foggy undertaking. Leaving the issue of "good" or "bad" composition aside momentarily, this appropriately foggy rendition underlines the fact that this strip has indeed been composed. With details diminished, one can readily see that the individual elements here have been interlocked with clear prior intent — not haphazardly dumped like puzzle pieces from a box.

There are two ways to consider the graphic composition in this strip: as individual panels and as a whole. Taken individually, the pictorial composition of the first panel can be considered as a lopsided funnel in repose, the wide end flush with the panel's left wall and the spout exiting through Sluggo's left arm. At center, the compact second panel stands in tense, horizontal stasis. And the last panel is a compositional inverse of the first: another lopsided funnel leading spout-first, with the fence delineating the funnel's cone.

Considered as a whole, the composition might be said to resemble a well-thumbed family-size tube of Crest squeezed out from the middle. This metaphor is applicable to the content of the strip itself: full of information on the front end, tight and constricted in the middle, with a surge exploding out the back.

Moral: Good storytelling is deliberately ordered.

NANCY

"I try to get some black into the object I am stressing if it is at all feasible." — Ernie Bushmiller, 1949

A. Context

Black ink is one of the cartoonist's best friends — and most powerful tools. The time-honored practice of "spotting blacks" refers to the graphic technique of distributing the areas of solid black within a composition. Its judicious practice is of immense value in comics, where these blackened areas can simultaneously stress a needed emphasis, clarify, impart depth, unify overall design, speed visual comprehension, and help tell the story.

During Ernie Bushmiller's years at the New York *World,* the art editors had laid down a rule that no artist was to ever use more than ten percent of his total space for solid black. Whether this call was arrived at because of aesthetic, economic, or reproduction issues, it forced the cartoonists to become acutely conscious of this precious commodity. According to *World* veteran Harry Haenigsen, "Herb Roth once figured just how much this would be and used

the maximum amount — with the result that this particular drawing turned out smeary and muddy." For Haenigsen the experience was decisive, and he cited this lesson (as he sparingly spotted his blacks) throughout the rest of his long career.

Nancy's hair and uniform vest were not designed arbitrarily. Bushmiller understood that a reader's eyes will always follow the solid black and provided accordingly. Nancy, in order to be a successful starring character, needed to be of primary visual importance in every panel of every strip in which she ever appeared. Her design contains more solid black area than any other cast member (unless Aunt Fritzi is wearing her negligee at a midnight funeral). All of *Nancy's* gags and, in essence, Bushmiller's life's work were designed around these two solid black shapes.

By Ernie Bushmiller

B. Text

Initially it appears that Bushmiller uses black here simply to isolate the stressed objects. When all the lines are dropped out, this may not look like much at first. But look again. The spots of solid black have been extraordinarily carefully placed, and the eye follows them swiftly across the strip. Just connect the blots and end up in the lap of Gagland. Even the black hose becomes a virtual arrow directing the eye to the inevitable dénouement.

It is doubtful that Bushmiller spent more than a moment or two consciously spotting the blacks in this strip. By this time in his long career, he was likely on automatic pilot, a master craftsman with the hard-won knowledge of where to drop his pools of black to direct his reader's eyes — and why. (See Appendix 12: Black Ink, page 201.)

Moral: Solid blacks emphasize.

NANCY

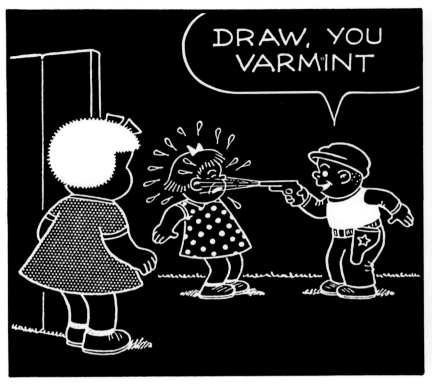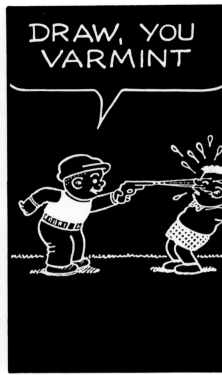

"My first published work was the lines of the crossword puzzle to be filled in." — Ernie Bushmiller, 1973

A. Context

The Japanese have a word for it: *ma*. More than simply describing negative space surrounding a mass, *ma* also implies that the space itself is what gives the mass its particular form and meaning.

As Laozi wrote over 2,000 years before Bushmiller:

*Thirty spokes meet in the hub,
but the empty space between them
is the essence of the wheel.
Pots are formed from clay,
but the empty space between it
is the essence of the pot.
Walls with windows and doors form the house,
but the empty space within it
is the essence of the house.*

By Ernie Bushmiller

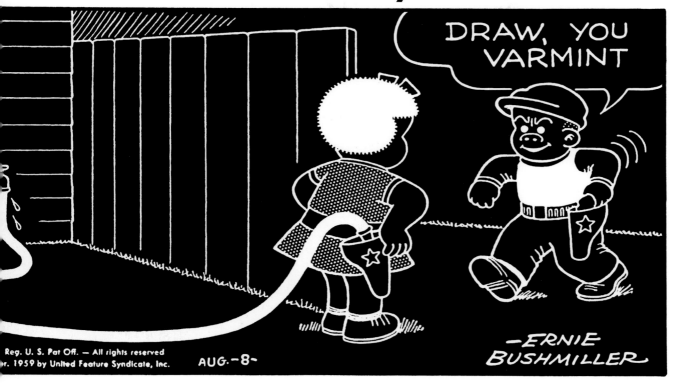

AUG. -8-

-ERNIE BUSHMILLER

DRAW, YOU VARMINT

B. Text

A cartoonist may not exactly "spot whites" in the same manner that he spots blacks, but white is a crucial player on the comic strip page. Bushmiller gives form its meaning here by allowing plenty of negative space. In fact, once the image is inverted it is clear that most of *Nancy* (if not the molecular universe) is made up of the stuff. Every single line of this strip element remains in clear, stark contrast.

It can be tempting to fill up "empty" space with marks to indicate objects, environment, texture, and climate, but in doing so one runs the chance of losing what is achieved by allowing the whiteness to frame, define, and reveal the essential data. It is a testimony to the clarity and balance of the cartoonist's linework that this strip reads as effortlessly in negative form as in positive.

Moral: If black ink delivers the message, white space is the medium of delivery.

NANCY

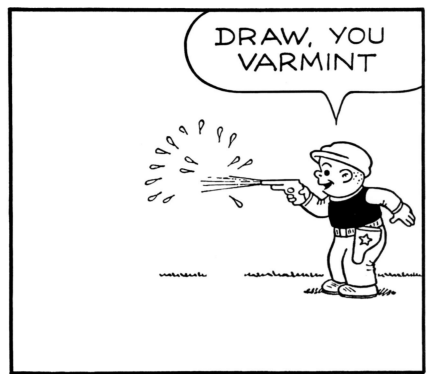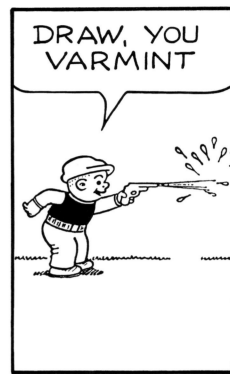

"You can't go to school to write a song." — Ernie Bushmiller, 1974

A. Context

One of least tangible yet most significant implements in the cartoonist's toolbox is the varied use of rhythms. Common to all modes of human communication (and perhaps hard-wired from our time in the womb), rhythms are patterns created by repetitions and their accruing frequency (or in-frequency). In comics, such patterns can be read in both the formal aspects of the medium (e.g., the number of panels per tier) as well as their content (e.g., the number of nephews per panel). Whether overt or subliminal, such rhythms help impart an inner cohesion and a gathering momentum for the reader — implying more, promising more, and delivering more.

One repetition makes a pair. But add another and the repetitions have become a series, the basic building block of all rhythm. A set of three has the smallest number of elements that can establish a pattern (as well as violate it). Three implies more to come.

Primitive systems of counting among our ancestors relied on a three-patterned concept of "one, two . . . many." In most ages and cultures the number three itself has been esteemed as a sacred and symbolic concept and considered significant in such diverse areas as mathematics (the first prime number), theology (the Holy Trinity), and storytelling ("Once upon a time there were three little . . ."). It was believed to denote completeness and perfection in ancient eras, and that perception has echoed into the present through wide-spread repetition in many facets of Western culture. From nursery rhymes to Judeo-Christian rituals to the rules of the street games we grow up playing, we have been conditioned to accept the number three as significant. So much so that when two repetitions are presented and the expected third repetition is withheld (or subverted), we notice.

This precept is the so-called "rule of three" touted by comedy writers in constructing jokes (set up, development, punch line) and is an underlying basis for much of the discourse that communicates "funny" (whether or not it actually makes us laugh). In his *Comedy Writing for Television and Hollywood* (1987), veteran jokesmith Milt Josefsberg recalls an impromptu experiment that Milton Berle conducted to make this point about rhythm to his writing staff. "When he finished that week's broadcast, he would do a monologue for the studio audience. He would start by doing three jokes all having the exact same rhythm. Then he would do a fourth joke in the same exact rhythm, but the punch line would be a nonsensical non sequitur; and it would get a laugh. It went exactly as Berle predicted." In this case Pavlovian form trumped function.

By Ernie Bushmiller

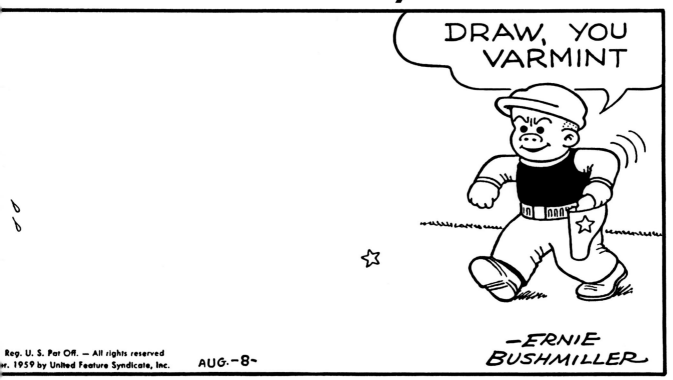

DRAW, YOU VARMINT

—ERNIE BUSHMILLER

AUG.-8-

B. Text

In this strip, rhythms of three abound. The strip is divided into three panels, containing three Sluggos triple-packing three water guns (framed by three horizon lines, three lawns, and three skies) and uttering the three words "DRAW, YOU VARMINT" three times in three word balloons. Depicted are three starred holsters, three expulsions of water, and three motion lines as Sluggo inches toward his third intended victim. There are even three groupings of "external" text (indicia, date, and signature) included in the third panel.

Compared to the primary and incomplete rhythm of this strip ("DRAW, YOU VARMINT"/ one squirt, "DRAW, YOU VARMINT"/ two squirts, "DRAW, YOU VARMINT"/. . .), these adjunct rhythms act as small catalysts, echoing and underscoring one another and upping expectations as the reader is propelled forward.

There are, in fact, so many triplets lurking in this strip that the leftover items that are not part of these rhythms function as subliminal signposts on the road to unfinished business. When all that was filed in triplicate is excised, it becomes evident that this unfinished business concerns Nancy and her close familiars: the kids, the fence, the house, and the hose. Significantly, these are Nancy's precise motive, means, and opportunity for the strip's true rhythmic completion, which lies just beyond the third panel, in our imaginations. All that remains visible of Nancy's side in this equation is the star on her holster, a lone symbol standing in for Sluggo's worthy opponent.

Moral: Rhythm, rhythm, *rhythm.*

NANCY

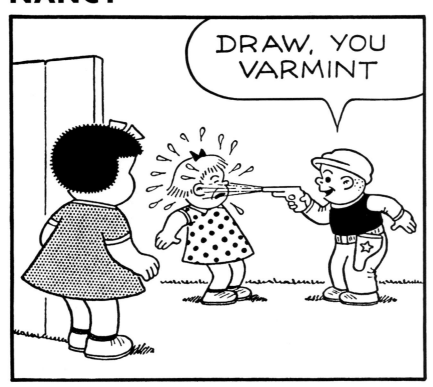 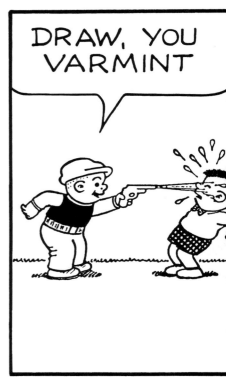

"When I draw, my lines don't have great flamboyance." — Ernie Bushmiller, 1974

A. Context

Comics grew up with the newspaper. The methods, limitations, and economics of mass reproduction in the print medium, as it evolved in the nineteenth and twentieth centuries, shaped not only what comics would be, but also how they would be physically generated. The graphic component of the comic strip developed as a practice of linework. Newspaper strips have traditionally been devised for "line art" reproduction — as opposed to the "halftone" method (which is the province of the screened photograph and painting). A strip cartoonist's education included intimate familiarity with a set of professional tools, and the working experience that came with seeing the various marks these tools could make when reproduced cheaply, at a reduced size, and with terrific speed.

All graphic artists have a signature "line" — a particular way of applying a mark to a surface that is as distinct as an actual signature (though usually far more conscious and practiced). A cartoonist's line is a professional commodity, and while it is only a single aspect of the interlocking systems that constitute comics, it is a vital one. Pre-digital-era comic strip artists usually began the process of preparing their finished strips by sketching lightly first in pencil and following carefully behind with permanent lines made with pen and ink. Some cartoonists used multiple pen nibs. Some used brushes. Some used both pen and brush. All used black ink and white surfaces. With these different tools, different worlds were delineated.

This application of ink (barring correction) became the direct basis for what the vast audience eventually saw reproduced on the page. But it did not necessarily mean that the reader consumed an accurate (or even approximate) duplication of the cartoonist's original. Once received by the syndicate, original artwork was subjected to the editorial process, and scrutinized and corrected if necessary.

In 1959, syndicates supplied copies of their features as both paper "mats" (for letterpress printing) and printed proof sheets (for offset presses). Either way, the newspapers would gang up the source materials of all of their features and through a series of complex technical processes ultimately produce a large plate of each entire page, which went directly on press. (See Appendix 13: Degeneration Gap, page 202.) In short, after the original strip left the drawing board it could have been successively reproduced as many as six times before hitting the newsstand. Inevitably, with each degree of separation came distortion and visual degradation.

Given the variables of newspaper reproduction (individual formatting practices, paper stock, ink quality, print run, press speed, the operator's attention span, etc.), a reader of the *Abilene Reporter-News* might have encountered a noticeably different *Nancy* on the same day as a reader of the Zanesville *Times Recorder*. Further degeneration accrues in each subsequent reprinting of the same strip, such as in comic books and collections (including this one) — especially when the original artwork has been lost. Even Bushmiller, an artist who deliberately crafted his bold, crisp style with all of these vicissitudes in mind, was ultimately a partner with (and at the mercy of) the printing press. (See Appendix 13: Degeneration Gap, page 202.)

Ernie Bushmiller was initiated into his profession at a wooden, metal-edged drafting board at 63 Park Row, methodically ruling the horizontal and vertical lines of the New York *World*'s crossword puzzles with a T-square and then brushing in the blacks of the small, neat squares that those intersecting lines created. This experience informed

The Cartoonist's Hand

By Ernie Bushmiller

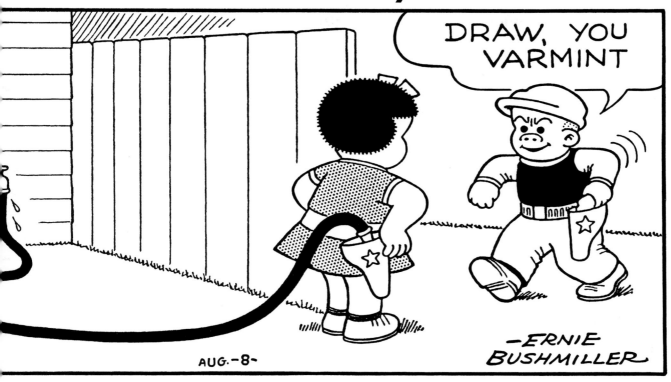

DRAW, YOU VARMINT

AUG.-8-

—ERNIE BUSHMILLER

his graphics for the rest of his life. The hallmark of the Bushmiller line remained its clean, unambiguous regularity, his graphic vision a deft balancing act of blacks and whites.

Although he set his ink lines down with the unerring precision of a machinist, he did so atop surprisingly loose pencil guides, sketched with a medium lead. He worked at his inking on a strip almost at random, adding a line or two in one panel and skipping across the page (or perhaps across the room) to the next. However, the very last item he apparently added to his nearly finished panels was the short, sharp ink strokes that crowned Nancy's hair — perhaps saving them for dessert. His originals were extraordinarily clean, although like all cartoonists he occasionally corrected errors with opaque white, paste-overs, and the rare photostat. (See Appendix 14: Unfinished Business, page 204.)

In the mid-1970s, Bushmiller was diagnosed with Parkinson's disease ("He could forget the day, but not the gag," recalled James Carlsson), and the strip was completed with the assistance of Will Johnson and Al Plastino. Plastino, a journeyman cartoonist who had worked on the *Superman* comic books of the 1950s as well as a wide variety of syndicated strips, was assigned the Sunday *Nancy* at this time. "I was able to do any style," Plastino recollected. "I could copy anyone. . . . Little *Nancy* was the toughest strip to draw. The toughest . . . because [Bushmiller] was a real German draftsman. And every line meant something. He drew simply, but clean, crisp lines of a certain thickness. No less, no more. No brush. In fact, I had to use a fountain pen for his stuff. When you drew Nancy's head — if you made just one slip . . . ! I had to hold my breath when I did Nancy's head!"

B. Text

Bushmiller drew this strip on a smooth-surface Strathmore three-ply art board, "which I prefer to two-ply because it doesn't buckle when I erase; it's easier to scratch out mistakes and it doesn't seem to develop ripples from the perspiration of my hand." It was drawn $19\frac{1}{8}$ inches wide and $5\frac{3}{4}$ inches high — well over twice the size of three-column newspaper reproduction, as was typical for comic strip artists of this era.

He claimed he liked his pen nibs fairly flexible and with a fine point, and like most cartoonists of his era, he probably favored a Gillott 290 in his E. Faber & Korka 78 holder. He dipped his Winsor Newton No. 3 sable brushes in Higgins India ink but admitted that he was "ashamed of the way I treat them. Always forgetting to wash them out after using. When I pick up one to use, the hairs are always stiff and shaped like reindeer antlers. I don't recommend this habit." Protractors, rulers, templates, and other tools of the draftsman's trade rounded out his arsenal.

This equipment delivered a hard consistent line and a cold consistent world where everything remained in sharp focus. The cartoonist's steady hand provided for rigid, unwavering lines with only a trace of mortal tensility. Any form not considered part of the solution was considered part of the problem and eliminated. The remaining lines outlined and enclosed their chosen shapes with the definitive strength of wrought metal. As such, Bushmiller's drawings resemble nothing so much as hot type itself, supremely appropriate to a cartoonist who wrote his story with pictures.

Moral: In comics, all is ultimately expressed through line.

NANCY

"When I draw words in the strips I draw them large. Older people tell me this saves wear and tear on their eyeglasses, and little kids who have just staggered through first grade tell me they can often get the point of a Nancy gag without bothering Pop to spell out the story."
— Ernie Bushmiller, 1949

A. Context

In his *Enjoyment of Laughter* (1936), Max Eastman sarcastically blamed his personal lack of enjoyment of comics on sloppy lettering. "My own explanation of the popularity of the comic strip and the funny page is that, the dialogue being scrawled into the picture in a rather messy manner, it requires a little brain work to decipher it and see how it applies, and to people who use their brains as little as the average American newspaper reader does, this intellectual effort is an exciting adventure — especially on Sunday mornings when he has had a good long sleep and feels up to it." While he may not have been in the majority, he did have a point — in comics lettering, neatness counts.

Just as *Nancy*'s drawing is characterized by a careful, even line weight, so is its lettering. Generations before the advent of digital fonts (and years before the word "font" was part of the average twelve-year-old's vocabulary), all comics lettering was produced by hand. Somebody's hand . . . anybody's hand. For many cartoonists of Bushmiller's generation who employed studio assistants, lettering was a routinely delegated job. Yet it is an exacting skill, requiring a certain dispassionate focus that comes only with much

practice (see Appendix 15: Assistants, page 207). Other cartoonists (e.g., George Herriman, Charles M. Schulz) took their lettering personally, regarding it much like handwriting. To them it was an intrinsic part of their expression and integral to the consistency of their strips' cosmos. Both approaches are valid, depending on the results desired. Bushmiller's cold graphic style was more impervious than most to the use of a skilled letterer, and indeed he did employ them at times throughout the years (including 1959) — as well as often doing the job himself.

Lettering can be considered as a group of specific symbols meant to be read as words, as well as a collective cluster of vertical, horizontal, and curved lines artfully arranged in space. Bushmiller spoke of "drawing" his words, and this is entirely apt — letterforms should rightly be regarded by the cartoonist as another pictorial element of a comic strip. They are, however, a very unusual kind of pictorial element that should be at once instantly legible but remain, in effect, invisible.

In short: the lettering in comics is generally meant to be read and not seen.

By Ernie Bushmiller

DRAW, YOU
VARMINT

B. Text

This cartoonist lettered large and in uppercase only. The dialogue was carefully chosen not only for meaning and sound, but also for minimal letter count and the space designed accordingly. Each balloon here contains only three words, yet Bushmiller deliberately divides those words into two separate lines, with an even amount of syllables and letters apiece. And though these elements are evenly parceled, notice the wide, deliberate spacing between "DRAW" and "YOU." This nuance adds a faint pause in the reading of these lines and allows "YOU VARMINT" to be taken together despite the linear separation.

These lines of lettering are arranged uniformly in each successive appearance, cementing their graphic rhythm. Like type set on a printed page of text, each line rests on its own distinct invisibly ruled plane, consistent even across the barriers of panel borders. Yet despite such rigors, these perfectly balanced letterforms still maintain their own individuality — because they were drawn by an individual. The lettering in panels 1 and 2 is nearly identical. Only upon closest inspection can it be detected that in panel 3 the lettering is incrementally larger and lands incrementally higher, a subtle shift of emphasis provided for the last beat.

If digital fonts had existed at the time, chances are Bushmiller would have rejected them outright — cloned characters call instant attention to their monotonous mechanical heritage especially in a case like this, with repeating dialogue. And in lettering, distraction is a most unpardonable sin. Cartooning students would do well to swallow Bushmiller's lettering whole. It is perfect: simple in form yet exacting in execution.

Moral: Letters form words, and their forms compound their meaning.

35. BALLOON DESIGN

NANCY

"Ya gotta remember . . . DO THE JOB RIGHT!" — Ernie Bushmiller (to Al Plastino), 1970s

A. Context

Fumetti, the Italian term for comics, is said to have been coined by that nation's early twentieth-century master, Antonio Rubino, who dubbed the medium "little puffs of smoke." The moniker derived from the conventional shape of word balloons, one of the form's earliest and most tacit conventions. It is perhaps a more appropriate name than the English "balloon," which may not always float away, while a puff of smoke, like sound itself, is fleeting.

Some have argued that it is the use of word balloons that defines comics. In fact, they precede the medium and date to eighteenth-century satirical and political cartoons (and arguably earlier, as in the "speech scrolls" of Pre-Renaissance painting). Whatever their lineage, for comics they are a vital contrivance that effectively corrals an area of lettering, allowing it to be instantly understood as the speaking voice of a particular subject. (Closely related is the scalloped variety known as "thought balloons," which in turn convey interior monologue.)

Any number of word balloons can be used within a panel, but like actors on a stage or in a filmed scene, characters in comic strips generally speak their piece before the next cast member chimes in. For Bushmiller one balloon per panel was the norm, two were the exception, and three or more were reserved for mass hysteria.

By Ernie Bushmiller

B. Text

Just as toy balloons are filled with air, air is the key element in the success or failure of any word balloon. The balloons in this strip fit the lettering they house comfortably, with plenty of open air all around. Too little space around the letterforms and the reader can feel suffocated. Too much space and the reader feels stranded in the arid Sahara (while the dialogue inside is reduced to a whisper). There is a specific yet unwritten ratio of visual elbow room required — think frying pan displaying the fried eggs and sausage links for the diner menu's beauty shot. Whatever the equation, this ex–crossword puzzle designer usually hit it on the mark daily.

The shape of these balloons informs as well. Wisely constructed, the lettering comes first and the word balloon is then inflated around it, in pleasing curvaceous proportion. In this example each balloon has risen to the top of the panel (as all good balloons should) and is efficiently cropped there, as well as along the edge. Unanchored, free-floating balloons attract a certain attention to themselves, emphasizing or underlining the dialogue they contain. Here the anchoring of all balloons to the top and side of each panel keeps the messages consistent and the messenger flexible.

In the first two panels, the balloons (like the lettering they contain) closely resemble each other, with panel 2's tail dipping lower (and curving more sharply) to accommodate a tinier Sluggo below. Panel 3's balloon is a different story: though the dialogue remains identical, the balloon's shape has changed in significant ways that help rupture the established rhythm.

On the left side, that balloon's curved edge has been indented, taking on an upper ridge. This reshaping accommodates the lettering, which, as noted, is larger than before. Additionally, the double ridge reinforces an implied depth, helping to separate the encroaching Sluggo from Nancy's personal space (while mirroring the contour of Sluggo's double-decker cap in the bargain). Below, Sluggo has violated this balloon's boundary line, effectively tearing right through it like a rusty nail through a rubber tire. Such planar violation was not common in *Nancy*, but can be observed, discreetly employed upon occasion, especially where the placement of character and balloon have come to loggerheads. In this case the surging, forward movement of Sluggo (imperative to the gag) prevails.

Moral: Design facilitates content.

NANCY

"There is only one way to learn cartooning . . . you just do it." — Ernie Bushmiller, 1973

A. Context

Wacky: *"What did the first cartoonist do when he lost his job?"*

Hacky: *"He enrolled the second cartoonist in his mail-order course."*

For almost as long as there have been professional cartoonists there have been books and gimmicks and schools and gadgets professing to initiate any solvent novice in the "tricks of the trade" (present volume included). The value of teaching tricks of any kind may be questionable, but to the working cartoonist of the twentieth century, the hard-won shortcuts picked up in the frenetic art rooms of big-city newspapers were of clear practical benefit. Professional art "tricks" such as the skilled use of blue pencil, razor blade, matchstick, cigar smoke, white paint, rubbing alcohol, shading film, the light box, and the photostat camera became part of the cartoonist's craft and culture.

Other "tricks" were less mechanical but no less coveted. The stylistic strategies, narrative techniques, and million-dollar ideas of a competitor (or coworker) usually were (and seemingly still are) considered fair game for creatively challenged hijackers. As these successful "tricks" accrued, so was formed the language of the comics.

By Ernie Bushmiller

B. Text

Throughout this strip Ernie Bushmiller employs a ubiquitous cartoonist's trick. This is an effect so subtle and instinctive that it does not seem to have an actual trade name, but it is analogous to a technique referred to in the jargon of newspaper photograph retouchers of Bushmiller's era as a "modified silhouette." For clarity's sake, we have singled out just one example from the scores that can be found lurking in this strip.

In this isolated instance in panel 2, just before the grass line intersects Sluggo at his ankle, the line abruptly stops — replaced by a small aura of emptiness. Then after another fractional gap, the grass line continues to repeat the same procedure at his victim's ankles. This mysterious stopping and restarting of what at first appears to be a continuous line creates an illusion of separation and space, causing the background to recede while freeing the characters from their moorings and allowing them to appear on a closer plane.

It is a simple artifice, the creation of a partial miniature halo, but one that benefits the larger image as a whole, affording a kind of visual breathing room where tangents collide. It helps bring a lighter touch to a composition, and its judicious use provides the reader with a perceptibly airier, less constricted environment.

It is usually most noticeable in direct comparison to cases where it is *not* employed. (Go back and take a look at the area in panel 3 where the fence meets the house, for example, which needs to be read as a continuous barricade with no breaks.) For cartoonists it is a technique well worth adopting, though it should be noted this effect does not play well with buckets of digital color.

Moral: A white halo around an object grants prominence.

NANCY

"Drawing comics is hard work but I'd rather be a cartoonist than anything I can think of. In fact I'll keep on drawing comics even if I hit the Irish Sweepstakes." — Ernie Bushmiller, 1934

A. Context

There are some marks made only by mathematicians, some marks made only by stenographers, some marks made only by hoboes — and then there are some marks made only by cartoonists. The language of cartooning recognizes a number of specific strokes that signify distinct motions, emotions, velocity, and quantity. These marks are absent in every other narrative media (and, of course, in "reality"), yet even on first exposure, the uninitiated seem to interpret them readily.

Motion lines are a ubiquitous example of this kind of mark. They are in essence shorthand abstractions of the multiple exposures familiar in long-exposure photography and the blurred, imperfect twenty-four-frames-per-second progression of motion pictures. In his *Lexicon of Comicana* (1980), cartoonist Mort Walker empirically classified such abstract impressions as "Hites" and "Sphericasia" and further isolated such "Lesser sphericasia" as "Agitrons" "Direct-a-trons" and "Turnatrons." Whatever they are called, Bushmiller was an absolute master of all such utensils and used them discerningly. If one needs to know precisely just how many lines a wrecking ball requires to indicate mid-swing or just how many arcs a Hula Hoop requires to convincingly rotate, simply consult the Encyclopedia Bushmiller.

By Ernie Bushmiller

B. Text

The three brisk strokes (not two, not four) trailing Sluggo's elbow in panel 3 express a specific degree of urgency. They immediately connote the speed of Sluggo's bending elbow toward his holster and secondarily the speed of his locomotion toward Nancy. Although they might appear incidental, the number, shape, and size of such marks are design elements demanding as much forethought as anything else in constructing this gag universe.

Notice how these strokes conform to the crescent of Sluggo's bent elbow like fragmentary air ripples left in the wake of his thrusting arm. This effect is enhanced as the line drawn farthest from his elbow is also drawn the shortest, just as an ocean ripple caused by the prow of a moving boat dissipates as it is supplanted by the next concentric crescent.

These three marks are the final pieces of visual information the cartoonist has situated into his narrative. As such, they function as ellipsis points do at the end of a sentence: as a pause, an unfinished thought as well as an intentional omission. They are our direct cue to imagine what might happen next . . .

Moral: Movement can be invoked by pure line.

NANCY

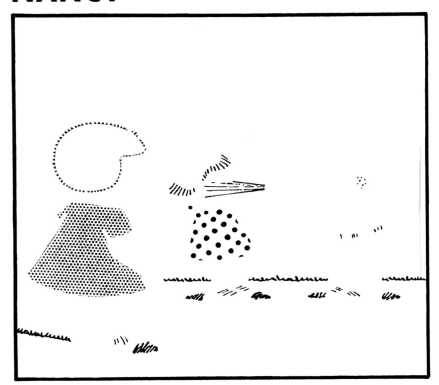

"WHAT'S THE REASON FOR THIS SMOG?" — Sluggo, September 5, 1960

A. Context

A world of solid blacks and whites, no matter how masterfully arranged, cries out from time to time for blessed relief. Bushmiller was expert at spotting blacks, but equally adept as well in the subsidiary art of spotting grays. In line art reproduction, shading can be accomplished by a number of means: by the close, repetitive placement of lines, known as hatching (above the fence in panel 3, for example); by overlaying such strokes with an opposing set, known as cross-hatching (see the little boy's short pants), or by means of a photochemical process (the dots on Nancy's dress).

Those dots were provided by a reproduction technique, now virtually eliminated by digital technology, known as the "Ben-Day" process (named after their originator, nineteenth-century illustrator and engraver Benjamin Day Jr.). Originally the province of the newspaper's engraving department, this was a common tool at the time this strip was drawn, dispensed on semitransparent, self-adhesive sheets of plastic film that were peeled, then razor-trimmed to size and applied to the original by the cartoonist (earlier versions required rubber cement). The sheets were marketed under a number of brand names (such as Zip-A-Tone, Top Sheet Films, and Bourges Sheets), came in a wide variety of patterns and densities, and produced uniform, mechanical shading. Ironically, Ben-Day screens are now perhaps best recognized in the paintings of Roy Lichtenstein, who used them (and their natural habitat of comics panels and newspaper ads) as subject matter for his large Pop Art canvases of the late twentieth century. (See Appendix 16: Ben Day and Ben-Day, page 209.)

By Ernie Bushmiller

B. Text

Surface pattern can be used to convey shading, texture, or form, or simply to denote a plane. Here, Bushmiller uses pattern primarily to identify and separate characters and space. The little boy and girl have distinctly different patterns on their clothes. Yet as separate as they appear, these bold patterns subtly help link them together as a pair.

Nancy's dress is also patterned, but the tiny black dots are so close together that the reader's eyes combine them with the surrounding white to create a continuous gray tone (a similar illusion is created in four-color comics). As previously mentioned, these tiny dots were not made by hand — although if anybody could have drawn such precise dots, it would have been Ernie Bushmiller.

In this comic strip dense patterning is reserved only for characters' costumes, and the only character lacking it is Sluggo. In balanced black and white, Sluggo is odd man out; his stark garb definitively separates him from the opposing players, emphasizing his otherness and allowing us to consider him accordingly when the time comes to dispense our justice.

Moral: Tone separates and clarifies.

NANCY

"WHAT MARK DO YOU THINK I SHOULD GIVE YOU FOR THIS?" — Sluggo's teacher, December 2, 1965

A. Context

Bushmiller may have been an A-list cartoonist, but his punctuation in *Nancy* wouldn't have earned him many A's in English class. By most standards it was downright quirky. Bushmiller's characters rarely ended sentences with punctuation. He avoided the use of the period at all costs. Given his inclination to brevity, his characters generally spoke only a single sentence within a word balloon. On the rare occasion that they needed to utter two full sentences in one panel, Bushmiller begrudgingly doled out three hyphens (- - -) to separate the two sentences. Anything, it seems, but a period.

Even odder was his disinclination to allow his dialogue even the occasional exclamation point, a punctuation mark virtually synonymous with comics vernacular. In the earliest days of *Nancy*, dialogue exclamation points were bountiful, but in the streamlined postwar strips he allowed only the question mark to be deployed as grammatically needed. Exclamation points became segregated, permitted only in strict isolation apart from the character's speech balloons. Clearly Ernie, in some executive decision, chose to simply banish periods and exclamation points from his dialogue. Why?

According to his associate James Carlsson, Bushmiller would line up each week's worth of unfinished *Nancy* strips on his studio wall and scrutinize every line of dialogue. Harry Haenigsen noted that "Ernie said when he wrote his captions, he wrote them as if he were writing telegrams," which are charged by the word. "He eliminated anything — *any* word that, to him, was not necessary to express his ideas. He was very careful about how he edited his balloons."

And according to Nelson E. Ross, in *How to Write Telegrams Properly* (1928): "Marks of punctuation . . . are not transmitted in telegrams unless the sender specifically requests it. . . . If it seems impossible to convey your meaning clearly without the use of punctuation, use may be made of the celebrated word 'stop,' which is known the world over as the official telegraphic or cable word for 'period.'"

And thereby hangs the Bushmiller justification. The last thing this cartoonist *ever* wanted a reader to do was "stop" — until the last panel.

By Ernie Bushmiller

B. Text

"DRAW YOU VARMINT"
"DRAW YOU VARMINT"
"DRAW YOU VARMINT"

Notice anything odd?
Now compare with:

"DRAW, YOU VARMINT"
"DRAW, YOU VARMINT"
"DRAW, YOU VARMINT"

The addition of the comma allows the reader to pause between the command and the provoking insult. William Strunk Jr. and E.B. White, authors of the seminal grammar guide *The Elements of Style* (1959), would have undoubtedly approved of the use of the comma after the imperative verb. Omitting the comma could imply that the varmint being addressed should, perhaps, draw himself.

A sentence ending without punctuation would be readily noticed anywhere else in a newspaper and objected to by even the most casual reader. Remarkably, one does not detect the absence here, but rolls right along with the strip without a hitch. Indeed, neither Bobbie Miller, Bushmiller's editor during his last years on the strip, nor any of her colleagues ever noticed anything amiss. Such is the persuasion of *Nancy*'s momentum. Strunk and White would surely look askance, but Bushmiller was holding his exclamation mark in reserve for whatever was coming after panel 3.

Moral: The smallest elements can help expedite communication.

NANCY

"Don't try to be a celebrity before you're a success." — Ernie Bushmiller, 1949

A. Context

The lettering in any episode of *Nancy* (dialogue balloons, sound effects, etc.) occupies its own distinct plane yet is as much a piece of the warp and woof as Nancy's bow or Sluggo's cap. But within the panels of *Nancy* lurk furtive, mysterious, parasitical bits of printed matter — the only part of this strip that Ernie Bushmiller did *not* want read. Along with his signature (which he would be glad you noticed) are the publication indicia (also known as the "syndicate stamp") and the print date — simultaneously part and not part of this universe. This information usually skulks along a strip's bottom, positioned onto the originals, as unobtrusively as possible. Unattractive, nearly indecipherable, and seemingly irrelevant to the proceedings, these persistent little marks cannot be entirely ignored and constitute narrative elements in their own right.

Although created by Ernie Bushmiller, *Nancy* was an intellectual property owned by United Feature Syndicate, Inc., which coincidentally first carried its mark on the *Fritzi Ritz* of January 3, 1933, the very day of Nancy's debut. The company had its roots in Edward Wyllis Scripps's Midwestern news publishing ventures, which he consolidated into United Press Associations in 1907. The syndicate itself was incorporated in 1923 and originally focused on the distribution of hard news stories and bylined features, by such statesmen as Winston Churchill, Benito Mussolini, and Herbert Hoover. When the failed New York *World* was sold to the Scripps-Howard chain in 1931, Press Publishing Co. (retaining many of the *World*'s "tangible assets," including its syndicate arm, the Daily Feature Service, and *Fritzi Ritz*) was acquired by United (which had just purchased Maximilian Elser's competing Metropolitan Newspaper Service in 1930), quickly making it a major player in the comic strip field.

Headquartered at 220 East 42nd Street (and later 200 Park Avenue) in Manhattan, in practice, United Feature was the cartoonist's publisher and partner, editing, promoting, and distributing *Nancy* to newspapers around the world. Over the years manufacturers have produced *Nancy* paper dolls, pencil tops, and peanut butter. The syndicate participated in, and inked the contracts for, such lucrative licensing arrangements.

Unlike the business model of book publishing, it was very rare in the early twentieth century for a syndicated cartoonist to retain ownership of his work, and Bushmiller was not one of the fortunate exceptions (Harry Haenigsen disclosed that a thirty percent cut for a cartoonist on his own strip's revenue was typical in his day). Bushmiller was a lifelong salaried employee and, according to Morris Weiss, not a particularly well-compensated one, until he renegotiated his contract after a serious bid from William Randolph Hearst in 1944. (Tellingly, since early 1932, *Fritzi Ritz* had been running in Hearst's tabloid the New York *Daily Mirror* — a somewhat unusual venue for a strip owned by the competition.)

Weiss recalled Bushmiller's play-by-play decades later: "I got an offer from King Features and it was a hell of an offer to start a kid strip. . . . So I went into [syndicate editor-in-chief George A.] Carlin's office, I showed him the letter, I showed him the offer. And Carlin said, 'Ernie, this is fabulous. I'm gonna called Roy Howard [of Scripps-Howard, president of United Press] right away and tell him.' So I went back to the bullpen and I'm working on my strip and the girl comes in and says that 'Mr. Carlin wants to see you again.' So I go into the office and Carlin says, 'Sit down, Ernie, I have wonderful news for you. Ernie, you're gonna make a lot of

By Ernie Bushmiller

AUG.-8-

money now. You're gonna be a rich man. We can't meet this offer but you're still gonna do very, very well." And Ernie said, "If it's one penny less, I'm walking." Bushmiller did not disclose the sum, but according to Weiss, "When Hearst made you an offer — he made an OFFER!"

The syndicate, later known as United Media and Universal Uclick, has continued the *Nancy* franchise to the present, through the hands of other cartoonists. (Though, as far as former editor Bobbie Miller is concerned, "it didn't work. *Nancy* is *Nancy*.")

All syndicated cartoonists date their work and maintain a backlog of strips to stay ahead of the curve. (Typical of most, Al Capp bragged at this time about stocking three months' worth of *Li'l Abner* in reserve.) Through his methodical manner, Bushmiller, at the top of his game, remarkably kept a full year ahead on *Nancy*. Days of the week may seem fairly interchangeable as far as Nancy and Sluggo are concerned — but not so to Bushmiller, his syndicate, or the hundreds of newspapers that printed the strip. Although not overtly topical, *Nancy*'s day-to-day content was never quite as random as it seemed. New characters entered and exited, gag themes built and spiked, national holidays were celebrated, and even costumes varied from season to season. Keeping *Nancy*'s publication date in black and white helped ensure that what Ernie Bushmiller meant to be funny on Saturday, August 8, would be funny *on* Saturday, August 8 (and not fall flat on Friday, December 25).

B. Text

In panel 3, as Nancy defiantly stands her ground above, so does the fine Futura print of her syndicate below. Here is the imprimatur of United Feature Syndicate, Inc. The presence

of this data on every *Nancy* daily is essential to the very existence of the strip, as well as the sole bridge to outer, if mundane, reality.

The first line informs us that *Nancy* is a registered trademark of the United States Patent and Trademark Office, like Marlboro cigarettes and Aunt Jemima pancakes. Nancy was first registered October 4, 1938, and her claim has been renewed four times since. This protection effectively prevents competing comic strip *Nancy*s as well as competing characters with round eyes, horizontal noses, and serrated haircuts from encroaching too closely on our heroine's visual turf. The bottom line serves notice of the copyright of this particular daily strip. Anyone reproducing it without permission would be infringing on an exclusive right.

To the right is the publication date. The practice of marking dates within the strips themselves was more for the convenience of the comics page editors than their readers (who had probably seen the top of the newspaper page and already knew what day it was). In this example, notice how the line weight and spacing in the lettering of "AUG" and "08" do not quite smoothly mate. Bushmiller earmarked this strip for August, but the specific date itself was determined and lettered later as a separate task, probably on a number of dailies in rapid succession. The minute mismatches in the inked dates are perhaps the only aspect of *Nancy* that is conspicuously (and often) sloppy.

And, last but not least, across the top, set in type larger than any lettering below, are the strip's title and the author's byline (in case you didn't know).

Moral: In most creative endeavors, some conventions must be accommodated.

NANCY

"I WISH HE'D FINISH THIS STRIP SO WE CAN GO OUT AND PLAY" — Nancy, November 23, 1944

A. Context

Panels in comics create gutters. The gutter, or the blank space between panels, serves as a sort of waiting room for the next image — a realm of relativity where time and space mutely commingle. And lurking in these evenly spaced corridors of empty newsprint are the infinite dimensions where most of the action of any comic strip actually takes place.

Here, time can jump a thousand years or a nanosecond; run backward or remain absolutely still. Plots can thicken, tables can turn, and all hope can be lost and found. Scenes can shift from the sprawling Byzantine Palace of Ice to the hard wooden bedroom floor of Little Nemo. Point of view can zoom outward from a tear forming in a baby's eye to a hundred bawling infants in the maternity ward. And the narrative world can derail entirely — from *The Family Upstairs* to *Krazy Kat*. The gutter functions analogously to the cut (and splice) in the language of film, the blackout or curtain on the stage, and the turn of a page in a photo album. Yet unlike those media, in comics the "past" and "present" remain entirely visible to the eye.

Gutters also serve as the mortar between the bricklike panels. As such, a certain even amount is required. Slender gutters crowd the panels and hurry the flow. Wide gutters weaken the bond between panels. Again, there is no rule, nor prescribed formula, but when the proportion is correct it is unnoticeable.

By Ernie Bushmiller

B. Text

What exactly has occurred between panel 1 and panel 2? Is it still the same day? Where has Nancy gone? Did Sluggo squirt her, too? What happened to the little girl? Or the fence? What further foul deeds has Sluggo perpetrated? Or has he temporarily reformed? Did he stop to refill his water gun? Did he stop for an ice cream cone? How many more times did he say "DRAW, YOU VARMINT"? And when did he change from a righty to a lefty?

The gutter between panel 2 and panel 3 might beg even more questions. Where did Nancy get the hose? Did she test it first? How far does the hose extend before it reenters the panel? Did she just buy the holster or did she already own it? Or did she steal it? Is she an outlaw too? Are the little children still wet? Have their parents been informed? How long did Nancy wait by the fence for Sluggo? Who lives in the house anyway? Did they pay their water bill last month?

These are the kind of questions that a reader never asks when a comic strip has done its job effectively. And chances are they have never been asked about this one. The spell that *Nancy* weaves stands as a testament to its creator's craft and conviction, permitting his audience to routinely accept the unbelievable — and in fact to demand it.

Moral: In between two panels of comics, anything can happen.

NANCY

"PLAN AHEAD" — sign on wall read by Nancy, September 2, 1958

A. Context

Since the height and width of a daily newspaper comic strip were (and are) a conventional given, the cartoonist has limited options in the matter of panel size. A further consideration of this era, as previously mentioned, was the demand for a panel break at dead center in daily strips to accommodate newspapers that stacked their features squarely in two even tiers. (See Appendix 2: Further Contexts, page 161.) Beyond these limitations, the cartoonist was essentially free to divide his horizontal real estate as he saw fit, given the crucial consideration of legibility. Bushmiller, like most others of the era, usually opted for three to four panels to put across his daily gag, but was known to artfully contrive as few as one and as many as eight panels in a single strip when absolutely necessary.

Functionally, panels parcel the content of any comic strip tier into discrete increments, and their actual width helps signal to the reader how those increments are to be ingested. The great radio and TV comedian Jack Benny, an acknowledged master of comedic timing, once reflected on how the pacing of communication impacts content: "A good joke without timing means nothing and a bad joke without good timing means nothing — except you can help a bad joke with timing, where you can't help a good joke with bad timing."

The Reader

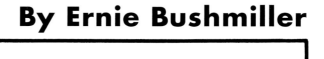

By Ernie Bushmiller

B. Text

Strip the strip down completely and all that is left is panel size. And size counts. Panel size is like the percussion track of a comic strip, helping to set the speed at which information is absorbed. The narrower panel tucked between panels 1 and 3 here increases the velocity of consumption. Were panels 1 and 2 of identical size, the movement to the third would occur less urgently.

Consider this strip as a measure of music in (approximately) 6/8 time. Even without knowing a thing about music, you can tap out the rhythm created by these panels by tapping the following capitalized words as you recite each number aloud in a steady rhythm: ONE two, THREE, ONE two three.

To clarify, the panels are represented in this cadence like this:

Panel 1: *ONE two*
Panel 2: *THREE*
Panel 2: *ONE two three*

Anything at all can go into these three empty panels, but now we know exactly what belongs in them — and why. They were designed to hold (and withhold) a certain gag created on a certain day by a certain cartoonist to be read in the twinkling of an eye on another certain day by a certain few million people. You can't strip it down much more than this.

Moral: Form follows function.

43. THE FOURTH PANEL

"HEY - - - WHO INVITED YOU IN?" — Sluggo, August 4, 1951

A. Context

Gag-a-day comic strips like *Nancy* tend to be an explicit art. Little is implied and much is shown. It is this intentional broadness that accounts for the form's great appeal — as well as its inherent limitations. *Nancy* was hardly lacking in subtleties. Yet its avowed goal was to hit the funny bone directly via instantaneous consumption — not through subtle inference, layered reflection, sub-context, or metaphor. Bushmiller would have undoubtedly considered any such occasion in *Nancy* an utter disaster.

Shortly after receiving his Reuben Award in 1976, Bushmiller confided to a reporter: "I win so many reader polls I can't keep count. I'm always in the top three no matter how many comics the papers have, but it's mostly kids and mothers that like it. The teenagers want me to swing a little more, they think I'm so corny they can't stand it. But I can smell the way kids think, and the strip is doing so well, I must be doing something right." (See Appendix 17: How They Read Nancy, page 211.)

He was. Thousands of other comic strips have come and gone through the newsprint pages over the years. Many used very similar characters, premises, and, at times, even gags. (See Appendix 18: How To/How Not To, page 219.) Yet *Nancy* transcends and endures.

Ernie Bushmiller also once said, "I dumb it down for the kids." Nice sound bite, but no artist as committed and exacting as Bushmiller ever really considers his audience "dumb." By leaving Nancy's facial expression to the reader's imagination, Bushmiller, in this small instance, shows the utmost respect for his audience. And by inviting them to "draw" the fourth panel in their minds themselves, he extends that respect a step further. Few cartoonists would have resisted the temptation to draw that inevitable image of Sluggo being blasted off his feet, yet Bushmiller reserves this pleasure here for the inner cartoonist in every reader.

In his essay "A Two-Stage Model for the Appreciation of Jokes and Cartoons: An Information-Processing Analysis"

(1972), psychologist Jerry M. Suls offers one of a number of alternative cognitive-based approaches to Freud's work on jokes. Suls posits that for narrative humor to operate it requires true participation on the part of the audience, who must reconcile meaning in an inherently contradictory informational structure (recall, once again, Bushmiller's early puzzle-making training).

Suls wrote, "In the first stage, the perceiver finds his expectations about the text disconfirmed by the ending of the joke. . . . In other words, the recipient encounters an incongruity — the punch line. In the second stage, the perceiver engages in a form of problem solving to find a cognitive rule which makes the punch line follow from the main part of the joke and reconciles the incongruous parts. A cognitive rule is defined as a logical proposition, a definition, or a fact of experience. The retrieval of such information makes it possible to reconcile the incongruous parts of the joke. Although it may be difficult to assemble these cognitive rules into a system, they appear to be part and parcel of the cognitive process. The perceiver must proceed through these two stages to find the joke funny. More succinctly, humor derives from experiencing a sudden incongruity which is then made congruous."

Or as the legendary Hollywood writer and director Billy Wilder suggests in his "Ten Rules of Screenwriting":

Rule #7: A Tip from Lubitsch: "Let the audience add up two plus two. They'll love you forever."

B. Text

There is no fourth panel. But grab a pencil and . . .

Moral: The reader completes the creative process.

NANCY

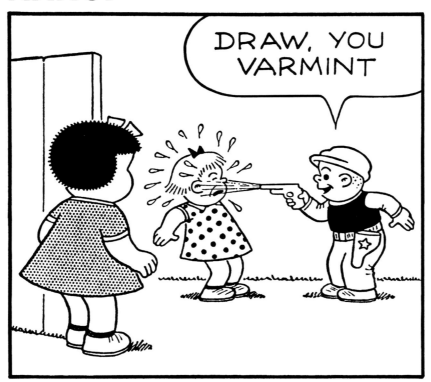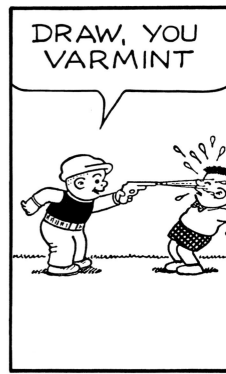

"The organization of Mr. Bushmiller's strips is a pleasure to analyze." — Milton Caniff, 1944

We have spent the previous forty-three chapters stripping this strip down to its very marrow, slicing and dicing each layer to smithereens under our Inquisitor's microscope. Now here we are back at post-op with none of the stitches showing.

Though it may be hard to believe, so help us God, we think it's still alive.

Ernie Bushmiller was a great cartoonist. Great not only *because* of his superb craftsmanship and mastery over the length and breadth of the comics form, but great *despite* that mastery — because there remains a deep poetry at work in *Nancy* that defies the scalpel.

Much has changed in comics reading, comics publishing, and comics discourse during the years since the publication of our original "How to Read *Nancy*" essay, back in the dark pre-digital days of 1988. Comics reading, as a mass cultural practice, may have had a near-death experience, but the rise of the so-called "graphic novel" has seemingly snatched it from oblivion — at least, perhaps, for a

little while. If there are any bookstores left in your vicinity, chances are good that they carry some form of comics. And if you *don't* have any bookstores nearby, publishers are banking on the chance that within a few clicks you can still have access to a reasonable facsimile.

Comics are very much with us today, very much alive and kicking. New avenues of delivery for this intrinsically adaptable medium will undoubtedly be paved and repaved by future technological road crews — but comics will persist. There were lousy comics in 1959, there are lousy comics today, and, needless to say, there will be lousy comics in the future.

But there will be plenty of good ones, too.

And we maintain, for anybody interested in making them, that crucial to achieving that goal is the hard-won language of all the great twentieth-century practitioners, a language exemplified by the clear, unambiguous example of Ernie Bushmiller.

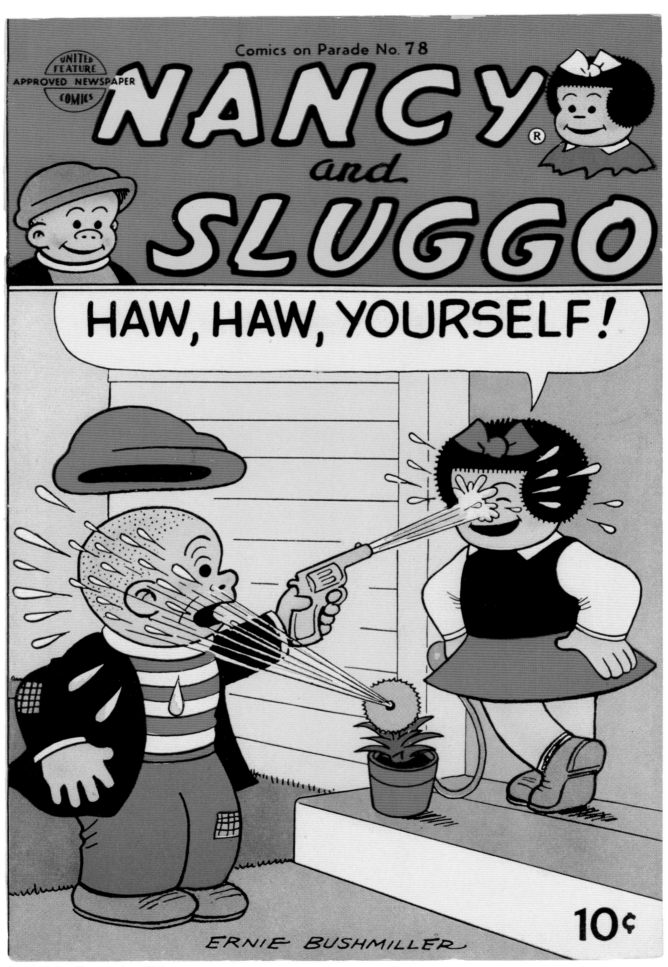

Comic book, United Feature Syndicate, 1951.

APPENDICES

Appendix 1: Inspiration

"GET THE IDEA?" — Nancy, June 20, 1950

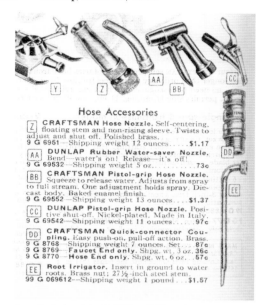
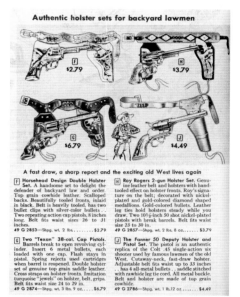

Sears, Roebuck and Co., Fall/Winter 1958 catalog.

In pursuit of his gag muse, Ernie Bushmiller routinely consulted the oracle of Sears, Roebuck and Co. of Chicago and was rarely disappointed. Its 1958 catalog for fall and winter (traditionally shipped in late summer) weighed in at over fifteen hundred pages of potential *Nancy* gags and included a separate index entry for dozens of pages of "WESTERN GOODS" — from "belts, boys'" to "suspenders, children's."

Appendix 2: Further Contexts

"LOOK - - - THE LAST PANEL OF THIS COMIC STRIP IS PRINTED UPSIDE DOWN BY MISTAKE" — Nancy, August 29, 1947

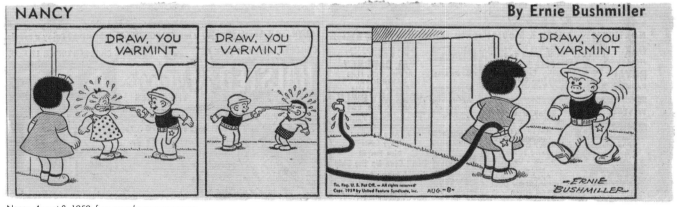

Nancy, August 8, 1959, from an unknown newspaper.

Compared to the images presented throughout this book, this version of the strip may look a little different. But it is essentially what most readers on August 8, 1959, saw when they scanned the comics page that morning. The drab, sour hue of cheap newsprint is a far cry from the crisp white paper that you hold in your hands. Made from coarse wood pulp (the entire log, bark and all, is utilized in its manufacture), newsprint absorbs printer's ink like a thirsty sponge and the results stand in dramatic contrast to the printer's ink that forms the letters of this sentence, which sits upon the surface of the slick coated stock so handsomely.

The strip above is neither quite black nor white (as the photostat camera saw Bushmiller's Higgins ink lines on fresh three-ply Strathmore) but a combination of gray newsprint (soon cream, then yellow, now dun), imperfect ink coverage, and lurking phantom grays — the visual artifacts of the soaked-in mystery images on the reverse side of the thin newsprint sheet. Paper itself is evocative, and the varieties and grades used in the printing trade can

affect the reader's preconceptions, the reading itself, and the memory of that reading as well. Printed newsprint, in particular, carries a distinctive tactility and unique scent and, when especially well inked, may not completely dry for many years.

Typical mid-twentieth-century newspaper technology may have produced a daily record that was dependably legible, but never one that was particularly definitive when it came to reproducing photos of NASA space monkeys, ads for the brand-new Bic ballpoint pen — or comic strips. Nor was it ever expected to be. Yesterday's newspaper has been synonymous with today's toilet paper since the invention of the daily press. In comparison, twenty-first-century technology delivers imagery that is so pixel-accurate that it is not to be believed. So don't believe it. In full disclosure, even the version of the strip presented in this book has been compromised. With the whereabouts of the original artwork for August 8, 1959's *Nancy* currently unknown and no extant proof sheet available, we began our production work with the best available source material: a 1960 paperback reprint on a paper grade only slightly better than newsprint (see illustration oppposite).

Even so, Bushmiller's lines had considerably thickened; some had vanished and others assumed the crunchy surface of the newsprint itself. Dots in the Ben-Day patterns had either swollen or shrunk. The indicia, date, and artist's signature (which had all been excised by the book's publisher) were grafted from the example above.

Weeks of painstaking pixel manipulation resulted in the restoration used in the preceding chapters. The unavoidable irony of crafting an appreciation of craftsmanship around a recrafted specimen (a fact not lost on the authors) leads one to ask if such a thing as a definitive version of any published comic strip can ever truly exist.

As mentioned, differences in paper stock, ink, printing quality, and innumerable other variables conspire to ensure that each reproduction of a daily comic strip is inherently unique. In addition, the specifics of the strip's *context* (editorial policy and layout practices of a given publication) can alter the reading of the work dramatically.

Some daily newspapers scattered their comic strips throughout their pages like raisins in a bowl of oatmeal. Others, like this example, segregated them onto a dedicated page (in this case the penultimate page of the day, sharing space with local ads and "Negro News"). Both editorial strategies had their adherents, and both have continued to the present. In 1959, United Feature Syndicate was servicing approximately 640-odd daily and Sunday newspapers with *Nancy*. Major venues included the *New York Post*, the *Los Angeles Mirror-News*, the *Chicago Sun-Times*, and the Philadelphia *Bulletin*. This obscure eight-page daily, "South Georgia's Most Complete Newspaper," was one of the many small-town venues where *Nancy* was probably obtained for a few dollars a week and remained a familiar fixture for many years.

Situated just above the page's fold in the upper stem of its T-formation of three-column thrills, *Nancy* was neither prominently featured nor completely buried; rather, it was just one more feature of the day to be consumed or ignored depending on which of Thomasville's 18,239 citizens this page reached. There is no official hierarchy of syndicated strips on a newspaper page (although the newest as well as the most popular are typically placed strategically) and each editor (one E.J. Jerger in this case) is free to present them in his own customary manner.

According to layout authority Edmund C. Arnold in his *Modern Newspaper Design* (1969), "Placement of comic strips has no measurable effect on their popularity. Some editors prefer to alternate dark strips (those with large masses of black, such as *Rex Morgan, M.D.* or *Buz Sawyer*) with light ones (such as *Peanuts* or *Andy Capp*). Some say that this makes it easier to control ink on the presses, but most admit that they do it only because it pleases their own eye." Certainly, on Mr. Jerger's comics page the strips appear to have been arranged in no systematic order that is discernible to these readers a half century later.

As an example of what can potentially go wrong in the presentation of a daily comic strip on a printed page, the *Thomasville Times-Enterprise* for August 8, 1959, stands as a virtual encyclopedia of small disasters. Strip titles were insensitively slapped onto (or directly into) the strips, vertically as well as horizontally, at the episode's start (or finish). Panel borders were randomly sliced and diced. The only thing on this page preventing *Dick Tracy* and *The Phantom* from morphing directly into *Blondie* and *Beetle Bailey* is a ninety-nine-cent car wash ad. The strikingly poor printing eradicates several entire titles, and although *Nancy*, with severed hose and obliterated panel lines, fares worse than many of her page mates, it is well worth noting that this still does not prevent the eye from being drawn to the strip (nor from the gag being quickly communicated).

Scientists David Hubel and Torsten Wiesel were awarded the 1981 Nobel Prize in physiology for their work in visual sensory processing, which uncovered a hierarchical sequence in the transmission of visual information in cats (but presumably applicable to humans as well). Their findings distinguish vision itself as true information processing, not simply direct transmission to the brain's processing centers. The number of neural transmitters in the eye is far greater than the optic nerve can accommodate simultaneously, so a hierarchy of information is created (with VIPs at the front of the line and the riffraff at the end). Part of their findings (in very general terms) asserts that one of the immediate tasks of the retina is to register *contrast* — which it does with shocking accuracy, sensitivity, and speed. Thus the eye itself can make a sort of snap judgment to help determine if what it is seeing is friend or foe (or comic strip).

On a large (17 x 22-inch) and noisy page abounding with so many competing parcels of dense visual information (the chiaroscuro of *The Phantom*, Craftint faux halftones of *Buz Sawyer*, and spidery lines of *Judd Saxon*), *Nancy*'s simple contrasting shapes, ample negative space, and bold linework does indeed command the reader's eye. (Although in the final analysis it is, in this case, clearly no match for that special on stewing hens at Jitney-Jungle.)

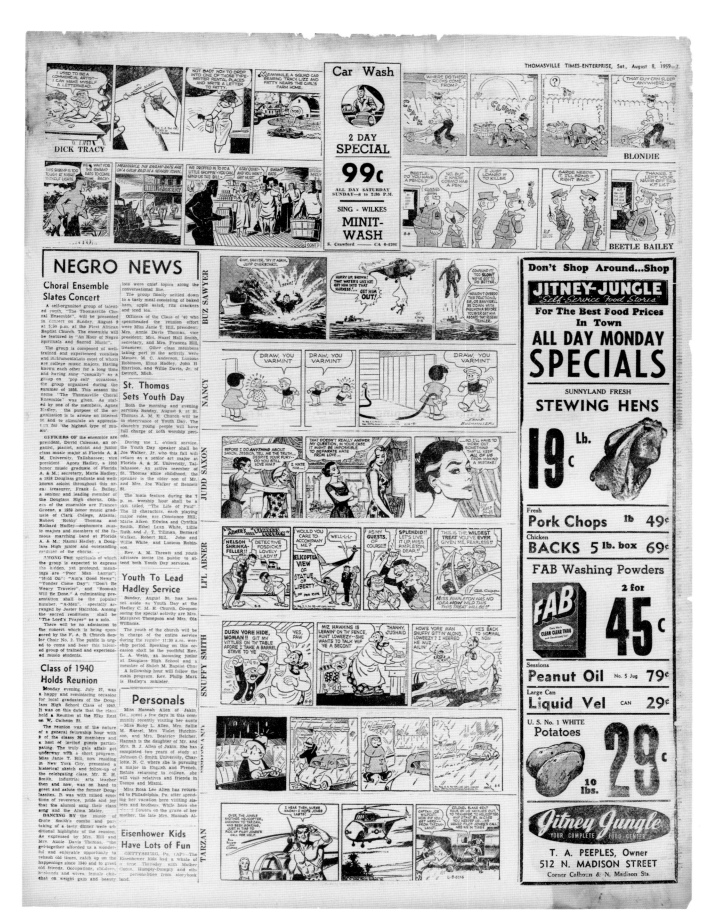

NEGRO NEWS

Choral Ensemble Slates Concert

A self-organized group of talented youth, "The Thomasville Choral Ensemble," will be presented in concert on Sunday, August 9 at 5:30 p.m. at the First African Baptist Church. The ensemble will be featured in "An Hour of Negro Spirituals and Sacred Music".

The group is composed of well-trained and experienced vocalists and instrumentalists most of whom are college music majors. Having known each other for a long time and having sung "casually" as a group on "pop call" occasions, the group organized during the summer of 1958. This season the name "The Thomasville Choral Ensemble" was given. As stated by one of the members, Agnes Eadley, the purpose of the organization is to arouse an interest in and to stimulate an appreciation for 'the highest type of music'

OFFICERS of the ensemble are president, David Coleman, an organist, pianist, soloist and junior class music major at Florida A. & M. University, Tallahassee; vice president Agnes Hadley, a 1999 honor music graduate of Florida A. & M.; secretary, Marie Hadley, a 1958 Douglass graduate and well-known soloist throughout this area; treasurer, Frank L. Bailey, a senior and leading member of the Douglass High chorus. Others of the ensemble are Frances Greene, a 1959 honor music graduate of Clark College, Atlanta; Robert "Bobby" Thomas and Richard Hadley—sophomore music majors and members of the famous marching band at Florida A. & M.; Naomi Hadley, a Douglass High junior and outstanding member of the chorus.

AMONG THE spirituals which the group is expected to express the hidden, yet profound, meanings are "Poor Man Lazrus"; "Hold On"; "Ain'a Good News"; "Yonder Came Day"; "Don't Be Weary Traveler", and "Boon-ah Will Be Done." A culminating presentation shall be the popular number, "A-Men", specially arranged by Jester Hairston. Among the sacred renditions shall be "The Lord's Prayer" as a solo.

There will be no admission to the concert which is being sponsored by the F. A. B. Church Senior Choir No. 2. The public is urged to come and hear this talented group of trained and experienced music students.

Class of 1940 Holds Reunion

Monday evening, July 27, was a happy and reminiscing occasion for local graduates of the Douglass High School Class of 1940. It was on this date that the class held a Reunion at the Elks Rest on W. Calhoun St.

The reunion was of the nature of a general fellowship hour with 9 of the class 39 members and a host of invited guests participating. The truly gala affair got underway with a short program. Miss Janie T. Hill, now residing in New York City, presented a historical sketch and follow-up of the celebrating class, Mr. E. H. Smith, industrial arts teacher then and now, was on hand to greet and salute the former Douglassites. It was with mixed emotions of reverence, pride and joy that the alumni sang their class song and the Alma Mater.

DANCING BY the music of Gene Smith's combo and partaking of a tasty dinner were additional highlights of the reunion. As expressed by Mrs. Hill and Mrs. Annie Davis Thomas, the get-together afforded us a wonderful and enjoyable opportunity to rehash old times, catch up on the happenings since 1940 and to greet old friends. Occupations, children, husbands and wives, female chitchat on weight gain and beauty

loss were chief topics along the conversational line.

The group finally settled down to a tasty meal consisting of baked ham, apple salad, ritz crackers and iced tea.

Officers of the Class of '40 who spearheaded the reunion effort were Miss Janie T. Hill, president; Mrs. Annie Davis Thomas, vice president; Mrs. Hazel Hall Smith, secretary, and Mrs. Frances Hill, treasurer. Other class members taking part in the activity were Messrs. M. C. Anderson, Lucious Robinson, Elmo Hadley, John B Harrison, and Willie Davis, Jr. of Detroit, Mich.

St. Thomas Sets Youth Day

Both the morning and evening services Sunday, August 9, at St. Thomas A. M. E. Church will be in observance of Youth Day. The church's young people will have full charge of both worship periods.

During the 1. o'clock service, the Youth Day speaker shall be Joe Walker, Jr. who this fall will return as a senior art major at Florida A & M. University, Tallahassee. An active member of St. Thomas since childhood, the speaker is the older son of Mr. and Mrs. Joe Walker of Bennett St.

The main feature during the 7 p. m. worship hour shall be a skit titled, "The Life of Paul" The 12 characters, each playing major roles, are Constance Hill, Marie Aiken. Edwina and Cynthia Smith, Ethel Lean White, Lillie Ruth and J. T. Tillman, Bernard Walker, Robert Hill, John and Willie White, and Lucious Robinson.

Rev. A. M. Threatt and youth advisers invite the public to attend both Youth Day services.

Youth To Lead Hadley Service

Sunday, August 30, has been set aside as Youth Day at the Hadley C. M. E. Church. Co-sponsoring the special activity are Mrs. Margaret Thompson and Mrs. Ola Williams.

The youth of the church will be in charge of the entire service during the regular 11:30 a.m. worship period. Speaking on this occasion shall be the youthful Rev. L. A. Webb, as incoming junior at Douglass High School and a member of Shiloh M. Baptist Chur

A fellowship hour will follow the main program. Rev. Philip Mark is Hadley's minister.

Personals

Miss Hannah Allen of Jakin Ga., spent a few days in this community recently visiting her aunts —Miss Ruby L. Allen, Mrs. Sallie M. Russel, Mrs. Violet Hutchinson, and Mrs. Beatrice Belcher. Hannah is the daughter of Mr. and Mrs. B. J. Allen of Jakin. She has completed two years of study at Johnson C. Smith University, Charlotte, N. C. where she is pursuing a major in English and French. Before returning to college, she will visit relatives and friends in Tampa and Miami.

Miss Rosa Lee Allen has returned to Philadelphia, Pa. after spending her vacation here visiting sisters and brothers. While here she placed flowers on the grave of her mother, the late Mrs. Hannah Al

Eisenhower Kids Have Lots of Fun

GETTYSBURG, Pa. (AP)—The Eisenhower kids had a whale of a time Thursday with Mother Goose, Humpty-Dumpty and other personalities from storybook land.

The comics page for the Thomasville (Georgia) Times-Enterprise, August 8, 1959.

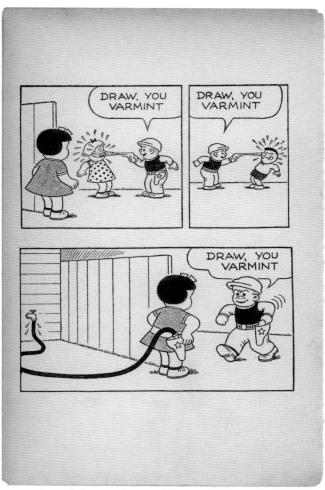

Cover, The Fun-Filled Cartoon Adventures of Nancy, *Pocket Books*, 1960.

Page 88, The Fun-Filled Cartoon Adventures of Nancy.

Books were a profitable part of *Nancy*'s afterlife from the 1930s onward. As a secondary character, she was initially included in the ten-cent comic book reprints of her early appearances in *Fritzi Ritz*, followed by slots in such United Feature anthology titles as *Comics on Parade, Tip Top,* and *Sparkler*. *Nancy* began her own long-running title in 1949, which continued for upward of 192 issues. In the ensuing years the strip was also adapted to a wide variety of other formats: from Big Little Books to children's pop-up books to "deluxe limited editions" to the volume you are presently reading.

The above right page, from a cheaply produced 1960 paperback reprint of *Nancy* dailies, attempts to thwart its standardized (and ill-suited) format by stacking the daily strip's panels in two even rows, creating two awkward bands of dead space in the bargain. Other paperback reprints (including the long-running *Peanuts* series) typically indulged in a more elaborate reformatting of daily strips, often eliminating the panel borders completely, resulting in a more airy and design-conscious page (which nonetheless completely sabotaged the cartoonist's original intentions).

Nancy's integrity here fares a bit better. A number of newspapers of the period ran multipanel strips (including *Nancy*) in a square "boxed" formation, similar to this paperback page (see *St. Louis Post-Dispatch* opposite, top right). Being culturally trained to read everything in order

— first from left to right and then from top to bottom — we do not question where to go after leaving panel 2. When creating a full page of comics (or a multiple-page story), the intended tracking of the page as a unit is (ideally) a primary compositional concern for the cartoonist.

Here the gag is still delivered, albeit haltingly, as the pause between panels two and three is necessarily extended and shifted, creating a momentary visual hiccup en route to the snapper. Although this sort of reformatting was never the norm, it was common enough that Bushmiller and his peers always needed to keep that eventuality in mind and conscientiously composed their strips with a panel break at dead center.

The Fun-Filled Cartoon Adventures of Nancy was no continuous narrative but a series of seemingly random dailies culled from the years 1958, 1959, and 1960. However, with all clues to their episodic nature obliterated (title, indicia, date, signature), this collection, it can be argued, was unintentionally encouraged to be read straight through as a kind of absurdist pseudo-narrative, built page by page on the nonstop miracles that constitute the lives of Nancy and her cohorts (even the earlier Big Little Book reprints parceled the gags out into discretely labeled "chapters"). Interestingly, comedian Jerry Lewis's directorial debut in *The Bell Boy*, released the same year, delivered a similar (though vastly more intentional) structure of episodic, gag-driven narrative to the contemporary

feature-length Hollywood film.

Here is an example of the unorthodox practice of a newspaper running its daily comics page (in addition to its Sunday section) in color. While that is common today, the *St. Louis Post-Dispatch* was decades ahead of this particular curve, inaugurating the practice in the early 1950s. The strips there were printed in three colors (the customary black plus two additional color plates) and showcased on the back page of their "Everyday Magazine" supplement.

While Bushmiller was probably well aware that his strips were being chromatically enhanced in St. Louis, it was still an anomaly and the "colorization" job was left up to the *Post-Dispatch*'s art department. For his Sunday strips, however, Bushmiller made regular accommodations, in the drawing itself (Sluggo's ubiquitous turtleneck sweater was striped on weekdays but always a solid primary color on the Sunday pages) as well as by always specifying gag-crucial color information to the engravers at American Color (it's ketchup in that bottle, folks — not soy sauce!).

Within so many contexts and with so many degrees of separation from the original drawing that this strip has been subjected to, Bushmiller's sturdiness as a communicator remains. The gag still works.

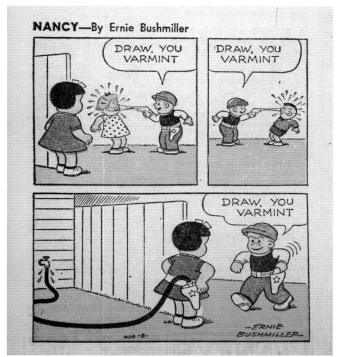

Nancy, St. Louis Post-Dispatch, *August 8, 1959.*

Appendix 3: Single-Panel Gag

"I DON'T BELIEVE IN THOSE THINGS" — Sluggo, November 21, 1966

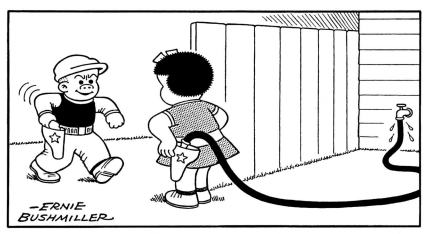

"Draw, you varmint."

Panel 3 of the August 8, 1959, strip reimagined by the authors as a single-panel gag cartoon.

Aside from his *Judge* magazine juvenilia of 1923 (see pages 37, 56–57), Ernie Bushmiller rarely — if ever — worked in the once ubiquitous (dialogue-captioned single-image) "gag cartoon" format we now most often associate with *The New Yorker,* one of its last standing venues. Though *Nancy's* gestalt often originated with a striking single image, gag cartoons operate on an entirely different system of image/text juxtaposition than comics do, and isolated panels rarely function as well as the above example. The unresolved narrative here is key to its success.

Certain fans, however, seem to prefer their *Nancy* panels singular and have often seen fit to liberate selected components of Bushmiller's strips to their own ironic ends.

Whether they are intended to fuel hipster parlor games or Tumblr feeds, there is something about the individual panels of this strip that seem to scream out "Liberate me!" — especially to those who may be blind to the functional beauty of *Nancy's* panel-to-panel transitions. While the results can be diverting, it is worth noting that these decontextualized panels usually command attention precisely for their inherent "otherness." Rarely extraneous and never modular, Bushmiller's panels were so rigorously tooled as precision parts of their greater engine that when disassembled from their intended sequence they can often seem particularly curious.

Appendix 4: "Too Many Words"

"Being a cartoonist is like having a bear by the tail; you can never let go." — Ernie Bushmiller, 1959

Peanuts *by Charles M. Schulz, March 8, 1962.*

As suggested by Linus's commentary above, Charles M. Schulz, creator of *Peanuts*, may have been in attendance at the particular National Cartoonists Society gathering where Ernie Bushmiller called for an industry-wide reduction in comic strip chatter. And if so, Bushmiller's speech may have been motivated with this particular visitor in mind. Of course, *Peanuts'* singular dialogue was key to its enormous success. Schulz was more than casually acquainted with Bushmiller's work as well and had in fact taught it while employed as an instructor at Art Instruction, Inc., in Minneapolis, where Ernie had contributed his "The Gag Strip" essay to the curriculum in 1949.

As early as 1950, just as Schulz was launching his strip, the two cartoonists had begun a sporadic correspondence with an effusive Schulz thanking Ernie for a Christmas card ("Being one of the lesser ones of United Features [sic] I sometimes have the feeling that no one knows I exist") and expressing hope to one day meet Ernie and "get a few working tips."

At this time *Nancy* was undoubtedly among United Feature's most widely syndicated strips, while *Peanuts* premiered that fall in only seven minor newspapers. However,

by 1962 the *Peanuts* star was well on its rapid rise, one that would soon eclipse *Nancy* (and every other comic strip of its era). In 1955 Schulz was named Outstanding Cartoonist of the Year by the National Cartoonists Society (where, ironically, he had been denied membership only a few years before — and long before Ernie, a co-founder of the group, or *Nancy* was ever recognized). *Peanuts* hit the 1,000-newspapers mark toward the end of the 1960s, becoming a global phenomenon.

Bushmiller, however, had grown critical of *Peanuts*, believing the strip had become overtly preachy, and he took Schulz for "a religious fanatic." For his part, Schulz felt *Nancy* was old-fashioned and lacked subtlety — and he had let the United Feature editors know it very early in their association. The two strips were in many ways the products of two completely different generations, approaches, and personalities — but formally, as comic strips, they probably shared more than differed. In both cases *Nancy* and *Peanuts* were the life's work of a conscious and committed kid strip creator, aiming at the same reader's eye while working opposite sides of the gutter.

Appendix 5: Enter Sluggo

"Sluggo was my answer to Nancy's need for a foil and I had to name him something. I picked Sluggo because he's a tough mug." — Ernie Bushmiller, 1974

Sluggo's heroic debut: Fritzi Ritz, *January 24, 1938.*

Some twentieth-century comic strip characters (any member of Dick Tracy's Rogues Gallery, for example) were deliberately introduced gradually over a successive series of episodes allowing the reader to participate in their day-to-day development. Most (like Krazy Kat, Snoopy, and Nancy herself) moved up the ranks over an extended period of time and inched their way into the limelight. But a select few (Superman, Popeye, and Mr. O'Malley included) appeared relatively fully formed from the onset, spontaneously combusting upon the printed page.

Panel 1: *Nancy is being assaulted.*
Panel 2: *Sluggo materializes to defend her with whirligig fists and a "BOP."*

Sometime, somehow, between those two panels, the jaws of fate snapped open and deposited Sluggo right where he needed to be, changing the outcome of January 24, 1938 — and the remainder of the strip's history.

Panel 3: *"Continued - - -"*

Appendix 6: "Hey! Where Have I Seen That Gag Before?"

"I'M LIVING IN THE PAST" — Nancy, September 21, 1970

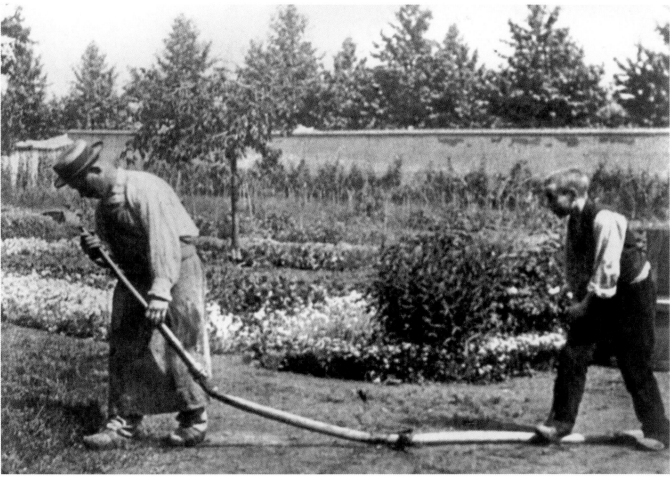

Louis Lumière, frame from L'Arroseur Arrosé, *1895.*

For as long as there have been kids and hoses there have jokes about kids and hoses. Trickster characters have been staple heroes for storytellers through the ages, and the so-called "mischief gag" was one of visual humor's seminal genres (and one that squirts on to the present day). Consider the fact that the garden hose was first being mass-produced around the same time as the earliest mass culture, and you have a match made in slapstick heaven.

In American popular culture of the early twentieth century, this particular meme carries an imposing pedigree and can ostensibly be traced back to the international success of Frenchman Louis Lumière's 1895 film *L'Arroseur Arrosé*, a forty-nine-second sight gag involving a kid, a hose, and a wet victim that has been celebrated as the earliest known instance of film comedy, as well as the first film to present a staged fictional story of any kind.

In the film, a gardener dressed in straw hat, apron, and clogs is presented on the left side of the frame sprinkling a lawn with a long hose before the backdrop of a small formal garden. A boy of about eleven, in long pants and a black vest, enters from the right side of the frame trodding on the length of the hose, then pausing in a coiled pose as he deliberately blocks the content's flow. The gardener

curiously examines the nozzle as a few final spurts of water escape.

Meanwhile the boy readjusts his stance and the gardener receives an unexpected faceful of water as his hat flies in the air. The boy runs into the distance, and as he arcs toward the left, the gardener follows suit and drags him back, first by the ear, then the arm, bending him closer to the static camera as he spanks him nearly a dozen times. The boy somewhat uncertainly exits from whence he came, briefly gazing into the camera's lens as the gardener resumes his sprinkling. *The End.*

Lumière always claimed that the short was a reenactment of an actual prank played by his younger brother Edouard on the family gardener, François Clerc (who also plays the part in the film). And maybe it was. Yet research by a number of intrepid film and comics scholars (including Donald Crafton, Yves Frémion, Lance Rickman, George Sadoul, and Antoine Sausverd) has demonstrated that the basic scenario for *L'Arroseur Arrosé* was an already hoary gag of the comic and children's periodicals of the era. But whichever Lumière brother, young or old, saw the concept and appropriated it first was irrelevant. The gag worked.

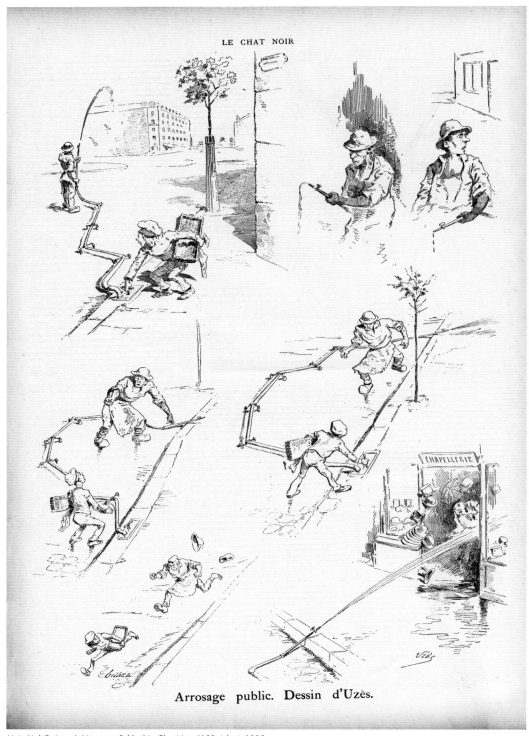

Arrosage public. Dessin d'Uzès.

Uzès (Achille Lemot), "Arrosage Public," Le Chat Noir #182, July 4, 1885.

The hose gag's first known public appearance seems to have been in the pages of *Le Chat Noir* a full ten years before the Lumières doused their first gardener.

Presented as *"Arrosage Public"* by the cartoonist Uzès, the hose in question here was that of an urban municipal watering system. More important, gag-wise, in this larval manifestation it is not yet the sprinkler (*L'Arroseur*) who gets sprinkled (*Arrosé*) but an unsuspecting *chapeau* vendor instead.

Le Chat Noir, which opened in 1881, was the first true cabaret in Paris, and an instant hit with the creative avant-garde of that metropolis. A humorous journal soon followed, published by the cabaret and also called *Le Chat Noir*. Contributors included the hugely influential graphic artist Théophile Steinlen (designer of the venue's iconic posters) and such comics pioneers as Caran d'Ache and Gustave Verbeek. *Le Chat Noir* was considered one of the hippest publications of its day and was widely read by the smart set of La Belle Époque (and, presumably, by a generation of aspiring humorists). Any gag dropped in its pages was poised to ripple.

(Sharp eyes will note the contradictory signature "Gillot" at the lower left. Charles Gillot, according to comics scholar Thierry Smolderen, was the inventor of a now obscure photomechanical process known as the Gillotage in 1870. He signed the line drawings printed with his process himself as if he were the engraver.)

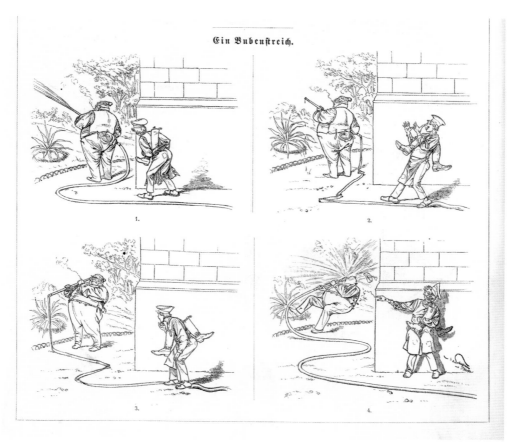

Ein Bubenstreich.

Hans Schließmann, "Ein Bubenstreich," Fliegende Blätter #2142, August 15, 1886.

This was followed within a year by a German rendition *"Ein Bubenstreich"* by Hans Schließmann in *Fliegende Blätter* (August 15, 1886) — perhaps the first pure "Sprinkler Sprinkled." Every step of this gag is telegraphed to the reader with a pile driver as a skinny, goofy-looking prankster is paired (for neither the first time in the history of humor, nor the last) with a tubby, pompous-looking fall guy.

A Spanish journal called *Madrid Cómico* published our next example on August 28, 1886. *"Una Picardia"* was the work of Cilla, a pseudonym of Francisco Ramón Cilla y Pérez. Look familiar? Hans Schließmann's version had been published only thirteen days earlier.

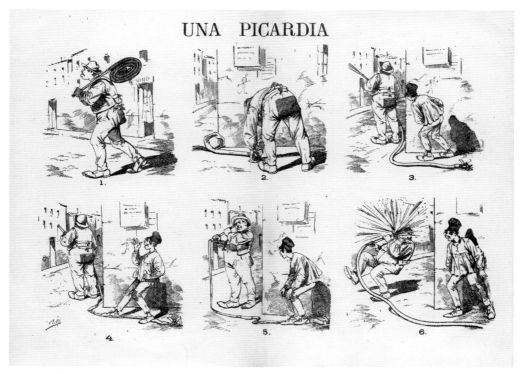

UNA PICARDIA

Cilla (Francisco Ramón Cilla y Pérez), "Una Picardia," Madrid Cómico, August 28, 1886.

L'ARROSEUR

IMPRIMERIE-LIBRAIRIE QUANTIN
7, rue Saint-Benoît, Paris.

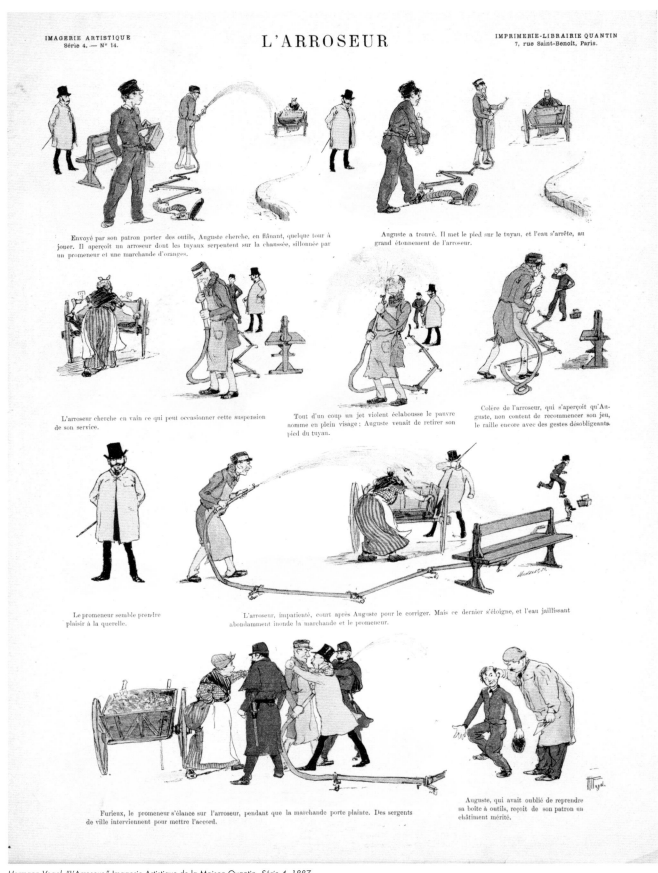

Envoyé par son patron porter des outils, Auguste cherche, en flânant, quelque tour à jouer. Il aperçoit un arroseur dont les tuyaux serpentent sur la chaussée, sillonnée par un promeneur et une marchande d'oranges.

Auguste a trouvé. Il met le pied sur le tuyau, et l'eau s'arrête, au grand étonnement de l'arroseur.

L'arroseur cherche en vain ce qui peut occasionner cette suspension de son service.

Tout d'un coup un jet violent éclabousse le pauvre homme en plein visage ; Auguste venait de retirer son pied du tuyau.

Colère de l'arroseur, qui s'aperçoit qu'Auguste, non content de recommencer son jeu, le raille encore avec des gestes désobligeants.

Le promeneur semble prendre plaisir à la querelle.

L'arroseur, impatienté, court après Auguste pour le corriger. Mais ce dernier s'éloigne, et l'eau jaillissant abondamment inonde la marchande et le promeneur.

Furieux, le promeneur s'élance sur l'arroseur, pendant que la marchande porte plainte. Des sergents de ville interviennent pour mettre l'accord.

Auguste, qui avait oublié de reprendre sa boîte à outils, reçoit de son patron un châtiment mérité.

Hermann Vogel, "L'Arroseur," Imagerie Artistique de la Maison Quantin, Série 4, 1887.

The gag resurfaced in France again the next year, this time as a picture-story print for children by Hermann Vogel (*Imagerie Artistique de la Maison Quantin*, 1887), complete with an explanatory text and moralizing conclusion in which both sprinkler and bystanders are sprinkled and the trickster is nabbed. Perhaps confusing at first glance, the shift in the depicted point of view brings the reader closer to the pivotal actions.

FAIT DIVERS, — par A. SOREL

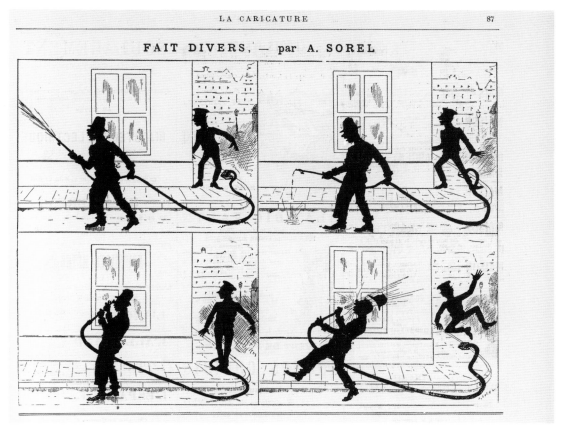

Sorel, "Fait Divers," La Caricature, March 12, 1887.

Next up, Sorel, who took his shot in silhouette in the more adult-oriented pages of *La Caricature* (March 12, 1887). Although depicted from a wholly different point of view, smart money would bet that Sorel saw Schließmann's version with its similar panel-to-panel staging.

God bless Gibey, who somehow managed to sell the very same gag with the very same name to the very same publication only a year or so later (June 2, 1888), perhaps by adding a bit of a socialist plot twist in which the aristocrat is hoist by his own petard.

FAIT-DIVERS, — par GIBEY

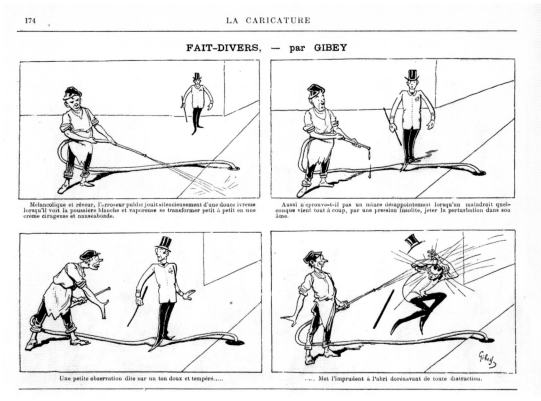

Gibey, "Fait-Divers," La Caricature, June 2, 1888.

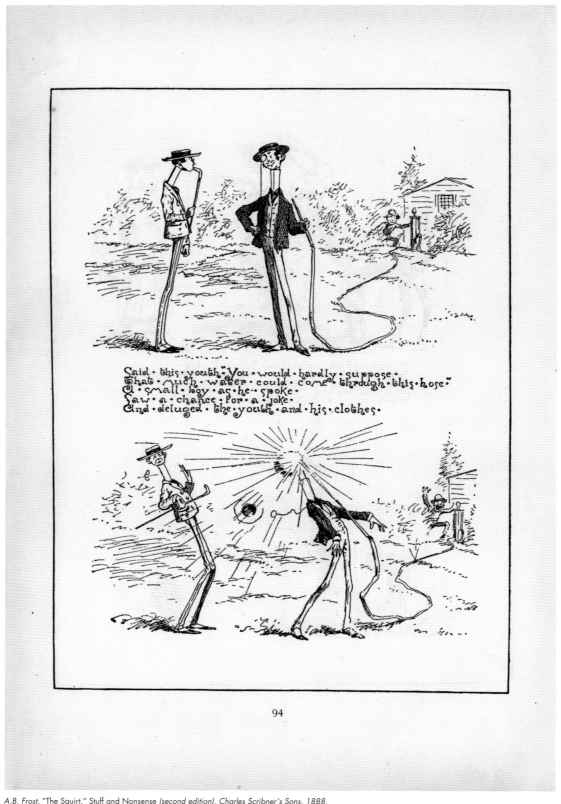

Said · this · youth · "You · would · hardly · suppose ·
That · much · water · could · come · through · this · hose."
A · small · boy · as · he · spoke ·
Saw · a · chance · for · a · joke ·
And · deluged · the · youth · and · his · clothes ·

94

A.B. Frost, "The Squirt," Stuff and Nonsense (second edition), Charles Scribner's Sons, 1888.

With "The Squirt," the illustrious American illustrator and cartoonist A.B. Frost tossed his formidable hat into the international hose gag ring.

This was one of several newly created pages that Frost added to the 1888 reprinting of his highly successful 1884 anthology, *Stuff and Nonsense*. The volume comprised extended wordless comic episodes punctuated by short illustrated limerick verses (such as "The Squirt") reportedly composed by Frost's brother, Charles.

Frost, who had illustrated virtually every important writer of his era from Twain to Dickens, and whose masterful sequential cartoons of the 1880s place him as a true godfather to the newspaper comic strip, had studied under painter Thomas Eakins during the period when that painter began to experiment with photographic motion studies — something of a wet dream for twenty-first-century interdisciplinary media scholars.

Histoire sans paroles. — Un Arroseur public

Christophe (Georges Colomb), "Histoire sans Paroles — Un Arroseur Public," Le Petit Français Illustré #23, August 3, 1889.

And then there was Christophe (Georges Colomb), whose version (*Le Petite Français Illustré*, August 3, 1889) has been most often cited as the direct inspiration for the Lumière film. And one can see why. While the differences are significant (the staging occurs in shallow parallel space and the positions of the players are switched left to right), the similarity in gag structure and costume make the correlation ring true.

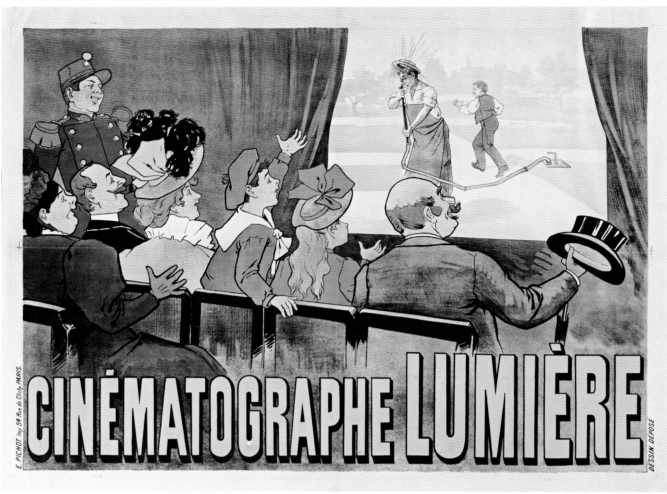

Marcellin Auzolle, "Cinématographe Lumière," E. Pichot, Paris, c. 1896.

In 1895 Louis Lumière filmed this gag in one continuous shot and (with his brother and business partner, Auguste) publicly premiered it on December 28, 1895, at Salon Indien du Grand Café in Paris, along with nine other brief subjects. Several direct imitations of this already imitative gag were quickly produced by competing pioneer filmmakers — as well as at least one direct imitation (the first remake?) by the Lumières themselves in 1896 in which the prankster does not get spanked as punishment but, more appropriately, sprayed.

From the outset of studio production, the motion picture, like toothpaste, chocolate, and bottled vermouth, was seen as yet another middle-class consumer product requiring repeated visual exposure to a vast sea of middle-class consumers with a few extra francs and a little extra time. (Among other ostensible "firsts," this is considered the first poster to advertise a film exhibition in which admission was charged.) Marcellin Auzolle (who had previously created posters for toothpaste, chocolate, and bottled vermouth) crafted this image for the Parisian lithographer E. Pichot as he had for scores of other clients: a bold and brightly colored scene, easily read at a distance and amusing enough to rate another glance.

The earliest movie posters were designed to advertise and promote the novel spectacle of the projected moving image itself, rather than a particular film or program.

Although this 1896 example omits the title, it was one of the earliest posters to feature the content of a specific motion picture, thus setting the tone for the future of a genre. Like so many alluring posters to follow, it presents an idealized image that does not directly correspond to a single specific moment in the film itself.

In both Lumière versions of *L'Arroseur Arrosé*, the trickster does not flee until after the gardener has been hosed. Yet for maximum visual effect this poster rearranges and condenses elements from the narrative's actual mise en scène into a single potent image that tells the tale (the essence of the illustrator's craft).

Not only does this poster rearrange time, it also reconfigures space. While the 1896 version of the film includes a diagonal path at the left of the frame, the deeply articulated perspective of the garden lanes in this poster resembles neither the Lumières' 1895 nor their 1896 version, nor any of the earlier comic strips.

As in the *Nancy* of August 8, 1959, we are presented with a surrogate to the scene of the crime looking further and deeper on our behalf while signaling the next move.

The message of this poster is clear. No difference if you are old, young, man, woman, soldier, or high-hat: If you come to Cinématographe Lumière you will look into a window on another world—and laff your fool head off.

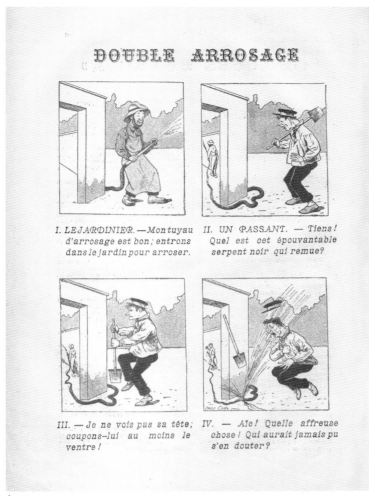

Émile Cohl, "Double Arrosage," Le Noël: Journal des Enfants #6, May 14, 1896.

By the time Émile Cohl took his turn at the hose gag for *Le Noël* in 1896, he had been drawing comics for over twenty years, largely for satirical magazines in France. He had also participated in several noteworthy bohemian artistic circles that celebrated the absurd (while ridiculing ruling class pomposity and bourgeois complacency) and had even been thrown in jail for an offensive political caricature.

While other cartoonists in other forums played this gag for social satire, *Le Noël* was basically a children's magazine, and here Cohl plays it safe, as he plays to his audience. He Who Gets Sprayed, in this case, is not a businessman, a store owner, or an aristocrat, or even a prankster, but just an anonymous "passerby" who happens to own a shovel and dislike snakes.

I. THE GARDENER. — My hose is good; let's go water the garden.
II. A PASSERBY. — Look here! What is this frightening black snake that moves?
III. — I don't see its head; let's cut it in the stomach, at least.
IV. — Oh dear! What a dreadful thing! Who could have ever suspected?

In addition to his long career as a cartoonist, Émile Cohl had seemingly been everything else as well, including a journalist, an inventor, a costume designer, a duelist, a puppeteer, a magazine publisher, a wood carver, a philatelist, a puzzle maker, an illustrator, a playwright, a toy designer, and a portrait photographer. Yet he would be largely forgotten today were it not for the work he created in the second half of his professional life.

Movies had become a viable business in the years just prior to the turn of the twentieth century. The Lumière brothers had premiered their first version of the hose gag only months earlier, yet its newfound currency did nothing to deter freelance cartoonists like Cohl with pages to fill and mouths to feed.

There are several versions of the story of how Cohl entered the film industry himself in 1906, but the one he liked to tell was that it transpired after he spotted a movie poster on the streets of Paris that had "obviously" stolen a gag from one of his strips (involving an enormous screw and an irate neighbor).

Cohl marched right into the offending Gaumont studio ready to read them the riot act, but hit it off with the boss instead and was hired on the spot as a scenarist. The cartoonist worked his way up through their primordial special effects department, swiftly became a director, and made an everlasting mark in the medium. Clocking in at two minutes, his 1908 *Fantasmagorie* is generally considered the first fully animated hand-drawn cartoon, and Émile Cohl the father of animation.

UN TUYAU BOUCHÉ

This hose is stopped! What's the matter with it? Der verstopfte Schlauch.

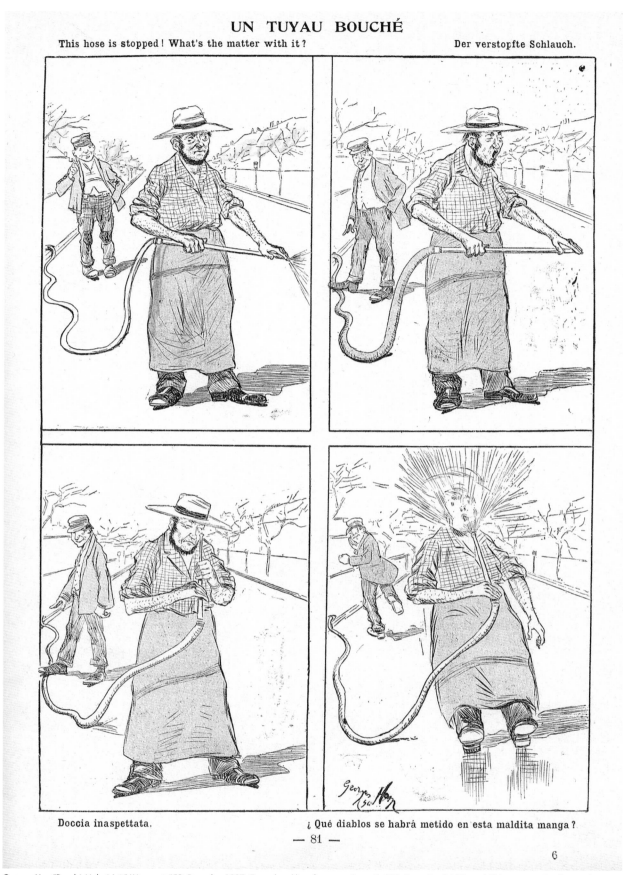

Doccia inaspettata. ¿ Qué diablos se habrá metido en esta maldita manga?

— 81 —

6

Georges Hem, "Douché Malgré Lui," *L'Amusant #52, December 1897. (Reproduced here from a reprint entitled "Un Tuyau Bouché," Recueil d'Histoires sans Paroles pour la Conversation et la Rédaction en Toutes Langues, Librairie Vanblotaque, 1904.)*

In 1987, after nearly a score of previous hose gag comic strips (appearing in half as many countries) and the Lumières' resounding international success, along came Georges Hem, who presented it to the readers of *L'Amusant* as though it had never existed.

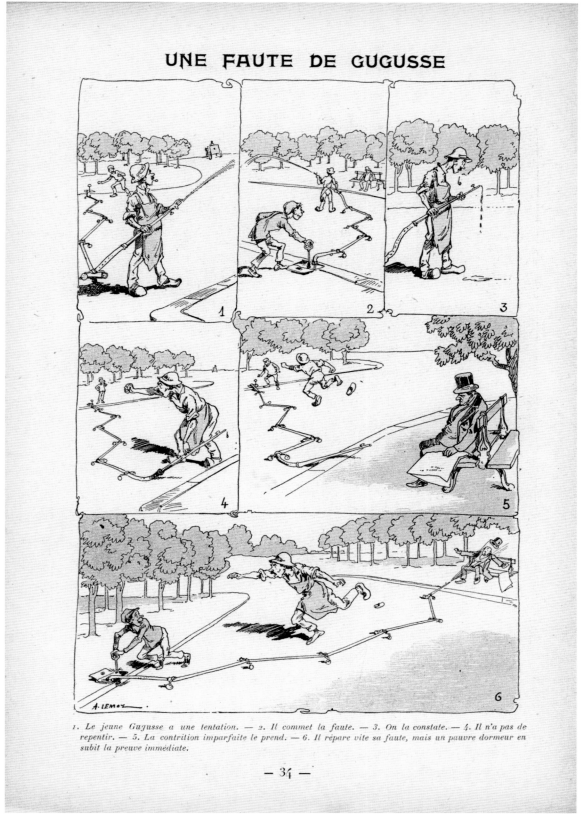

UNE FAUTE DE GUGUSSE

1. Le jeune Gugusse a une tentation. — 2. Il commet la faute. — 3. On la constate. — 4. Il n'a pas de repentir. — 5. La contrition imparfaite le prend. — 6. Il répare vite sa faute, mais un pauvre dormeur en subit la preuve immédiate.

— 34 —

Uzès (Achille Lemot), "Une Faute de Gugusse," Album Noël, 1900.

Not to be outdone, Uzès redrew his original concept all over again in 1900, this time proudly signing it "A. Lemot." Why he chose to sign his real name in this case is unknown, as is why he used the pseudonym Uzès in the first place, as he did not live in or come from the town of Uzès. This page ran in the 1900 edition of *Album Noël*, perhaps as a reprint.

"Une Faute de Gugusse" roughly translates as "The Misdeed of Gugusse." In the French circus, Gugusse is a standard name for one of the traditional clown characters (*"le clown Auguste,"* often called Gugusse by his fellow buffoons). In France *"faire le gugusse"* is still a common way of saying that someone is doing foolish things.

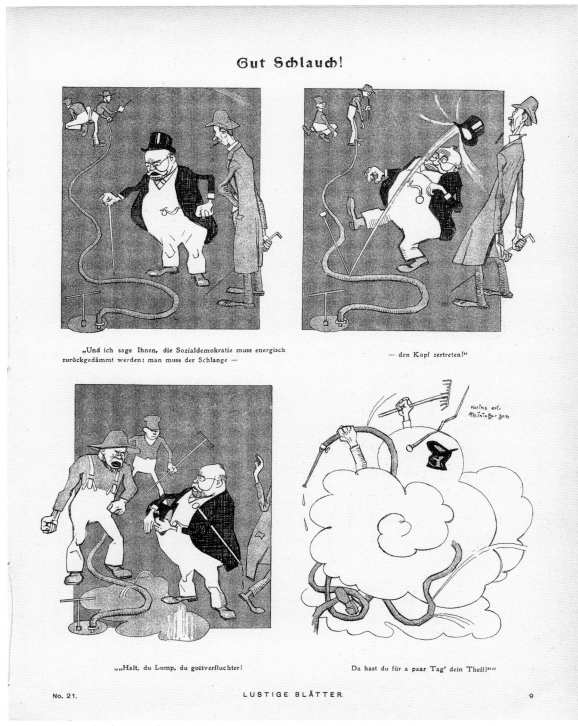

Lionel Feininger, "Gut Schlauch!," Lustige Blätter #21, May 24,1900.

The gag migrated back to Germany, where it was last seen in 1886. The German-American Lyonel Feininger is better known today by art historians as an important Expressionist painter, but he is equally well known by comics historians as the creator of two ethereal Sunday strips, *The Kin-der-Kids* and *Wee Willie Winkie's World*. He got into the hose act in the Berlin-based humor magazine *Lustige Blätter*, in 1900.

Title: *Good Hose!*
Panel 1: *"And I tell you Social Democracy
must be nipped in the bud. You have to seize
the serpent—"*
Panel 2: *"—and you crush its head!"*

Panel 3: *"Stop that, you goddamned rascal!"*
Panel 4: *"I'll show you!"*

Again, the social schism is the real subject, with the bourgeois political scientist undone by his own metaphor and inevitably pummeled by the working class.

The unusual signature, as decoded by comics scholar Eckart Sackmann, reveals that Hans Horina was the "author" of this already crotchety gag ("erf" is short for *erfunden*, meaning "created"), and that Feininger drew it ("gez" is short for *gezeichnet*, which means "drawn").

Both Horina and Feininger were part of a group of elite German cartoonists recruited by the *Chicago Tribune* in 1906 to give their Sunday funnies an international sheen.

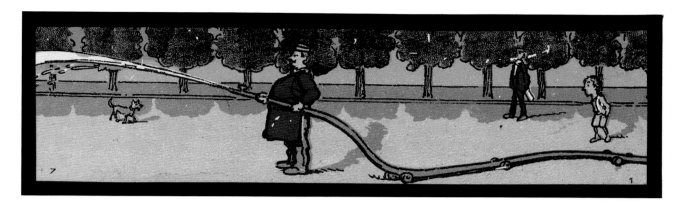

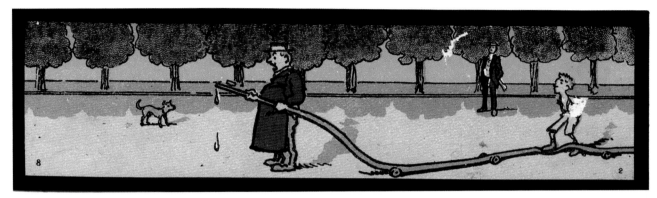

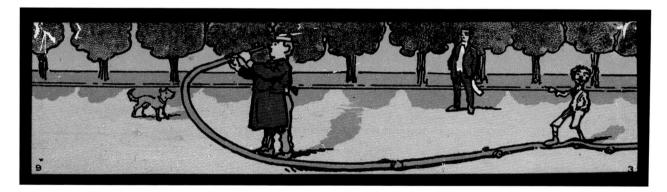

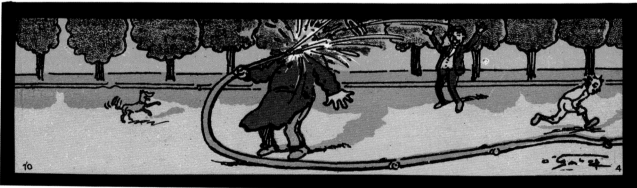

O'Galop (Marius Rossillon), glass slides, 1900.

During this period, O'Galop, a.k.a. Marius Rossillon (an early French animator, illustrator, and creator of the immortal Michelin Man), adapted the gag to yet another medium — a set of children's glass magic lantern slides. (Lantern historians note that Hans Schließmann's 1886 *"Ein Bubenstreich"* [page 169] had already been pirated by slide makers Bamforth & Co. of Holmfirth, Yorkshire, England, shortly after publication.)

Further examples regularly dotted the pages of European comic magazines well into the next century. These included Ymer in *La Semaine de Suzette* in 1905, and Pierre Falké in *American Illustré* in 1907. It even showed up as a hand-colored *Imagerie d'Épinal* juvenile broadsheet (#4014, for you collectors) by Augé as late as 1920.

LE TREMPEUR TREMPÉ

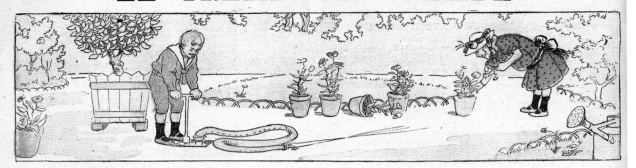

Malgré la défense de sa maman, Guy, profitant de l'absence du jardinier, joue avec la lance d'arrosage.

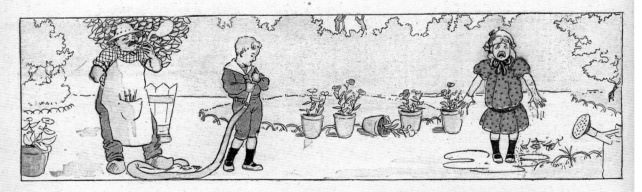

Avisant sa sœur Simone, le méchant espiègle l'inonde de son jet d'eau. Mais le jardinier qui revient, voulant mettre fin à cette douche...

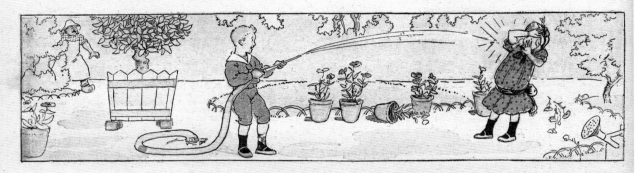

... pose son pied sur le tuyau. Guy, surpris, examine la lance, voulant voir d'où provient cet arrêt. Mais, à ce moment...

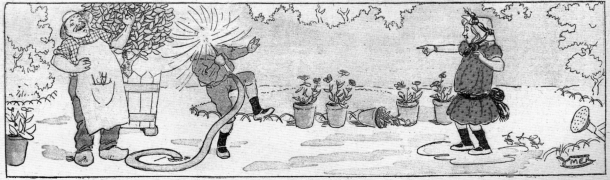

...le jardinier, qui veut lui donner une leçon, ôte son pied de dessus le tuyau. Guy, à son tour, se trouve douché d'importance. Avouez qu'il ne l'a pas volé !

YMER.

Sceaux. — Imprimerie CHARAIRE.

Le Directeur-Gérant : HENRI GAUTIER.

Ymer, "Le Tempeur Trempé," La Semaine du Suzette, *September 28, 1905.*

UN BON TOUR, par Pierre FALKÉ

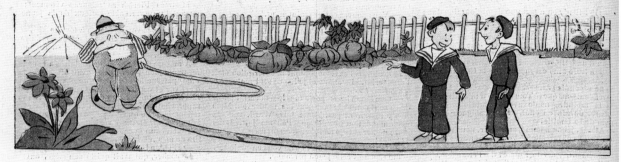

1. — Tiens on va monter sur le tuyau pour voir ce que ça fait.

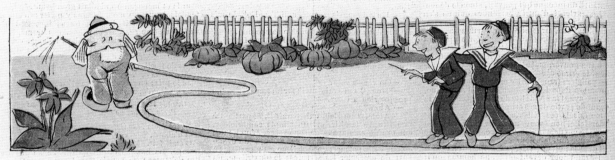

2. — Ça coule déjà moins fort !

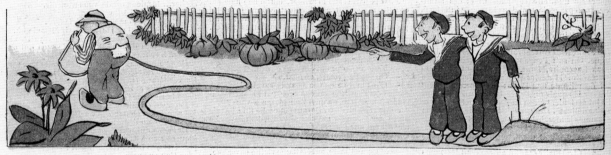

3. — Ça ne coule plus du tout !

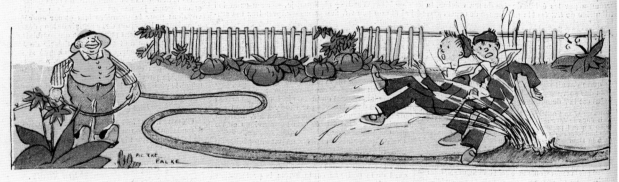

4. — Cette fois-ci c'est un peu trop fort !!!

Pierre Falké, "Un Bon Tour," American Illustré, September 28, 1907.

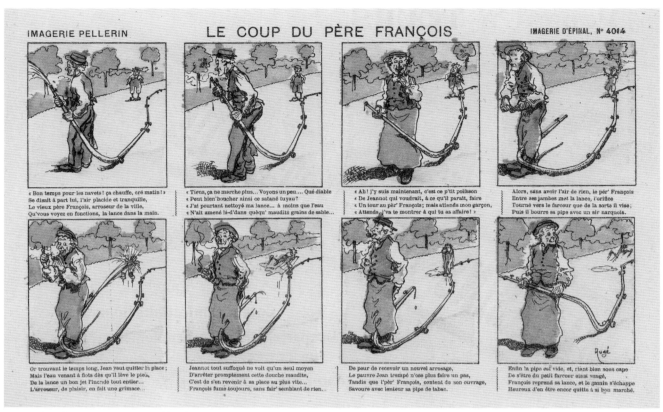

Augé, "Le Coup du Père François", Imagerie d'Épinal #4014, 1920.

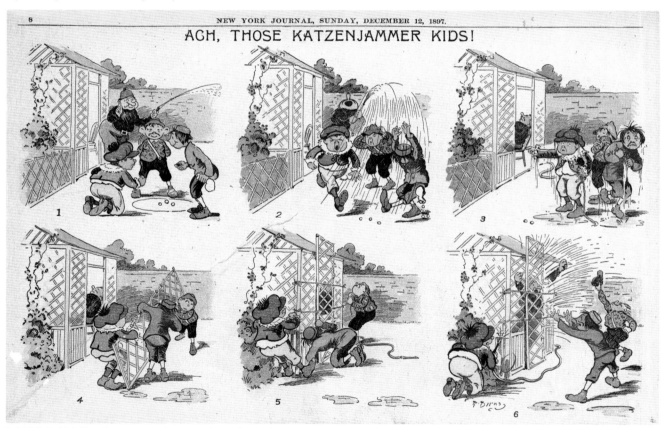

Rudolph Dirks, "Ach, Those Katzenjammer Kids!," New York Journal, December 12, 1897.

As the hose gag continued to spray over Europe, back on this side of the Atlantic, in New York City (where, in 1896, the Lumière brothers opened a theater to exhibit their invention), the gag was introduced as the very first *Katzenjammer Kids* prank. The initial episode (Sunday, December 12, 1897), which was drawn by the twenty-year-old Rudolph Dirks for William Randolph Hearst's *New York Journal*, featured characters "inspired" by yet another European property: Wilhelm Busch's *Max and Moritz* of 1865.

If a hose gag in the pages of *Le Chat Noir* (a publication that catered to Parisian bohemians) caused a ripple in 1885, then a hose gag in the funny pages of the *New York Journal* in 1897 would cause a tidal wave.

It is impossible to exaggerate Hearst's impact on twentieth-century popular culture. The *New York Journal*'s focus on the sensationalized coverage of crime, war, and corruption kept it on top of the circulation charts. In addition to furnishing the template for "yellow journalism," its groundbreaking Sunday color comics section made this newspaper one of the most influential on earth.

Rudolph Dirks later became a mentor of Ernie Bushmiller during his early New York *World* years and, as the story goes, once passed his old drawing board along to the young cartoonist (at which Bushmiller may have — conceivably — drawn the subject of this study several decades later).

This single (and no doubt incomplete) thread provides a nutshell history of the emerging mass culture of the late nineteenth and twentieth centuries. Bushmiller's life's work was carried out in the field of mass culture and, like most of its contributors (especially in the area of humor), he understood the value of working in novel ways with familiar material. As did his audience. It was common practice for every branch of twentieth-century popular entertainment to regularly recycle specific ideas, general concepts, and ritualistic approaches — as well as to import them from other branches.

As Anthony Balducci notes in his *The Funny Parts: A History of Film Comedy Routines and Gags* (2012), "Many of these gags and routines survive to present day due to one plain fact: a good routine is indestructible. It can be transferred, altered, rearranged, extended and updated, but it can never be wiped out." For strip cartoonists who were working against a daily deadline, the very precepts of repetition and variation were hardwired into the gestalt of the emerging medium as a creative strategy — as well as a practical necessity. (If Ignatz Mouse had hit Krazy Kat on the head with a brick just that once, would anybody remember today?)

Therefore, it is hardly surprising that certain themes, settings, situations, and objects appear repeatedly in the *Nancy* universe. What is more remarkable is the sheer durability of some of Bushmiller's gags themselves. Bushmiller dearly understood the value of a good gag (and what it took to bring it to the page), and his decades of *Nancy* are rife with examples of repetitions, recycles, and riffs.

As mentioned, Bushmiller got a lot of gag mileage in *Nancy* out of certain regularly recurring props, including hoses, fences, and water guns. The following Sunday strips are by no means a complete inventory but rather a representative survey of variations on these themes. Hoses, fences, and water guns apparently spun around like Lotto balls inside Bushmiller's noggin, dropping out of the chute in an unpredictable but reliable new sequence time and again.

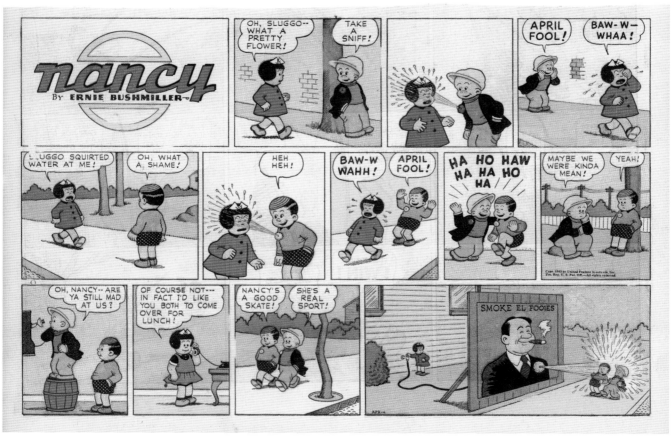

Nancy, Sunday, April 4, 1943.

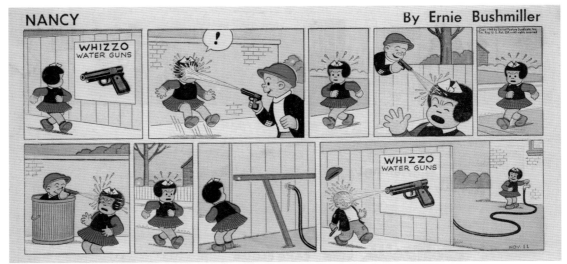

Nancy, *Sunday, November 11, 1945.*

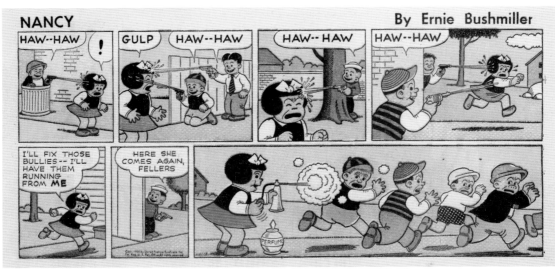

Nancy, *Sunday, May 14, 1950.*

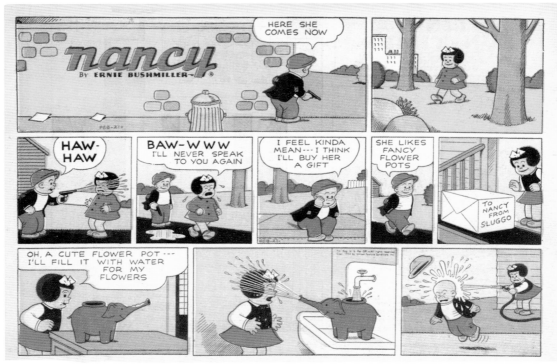

Nancy, *Sunday, February 21, 1954.*

Like a seasoned jazz musician improvising on an old standard, Bushmiller would often revisit a beloved gag and reinterpret it anew. However, throughout his career, there were times when, in deadline desperation, the cartoonist was known to reach into his archive of published originals and renovate an elderly strip with some white-out and a few deft strokes in the hope that his readers might not detect an old chestnut with a fresh facelift. More often, surefire gags were dusted off and redrawn from scratch (usually by assistants in the last years of Bushmiller's life).

Both of these practices were frowned upon by the executives of United Feature Syndicate. "One of my first jobs was to stop it," Bobbie Miller, Bushmiller's editor from 1978 until his death, confessed. "What were we paying for? We weren't paying for reruns!" It has been intimated that one editorial voice at the syndicate contemptuously referred to these practices as "smuggling in Mexicans under the border" — and singled out Bushmiller's gags as the chief wetbacks!

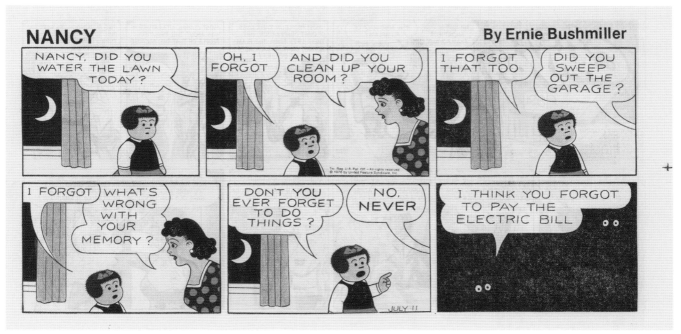

Nancy, *Sunday, July 11, 1976.*

This "blackout" gag, which saw distinguished service in *Nancy* throughout the decades (and appeared as late as Sunday July 11, 1976), can trace its Bushmiller lineage to a *Fritzi Ritz* daily of April 24, 1930 (and before that, who knows?). The same gag by the same cartoonist in the same newspaper that might have tickled a child of the Depression was still being served up to her grandchildren at the dawn of the punk rock era. Roy Doty, a cartoonist and Stamford, Connecticut, resident, once observed of his colleague and neighbor: "As the world became sharper and sharper and strips became more complicated and clever . . . Ernie never left Ernie."

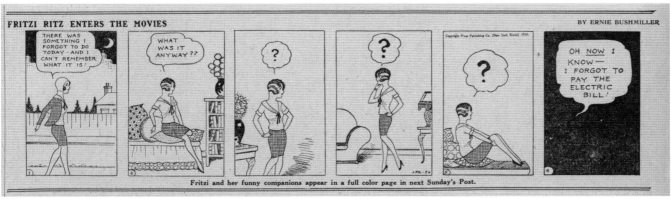

Fritzi Ritz, *April 24, 1930.*

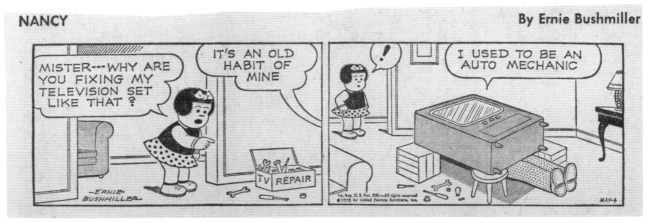

Nancy, May 4, 1970.

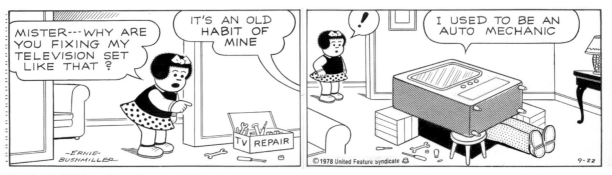

Nancy, September 22, 1978 (original artwork).

Here is a true "Smuggled Mexican" that appeared only eight years after its original (?) appearance. The differences between the 1970 version (shown above in its printed form) and its 1978 descendent (shown here as original artwork) are minor but telling. The crude but effective application of white paint masks the original date and indicia. Cruder, and less effective, is the casually slapped-down replacement indicia for 1978. Shading film was removed from both the face of the TV set and the chair in the first panel, which helps streamline the reading. Without the

subtle interference of the dense gray patch in panel 1, the reader's eye reaches Nancy (even more) immediately. But the most meaningful revision was the black shadow now cast under the TV set, which added both weight and graphic power to the payoff. Bushmiller may have been guilty of retooling his old strips in his final years, but the alterations, in this case, were all upgrades.

Although the below renditions of the exact same gag were drawn fifteen years apart, they may appear virtually identical at first glance. Yet closer inspection reveals the

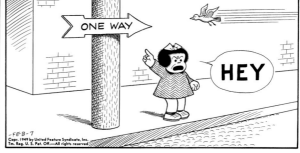

Nancy, February 7, 1949.

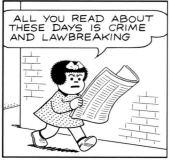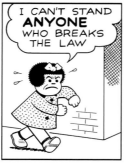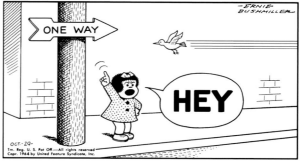

Nancy, October 29, 1964.

considerable refinement of craft Bushmiller achieved in the decade of the 1950s. Leaner, cleaner, bolder, and more carefully composed on every count, the 1964 strip also reframes the original 1949 premise by substituting a more concrete grounding for its absurdist snapper. The addition of today's newspaper in Nancy's hand in panel 1 likewise provides an immediate point of identification for any contemporary reader, rather than relying on chance sympathy for Nancy's uncharacteristic (and completely arbitrary) foul mood.

Nancy's graphic evolution is made explicit in these two strips as well. In the ensuing fifteen years between their creations, she became a squatter, rounder, and more compact Nancy, the so-called "Mussolini model" with a heavier jowl and a lighter stride. Her pose, expression, and line of vision in the final panel are perhaps the most revealing of Bushmiller's fine-tuning here, substituting the original's raw, unmotivated rage with a studied attitude of juvenile, girlish bossiness. Even the scofflaw pigeon has been improved, with an efficient profile substituted for the more awkward three-quarter-head view of the original.

In terms of such concentrated focus, the 1950s and early 1960s were perhaps Bushmiller's peak years on *Nancy*. Age and a series of health crises began to take their toll on the cartoonist as he approached his next decade. By 1976 (when he won the National Cartoonists Society's Reuben award for Best Cartoonist of the Year), Bushmiller was physically unable to make the trip to Manhattan to accept that honor and his own hand was often absent from the strip that carried his name.

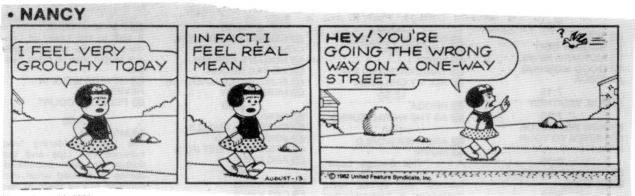

Nancy, August 13, 1982.

Bushmiller's declining physical condition, coupled with a definitive diagnosis of Parkinson's disease in 1979 saw the myriad particulars of any given *Nancy* strip become increasingly dependent upon the decisions of assistants, with an inevitable erosion of standards. This gag saw one last incarnation, which was rendered by Will Johnson (who had worked with Bushmiller for decades) and ran on August 13, 1982, two days before Bushmiller's death from a heart attack at age seventy-six.

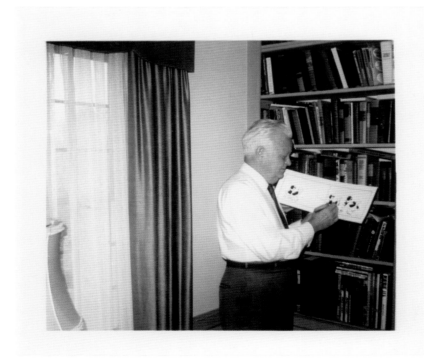

Scrutinizing a daily strip, 1970s.

Appendix 7: Architecture

"NANCY IS GOING VERY HIGH-HAT SINCE SHE HAS HER OWN LITTLE HOUSE" — Fritzi Ritz, August 3, 1944

Ernie Bushmiller, pen-and-ink sketch of 552 Haviland Road, with a studio wing addition, early 1950s.

Ernie Bushmiller, watercolor sketch for a studio wing, early 1950s.

On at least one occasion, Bushmiller did turn his drafting talents toward real-life architecture with curiously revealing results.

On December 15, 1950, the Bushmillers closed on their new digs, located on a quiet stretch of Haviland Road in Stamford, Connecticut, and undoubtedly more spacious than the series of modest Bronx apartments they had left behind. (Morris Weiss, who believed Bushmiller was a somewhat "fearful" man, was told by a mutual friend that the move was precipitated by Ernie's concerns of a nuclear attack on New York City.) This two-story Cape Cod–style dormered house included an enclosed porch from which to gaze upon the expansive yard of mature trees, scattered white rocks, and tall clipped hedges. All that was missing was a studio.

Some suburban Connecticut cartoonists maintained their studios in nearby villages. Others commuted regularly into New York City to work. But Bushmiller, a man who rose "at the crack of noon" and who valued his privacy, his marriage, and his odd working hours, required a studio not far from the bedroom. So he sat down and designed himself an attached studio annex big enough for plenty of bookshelves, a desk, a wingback chair, and numerous drawing boards to line the room.

Interestingly, these two designs appear looser and somehow more freewheeling than any home ever depicted in *Nancy*. One assumes that they were drawn for himself or the builder (or perhaps Mrs. Bushmiller) to see what an added studio might look like — might *feel* like. With their quick, dashed-off strokes and slapped-down ink and color, they give a good sense of the proportion, layout, and ambience of Bushmiller's dream studio. These sketches were not meant to amuse.

This third drawing, a rear view, created for one of Bushmiller's annual illustrated Christmas cards, sets the house (with addition in place) solidly back in the familiar *Nancy* landscape, where clapboards are ruled and bricks are pointed. A world where kids go sledding without their winter coats and dogs are suspended in midair like prancing reindeer and everything seems completely normal. If Bushmiller, the cartoonist, rendered his buildings like blueprints, Bushmiller, the architect, rendered his blueprints like cartoons.

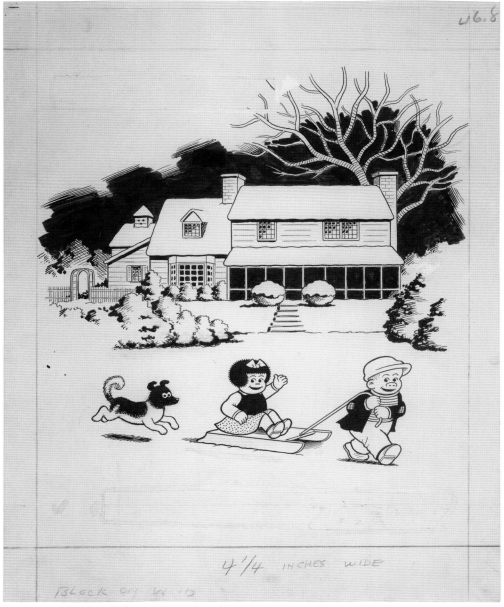

Seasons Greetings from the Bushmillers, 1950s (original artwork).

Appendix 8: *Tableaux Vivants*

"HMMM - - - I SEE YOUR SHOW IS A SUCCESS, NANCY" — Fritzi Ritz, February 1, 1944

Tableau vivant, *1890.*

This striking image might best be described as a rare documentation of a multi-meta *tableau vivant*. It was taken by an unknown photographer in the Dutch East Indies, ostensibly on the occasion of the Netherlands' Queen Wilhelmina's accession to the throne in 1890. At least six *tableau* scenarios are here being presented to the viewer simultaneously, giving an unusually comprehensive snapshot of that medium's methodology and iconography (as well as immediately recalling the work of 1950s *Mad* cartoonist Will Elder in its highly disconnected yet earnestly wrought juxtapositions).

The groupings are in fact almost certainly allegorical, the proud woman with the flag and cardboard lion personifies "freedom" (for the Netherlands), and flanking her are the forces of "law and order" that uphold it; the child, "innocence"; the painter, "art." And for good measure, four distinct types of "love" are thrown into the proceedings as well: "spousal," "familial," "religious," and "charitable." Whether Queen Wilhelmina (who was all of ten years old at the time) would have been able to decode this mixed bag is completely open to conjecture.

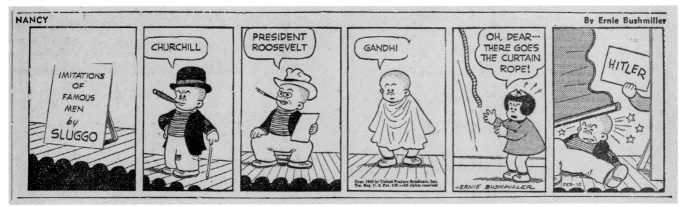

Nancy, February 10, 1944.

Ernie Bushmiller missed Queen Wilhelmina's coronation festivities by fifteen years, but he was certainly aware of *tableaux vivants* as an archaic American vaudeville attraction and parlor game — and no doubt his readers were as well. In a series of early 1944 dailies, Nancy and Sluggo open their own neighborhood vaudeville theater, and within a week Sluggo is enacting his own *tableaux vivants* of contemporary world leaders (in this case ironically dumbed down with explanatory speech balloons to make sure absolutely nothing is lost on his — or Bushmiller's — audience).

Appendix 9: Aunt Fritzi's Other Relatives

"WHY DO YOU PREFER MY LOWBROW COUSIN TO ME?" — Chauncey, February 11, 1939

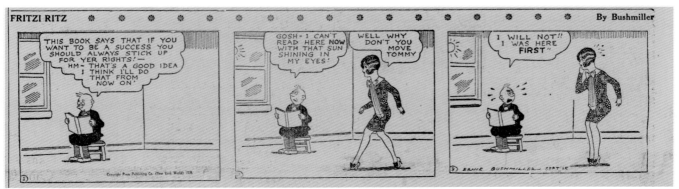

Fritzi Ritz, September 15, 1928.

Mischievous kids were a staple of the comic strip from the start, going back as far as 1922's *Trixie's Tricks* in the Ernie Bushmiller canon. In the years prior to Nancy's debut in January 1933, Bushmiller experimented in *Fritzi Ritz* with a few other sassy young relations to serve as comedy relief for his long-suffering heroine. As Nancy was never originally intended to last longer than any of these exceedingly similar characters, it is instructive to observe exactly what survival traits they lacked in regard to the same audience that took to her so decisively.

The earliest juvenile foil on record is "Tommy," a cheeky office boy at the Star Studio who entered the scene in 1928, if not earlier. Perhaps modeled after ex–office boy Ernie himself, Tommy hung around the strip's periphery in a perpetually surly mood for years, needling Fritzi, her parade of leading men, and Mr. Blobbs, the rotund director. Elements of his simple design were reused in each successive relative, and at least one (the bow) was carried over to Nancy herself.

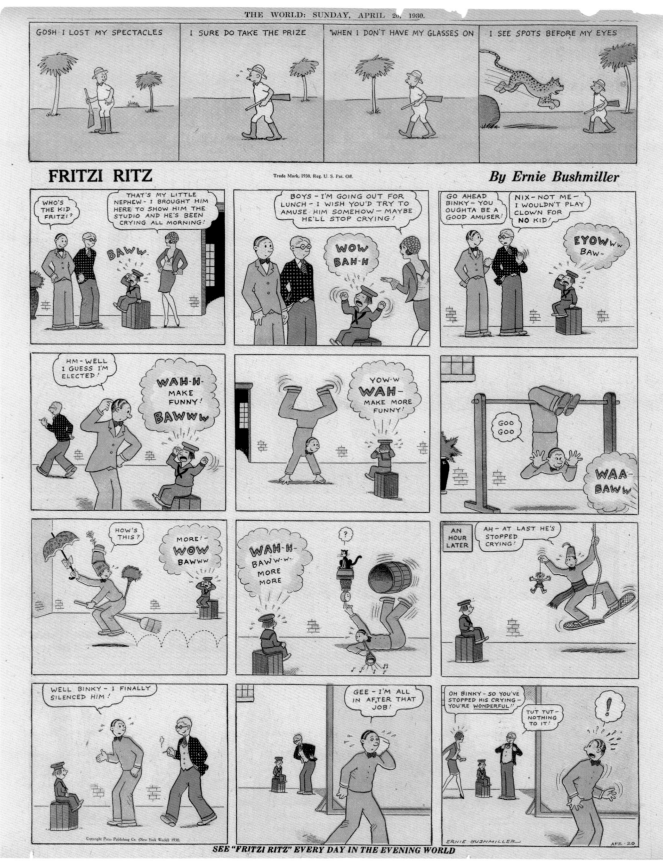

Fritzi Ritz, *Sunday, April 20, 1930.*

The first of Fritzi's extended clan to be given a tryout, this unspecified "nephew" bears more than a passing resemblance to Tommy the office boy. He is depicted here in a small boy's sailor suit and appears closer to Nancy's age at her debut (if not younger) — an all-purpose template of a whining cartoon brat.

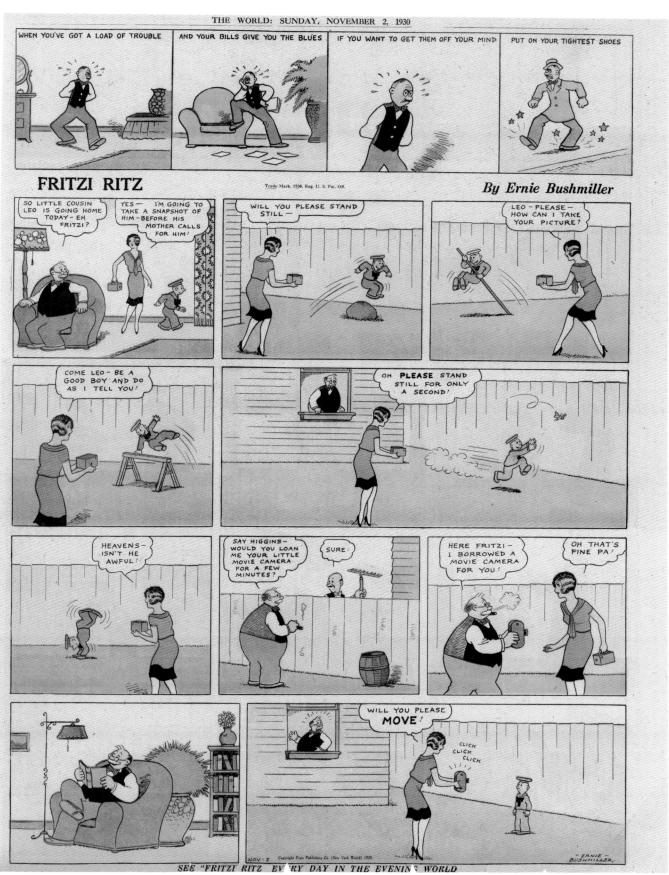

Fritzi Ritz, Sunday, November 2, 1930.

Now shorn of his girlish locks and positively identi-
fied as "Cousin Leo," this youngster reappeared later that
year, both older, wiser, and much more active.

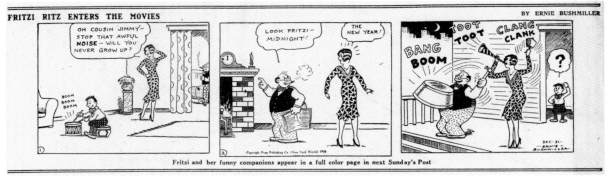

Fritzi Ritz, December 31, 1930.

"Cousin Jimmy" was concocted purely for the sake of a single gag: a kid's-eye witness to the ironic childishness of the adult New Year's revelers. After the stroke of midnight, Cousin Jimmy was never seen nor heard from again.

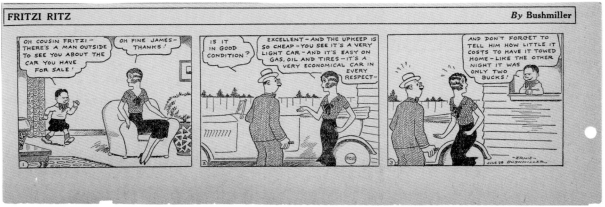

Fritzi Ritz, June 29, 1931.

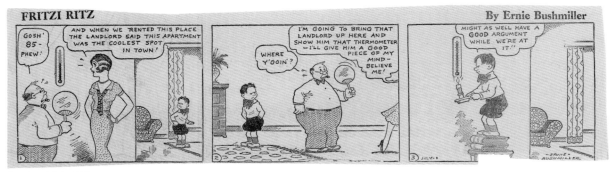

Fritzi Ritz, July 1, 1931.

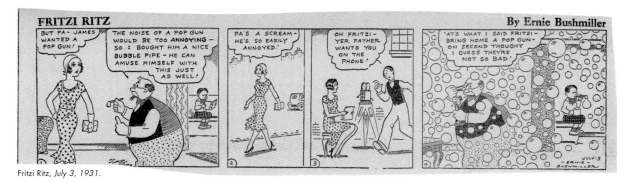

Fritzi Ritz, July 3, 1931.

Over a half-year later, "Cousin James" (whose sour, deadpan face is reminiscent of the then recently retired President Coolidge) showed up. James appeared periodically throughout 1931 and 1932, and although he provided Bushmiller with the kind of new gag opportunities he was seeking, James undoubtedly lacked the vital cuteness quotient that helped his second cousin Nancy gain a rapid public following.

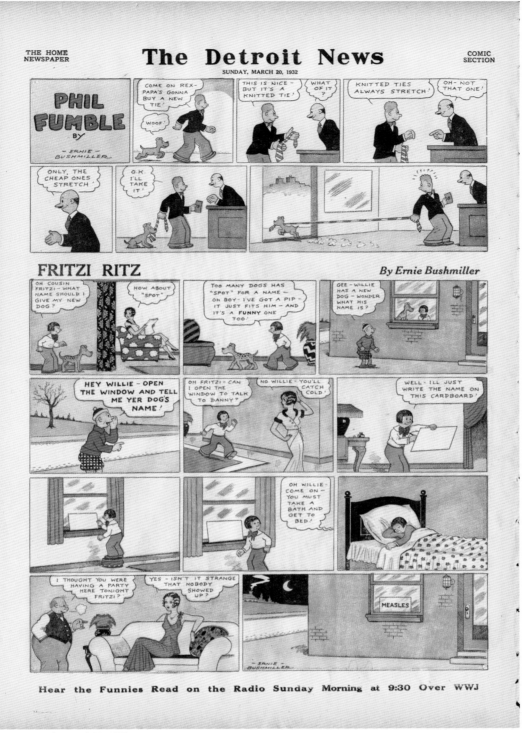

Fritzi Ritz, Sunday, March 20, 1932.

"Cousin Willie," it seems, made only two appearances, in 1932 (January 24 and March 20). His pageboy haircut and feminine design provided a close visual prototype for the earliest version of Nancy, who would enter Fritzi's orbit within a year. It is unknown why his duration was so brief, nor why it was limited only to the strip's Sunday pages. His antics were replaced in the Sunday episodes with the sporadic return of James during that year's summer and fall.

The gags Bushmiller gave these nephews and cousins, though unremarkable, were not very dissimilar to many that would help fuel Nancy for decades. But as Bushmiller suggested in 1949 (in the form of advice to aspiring cartoonists), timing is everything: "Try to create a character

or characters that will be the best vehicle for putting over your type of humor. It may take time and many false starts before you strike one that clicks with an editor. . . . When you finally launch your strip don't be impatient — most of them are slow starters and take time to build up to a hit. A few of course are successful immediately, but most of them run along for several years until some intangible gimmick makes them click. This happened with Popeye." And, as we know, this also happened with Nancy. Bushmiller was always stingy about enlarging his permanent cast, but clearly he felt that there was room in the strip for a fresh kid in Fritzi Ritz. Tommy, Jimmy, James, and Willie's brief auditions set the stage for Nancy's success.

Appendix 10: *Luncheon of the Boating Party*

"I'D LOVE TO KNOW WHY THESE KIDS ARE STARING AT ME" — Sluggo, April 12, 1970

Pierre-Auguste Renoir, Luncheon of the Boating Party, 1880–81, Oil on canvas, 51¼ x 69⅛ in. Acquired 1923, The Phillips Collection, Washington, D.C.

Pierre-Auguste Renoir's *Luncheon of the Boating Party*, set on the banks of the Seine not far from Paris in the suburban town of Chatou, is an excellent example of how lines of vision function in narrative art and is worth a closer look here.

If these lines of vision were traced from one figure to another, a spider's web of overlapping invisible lines would crisscross the enormous canvas (which, by the way, takes up an entire wall at the Phillips Collection in Washington, D.C.).

To the modern eye, this group of revelers may appear to be a homogeneous gathering. Not so. Artists and collectors have broken bread here with actresses, aristocrats, and laborers. While historians have identified almost all of the actual individuals depicted in this painting by name, the subjects were types, likely recognizable by gallery patrons at the time through dress, gesture, or notoriety. The image celebrates the late-nineteenth-century breakdown of a centuries-old social order. Not only does the invisible matrix of lines of vision hold this composition together, but the bold staring and implied flirting also audaciously suggest the newfound fluidity between the social classes in suburban France of the 1880s.

A remarkable aspect of this painting is that with all of these lines of vision ping-ponging around the canvas, almost nobody is actually returning anyone else's gaze (with the exception of the small terrier in the foreground). Ironically the humans here seem only half-aware of one another as their implicit desire for "connection" is inevitably aimed elsewhere across the sunny back porch.

Here, the gaze *is* the story.

Appendix 11: Sunday Strategies

"I WANT THE NECK LOWER — THE SLEEVES LONGER — AND TAKE IT IN HERE — LET IT OUT THERE — LOWER THE WAISTLINE — TAKE IN THE HIPS — SHORTEN THE SKIRT — ETC ETC" — Fritzi Ritz, December 8, 1934

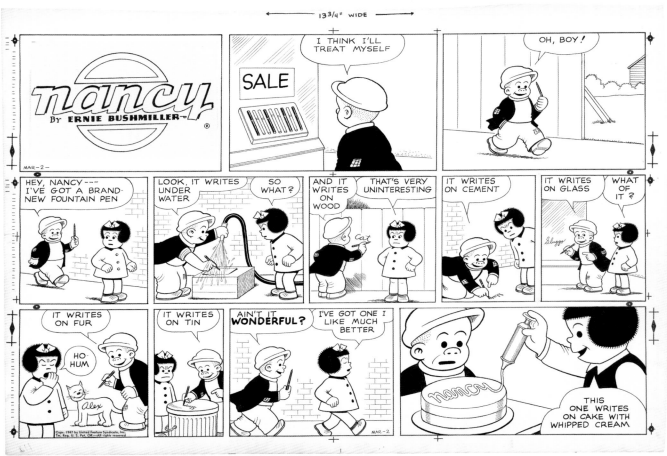

Nancy, Sunday, March 2, 1947 (original artwork).

In addition to producing six one-tier daily strips a week, newspaper strip cartoonists of Bushmiller's era generally had an extended four-color Sunday page to contend with. As wider syndication became crucial to the comics business in the 1930s, this meant devising a standardized Sunday feature that could simultaneously accommodate an increasing variety of newspaper sizes and formats. For Bushmiller this system became codified during the period of *Nancy*'s initial success.

The *Nancy* episode for Sunday, March 2, 1947, illustrates many of the formal challenges faced by the cartoonist. The original artwork was required to be drawn in a stratified three-tier, half-page format, roughly analogous to three daily strips in sheer yardage. Beginning in this era, United Feature Syndicate provided preformatted art boards to its cartoonists (the Sunday pages measured 16⅞ x 24 inches), complete with preprinted lettering guides and registration marks. Panel widths were somewhat flexible, as this example illustrates, but the work still needed to adhere to a rigidly predetermined grid. Thus the strip was required to be able to break into two, three, or four chunks of equal length. Most crucially, the content of the panels in the entire top tier needed to be made deliberately superfluous to the overall narrative.

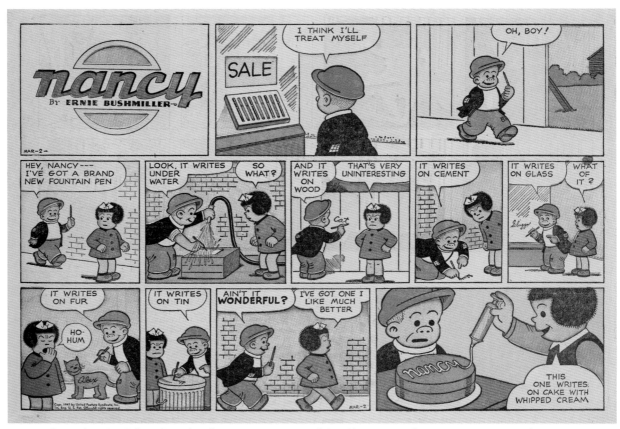

Nancy, Sunday, March 2, 1947, half-page format, the Dallas Morning News. *Courtesy of The Dolph Briscoe Center for American History, University of Texas, Austin.*

Broadsheet-sized newspapers (a 17 x 22-inch page size is typical) ran *Nancy* (with and often without its ancillary Sunday feature *Fritzi Ritz*) in a half-page format just as drawn, with a four-color separation added.

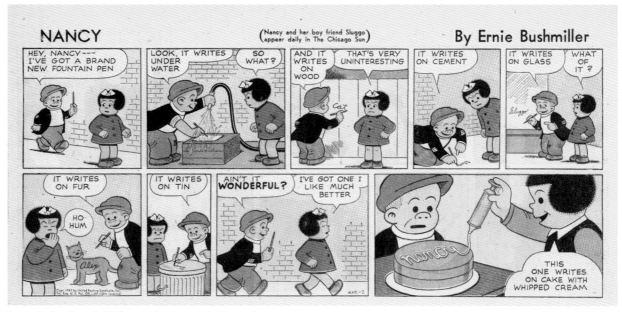

Nancy, Sunday, March, 2, 1947, one-third-page format, the Chicago Sun.

As time passed, however, most markets wanted the main attraction exclusively (in this case shown reduced to a one-third-page format). Notice that the top tier, including its internal logo art (or "headstone"), has now been completely excised. This system freed up space and allowed newspapers to cram their pages with more and more popular comics (and advertisements), keeping them competitive but seriously eroding the luxurious canvas of the full-sized Sunday color newspaper page that cartoonists once had to play with. It was during this period that Bushmiller turned over the secondary *Fritzi Ritz* Sunday feature (now clearly past its prime and appearing in fewer and fewer venues) to the hands of a succession of assistants and ghost artists until its demise in 1967.

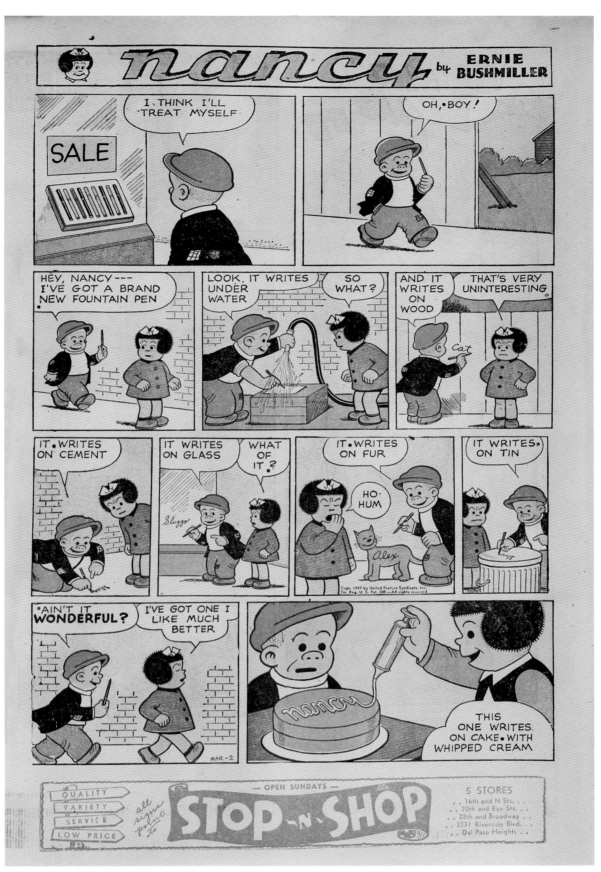

Nancy, *Sunday March, 2, 1947, tabloid format, the* Sacramento Union.

Compact tabloid-sized newspapers (15⅛ x 10⅛ inches in this instance), which first became popular in urban cities in the 1920s (easier to wrangle on the bus or subway), reconfigured the strip's layout entirely, presenting it as a complete single page.

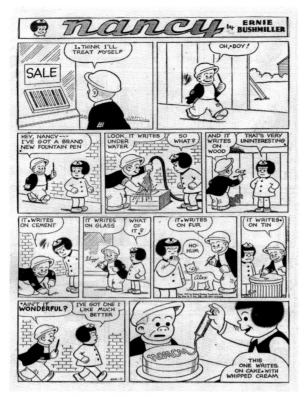

Nancy, *Saturday, March 1, 1947, tabloid format,* The Laredo Times.

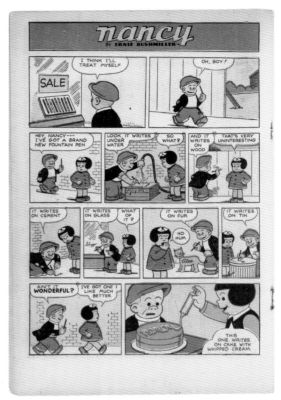

Nancy and Sluggo *#17, Summer 1950, page 19,* United Feature Syndicate, Inc.

In 1947, *The Laredo Times* did not run a Sunday edition. Instead it offered an expanded Saturday edition that was beefed up with the Sunday funnies, sans color. Lucky readers of the paper came to expect a double dose of *Nancy* on Saturdays and got it all in black and white.

These tabloid format pages, in turn, were later reprinted in comic books at an even smaller size (6¾ x 10¼ inches) with additional reformatting (notice the slight cropping of the artwork along the bottom of the first tier here). This comic book page hit the newsstands in the summer 1950 issue of *Nancy and Sluggo,* well over three years after its original newspaper appearance.

And finally, some rogue publications (e.g., the *St. Louis Post-Dispatch*) simply concocted their own oddball formats. In this case the strip was run in a truncated tabloid-like "full-page" format at a greatly reduced two-column size (6 x 9 inches) sharing an actual 14 x 21-inch broadsheet-sized page with *Willie Doodle, Herkimer,* and an ad for Pond's cold cream. The comics department in St. Louis evidently felt no compunction about completely butchering the strip's top tier to accommodate a pasted-in logo. (At this stage in his career Bushmiller would have never overlapped a word balloon across a panel border for no good reason — let alone such a poorly rendered one.) The *Post-Dispatch* production team also recolored the strip themselves, once again badly (the browns on brown are particularly woeful), although Sluggo's weekday shirt stripes mysteriously endure.

Why all this matters to our study is that as good as *Nancy* was, she was generally not at her best on Sundays. While the daily comic strip was Bushmiller's game, here function was forced to follow a particularly convoluted form. The imposition of an expendable first tier seems to fly in the face of the entire Bushmiller aesthetic — analogous to a standup comedian beginning a joke with an opening line that a good deal of his audience will never hear. Additionally, the loss of control over precisely *how* the reader would consume his panels must have proven frustrating to a cartoonist who was so profoundly attuned to the pacing and visual flow of his gags.

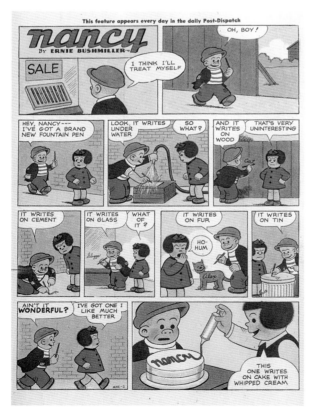

Nancy, *Sunday March 2, 1947,* St. Louis Post-Dispatch.

But even beyond these burdens (which, it must be stressed, were shared by all of Bushmiller's syndicated peers), many *Nancy* Sunday pages (the above example, for instance) still feel protracted, literally meandering their way to the snapper. Consequently, Bushmiller's solution to Sunday installments often read as exercises in comedic list making, often amusing — but rarely succinct. It's perhaps worth noting that over the years, many of those Sunday gags were eventually recycled and boiled down to their essence in *Nancy*'s daily format, perhaps a small private victory of sorts for the cartoonist.

Appendix 12: Black Ink

"WE WANT BLACK INK - - - AND QUICK!" — Sluggo, December 5, 1943

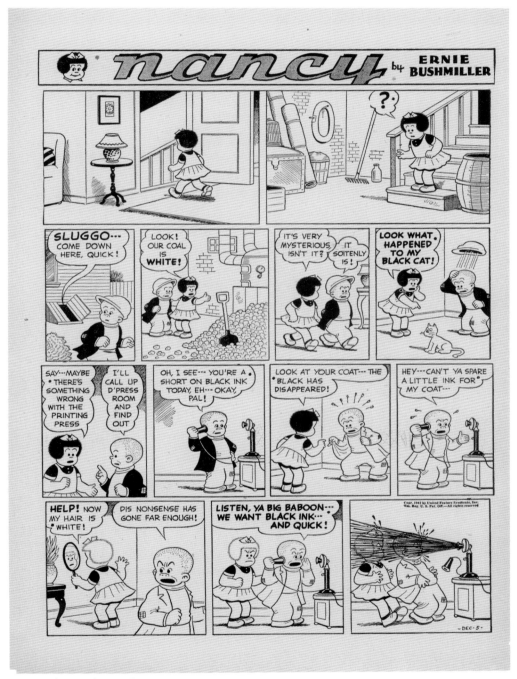

Nancy, *Sunday, December 5, 1943.*

By the early 1940s Ernie Bushmiller had long absorbed the technique of spotting blacks in his work, but as this Sunday page of December 5, 1943, suggests, he still did not take it for granted. This is one of the rare instances where Bushmiller's mandate to perfect his craft overrode the dictates of his gag. The final tier (and the gag itself) would have packed a stronger punch, conceptually and graphically, devoid of any solid blacks whatsoever. Bushmiller, a master of balanced black-and-white composition, seemingly could just not help himself this time.

Appendix 13: Degeneration Gap

"MY PICTURES ARE AWFUL" — Nancy, July 11, 1954

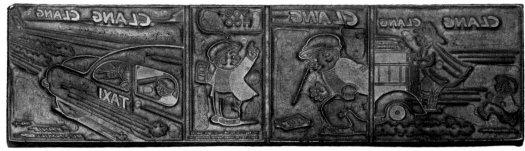

Nancy, June 4, 1957 (metal plate).

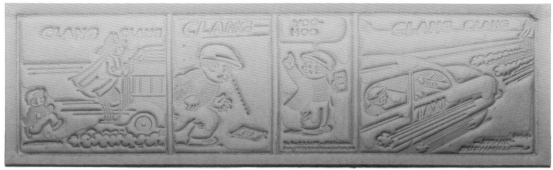

Nancy, June 4, 1957 (stereotype matrix, or "mat").

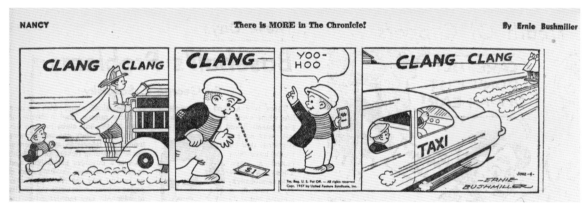

Nancy, June 4, 1957 (printed strip on newsprint).

Although a daily comic strip is a work designed for reproduction, the fact is that once it leaves the cartoonist's drawing board there will never be a "definitive" version. As we have seen, even Bushmiller's work, with its strong lines and solid blacks, was not immune to the myriad ravages inflicted by mid-twentieth-century production processes.

Integral to this era's newspaper letterpress reproduction of comic strips was the manufacture of a lightweight paper mat (short for "matrix" and also known as a "stereotype mat"). To create these, a glass plate was photographically shot from the original artwork (or a clean corrected photostat) and transferred to negative film. The negative film was exposed onto a sensitized metal plate, which was then etched with acid, resulting in a raised image (see illustration). This plate, now containing the transferred relief image in reverse, was next mechanically or hydraulically pressed into a dampened thick paper, which dried into a rigid cardboard-like mold (see illustration).

These lightweight mats were inexpensive to produce and mail to the individual client newspapers, which paid on a sliding scale and could then boast proven first-rate material for far less cost than keeping a local comic strip artist on salary. The stereotypers at the newspaper would gang up the mats of all of their features to form a larger mold of the entire page. The mold was then pressed into a cylinder into which molten metal (zinc or lead) was poured. This curved cast (variously known as a "press plate," "stereotype," "half-round," or "boilerplate"), when set upon the printing press, ultimately transferred the inked image to fresh newsprint (see illustrations above).

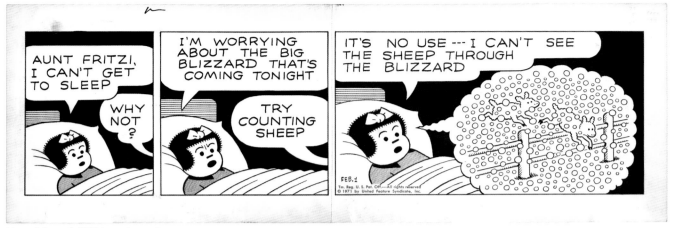

Nancy, *February 1, 1971 (original artwork).*

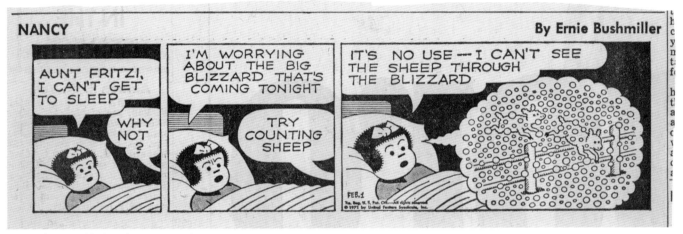

Nancy, *February 1, 1971 (printed strip on newsprint).*

Solid black may be a cartoonist's best friend, but it is the nemesis of printers. Getting black to print solidly on porous newsprint in enormous high-speed runs is considered to be next to impossible. Examined closely, Nancy's hair in this printed example appears to be sprinkled with dandruff, an illusion created by the scattered white newsprint peeking through. Further diluting the integrity of the image is not only what's printed on the page itself, but what's printed on *other* pages. Often (as in this case) the see-through effect of bold coverage on the backside of the newsprint is evident.

Not that the cartoonist's original is pristine, either. Comics are an inherently democratic medium, crafted as art-for-reproduction, not Art-to-hang-on-the-wall, in which every brushstroke awaits the scrutiny of the connoisseur (and the checkbook of the collector). The camera that was designed to photograph such linework does not acknowledge color, shade, or surface nuance. While possessing a secondary beauty of their own as handcrafted objects, comic strip originals can look downright grungy on the drawing board yet perfectly acceptable to the lens.

An examination of just about any comic strip original will reveal a multitude of marks undetectable by the camera and hence unpublished, including: semi-erased penciling, lettering guides, stamps, scribbles, notes and other marginalia, nonreproducible blue pencil (and, in this case, blue shading to indicate where the Ben-Day screen should be applied), white paint (in this case obliterating the lettering guides), glued-on corrections, and brushed-on (in this case, unevenly) black ink.

Furthermore, this example, as with most existing *Nancy* dailies, was scored down the center and folded, presumably to facilitate processing at the syndicate, where they were shipped after the work was done. Ultimately, the camera views the cartoonist's world in black and white. Blood will show, but the sweat and tears dripped onto the surface remain invisible.

Appendix 14: Unfinished Business

"WELL I'M GONNA FINISH IT MYSELF" — Sluggo, November 23, 1944

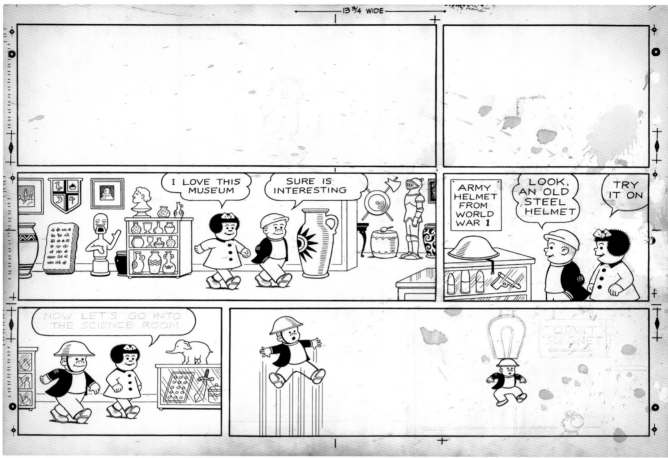

Unfinished Nancy *Sunday page circa mid-1950s (original artwork).*

It is hard to imagine such a purposeful, deadline-driven artist as Ernie Bushmiller embarking on a strip that he would not complete; not surprisingly, very few unfinished *Nancy* originals exist. Forget about blood, sweat, or tears — there is little question why work was halted on this Sunday page. It appears to have been done in by a fatal cup of coffee. Fortunately, what may have been an afternoon's disaster for Ernie can provide some interesting clues to this cartoonist's working methods. (Lesson one: Do not rest coffee cup on drawing board.)

Here Nancy and Sluggo pay a museum visit, seemingly for the express purpose of getting Sluggo into a doughboy's helmet and within proximity of a giant magnet, where, in the last panel (as always), comedy ensues. In this mid-1950s Sunday page (a reworking of the February 21, 1945, *Nancy* daily), several panels were virtually completed, while the first and second panels were barely even sketched in.

Although he may have thought up his gags backward, Bushmiller did not necessarily execute his work that way. His routine rendering methods were perhaps even more eccentric. "I work on my six daily strips at one session. By that I mean I work on six drawings at the same time — jumping from one to another — inking for a while and then penciling on another. This keeps me from getting bored and seems more stimulating. I don't particularly recommend all of my unorthodox methods, they just happen to work well with me. I think every cartoonist should find his own individual approach. I think everyone should work in the way he finds easiest." That method is readily evident in this aborted example. It is a credit to both Bushmiller's craft and his vision how seamlessly the whole of his finished strips ultimately emerges from such randomly executed piecework.

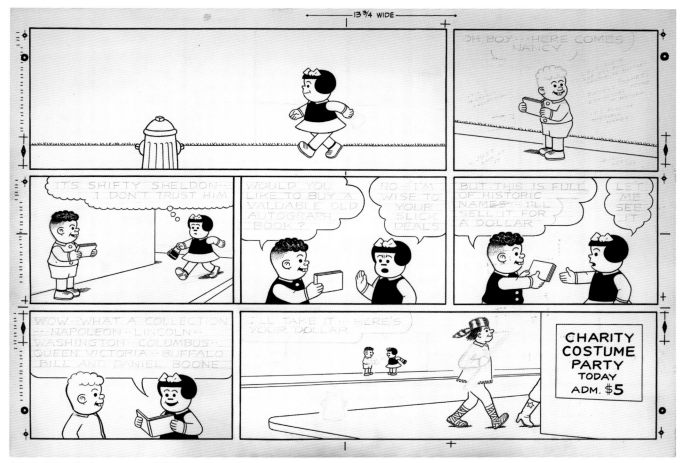

Unfinished Nancy Sunday page circa mid-1950s (original artwork).

Who knows why *this* particular episode never saw the light of day? The job was nearly heading into the home stretch before it was abandoned. Perhaps Bushmiller was having second thoughts on introducing his newest character "Shifty Sheldon" to *Nancy*'s cast. As far as we know this junior Sgt. Bilko never appeared in print.

The second panel offers a fascinating peek at Bushmiller trying out variations on a spiel for this li'l con man's use in the panel directly below. "But these are all famous people in history"? No . . . "But this is full of historic names!" The cartoonist was clearly groping for the perfect combination of meaning, tone, rhythm, and letter space — and keeping all options open before the final decision needed to be made.

Though the lettering here is still uninked, the ruled pencil guides are in place and all the letterforms are penciled tightly. This allowed these balloons to be inked in advance with dead certainty. As with all the extant unfinished Bushmiller strips, this example betrays some surprisingly loose sketch work, especially considering the extreme precision of the final inked lines. It is possible that after decades of drawing *Nancy*, Bushmiller did not need to make his pencil drawings very tight prior to inking. On the other hand, perhaps these uninked areas were ones that he wanted to accurately tighten up before the inking commenced. In either event, the chasm between sketch and finish, seen here side by side, is striking.

Most notably, it is revealed that (at least on this occasion) Bushmiller held off drawing those final short, sharp strokes that describe Nancy's kinky coiffure until the very end of the job.

Nancy, *September 20, 1967 (original artwork, verso).*

The flipside of the original board for this 1967 *Nancy* daily (redated when recycled by Bushmiller a decade later) provides a further peek into both the cartoonist's reverse gag-engineering process and his dedicated perfectionism.

Here Bushmiller has gone so far as to lovingly ink each intricate crisscross of the all-important "object that tells the story" before rejecting the drawing completely and starting all over again on the other side.

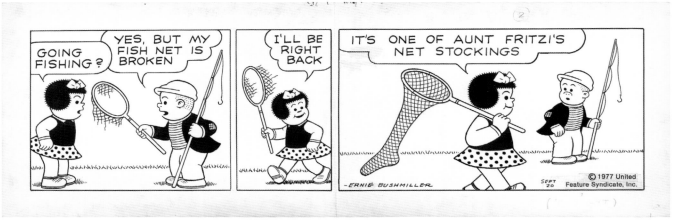

Nancy, *undated (original artwork).*

The final composition is far more dynamic and iconic, with the fishnet (stocking) displayed on a severe, somewhat eerie angle, looking for all the world like a disembodied ghost leg on a stick. Sluggo here has been distanced from this grotesque display and wisely repositioned as a startled onlooker rather than a vaguely puzzled participant.

Bushmiller also inserted a middle panel to better the tension and even managed to shave a word off of Nancy's dialogue in the bargain. Morris Weiss summed it up: "Sometimes he'd have all the panels blank and the last panel finished and completely inked . . . [because] if he's got the last panel — he's got the page."

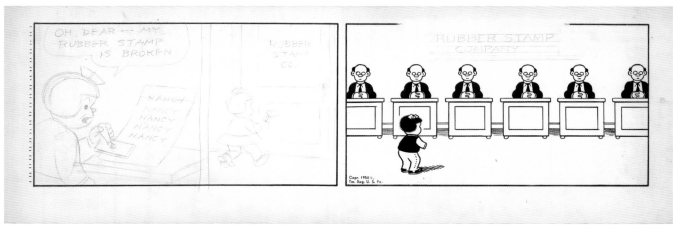

Nancy, *September 20, 1967 (original artwork).*

Appendix 15: Assistants

"Guys tell me, 'It's so simple! Anyone could draw that!' HA! I betcha a million bucks you couldn't draw like Bushmiller! You can't! It's impossible!" — Al Plastino, 2012

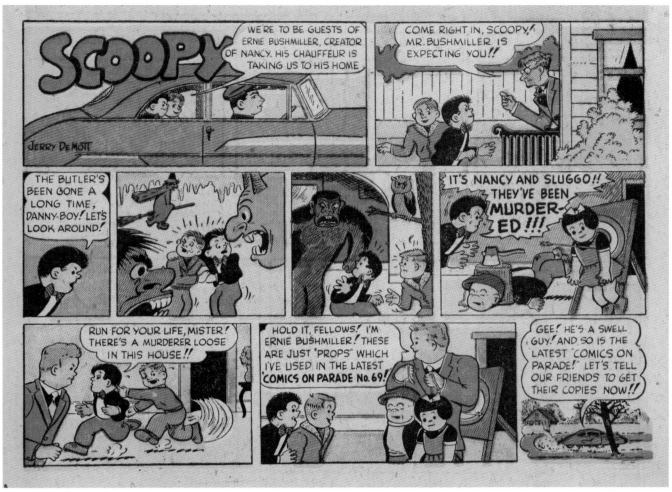

Scoopy *by Jerry DeMott,* Sparkler Comics *#91, January–February 1950.*

Part of the professional culture of the twentieth-century syndicated newspaper cartoonist was the reliance on the aid of uncredited helpers. While Renaissance painting studios similarly employed a division of labor in executing their images, a more direct corollary might be found in the newsroom, where a front-page story on a large daily might typically be reported by one man, its headline written by an editor, its "lede" (the first few sentences or paragraphs) contributed by another reporter, ending with a "rewrite man" who followed through with the balance of the job.

For cartoonists, aside from the delegation of such mechanical and time-consuming chores as ruling panel borders, erasing pencil lines, filling in blacks, and notating color breakdowns on a Sunday page, the primary reason for a dedicated (and capable) assistant was often simply a matter of insurance. For better or worse, in sickness or in health, the daily strip must go on.

Such masters of the medium as George Herriman (*Krazy Kat*), E.C. Segar (*Thimble Theater*), Charles M. Schulz (*Peanuts*), Cliff Sterrett (*Polly and Her Pals*), George McManus (*Bringing Up Father*), Milton Caniff (*Terry and the Pirates*), Frank King (*Gasoline Alley*), Chic Young (*Blondie*), Crockett Johnson (*Barnaby*), Walt Kelly (*Pogo*), Billy DeBeck (*Barney Google*) and Milt Gross (*Dave's Delicatessen*) all benefited, in their long careers, from the skilled hands of assistants at one time or another, to one degree or another.

Some notable long-running strips (such as Bud Fisher's *Mutt and Jeff*, Pat Sullivan's *Felix the Cat*, Ham Fisher's *Joe Palooka,* and Walt Disney's *Mickey Mouse*) were all but completely generated by uncredited "ghost" artists. Other cartoonists, such as Chester Gould (*Dick Tracy*), Al Capp (*Li'l Abner*), and Mort Walker (*Beetle Bailey*) orchestrated what amounted to tight, dedicated production teams to complete their product. In the best-case scenarios the strong, clear creative vision and carefully developed graphic systems of a strip's originator overshadowed such perpetually thorny (and ultimately pointless) questions of what hand made which line on what day.

Ernie Bushmiller was no exception to this practice. He furthered his own career by "filling in" for absentee cartoonists in the art room of the New York *World* and well understood the necessity of an able assistant in meeting daily deadlines (as well as the direct benefits to that assistant in mastering his craft). By the time he inherited *Fritzi Ritz* from Larry Whittington in 1925, this ex-assistant had progressed to a professional standard and was deemed capable to captain a comic strip on his own.

Aspiring cartoonist Morris Weiss first met his successful Bronx neighbor in 1934 while still a teenage fan, systematically ferreting out his favorite cartoonists for autographs or originals, despite unlisted phone numbers and surly gatekeepers. While visiting Dow Walling (a former assistant of Milt Gross and creator of *Skeets,* a kid

strip for the *New York Herald Tribune*,) Weiss noticed a small drawing of Fritzi hanging in Walling's studio and expressed interest in meeting the artist. Walling directed him to the United Feature offices, where he was received by Bushmiller and duly rewarded with an inscribed original. Weiss was shocked to learn that Bushmiller was only ten years older than he was and lived just a few blocks away from his family's home. The two kept in close touch as Weiss broke into the business with entry-level positions on such strips as *Minute Movies* and *The Katzenjammer Kids*.

During this period Bushmiller was, according to Weiss, "always fighting deadlines." Weiss once dropped in for a social call and was asked, on the spot, to do a bit of background inking on one strip so that Ernie could finish another on its way to the engravers. After working for seven years as an assistant for Lank Leonard on *Mickey Finn* as well as for Pedro "Pete" Llanuza (whose job he eventually assumed) on *Joe Jinks*, Weiss was finally invited to become Bushmiller's assistant in 1943, with an offer of $45 a week. The job was never specifically outlined, but Weiss understood that the tasks would include lettering and rendering backgrounds. "I knew it would be much easier than the assisting I was doing for Lank Leonard," he concluded. But Weiss declined Bushmiller's offer, deciding that he was ready to move past assistant work and into a more creative phase of his career.

Those who *did* assist Bushmiller on *Nancy* and *Fritzi Ritz* over the years included future *New York Post* editorial cartoonist John Pierotti (1937–early 1940s), *Streaky* cartoonist Loy Byrnes (1940s), future ad man Richard E. "Dick" Grace (early 1950s), sports cartoonist and United Feature Syndicate promotion manager Alan Maver (lettering, 1950s–1970s), comic book packager Jerry DeMott (comic book material, gag concepts, 1940s–1970s), *Danny Dingle* creator and *Captain and the Kids* daily strip artist Bernard Dibble (*Fritzi Ritz,* 1950s–1961), *Snuffy Smith* assistant Bob Donovan (gag concepts, 1960s–1970s), magazine gag cartoonist Will Johnson (daily strips, from the late 1940s until Bushmiller's death), DC comic book artist Al Plastino (who came on board in the mid-1970s and drew the Sunday *Nancy* page when Bushmiller was in declining health), and Mark Lasky, a young UFS staffer who ghosted an occasional strip in the late 1970s and ultimately inherited *Nancy* in 1982.

In 1957 the license for the *Nancy* and *Fritzi Ritz* comic books (which for years had simply reprinted the newspaper strips) was awarded to Western Publishing, which began commissioning original material for its series. (These were initially published in partnership with Dell, and then under Western's own Gold Key label starting in summer 1962.) Most notable were the long-form *Nancy* stories written by John Stanley and rendered by Dan Gormley from 1957 to 1961. Others who contributed to the run (which lasted through 1963) included writers Dave Berg, Fred Fredericks, Jack Mendelsohn, Paul S. Newman, and Tom Ruth and artists Hy and Adri Eisman, Vernon Greene, and Irving Tripp. (Morris Weiss, apparently keeping a date with destiny, wound up both writing *and* drawing *Nancy* for these publications.)

All of these individuals presumably gave Bushmiller the resources he required to keep his strips (as well as comic books, merchandising, and other endeavors) running on schedule and up to his exacting standards.

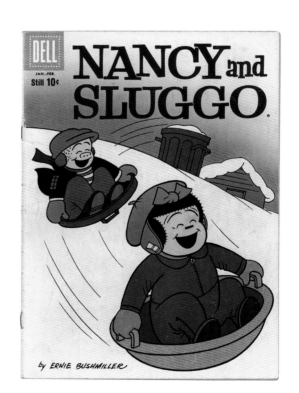

Nancy by Dan Gormley (original artwork and printed comic book), Dell Publishing Company, 1960.

Appendix 16: Ben Day and Ben-Day

"OH DEAR - - - I CAN'T GET THE FLESH TINT RIGHT" — Nancy, December 7, 1945

Patent application art for a distinctive Ben-Day pattern, December 11, 1900.

Virtually every twentieth-century newspaper cartoonist had a silent collaborator in illustrator and engraver Benjamin Henry Day Jr. (1838–1916), who designed, executed, and first patented the "Ben-Day tint" in 1879. Day was the offspring of the sensationalist publisher Benjamin Day, who founded the New York *Sun* in 1833 and gave America a seminal taste of newsprint humbug with his "Great Moon Hoax" of 1835. This was a series of deadpan articles allegedly written by an aide-de-camp of prominent astronomer Sir John Herschel, detailing the moon's bat-winged humanoids, biped beavers, and shaggy blue unicorns newly discovered by way of the latest miracle telescope. Within weeks of these exclusive revelations, the *Sun's* circulation quickly jumped to the largest of any newspaper on earth. Despite this impressive legacy, Day's son may have had an even greater influence on the art of modern journalism. For all intents and purposes the Ben-Day dot was the pixel of the twentieth century.

As Day wrote in his original 1879 patent: "To execute good cross lining or hatching, either in a drawing or engraving by hand in the usual manner, is one of the most difficult, laborious, and expensive operations known to the artist; but, by means of my improved films, the artist is enabled to execute the finest and most beautiful species of straight-lining, swelled lining, waved lining and cross lining or hatching with greater rapidity, doing in one hour's time, by means of my improvements, an amount of work that would require a month's labor if executed in the usual manner." By Bushmiller's era Day's straight, swelled, waved, and cross lines had become ubiquitous, and thanks to his own innovation, perhaps no other graphic artist of the twentieth century's work was reproduced as regularly as Benjamin Day's.

In the production of newspaper comic strips, the mechanical application of the Ben-Day process (which was first commercially introduced in 1901) was initially part of the newspaper engraver's job. (Day had also developed an early artist-based application, but given that most newspaper artwork was executed at far larger than reproduction size, it was wise practice to introduce these delicate dot patterns after the image had been reduced to avoid smudging and filling.)

Using his original line drawing as a guide, the cartoonist would indicate in nonreproducible blue pencil or wash the empty areas to be shaded, as well as his selection of over 150 Ben-Day designs. After an initial (un-etched) zinc or copper plate of the artwork had been created in the customary manner (see Appendix 13, Degeneration Gap, page 202), undesired areas were carefully masked out with gamboge (a yellow, water-soluble resin) or a similar gum arabic solution. The engraver would then align the plate within a wood frame "machine" housing a gelatin Ben-Day screen of the chosen pattern and transfer the relief pattern by means of a roller or stylus and acid-resisting ink. This plate, including these newly shaded areas, was then dusted with "dragon's blood," a powder used to prevent smearing. The plate was next acid-etched as usual, resulting in the patterned areas standing in relief, ready for press. This process enabled a simple black-and-white line drawing to enjoy the same potential range of tone as a screened ("halftone") photo or illustration at far less cost.

While the Ben-Day process undoubtedly changed the look of the daily newspaper page, it was in the color Sunday supplements that the process arguably had its most iconic (and cost-effective) impact, furnishing the familiar dot screens used in the traditional four-color CMYK (Cyan, Magenta, Yellow, blacK) separation technique found in every newsprint comic section and comic book of the recent past.

Today the use of actual Ben-Day screens (and their various successors) is long extinct and the traditional Ben-Day "look" is usually encountered as a faked visual artifact — in oil paintings or Photoshop files or scanned from original newsprint and reproduced digitally (all too often dramatically enlarged to ironically counterpoint painter Roy Lichtenstein's own ironic, dramatically enlarged canvas translations.

No. 319. No. 325. No. 426.
Fig. 66.—The Ben Day machine. The three samples show representative Ben Day patterns. (*Courtesy of Ben Day, Inc.*)

Promotional image of the Ben-Day application apparatus from the 1937 textbook Principles of Advertising *by H.K. Nixon.*

"Yeah, university kids . . . they think they're very hip. They think they're a little offbeat." — Ernie Bushmiller, 1976

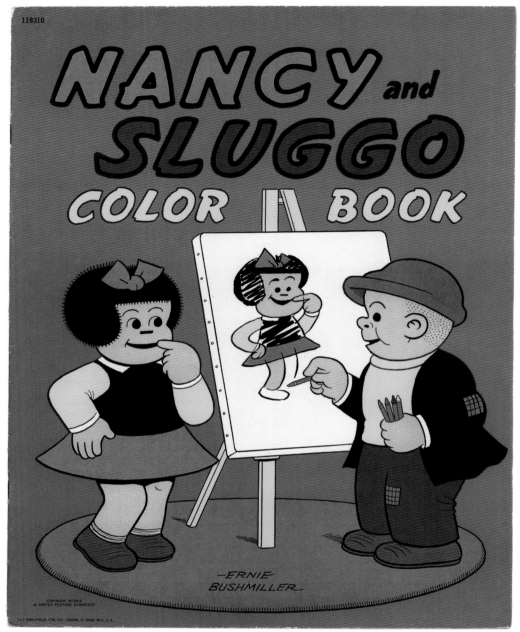

Coloring book, The Saalfield Pub. Co., 1952.

On February 28, 1976, those viewers who were still awake at the very end of NBC's new late-night sensation *Saturday Night Live* would have encountered a massive body of superimposed type rapidly scrolling down their television screens shortly before 1:00 a.m.

Entitled "These People Are Definitely Not As Smart As Dolphins," the lengthy list included such household names as President Gerald Ford, "The First Lady of the Theatre" Helen Hayes, pop stars Sonny and Cher, movie legend John Wayne — and Ernie Bushmiller.

While the cartoonist's response was not recorded (although, coincidentally, the next morning's Sunday page began with Nancy grumbling "Nothing good on TV today"), this was a cultural marker, as clear as any, that *Nancy* had become officially ordained passé among the young and the hip.

Or had it?

According to filmmaker Tom Schiller, a *Saturday Night Live* writer and cast member that season, the list was the work of the late Michael O'Donoghue (a comic strip creator himself), "whose dark side included making fun of beloved comic book characters and their creators." "The simple reply is that we hated *Nancy* and, of course, Ernie Bushmiller," admits Schiller. "The complex answer is that we loved *Nancy* and didn't want to be branded as sissies."

Perhaps more than with any comic strip of its era, *Nancy*'s readers seemed to take it personally and projected a broad spectrum of complicated, ambivalent, and often intense responses upon its star. Long before the *Saturday Night Live* era, Nancy had been adopted by an earlier generation of influential hipsters, the young postwar New York artists and poets who would soon give rise to the Pop Art era.

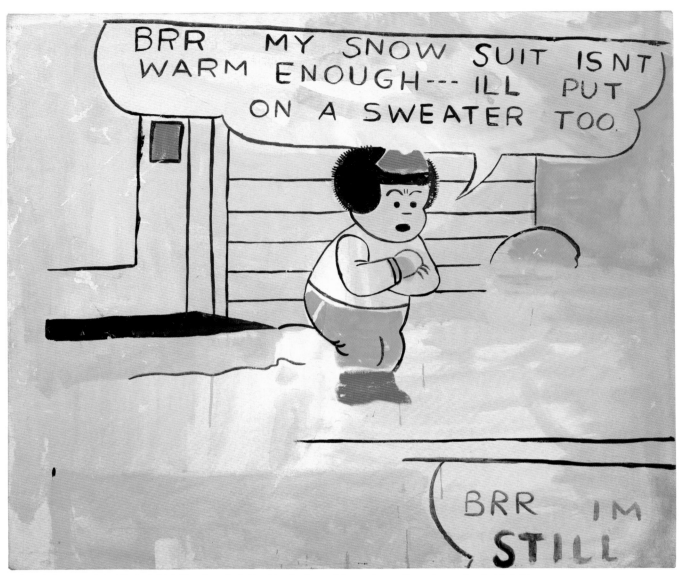

Andy Warhol, Nancy, 1961. © The Andy Warhol Foundation for the Visual Arts, Inc. Private Collection, Courtesy Thomas Ammann Fine Art AG, Zurich.

Nancy was among young Andy Warhol's earliest mass-cultural muses. His 1961 *Nancy* (via Bushmiller's February 19, 1961, Sunday page), along with contemporaneous canvases of Popeye, The Little King, Dick Tracy, Pepsi bottles, and stock ad cuts for hernia cures, debuted in Manhattan that spring. These were not unveiled for any imagined art-world upending, but to catch the eyes of midtown shoppers in the department store windows of Bonwit Teller. The large, striking paintings specifically addressed the natural domain of such images as printed marks on a daily newspaper page, a jungle of logos, panel borders, and bleed-through crossword puzzles achingly familiar to most any

passing pedestrian. But Warhol shrewdly reformulated these painterly approximations as Art by dumbing them down with strategic dollops of au courant abstract-expressionist drips, daubs, and smears — lest anybody miss the gag. (Warhol was neither the first nor the last to go there, and Roy Lichtenstein soon made such strategies his trademark, albeit with a less messy translation.) At this stage of his career Warhol read *Nancy* as one more twentieth-century print icon to be glorified (or exploited), as he intentionally borrowed from both the iconic "low" and the iconic "high" to help peddle fashion accessories to the easily distracted middle.

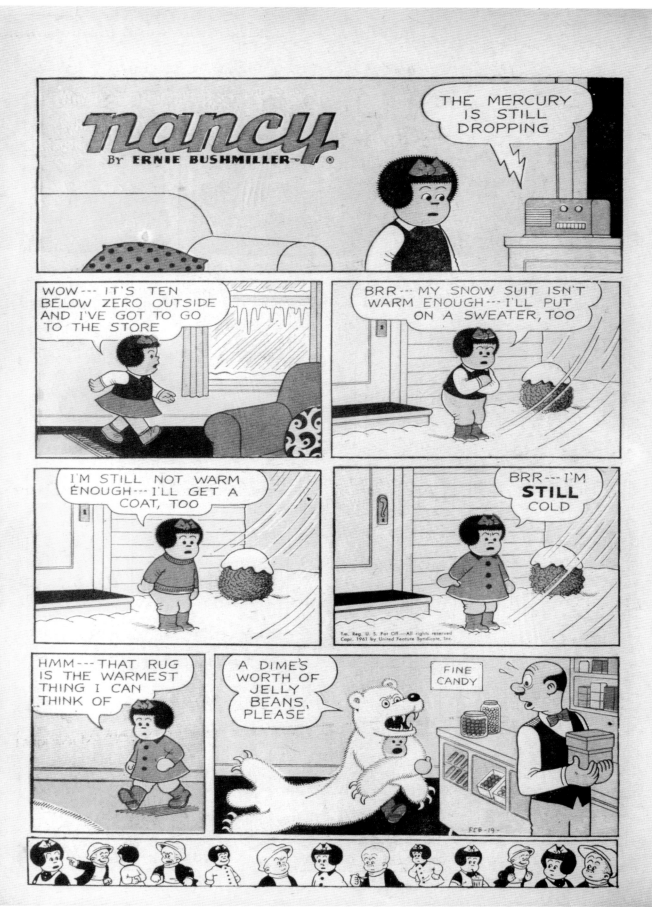

Ernie Bushmiller, Nancy, *February 19, 1961.*

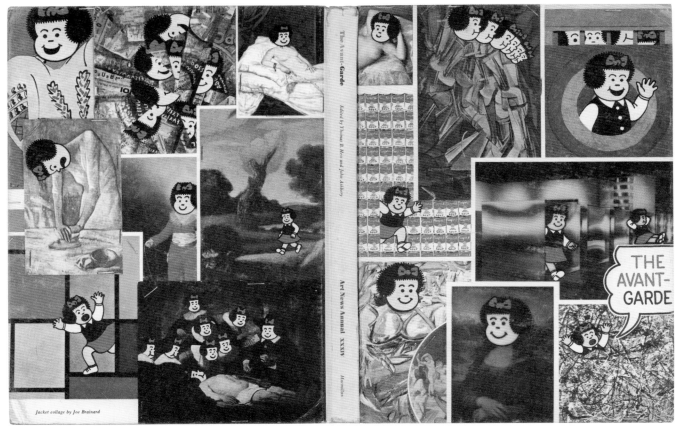

Joe Brainard, *The Avant-Garde, Art News Annual XXXIV, 1968.*

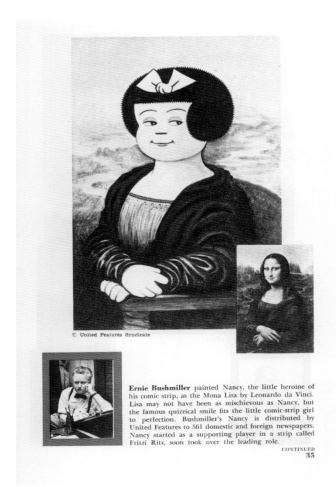

© United Features Syndicate

Ernie Bushmiller painted Nancy, the little heroine of his comic strip, as the Mona Lisa by Leonardo da Vinci. Lisa may not have been as mischievous as Nancy, but the famous quizzical smile fits the little comic-strip girl to perfection. Bushmiller's Nancy is distributed by United Features to 561 domestic and foreign newspapers. Nancy started as a supporting player in a strip called Fritzi Ritz, soon took over the leading role.

CONTINUED
35

Ernie Bushmiller, *"Art Show," Pageant magazine, July 1950.*

After Warhol (whose work swiftly graduated to the high-rolling gallery market and institutional posterity), a growing corps of ambitious image makers would continue to take what they needed from *Nancy*. In the work of poet and collagist Joe Brainard, Nancy seems to have become nothing short of a personal proxy for a gay young man from the Midwest in search of an art-world identity. Her ever-smiling (yet sometimes crudely sexual) appearances in his large body of intimately scaled drawings, collages, and texts originally dated to his move to New York in 1963 and continued for over a decade. These often echo a semblance of the Bushmiller aesthetic in their absurdist sense of humor, and while they initially read as a compulsive series of outsiders' in-jokes, they also accumulate a subtle, desperate weight as the silliness accrues. In the best of Brainard's work *Nancy* was retrofitted to embody all of Western art history from Leonardo to Picasso, and if his renditions more resembled the work of an anonymous *Nancy* coloring book artist than those of her creator, they were at least a direct response to the spirit of his source. (Bushmiller had in fact gotten the ball rolling by unveiling Nancy as the Mona Lisa for *Pageant* magazine in 1950.)

Other artists and writers connected to the New York School of poets were likewise attracted to *Nancy,* including Brainard's sometime collaborators Ted Berrigan, Ron Padgett, and Frank O'Hara. So was San Francisco collagist "Jess" (Collins). In Chicago, Karl Wirsum and his Hairy Who cohorts riffed on her likeness. Painter/poet/mail-artist Ray Johnson incorporated Nancy in his work and apparently reached out to Bushmiller directly in 1978 for a planned *Art in America* interview (there is sadly no evidence that it ever came off). And in 1979 three New Orleans composers — Steve Cunningham, Steve Sweet, and Jesse Poimboeuf — translated sixteen strips from back issues of *Comics on Parade*, casting such instruments as theremins,

straws-in-water, and roller skates as characters, objects, and locations for their performance piece *Music from Nancy*.

From the 1980s onward, more and more art-world aspirants began reflexively casting Nancy and Sluggo in their imagery. These were most often purely in the Warhol vein, reading *Nancy* as a ready-made pop-cultural talisman, all set to plug and play in pictorial approaches ranging from pornography to idolatry. But, as often as not, these artists settled for the conventionally ironic and exhibited little understanding and zero interest in what made *Nancy* worth "appropriating" in the first place.

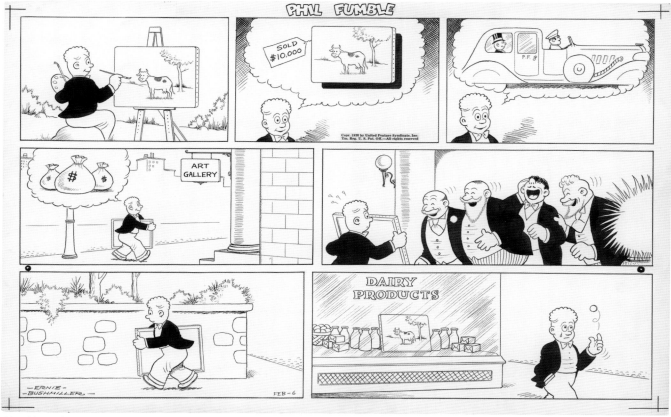

Phil Fumble, *Sunday, February 2, 1938 (original artwork).*

Part of what may have attracted some of these artists to *Nancy* was Bushmiller's incessant interest in *them*. Modern art and modern artists were a frequent gag meme in his strips and one that probably dates back to his personal experiences as a young newspaperman enrolled at the National Academy of Design. James Carlsson describes his former employer as an intellectually curious man with both an interest in and an appreciation of the latest cultural developments outside the comics pages, as well as a "healthy bullshit detector." "I think he was at first amused and upon further reflection embraced imitation as a form of flattery without trying to overanalyze. Let's face it, this was good publicity and made a lot of *Nancy*-haters scratch their heads."

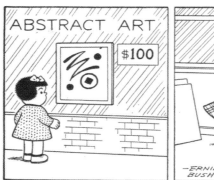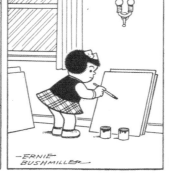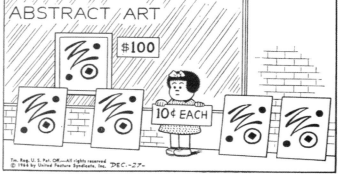

Nancy, *December 27, 1966.*

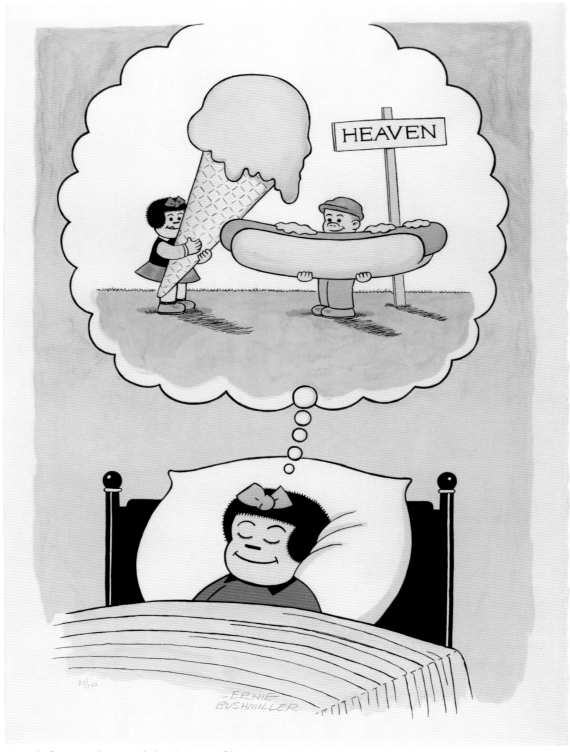

Ernie Bushmiller, Nancy, Abrams Limited Edition Comic Art Portfolio, 1978.

Bushmiller's sole concession to this vogue for comic characters on the gallery wall was his participation in a series of twenty signed "museum-quality" lithographs created by newspaper cartoonists and marketed by art publisher Harry N. Abrams in 1978, with a *Nancy* image that might have made Joe Brainard smile. (Fred Lasswell, however, trumped all of his peers on this project by insisting his *Snuffy Smith* be printed on a large brown paper bag). But at the end of the day Bushmiller was a humorist. The humorless, fundamentally self-important culture of twentieth-century Art and its practitioners, patrons, critics,

and followers were invariably depicted in *Nancy* as highly suspect (if not highly delusional) — yet above all, highly funny. Today these strips easily rank among Bushmiller's best-loved work, particularly among their targets.

While *Nancy*'s influence was significant to only a handful of gallery artists, the strip's impact on print artists was seismic. Many of Bushmiller's contemporaries thought highly of his work (Al Capp once cited *Nancy* as his favorite comic strip), but his greatest influence was among a younger cadre of underground and post-underground cartoonists who took *Nancy* at face value.

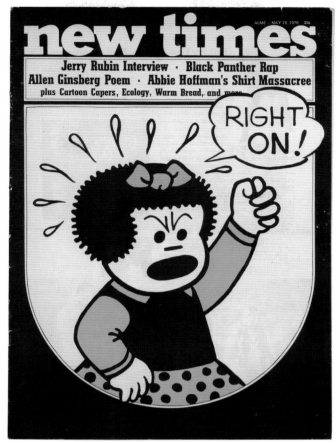

Cover girl for the underground press, New Times, March 18, 1970.

Beginning in the mid-1960s, these children of the counterculture rebelled against the strictures of the medium's long-entrenched delivery systems, founding their own newspapers and comic book companies, unfettered by syndicates, censors, and mass-market economics. Many of these cartoonists were well educated and well read in the subject of comics (as well as art) history. This knowledge and genuine appreciation squares the group in Tom Schiller's camp.

For them *Nancy* is not camp, cool, or contemptible, but essential. These include such diverse practitioners as Mark Beyer, Charles Burns, Dan Clowes, Robert Crumb, Bill Griffith, Kaz, Denis Kitchen, Jerry Moriarty, Mark Newgarden (co-author of this volume), Gary Panter, and Chris Ware, all of whom have benefited from a working familiarity with the Bushmiller system and who have long taken *Nancy* for the comics textbook that it is. (This list is by no means complete, and it may be argued that the ripple effect of Bushmiller's strip on any working cartoonist today is incalculable.)

Of course the vast majority of Bushmiller's readers did not write jokes or draw pictures, but they were nonetheless silent partners in the strip's continued success. As *Nancy* entered its fourth, fifth, and sixth decades, its most ardent followers were of those culturally savvy generations who rediscovered the same unchanging strip that they (and their parents) had grown up on. "My own unprovable theory as to the strip's intrinsic appeal is based on the period when a generation or two of young children essentially learned to read via comic strips," posits cartoonist and publisher Denis Kitchen. "The most attractive to a child's eye and the easiest to read was *Nancy*. This would not be something anyone consciously remembered,

but subconsciously there would always be this subliminal link with *Nancy* and their earliest cognitive memory."

In a popular culture that defined itself by constant change, *Nancy* grew increasingly incongruous on the daily newspaper page, a typical 1970s strip seemingly interchangeable with a 1950s episode, down to such typically telltale details as clothing, hairstyles, and automobiles. The results (depending on the mindset of the reader) could be viewed as anachronistic — or comforting. "*Nancy* hasn't reached the point of being camp or nostalgic," Bushmiller asserted in a 1976 article by Rod Mickleburgh published in *The Vancouver Sun*. "At the same time though, people who are fifty and have been reading the strip for thirty years see that it's still the same and then think maybe they haven't changed either."

With less comedy machismo at stake than first-season *Saturday Night Live* writers, many younger fans of that time admitted to *Nancy* (or any newspaper comic strip for that matter) as only a slightly guilty pleasure. For others, however, the strip became something worth fighting for. Mickleburgh, in his "Carry On Nancy" (written in response to an April 22 letter signed by six University of Vancouver students bemoaning the strip's "stale wit and disinterred humor" and demanding its retirement), sounded a battle cry: "We are a movement. Together we form a cult rivaling the Spanish Inquisition in secrecy and devotion. Calling ourselves simply 'Nancy' fans' we gather conspiratorially at parties whispering 'Did you see *Nancy* today? Wasn't it great?' Then we roar with laughter."

The era of the "Secret Ernie Bushmiller Society" (as it came to be called) — which was neither secret, nor a society — had arrived. Comics readers have since been increasingly divided into the proverbial two factions, those

who innately connect with Ernie Bushmiller's *Nancy* and consider it (as Mickleburgh did) the "quintessence of comic strip art" and those who cannot and do not.

Among the latter can be counted a number of notable critics, cartoonists, and researchers, including the late Bill Blackbeard of the San Francisco Academy of Comic Art. His summary of *Nancy*'s flaws in his entry on the strip for *The World Encyclopedia of Comics* (Chelsea House, 1976) admittedly comprises many of the precise qualities that drew others directly to the strip. These included "incredibly simple points which could be grasped at a glance, acted out by a minimal and unconfusing cast of cute kids drawn with stark plainness against an unadorned background." Designating these opposing groups as the "brainy people" versus "the broad middle-aged public," Blackbeard proceeded to a harsh conclusion: "Bushmiller's work is best read from the start 'til 1940 when *Nancy* began [sic]. The remainder will be on tap at an institution or two for the stalwart and devoted research student; the rest of us would be happier forgetting it."

By the 1970s such enterprises as *The World Encyclopedia of Comics* (less a true encyclopedia than an attempted canon) tried, however imperfectly, to give critical shape to the amorphous landscape of an already shadowy early century. Demonstrating the "relevance" of this largely forgotten work to a contemporary audience would typically require that such virtuoso (and completely atypical) strips as *Krazy Kat* and *Little Nemo* be positioned front and center, easily recognized as Art by Blackbeard's "brainy people." *Nancy*, still very much *Nancy* and still very much the apple of his generation's aging eye, became for Blackbeard a convenient symbol of the form's ennui.

Determining precisely where *Nancy* should be situated in a comics pantheon continues to challenge, even for those who appreciate the strip. In assembling an A-list of fifteen exemplary twentieth-century cartoonists for their 2005 *Masters of American Comics* exhibit at the Hammer and MoCCA museums in Los Angeles, neither curators John Carlin and Brian Walker nor advisor Art Spiegelman felt that Ernie Bushmiller belonged in their exhibit's final cut. While the show put forward no stated criteria for the designation of comics "Master" beyond inclusion in its exhibit, it stood as a revealing snapshot of the "high" and "low" cultural exchange at the dawn of the twenty-first century.

A link between the *Encyclopedia* and the *Masters* show can be found in their agendas. In attempting to "legitimize" comics, both ironically promoted an insider's hierarchy as they outwardly championed the elevation of the medium's "lowly" status. These and similar exercises, playing to a presumed tough room, argued that comics (which, after all, share so many of the literary and aesthetic qualities of what already "matters") should assume their rightful place in the sun. Unapologetically *comic* comic strips like *Nancy*, typically deemed useless in such tactical arguments, inevitably got lost in the shuffle. "It seems that the American temperament doesn't associate art with humor," postminimalist Robert Smithson once observed. "Humor is not considered serious."

Today comics are arguably out of the gutter and inching their way along a leveling playing field, where such old-fashioned high/low distinctions have all but flattened. The case will be closed, it seems, not by storming the gates of Parnassus, but by a series of generational and technological shifts, and the steadfast inexorability of Manny Farber's "termite art." The comics medium is a survivor. A typical *Nancy* fan of today's generation may sport the odd Nancy tattoo or a Sluggo avatar on Facebook but has probably never actually encountered a Bushmiller strip itself (or a Warhol painting or an underground comic) outside of a historical reprint or internet scan. Yet whatever the means of delivery, nearly eighty years after her public debut, *Nancy* continues to be seen, to be read, and to matter.

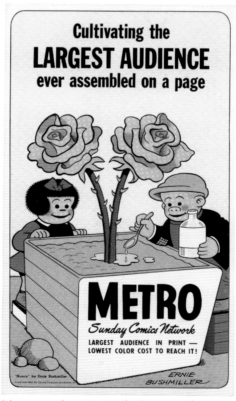

Cultivating an audience, Metro Sunday Comics Network promotional postcard, 1951.

Appendix 18: How To/How Not To

"WATCH WHAT YOU'RE DOING" — Sluggo, November 4, 1954

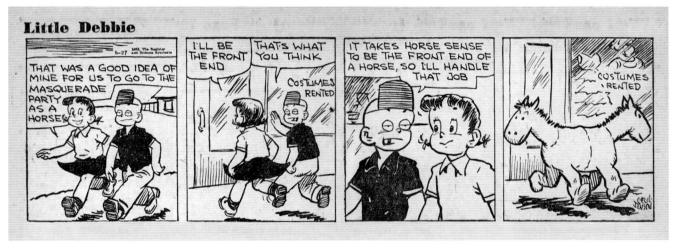

Little Debbie, *June 27, 1955.*

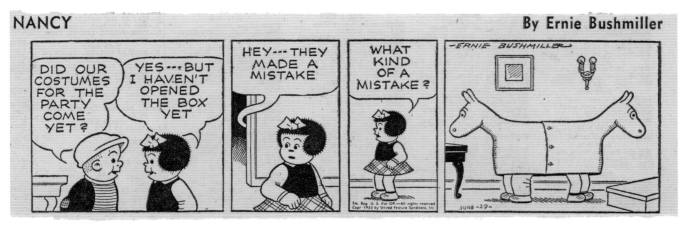

Nancy, *June 29, 1955.*

"No great mystery as to how these two cartoonists working independently and a thousand miles apart should have come up with the same idea at the same time," explained *Oakland Tribune* sports cartoonist Leland "Lee" Susman. "They probably just happened, at about the same time, to see a live two-headed horse."

Perhaps this coincidence is no great mystery, but comparing Cecil Jensen's *Little Debbie* from Monday, June 27, 1955, with Ernie Bushmiller's *Nancy* published only two days later is enlightening.

Cecil Jensen began his newspaper career as a political cartoonist on the *Chicago Daily News*. His *Elmo* (handled by the Register and Tribune Syndicate from 1946–49) was a quirky, satiric strip with superior dialogue in the *Li'l Abner* vein, yet was ultimately unsuccessful with the public. *Elmo* was promptly dumbed down and rechristened *Little Debbie* (also known simply as *Debbie*) in 1949 and the focus shifted to the antics of Elmo's spunky kid sister (in all likelihood to compete directly with *Nancy*). *Little Debbie* (no relation to the beloved snack cake mascot) survived until 1961.

In this example Jensen manages to execute just about every aspect of his chosen gag ineffectually. The characters enter walking left (in effect, exiting) and apparently circle the reader's head 360 degrees before reappearing in panel 2 — where Debbie has now inexplicably switched places with her pal, Tugwit. The awkward design, sketchy rendering, inexpressive gestures, and utterly misleading facial expressions offer no grounding to the reader for a gag that is essentially dependent on visual clarity. And the meager gag itself literally self-destructs as the cartoonist (who on this occasion apparently had little faith in his own material) spells out the dénouement before it occurs.

Bushmiller, as usual, succeeds. The succinct dialogue sets the premise in panel 1. The concept of "mistake" is reinforced in panel 2 with the snaking of the foreboding balloon's tail into the darkness. The pause created by the brief beat and the repetition of "mistake" in the abbreviated panel 3 ups the ante. And finally, the purely visual reply to the posed question: a deathly still last panel with the lead characters (still easily identifiable) frozen in a silent moment of realization shared with the reader.

As Ernie Bushmiller put it, "Remember . . . Ya gotta DO THE JOB RIGHT!"

DO IT YOURSELF!

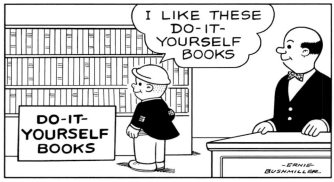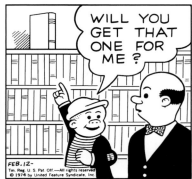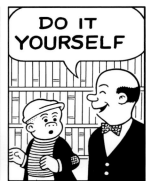

Nancy, February 12, 1974.

The forty-two lessons of *Nancy,* August 8, 1959, that have been extracted in this volume's analysis can profitably be applied to most, if not all, comics — from gag strips to graphic novels. (In fact as the scope of a work's narrative ambition widens, these foundation concepts become all the more crucial.) To emphasize each of them, the strips in this section have been selected as exemplary. Now it's your turn to connect the blacks, measure the horizon lines, and size up the panels.

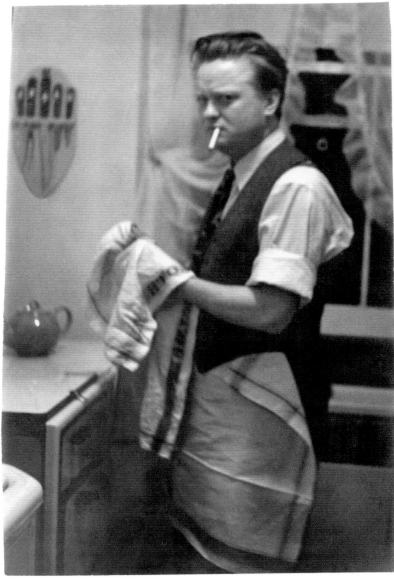

A night at home, 1930s.

THE GAG
Content comes first and stays last.

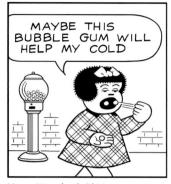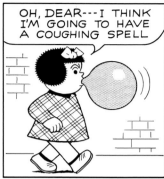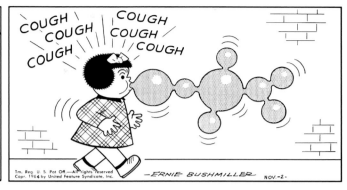

Nancy, November 2, 1964.

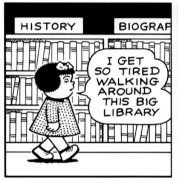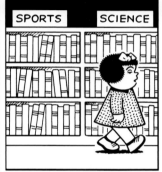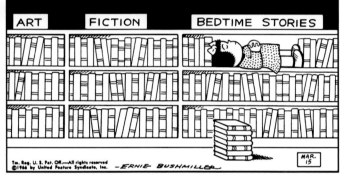

Nancy, March 15, 1966.

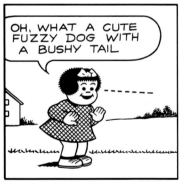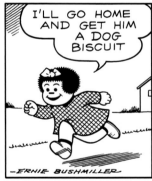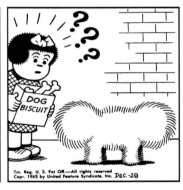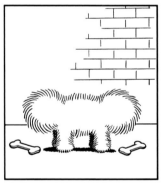

Nancy, December 28, 1963.

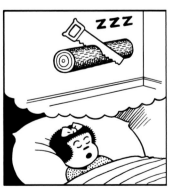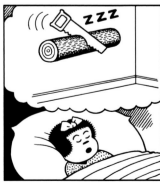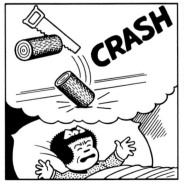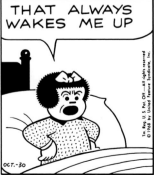

Nancy, October 30, 1968.

THE LAST PANEL
Ideas can flow from any direction.

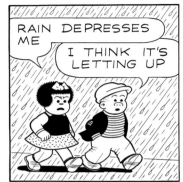
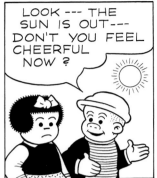
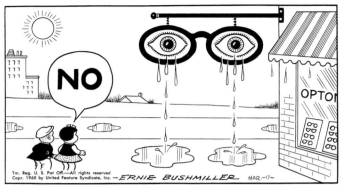

Nancy, March 17, 1960.

Nancy, July 29, 1974.

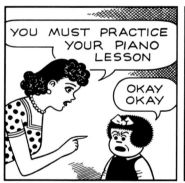
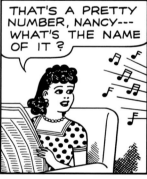
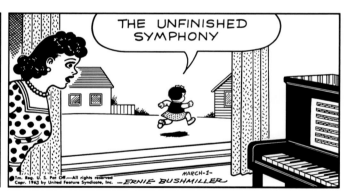

Nancy, December 19, 1962.

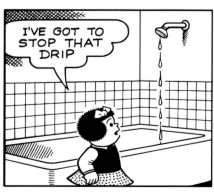
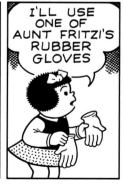
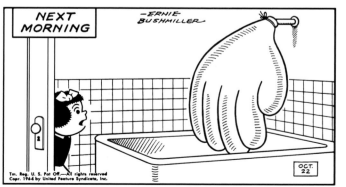

Nancy, October 27, 1964.

DIALOGUE

Concise and considered words complement concise and considered images.

 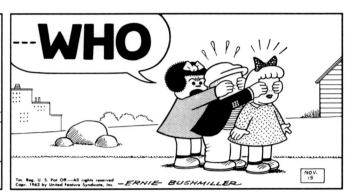

Nancy, November 15, 1962.

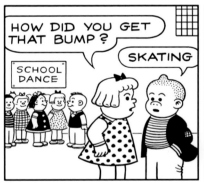 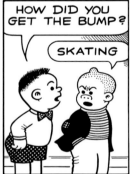 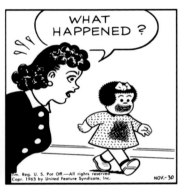 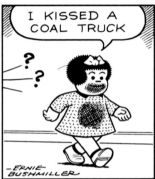

Nancy, November 30, 1963.

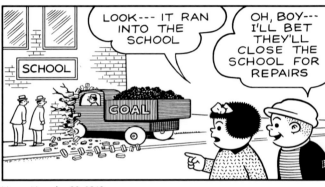 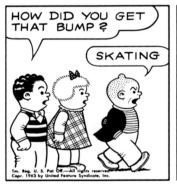 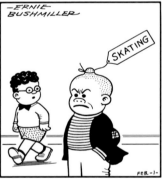

Nancy, February 1, 1963.

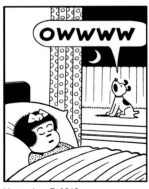 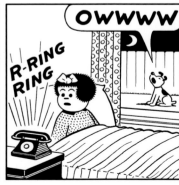 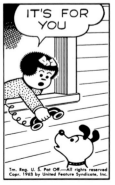 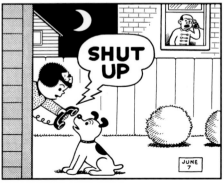

Nancy, June 7, 1963.

BALLOON PLACEMENT

In the design of comics, situating the text is primary.

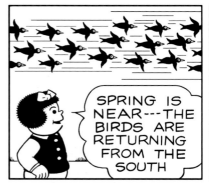
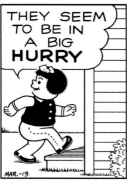
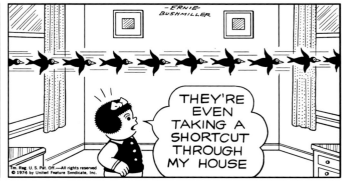

Nancy, March 15, 1974.

Nancy, July 24, 1974.

Nancy, February 23, 1974.

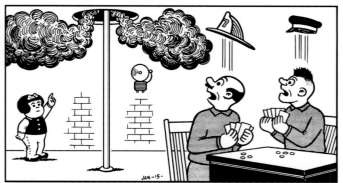

Nancy, January 15, 1963.

SLUGGO

Attractive character traits are often not positive ones.

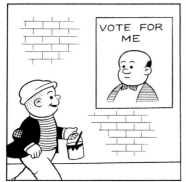 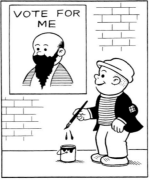 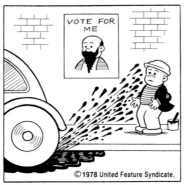 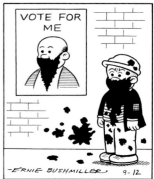

Nancy, September 12, 1978.

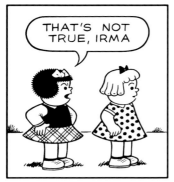 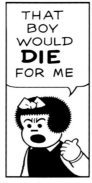 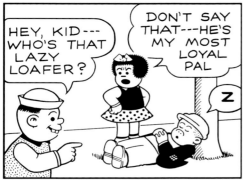 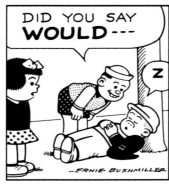 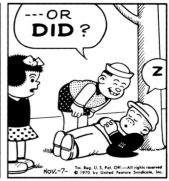

Nancy, November 7, 1970.

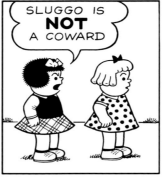 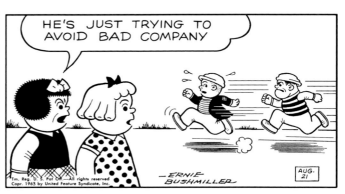

Nancy, August 21, 1963.

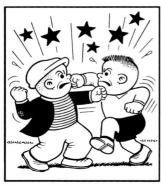

Nancy, June 18, 1963.

225

NANCY

Engaging characters remind us of ourselves.

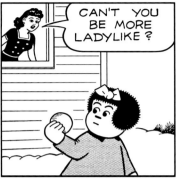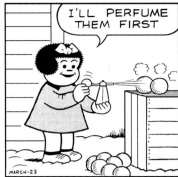

Nancy, March 23, 1964.

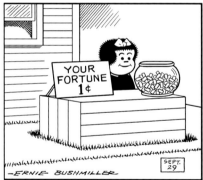

Nancy, July 10, 1974.

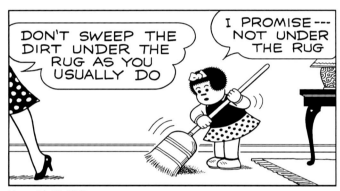

Nancy, September 29, 1966.

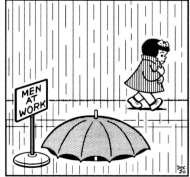

Nancy, December 20, 1963.

THE EXTRAS
Every character is made to order.

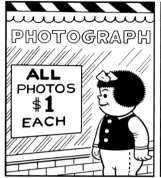
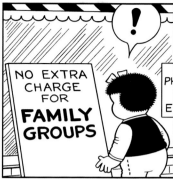
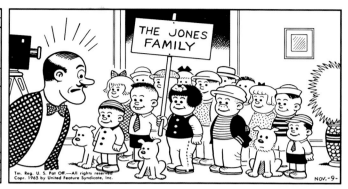

Nancy, November 9, 1963.

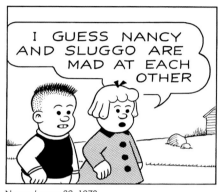
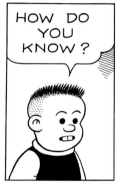
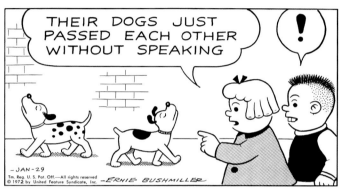

Nancy, January 29, 1972.

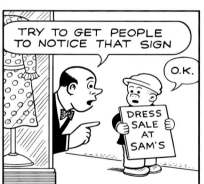
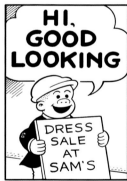
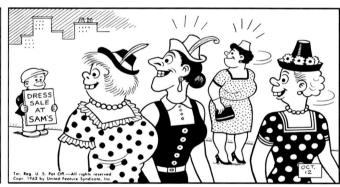

Nancy, October 12, 1962.

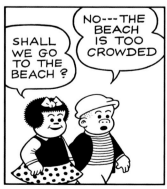
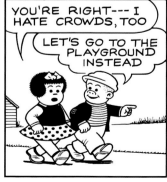
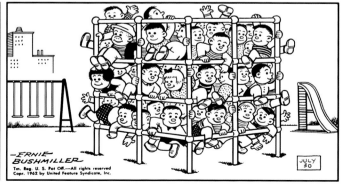

Nancy, July 30, 1962.

NANCY AND SLUGGO

In fiction as in life, the closest relationships are often the most complicated.

 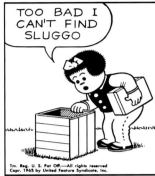 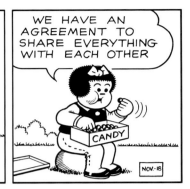

Nancy, November 18, 1963.

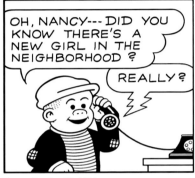 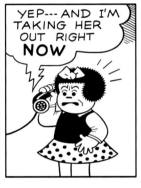

Nancy, October 16, 1964.

 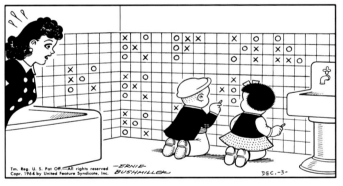

Nancy, December 3, 1964.

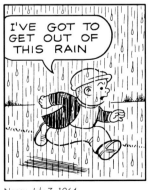 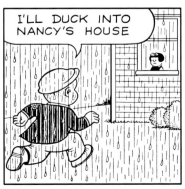 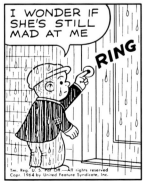 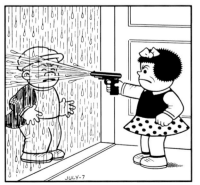

Nancy, July 7, 1964.

ERNIE BUSHMILLER

Pay attention to that man behind the curtain.

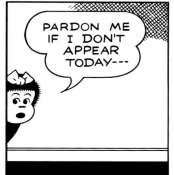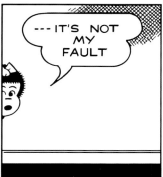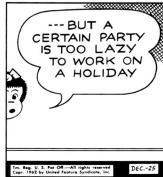

Nancy, December 25, 1962.

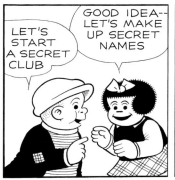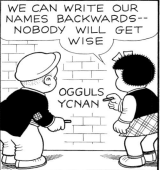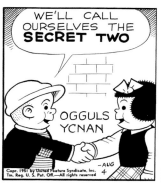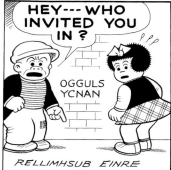

Nancy, August 4, 1951.

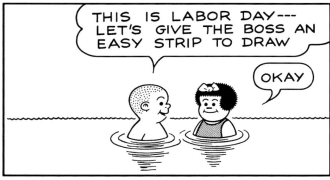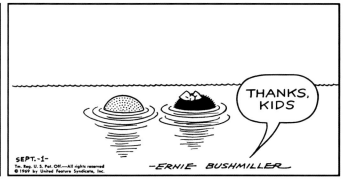

Nancy, September 1, 1969.

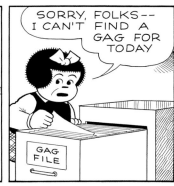

Nancy, December 25, 1951.

229

THE WATER GUN

Worlds can revolve around a single object.

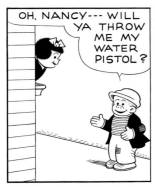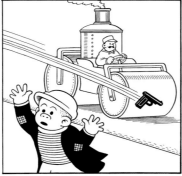

Nancy, April 27, 1949.

Nancy, February 20, 1964.

Nancy, November 27, 1976.

Nancy, November 11, 1963.

THE PISTOL-GRIP NOZZLE

"Common knowledge" is a calculated risk.

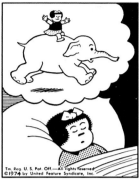
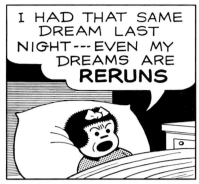

Nancy, May 31, 1974.

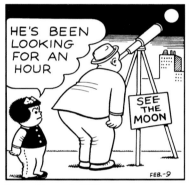
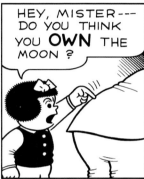

Nancy, February 9, 1960.

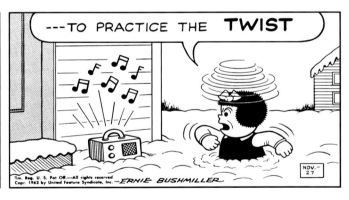

Nancy, November 27, 1962.

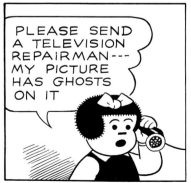
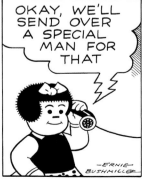
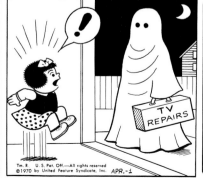
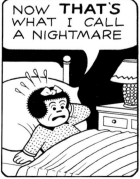

Nancy, April 1, 1970.

THE LEAKY SPIGOT

The placement of the object helps define the place.

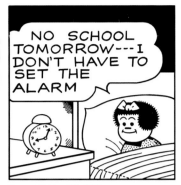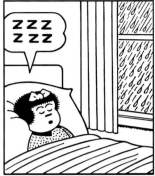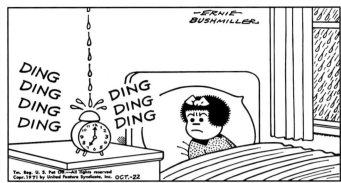

Nancy, *October 22, 1971.*

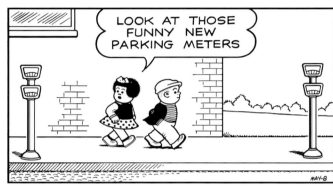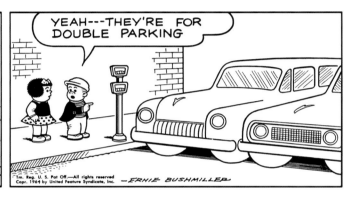

Nancy, *May 8, 1964.*

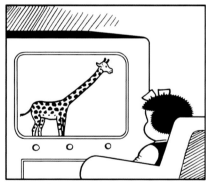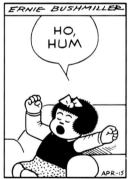

Nancy, *April 15, 1954.*

Nancy, *August 6, 1953.*

THE HOSE
Tension is a prerequisite of laughter.

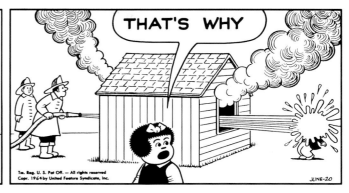

Nancy, June 20, 1964.

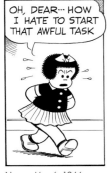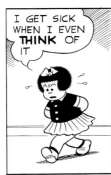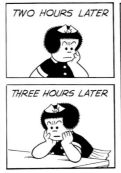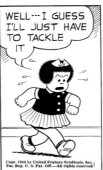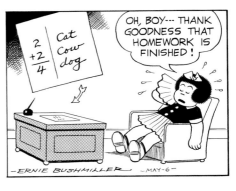

Nancy, October 6, 1955.

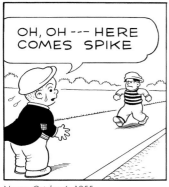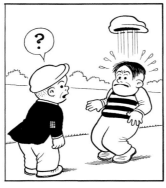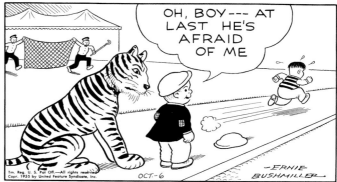

Nancy, May 6, 1944.

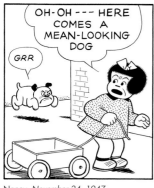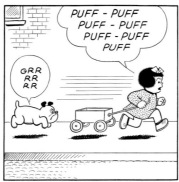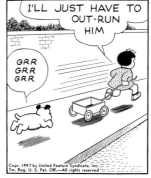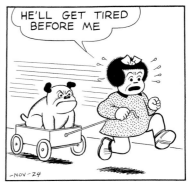

Nancy, November 24, 1947.

STRIP UNIFORMS

Familiarity breeds content.

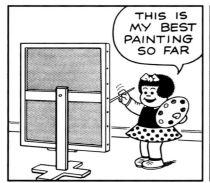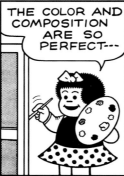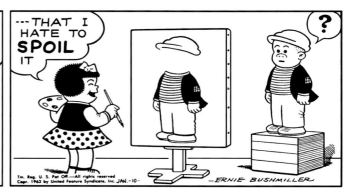

Nancy, January 10, 1963.

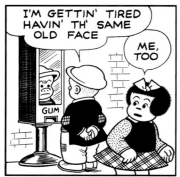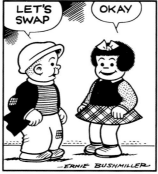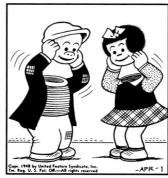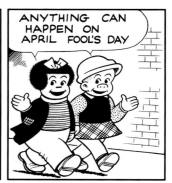

Nancy, April 1, 1948.

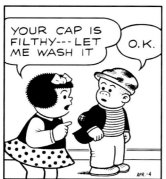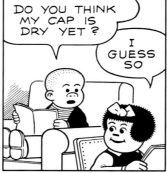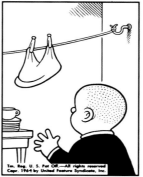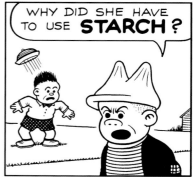

Nancy, April 4, 1964.

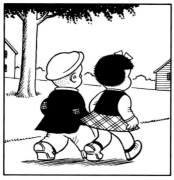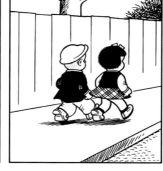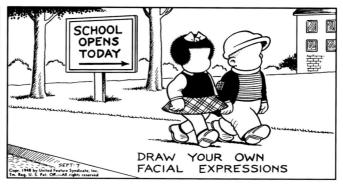

Nancy, September 7, 1948.

THE COWBOY OUTFIT

The concern of pop culture is often pop culture.

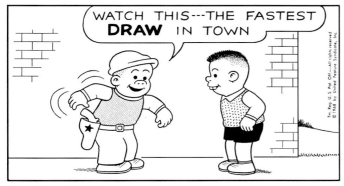
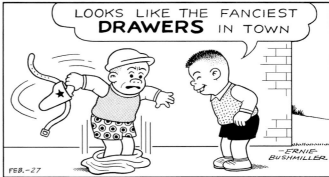

Nancy, February 7, 1968.

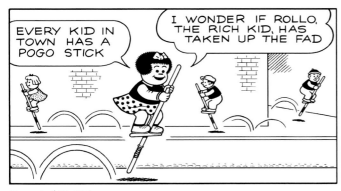
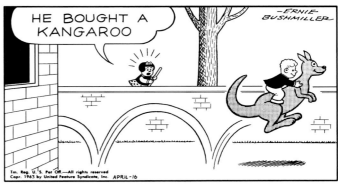

Nancy, April 16, 1963.

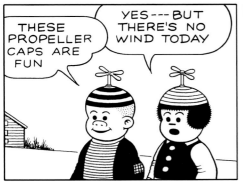

Nancy, February 5, 1963.

Nancy, May 19, 1980.

THE HORIZON LINE

The delineation of space supports the narrative.

Nancy, *January 11, 1964.*

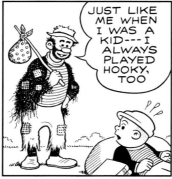

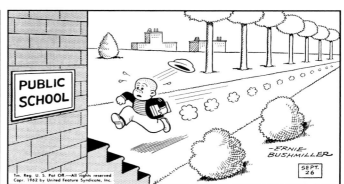

Nancy, *September 26, 1962.*

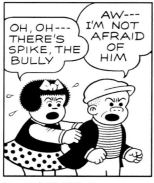

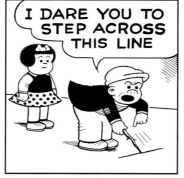

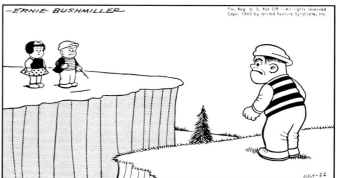

Nancy, *July 22, 1963.*

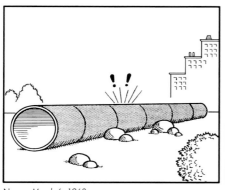

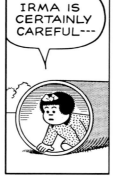

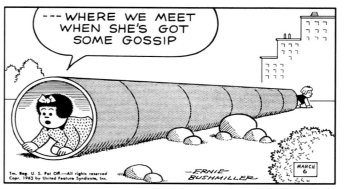

Nancy, *March 6, 1963.*

THE BACKGROUND

Location can largely be implied with little.

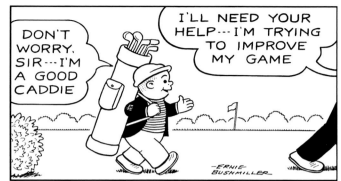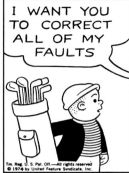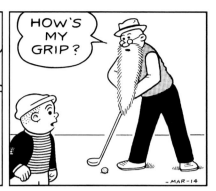

Nancy, *March 14, 1974.*

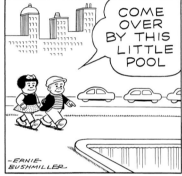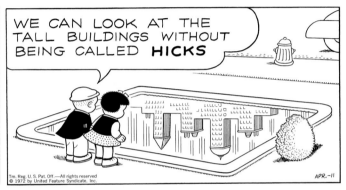

Nancy, *April 11, 1972.*

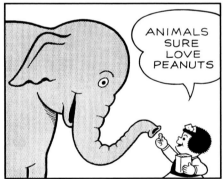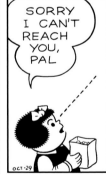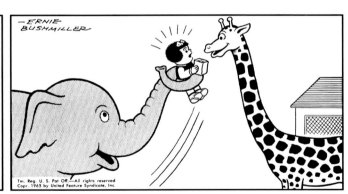

Nancy, *October 9, 1963.*

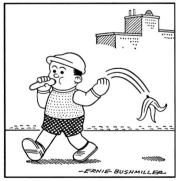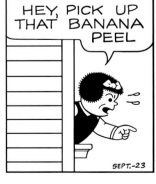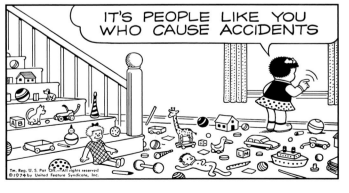

Nancy, *September 3, 1974.*

THE FENCE

Cartooning is the intentional balance of the observed and the abstract.

Nancy, April 29, 1963.

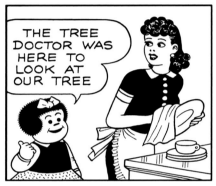 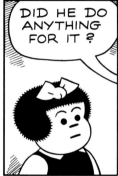 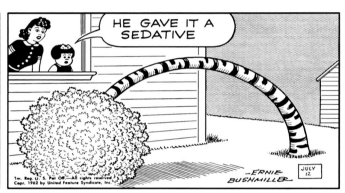

Nancy, July 12, 1962.

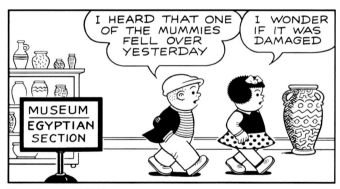 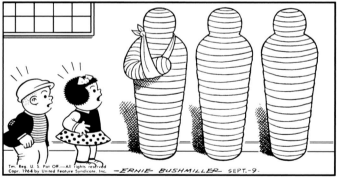

Nancy, September 9, 1964.

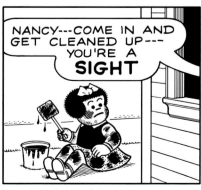 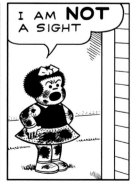 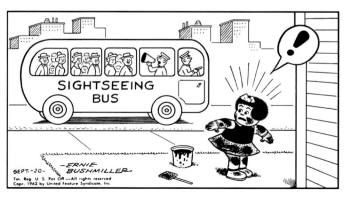

Nancy, September 20, 1962.

THE HOUSE

Solid rendering encourages belief.

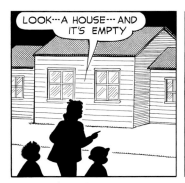

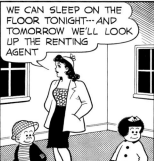

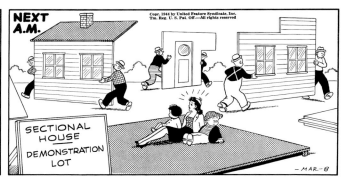

Nancy, March 8, 1944.

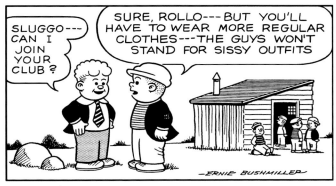

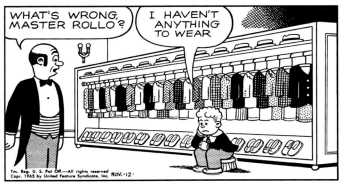

Nancy, November 12, 1963.

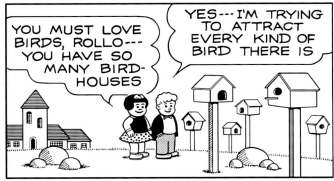

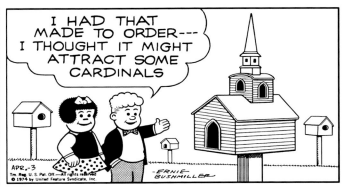

Nancy, April 3, 1974.

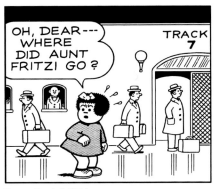

Nancy, March 4, 1964.

FORCES OF NATURE

Nature is messy, but its depiction is deliberate.

Nancy, April 16, 1949.

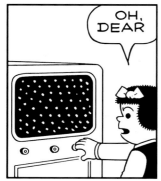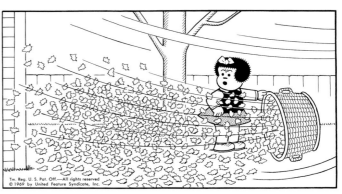

Nancy, November 8, 1969.

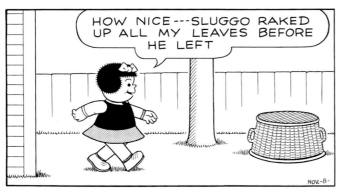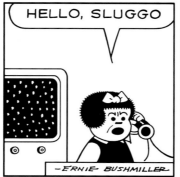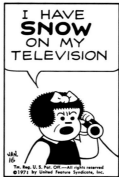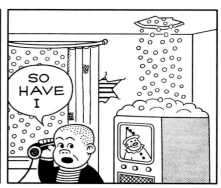

Nancy, January 16, 1971.

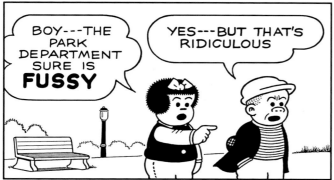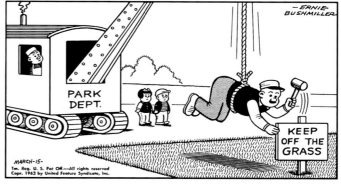

Nancy, March 15, 1963.

ACTION

In comics, all action is composition.

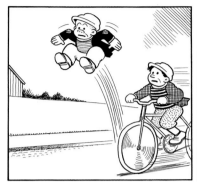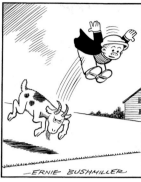

Nancy, May 1, 1948.

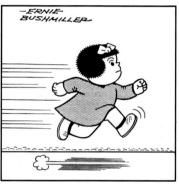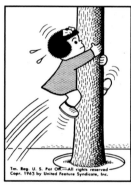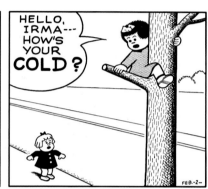

Nancy, February 2, 1963.

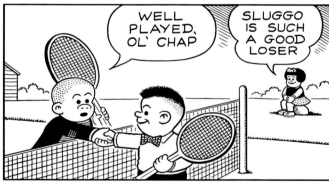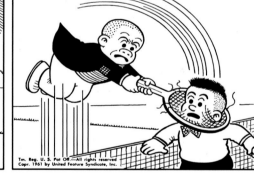

Nancy, June 10, 1961.

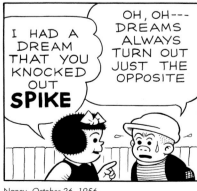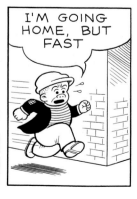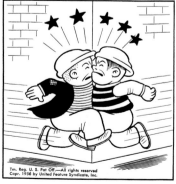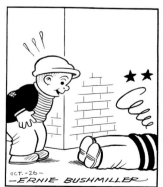

Nancy, October 26, 1956.

NANCY AND THE FENCE
Where it happens matters as much as what happens.

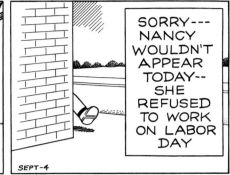

Nancy, *September 4, 1972.*

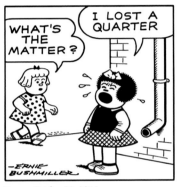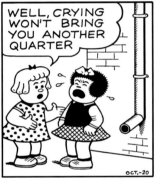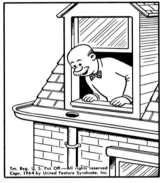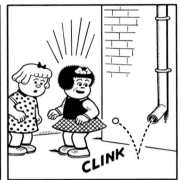

Nancy, *October 20, 1964.*

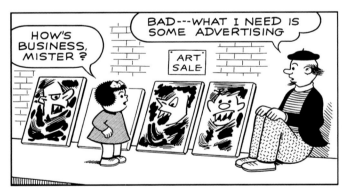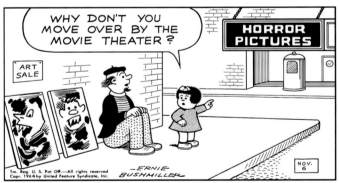

Nancy, *November 6, 1964.*

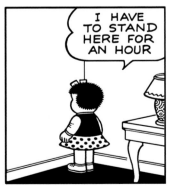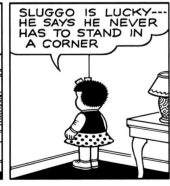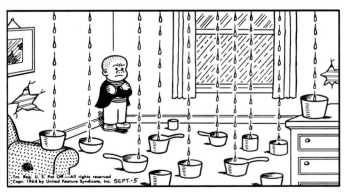

Nancy, *September 5, 1964.*

242

THE SECOND-PANEL SHIFTS

A shift in viewpoint can redefine a universe.

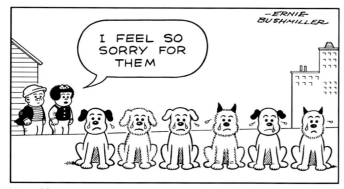
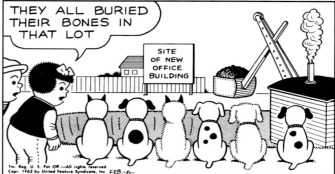

Nancy, February 6, 1963.

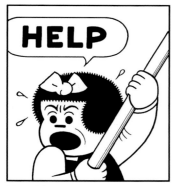
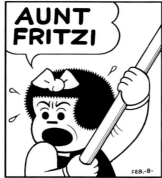
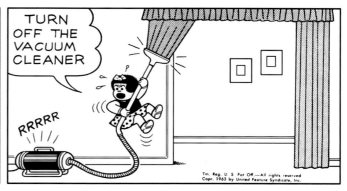

Nancy, February 8, 1963.

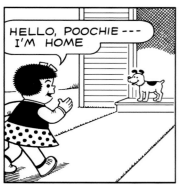
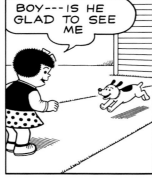
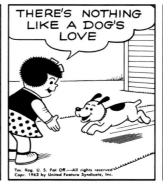
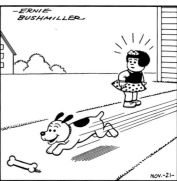

Nancy, November 21, 1962.

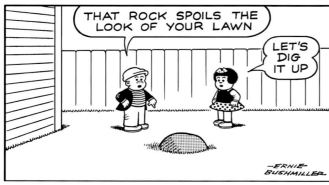
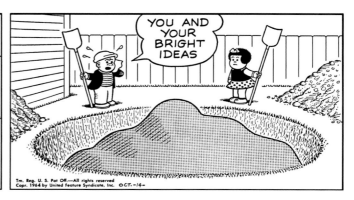

Nancy, October 14, 1964.

CHARACTER DESIGN

Characters are designed, not born.

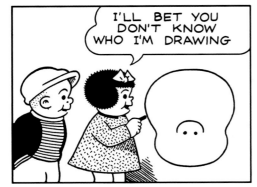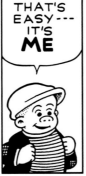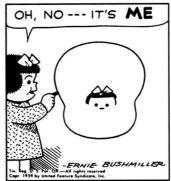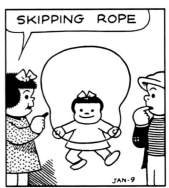

Nancy, January 9, 1954.

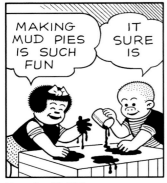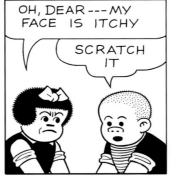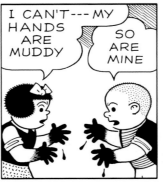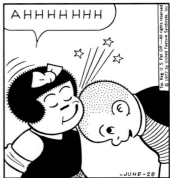

Nancy, June 28, 1972.

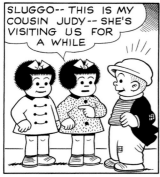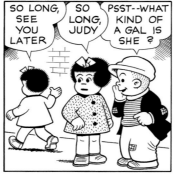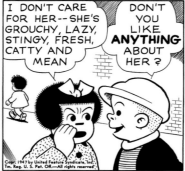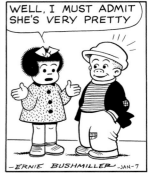

Nancy, January 7, 1947.

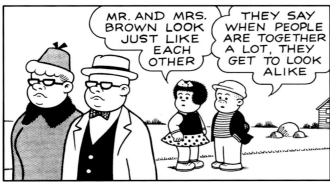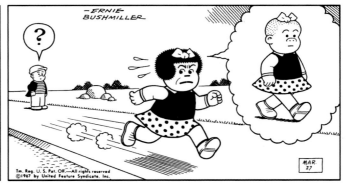

Nancy, March 27, 1967.

GESTURE

Acting is storytelling.

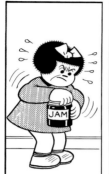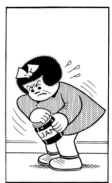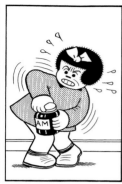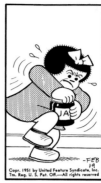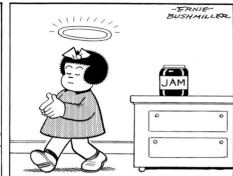

Nancy, February 19, 1951.

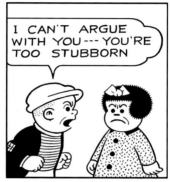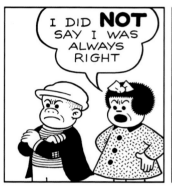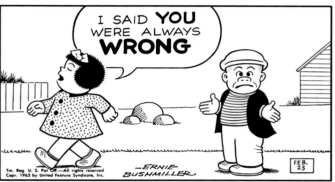

Nancy, February 23, 1963.

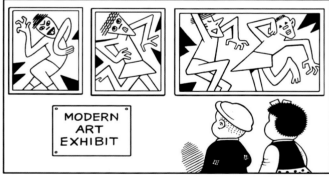

Nancy, September 30, 1964.

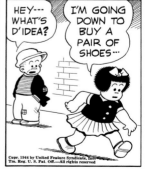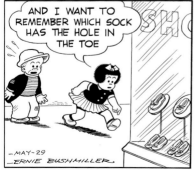

Nancy, May 29, 1944.

FACIAL EXPRESSION
Faces communicate.

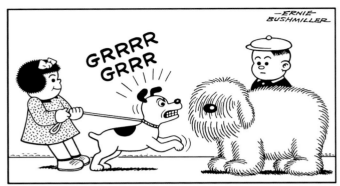
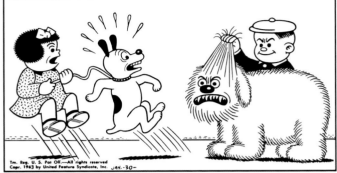

Nancy, January 30, 1963.

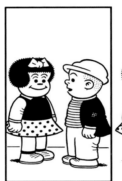
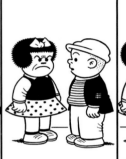
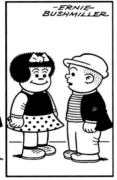
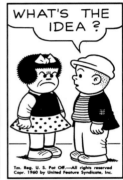
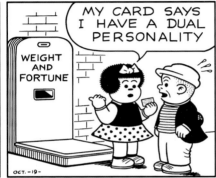

Nancy, October 19, 1960.

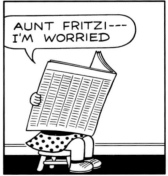
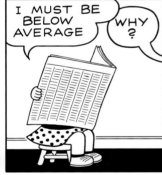

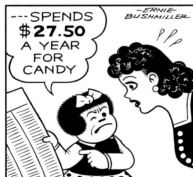

Nancy, September 7, 1962.

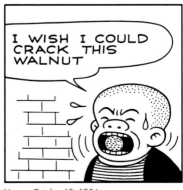
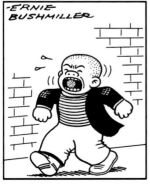
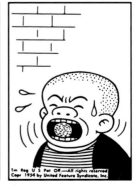
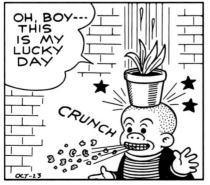

Nancy, October 13, 1954.

LINES OF VISION

Seeing seeing is believing.

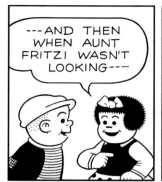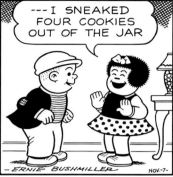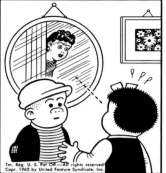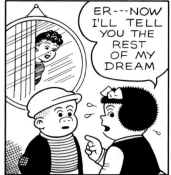

Nancy, November 7, 1963.

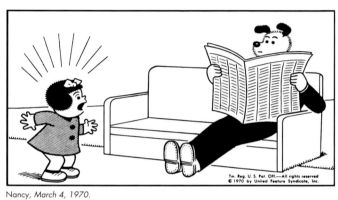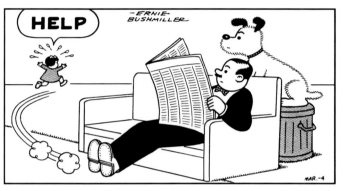

Nancy, March 4, 1970.

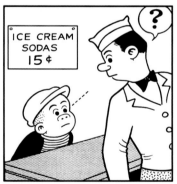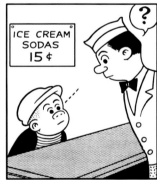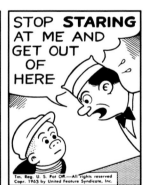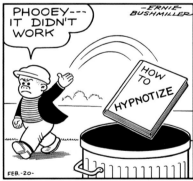

Nancy, February 20, 1963.

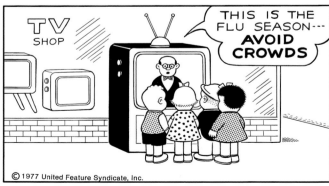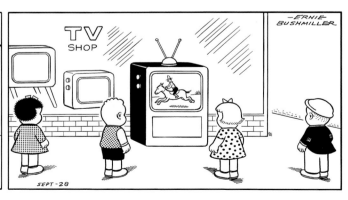

Nancy, September 28, 1977.

COMPOSITION
Good storytelling is deliberately ordered.

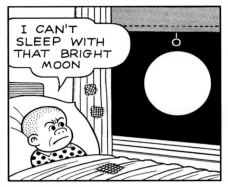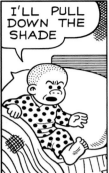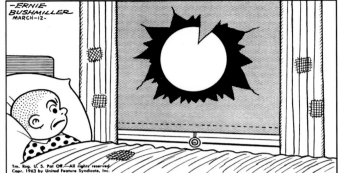

Nancy, March 12, 1963.

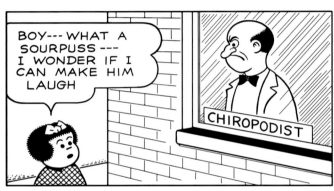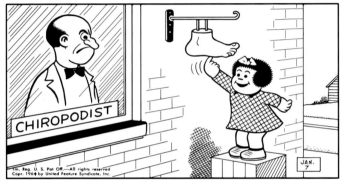

Nancy, January 7, 1964.

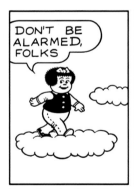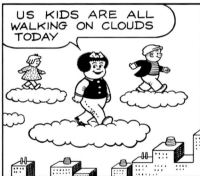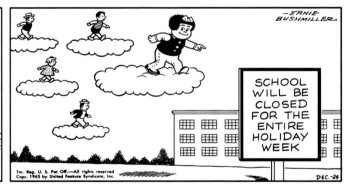

Nancy, December 24, 1963.

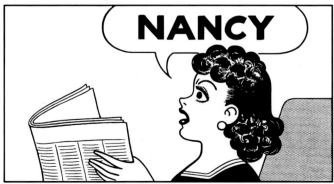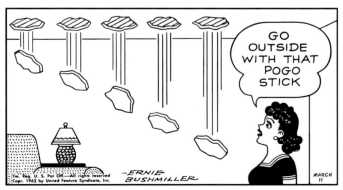

Nancy, March 11, 1963.

SPOTTING BLACKS

Solid blacks emphasize.

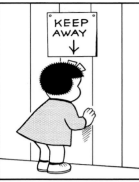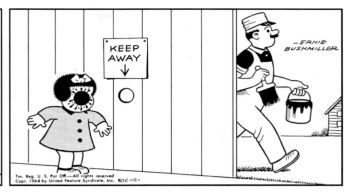

Nancy, November 11, 1964.

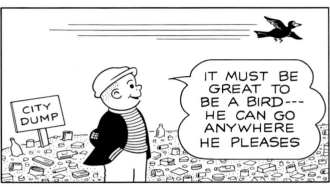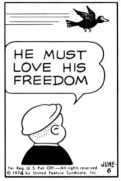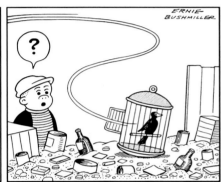

Nancy, June 6, 1974.

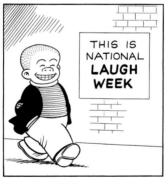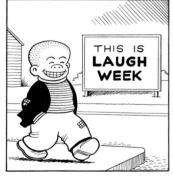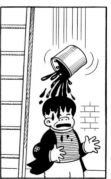

Nancy, April 3, 1946.

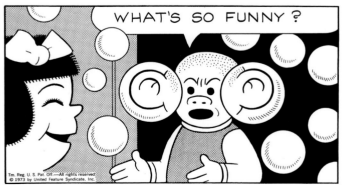

Nancy, September 27, 1973.

NEGATIVE SPACE

If black ink delivers the message, white space is the medium of delivery.

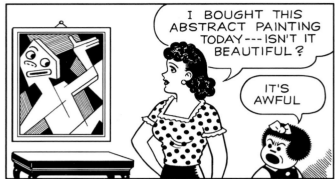

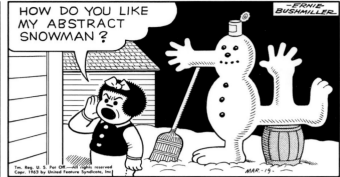

Nancy, March 19, 1963.

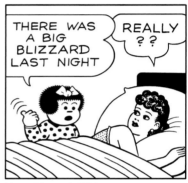

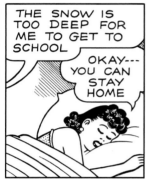

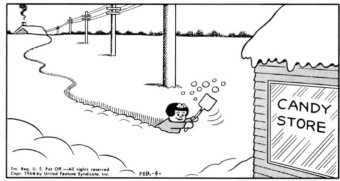

Nancy, February 4, 1964.

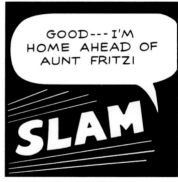

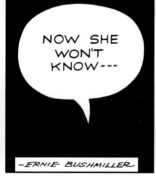

Nancy, December 19, 1962.

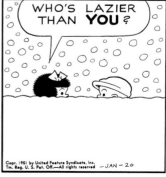

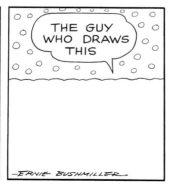

Nancy, January 20, 1951.

RHYTHM
Rhythm, rhythm, rhythm.

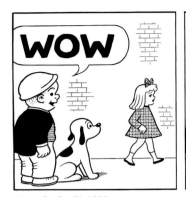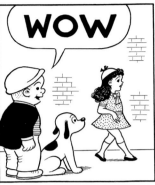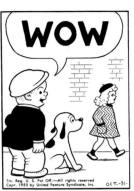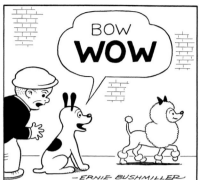

Nancy, October 31, 1955.

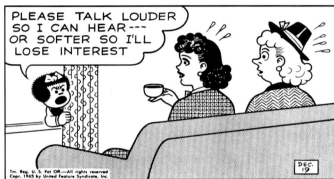

Nancy, December 19, 1963.

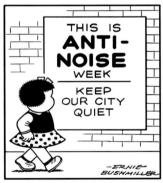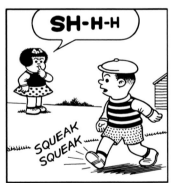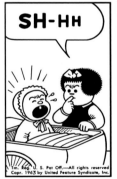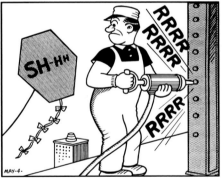

Nancy, May 4, 1963.

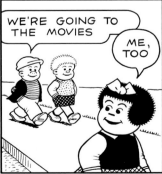

Nancy, October 9, 1964.

THE INKED LINE

In comics, all is ultimately expressed through line.

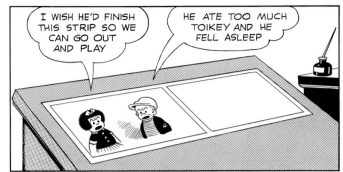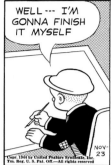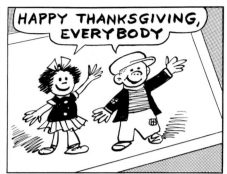

Nancy, November 23, 1944.

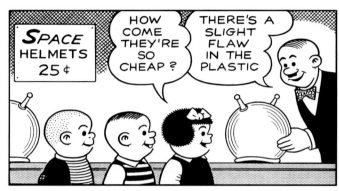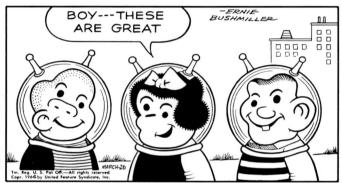

Nancy, March 26, 1964.

Nancy, August 6, 1964.

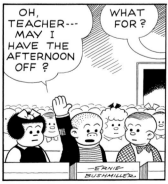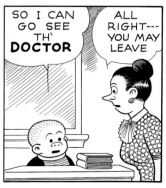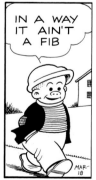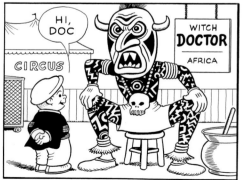

Nancy, March 18, year unknown.

LETTERING

Letters form words, and their forms compound their meaning.

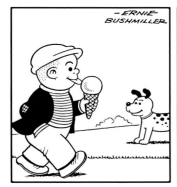
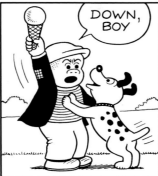
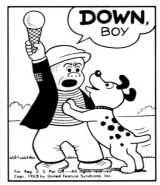
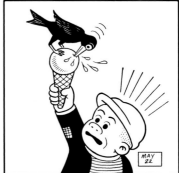

Nancy, May 22, 1963.

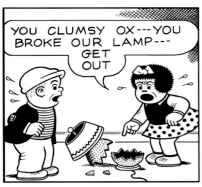
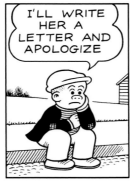
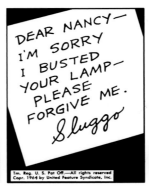
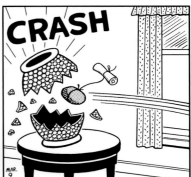

Nancy, March 9, 1964.

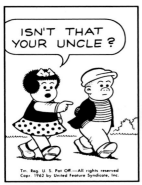
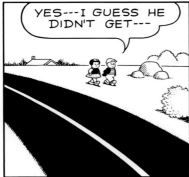
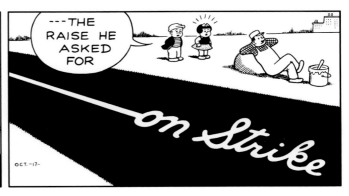

Nancy, October 17, 1962.

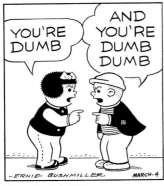
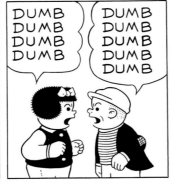
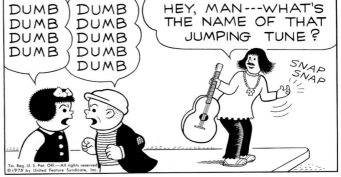

Nancy, March 4, 1975.

BALLOON DESIGN

Design facilitates content.

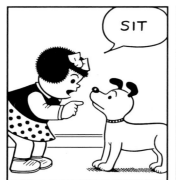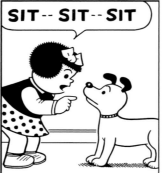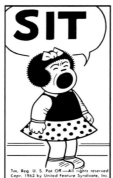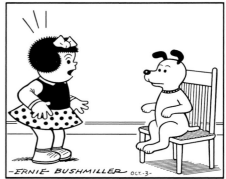

Nancy, October 3, 1962.

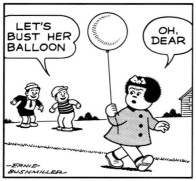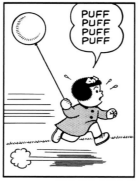

Nancy, November 28, 1964.

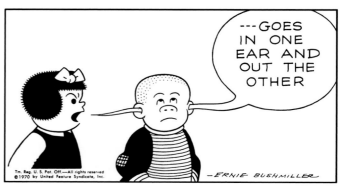

Nancy, January 14, 1970.

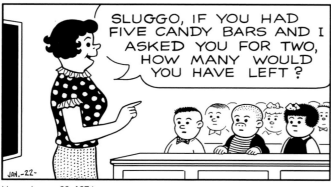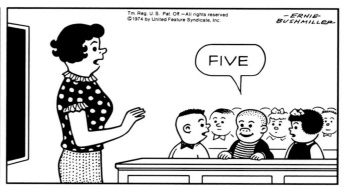

Nancy, January 22, 1974.

THE MODIFIED SILHOUETTE

A white halo around an object grants prominence.

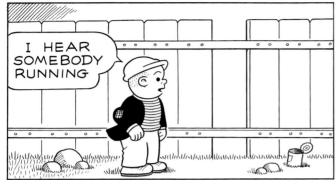
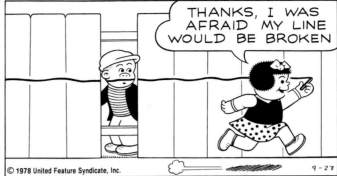

Nancy, September 23, 1978.

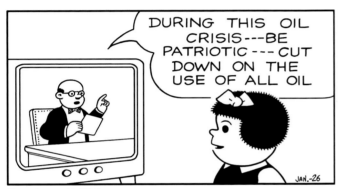
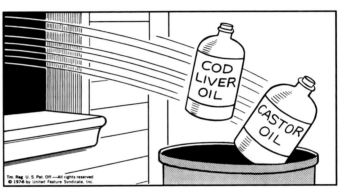

Nancy, January 26, 1974.

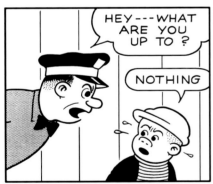

Nancy, July 8, 1963.

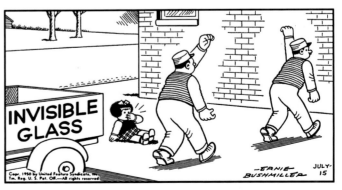

Nancy, July 15, 1950.

MOTION LINES

Movement can be invoked by pure line.

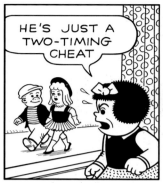
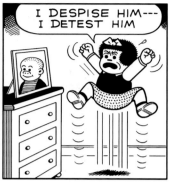
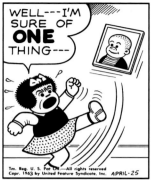
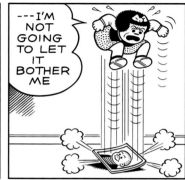

Nancy, April 25, 1963.

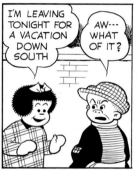
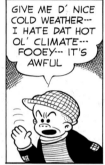
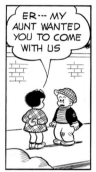
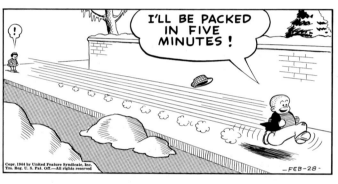

Nancy, February 28, 1944.

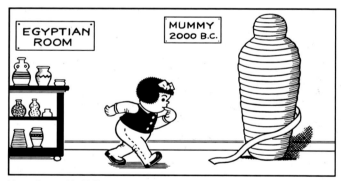
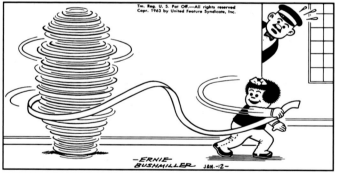

Nancy, January 12, 1963.

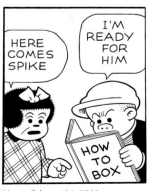
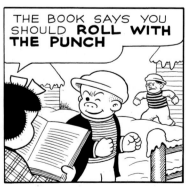
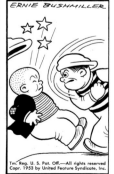
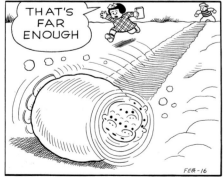

Nancy, February 16, 1953.

SURFACE PATTERN

Tone separates and clarifies.

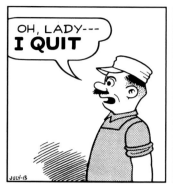

Nancy, *July 13, 1963.*

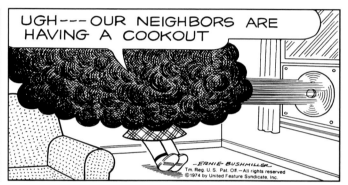

Nancy, *September 25, 1974.*

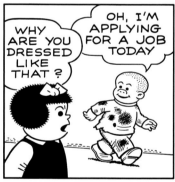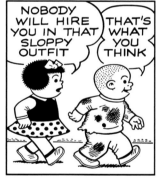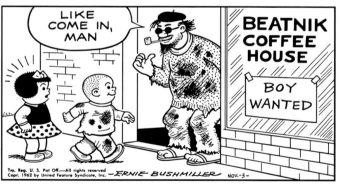

Nancy, *November 3, 1962.*

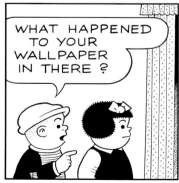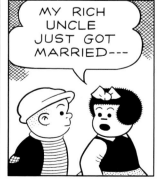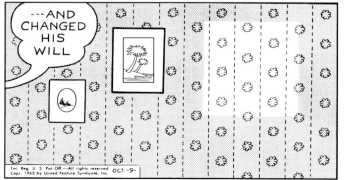

Nancy, *October 9, 1962.*

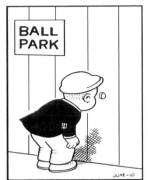
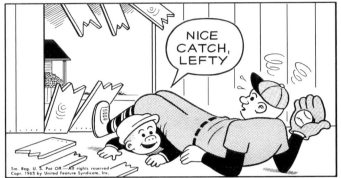

Nancy, *June 10, 1963.*

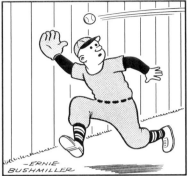
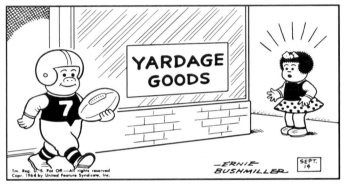

Nancy, *September 14, 1964.*

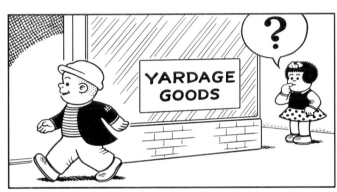
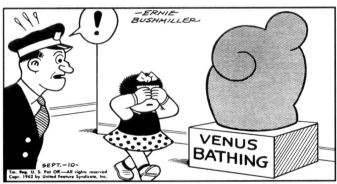

Nancy, *September 10, 1962.*

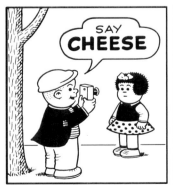
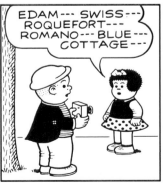
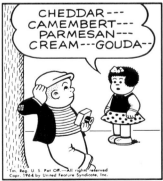
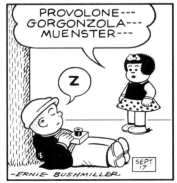

Nancy, *September 17, 1964.*

TYPE

In most creative endeavors, some conventions must be accommodated.

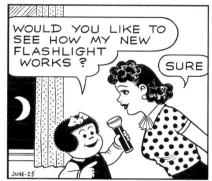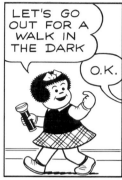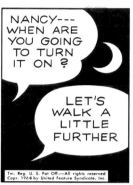

Nancy, June 25, 1964.

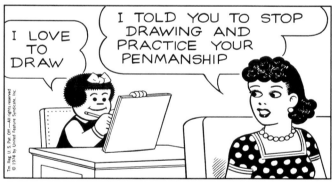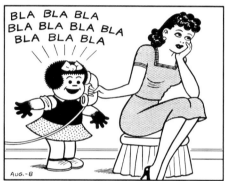

Nancy, August 8, 1963.

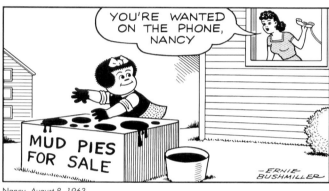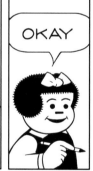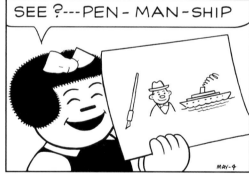

Nancy, May 4, 1974.

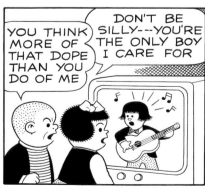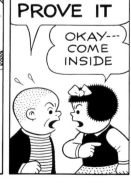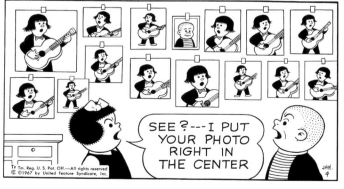

Nancy, January 9, 1967.

THE PANEL GUTTERS

In between two panels of comics, anything can happen.

Nancy, January 16, 1960.

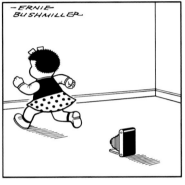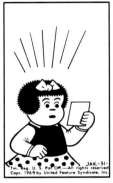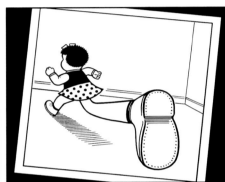

Nancy, January 31, 1964.

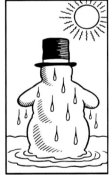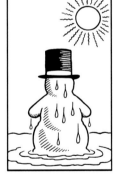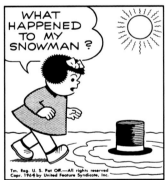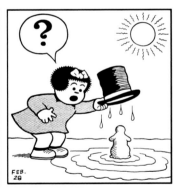

Nancy, February 28, 1964.

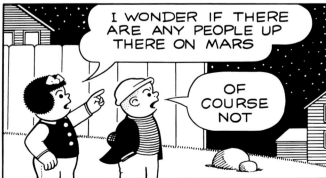

Nancy, November 20, 1974.

PANEL SIZE
Form follows function.

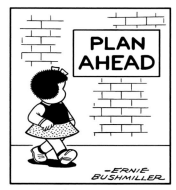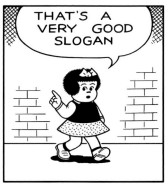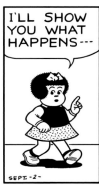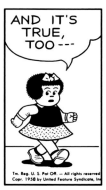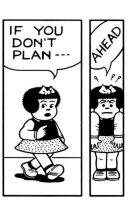

Nancy, *September 2, 1958.*

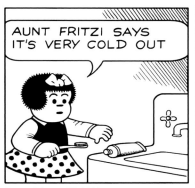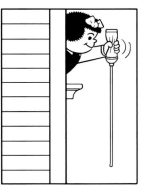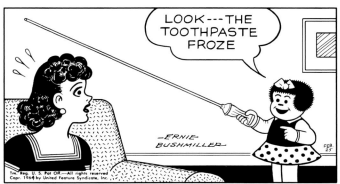

Nancy, *February 25, 1964.*

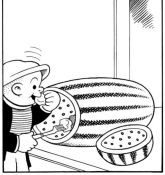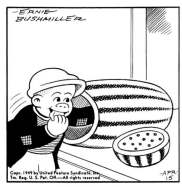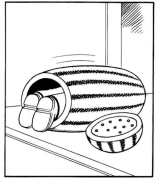

Nancy, *April 15, 1949.*

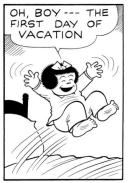

Nancy, *July 1, 1949.*

THE FOURTH PANEL
The reader completes the creative process.

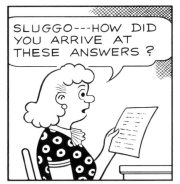
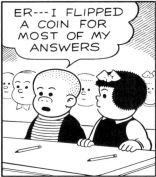
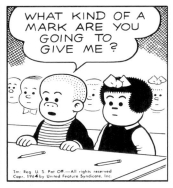
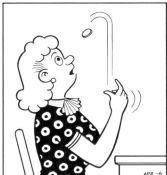

Nancy, April 6, 1964.

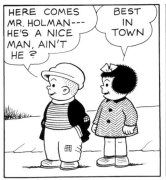
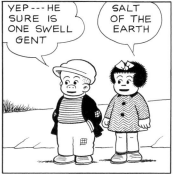
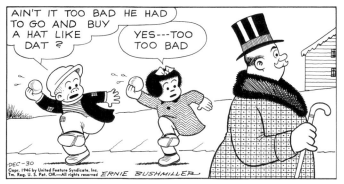

Nancy, December 30, 1946.

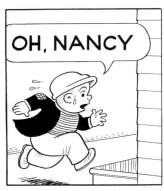
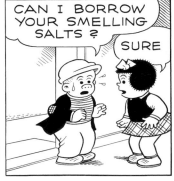
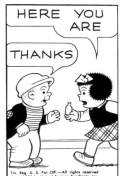
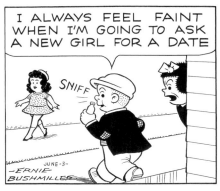

Nancy, June 3, 1955.

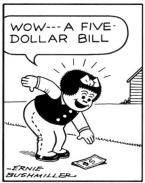
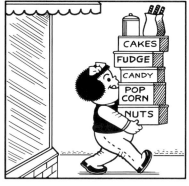
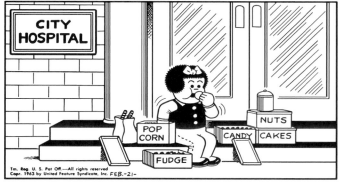

Nancy, February 21, 1963.

SELECTED BIBLIOGRAPHY

ARTICLES

NEWSPAPERS

Anderson, Tom, Gerald Hasse, Robert Carruthers, Ernie Olgivie, Myat Htoon, Gerry Kripps. "Letter to the Editor: It's Time to Retire Nancy." *Vancouver Sun*, April 22, 1976.

"The Art of Ernie Bushmiller's Nancy on Exhibit at Museum of Cartoon Art." *Comics Buyer's Guide*, May 4, 1990.

Aswell, James. "My New York." Syndicated column, July 6, 1931.

Bahn, Chester B. "And What's Wrong with Movies." *Syracuse Herald*, October 7, 1928.

—. "Drop Nize Baby for Another Year." *Syracuse Herald*, October 28, 1928.

"Becomes the Bride of Ernie Bushmiller, Fritzi Ritz Creator." *Albuquerque Journal*, July 16, 1930.

"Bushmiller Aging Fast." *Denton Chronicle Record*, October 4, 1964.

Carrier, James. "Relevant Comics . . . Cartoonists Break Old Taboos; Some Don't Change." Associated Press, January 7, 1973.

Carroll, Harrison. "Behind the Scenes in Hollywood." Syndicated column, *San Mateo Times*, August 29, 1931.

"Cartoonist Bushmiller Satisfactory." United Press International, June 6, 1980.

"Cartoons Tough Chore in Eyes of Cartoonist." *Niagara Falls Gazette*, June 23, 1957.

Cavna, Michael. "RIP United Media: A Century-Old Syndicate Closes Its Historic Doors." *Washington Post*, July 7, 2011.

"Creator of 'Nancy' Comic Strip Dies." United Press International, August 17, 1982.

"Creator of Nancy Dies at 76." Associated Press, August 17, 1982.

Crouch, Bill, Jr. "He Rises at the Crack of Noon . . . and Works Backwards." *Pittsburgh Press*, June 23, 1974.

"Daily Knave." *Oakland Tribune*, July 1, 1955.

Davis, Jim. "Around the World." *Dover* (Ohio) *Daily Reporter*, August 8, 1959.

Driscoll, Charles. "New York Day by Day." Syndicated column, July 29, 1938.

"Ernie Bushmiller, Creator of Nancy." Obituary. Wire reports, August 17, 1982.

"Ernie Bushmiller, 'Nancy' Cartoonist for 40 years; at 76." *The Advocate* (Stamford, CT), August 17, 1982.

"Ernie Bushmiller, 76, Is Dead: Drew Nancy for Half Century." *New York Times*, August 17, 1982.

"Ernie Bushmiller's Nancy to Join Times Comic Strip Family Monday." *Geneva Times*, February 5, 1960.

Fine, Dr. Benjamin. "Study Being Organized: Good Comics Said Helpful." *Charleston Gazette-Mail*, November 8, 1959.

"Freeman Adds 'Nancy' Strip." *Kingston Daily Freeman*, May 25, 1967.

"Fritzi Ritz, Bushmiller's 'Best Girl,' Comes to Entertain Review's Readers." *Hayward Review*, September 27, 1930.

"Funniest Picture We've Ever Made." *Northport Observer*, July 21, 1949.

Gold, Julie Anne. "Creator Of 'Nancy' Comic Strip Cartoonist Ernie Bushmiller, 76, Dies." Untraced newspaper clipping, 1982.

Gross, Milt. "Walter Winchell on Broadway." Syndicated column, July 6, 1939.

"Honor Awarded to Cartoonist." *Bridgeport Post*, May 16, 1962.

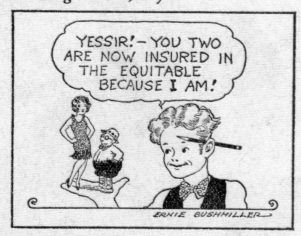

Product endorsement, 1927.

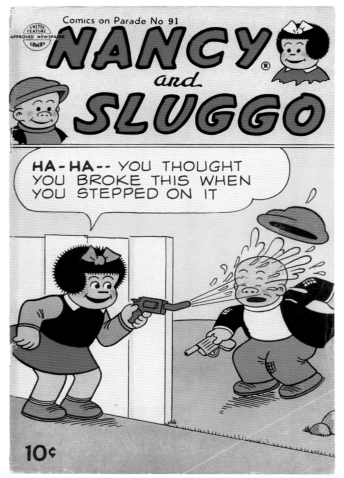

Comic book, United Feature Syndicate, 1951.

Irwin, Virginia. "Nancy." *St. Louis Post-Dispatch*, February 13, 1949.

"Jazz Benefit May 3 to Feature Barber and Five Fanatics." *Wilton Bulletin*, April 27, 1957.

"John Pierotti Dies; Editorial Cartoonist for New York Post." *New York Times*, May 7, 1987.

Kelly, Daniel P. "Award Winning Comic Strip Artists Are Poles Apart." *Milwaukee Journal*, September 7, 1977.

Kidwell, Brian. "New Look for Nancy?" *Oswego Palladium-Times*, June 6, 1983.

Kingsley, Grace. "Edward Small Makes Talkies." *Los Angeles Times*, August 2, 1928.

—. "Nize Baby Has Troubles." *Los Angeles Times*, October 11, 1928.

"LaSalle Girl, Named for 'Nancy,' to See Uncle's Humor in Gazette." *Niagara Falls Gazette*, September 21, 1957.

"Last Panel Drawn First by Cartoonist Creator of Nancy in Tribune-Sun." *San Diego Tribune-Sun*, August 9, 1948.

"Latest Gossip." *San Mateo Times*, August 29, 1931.

Los Angeles Evening Mirror-News, August 8, 1959.

Maeder, Jay. "Tales of Incredible Shrinking Comics." *Baltimore Sun*, September 30, 1979.

McIntyre, O.O. "New York Day by Day." Syndicated column, March 30, 1933.

McQuade, C.J. "Bug Dust: Nancy Joins Comics Family on Monday." *Raleigh Register*, April 23, 1961.

Meegan, Owen D. "Letter to the Editor." *Idaho State Journal*, December 15, 1974.

Mickleburgh, Ron. "Carry on, Nancy." *Vancouver Sun*, April 28, 1976.

"Nancy and Her Dad." *Pittsburgh Press*, July 1, 1962.

"Nancy Comic Starts in Herald Monday." *Hagerstown Morning Herald*, September 19, 1947.

"Nancy, Sluggo, Fritzi Ritz Coming to C-A." *Auburn Citizen Advertiser*, January 26, 1961.

"Nancy Top Comic in Popularity." *Elyria Chronicle-Telegram*, April 15, 1955.

"Nancy Turns 40 This Year, but Fans Say She's Timeless." *Elyria Chronicle-Telegram*, July 13, 1980.

"'Nancy' Wrote Back!" *Yonkers Herald Statesman*, April 24, 1971.

New York Times, August 8, 1959.

Olmstead, Fred. "Case of Nancy vs. E.Z. Life." *Detroit Free Press*, October 5, 1948.

"The Other Monday Newcomer . . ." *Greenville Record-Argus*, November 19, 1958.

Ouston, Rick. "Death of Comic Nancy's Creator Leaves Long-Running Strip in Air." *Vancouver Sun*, August 18, 1982.

"Post-Dispatch Comic Artists: Ernie Bushmiller Creator of 'Nancy.'" *St. Louis Post-Dispatch*, October 14, 1951.

Richard E. Grace (obituary). *Cape Cod Times*, January 31, 2007.

Rockmore, Milton. "What's Funny?" *Hartford Courant*, December 25, 1975.

Schneebaum, Suzanne, and Elsie Levite. "Bushmiller Brainchild Cuts Caper in Comics." Untraced newspaper clipping, 1946.

"Self Portraits (Famous Artists Who Live the Life of Easel Here)." *The Advocate* (Stamford, CT), undated clipping, c. 1960s.

Smucker, Tom. "Deep in the Heart of Dallas." *Village Voice*, November 23, 1982.

Taylor, Charles. "The Zen of Nancy." *Boston Phoenix*, June 20, 1997.

"This Is About Ernie Bushmiller Who Draws Me." *New Haven Register*, January 18, 1959.

Thomasville Times-Enterprise, August 8, 1959.

Updegraff, Marie. "Man Who Can Laugh at Himself Says There's Gag in Everything." *The Advocate* (Stamford, CT), December 24, 1966.

Webb, Dewey. "What's It All About, Nancy?" *New Times*, November 30, 1988.

Winchell, Walter. "Walter Winchell on Broadway." Syndicated column, July 21, 1930.

MAGAZINES

Bushmiller, Ernest. "Amateur Knights of the Pencil." *Judge*, October 2, 1925.

Bushmiller, Ernie. "Comics — and Their Creators." *Literary Digest*, September 1934.

—. "Nancy and Me." *Collier's*, September 18, 1948.

—. "Art Show." *Pageant*, July 1950.

Capp, Al. "Fifteen Minutes with Al Capp." *Pageant*, September 1951.

"Cartoons Teach Physics with a Smile." *Popular Mechanics*, June 1948.

Crouch, Bill, Jr. "An Interview with Ernie Bushmiller." *Foreign Comic Reviews*, 1973.

Davis, Hartley. "The Journalism of New York." *Munsey's Magazine*, November 1900.

Farber, Manny. "Comic Strips." *New Republic*, September 4, 1944.

"The Funny Papers." *Fortune*, April 1933.

Harkins, John. "H.T. Webster." *Life*, November 1932.

"Ingenuities," New York *World Magazine*, Sundays, 1921–1925.

Johnson, Ray. Interview with Randy Delbeke and Diane Spodarek. *The Detroit Artists Monthly*, February 1978.

LeWitt, Sol. "Paragraphs on Conceptual Art." *Artforum*, June 1967.

Murtfeldt, Edward W. "The Making of a Funny." *Popular Science*, January 1940.

Plumb, Charlie. "Inside the Funny Papers." *Esquire*, April 14, 1942.

"Presenting the Rise of Ernie Bushmiller Creator of Fritzi Ritz." *United Comics* vol. 1, no. 1, August 1940.

"The Press: Nancy, Sluggo, and Ernie." *Newsweek* vol. 31, no. 26, August 1948.

"The Press: Red Magic." *Time*, November 24, 1924.

"Red Magic." New York *World*, Sundays, 1924–1925.

Spencer, Herbert. "The Physiology of Laughter." *Macmillan's*, March 1860.

TV Guide, August 8–14, 1959.

Wood, Wallace (pictures). "Nansy." *Mad*, April 1957.

JOURNALS

"And Now Fritzi Ritz . . . " United Feature Syndicate (advertisement). *Editor and Publisher*, November 20, 1938.

Brainard, Joe. *The Avant-Garde: Art News Annual XXXIV*, 1968.

Bushmiller, Ernie. "Best Wishes." *Washington and Lee University Bulletin*, vol. 47, no. 4, 1948.

—. "Million Dollar Decision." *The Cartoonist*, Summer 1953.

Dunn, Bob. "Said and Dunn." *Cartoonist Profiles*, no. 20, 1973.

—. "Said and Dunn." *Cartoonist Profiles*, no. 33, 1977.

"For Leadership in Readership . . . " United Feature Syndicate (advertisement). *Editor and Publisher*, March 1, 1958.

Fremion, Yves. *"Le Plagiare Plagie 'L'Arroseur Arrosé' et Ses Inventeurs."* *Papiers Nickeles*, no. 32, 1st Trimester 2012.

Guptill, Arthur L. "Technical Hints from Artists' Studios: Films for Ben-Day Effects. (Tenth in a Series)" *Art Instruction*, February 1939.

Heintjes, Tom. "Punch Lines: Ernie Bushmiller's Mac the Manager." *Hogan's Alley*, no. 10, Summer 2002.

Klein, I. "Memories of Milt Gross." *Cartoonist Profiles*, no. 14, 1973.

Levin, Hugh L. "Limited Edition Comic Art from Famous Fine Art Book Publisher." *Cartoonist Profiles*, no. 51, 1981.

"Meet Nancy." United Features Syndicate (advertisement), *Editor and Publisher*, December 18, 1937.

Mendelson, Lee. "The Fabulous Funnies!" *The Cartoonist*, January 1968.

"Most Popular Strip We Have." United Features Syndicate (advertisement), *Editor and Publisher*, June 11, 1938.

"Movie Crazy." *Hollywood Reporter*, September 26, 1932.

"Nancy . . . Voted Most Popular." United Features Syndicate (advertisement), *Editor and Publisher*, December 3, 1949.

"Nancy . . . 1st Again." United Features Syndicate (advertisement), *Editor and Publisher*, July 6, 1950.

Pew, Marlen E., Jr. "Ernie Bushmiller Changes Name of Strip to 'Nancy.'" *Editor and Publisher*, July 11, 1938.

—. "Ernie Bushmiller Renews United Feature Contract." *Editor and Publisher*, July 12, 1939.

Randall, S.N. "Your Friend the Engraver: The Ben Day Process." *Art Instruction*, December 1937.

—. "Your Friend the Engraver: Color Reproduction by the Ben Day Method." *Art Instruction*, August 1938.

Rickman, Lance. "Bande Dessinée and the Cinematograph: Visual Narrative in 1895." *New Journal*, University of Liverpool Press, 2009.

Sadler, Peter, Gerhard Sonnert, Marc S. Schwartz, and Robert H. Tai. "Depth Versus Breadth: How Content Coverage in High School Courses Relates to Later Success in College Science Coursework." *Science Education*, September 2009.

Schnurer, Herman. "Notes on the Comic Strip." *Antioch Review,* vol. 1, no. 2, Summer 1941.

Sheridan, Martin. "He Led Double Life and Became Cartoon Star." *American Press*, March 1937.

Shortz, Will. "Ephemera Offers a Clue to Crossword Origins." *Ephemera News,* vol. 19, no. 4, Summer 2001.

Shulman, David. "How It Began." *Word Ways, The Journal of Recreational Linguistics*, Butler University Press, February 1969.

Smolderen, Thierry. "A Chapter on Methodology." *Signs, the International Journal for the History of Early Comics and Sequential Art,* Supplement no. 2/01, 2011.

Staunton, Helen M. "And So Ernie Bushmiller Got Kidnapped by Nancy." *Editor and Publisher*, September 8, 1945.

"United Feature Syndicate Buys Metropolitan Service from Elser." *Editor and Publisher*, March 15, 1930.

Walker, Brian. "Dumb It Down." *Nemo: The Classic Comics Library*, April 1989.

"Was Nancy Used by Numbers Players?" *Editor and Publisher*, August 28, 1982.

Watson, Karil K., Benjamin J. Matthews, and John M. Allman. "Brain Activation During Sight Gags and Language Dependent Humor." *Cerebral Cortex*, February 2007.

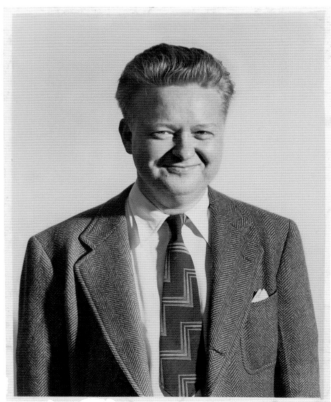

Publicity portrait, 1940s.

Weiss, Jerry N. "The Artist's Life." *Artist's Magazine*, July/August 2011.

Winchell, Walter. "The Wisecrack and the Gag." *The Bookman: A Review of Books and Life*, October 1927.

"The Winner on Everyone's Ballot." United Feature Syndicate (advertisement), *Editor and Publisher*, July 16, 1960.

BOOKS

Adams, Laurie Schneider. *The Methodologies of Art: An Introduction*. Boulder, CO, and London: Westview Press, 1996.

Adler, Mortimer J., and Charles Van Doren. *How to Read a Book*. Rev. ed. New York: Simon and Schuster, 1972.

Allen, John Edward. *Newspaper Makeup*. New York: Harper & Brothers, 1936.

American Heritage Dictionary. Boston: American Heritage/Houghton Mifflin, 1973

Arnheim, Rudolf. *Art and Visual Perception*. Berkeley: University of California Press, 1954.

—. *Visual Thinking*. Berkeley: University of California Press, 1969.

Arnold, Edmund C. *Functional Newspaper Design*. New York: Harper & Row, 1963.

—. *Ink on Paper*. New York: Harper & Row, 1963.

—. *Modern Newspaper Design*. New York: Harper & Row, 1969.

—. *Designing the Total Newspaper*. New York: Harper & Row, 1981.

Baker, Nicholson, and Margaret Brentano. *The World on Sunday*. New York: Bullfinch Press, 2005.

Baker, Stephen. *Advertising Layout and Art Direction*. New York, Toronto, and London: McGraw-Hill, 1959.

Balducci, Anthony. *The Funny Parts: A History of Film Comedy Routines and Gags*. Jefferson, NC, and London: McFarland, 2012.

Bang, Molly. *Picture This: Perception and Composition*. Boston: Little, Brown, 1991.

Barrett, James Wyman. *The End of The World: A Post-Mortem by Its Intangible Assets*. New York: Harper & Brothers, 1931.

—. *The World the Flesh and Messrs. Pulitzer*. New York: Vanguard Press, 1931.

Becker, Stephen. *Comic Art in America*. New York: Simon and Schuster, 1959.

The Best of Uncle John's Bathroom Reader. Ashland, OR: Portable Press, 2002.

Boardwell, David, and Kristin Thomas. *Film Art*. 5th ed. New York: McGraw-Hill, 1997.

Boylan, James, ed. *The World and the 20's: The Golden Years of New York's Legendary Newspaper*. New York: Dial Press, 1973.

Brainard, Joe. *The Nancy Book*. Los Angeles: Siglio Press, 2008.

Briggs, Clare. *How to Draw Cartoons*. New York: Harper & Brothers, 1926.

Bringhurst, Robert. *The Elements of Typographic Style*. 2nd ed. Port Roberts, MA: Hartley and Marks, 1997.

Bruce, Vicki, and Andy Young. *In the Eye of the Beholder*. Oxford: Oxford University Press, 1998.

Buranelli, Prosper, F. Gregory Hartswick, and Margaret Petherbridge, eds. *The Cross Word Puzzle Book, First Series*. New York: Simon and Schuster, 1924.

Burke, Edmund. *A Philosophical Enquiry into the Origin of Our Ideas of the Sublime and Beautiful*. 1757. Reprint. Oxford: Oxford University Press, 1990.

Bushmiller, Ernie. *Nancy Has Fun!* Racine: Whitman, 1944.

—. *Nancy and Sluggo*. Racine: Whitman, 1946.

—. *The Fun-Filled Cartoon Adventures of Nancy*. New York: Pocket Books, 1960.

—. *Nancy & Sluggo*. New York: Pocket Books, 1976.

—. *Nancy Eats Food*. Princeton: Kitchen Sink Press, 1989.

—. *How Sluggo Survives*. Princeton: Kitchen Sink Press, 1989.

—. *Nancy's Dreams and Schemes*. Princeton: Kitchen Sink Press, 1990.

—. *Nancy: Bums, Beatniks and Hippies/Artists and Con Artists*. Princeton: Kitchen Sink Press, 1991.

—. *Nancy's Pets*. Princeton: Kitchen Sink Press, 1991.

—. *Everything I Needed to Know I Learned from Nancy*. Edited by Kevin McDonough. New York: Pharos Books, 1992.

—. *Nancy Is Happy, Dailies 1943–1945*. Edited by Kim Thompson. Seattle: Fantagraphics Books, 2012.

—. *Nancy Likes Christmas, Dailies 1946–1948*. Edited by Kim Thompson. Seattle: Fantagraphics Books, 2012.

—. *Nancy Loves Sluggo, Dailies 1949–1951*. Edited by Eric Reynolds. Seattle: Fantagraphics Books, 2015.

Cahn, William. *Harold Lloyd's World of Comedy*. New York: Duell, Sloan & Pearce, 1964.

Carrier, David. *The Aesthetics of Comics*. University Park: Pennsylvania State University Press, 2000.

Castleman, H., and W. Podrazik. *The TV Schedule Book: Four Decades of Network Programming from Sign-on to Sign-off*. New York: McGraw-Hill, 1984.

Chomsky, Noam. *Reflections on Language*. New York: Pantheon, 1975.

Ciardi, John, and Miller Williams. *How Does a Poem Mean?* 2nd ed. Boston: Houghton Mifflin, 1975.

Cohen, Lester. *The New York Graphic: The World's Zaniest Newspaper*. New York and Philadelphia: Chilton, 1964.

Collins English Dictionary, Complete and Unabridged. New York: HarperCollins, 2003.

Cooke, Harry T. *The Borough of the Bronx*. New York: Harry T. Cook, 1913.

Crafton, Donald. *Before Mickey*. Chicago: University of Chicago Press, 1990.

—. *Emile Cohl: Caricature and Film*. Princeton: Princeton University Press, 1990.

Crowe, Cameron. *Conversations with Wilder*. New York: Alfred A. Knopf, 1999.

Dale, Edgar. *How to Read a Newspaper*. Chicago, Atlanta, Dallas, and New York: Scott Foresman, 1941.

Eastman, Max. *Enjoyment of Laughter*. New York: Simon and Schuster, 1936.

Eisner, Will. *Graphic Storytelling and Visual Narrative*. Rev. ed. New York: W.W. Norton, 2008.

Elkins, James. *The Object Stares Back*. New York: Harcourt, 1996.

—. *How to Use Your Eyes*. New York and London: Routledge, 2000.

Fell, John L. *Film and the Narrative Tradition*. Berkeley and Los Angeles: University of California Press, 1974.

Freud, Sigmund. *Jokes and Their Relation to the Unconscious*. Translated and edited by James Strachey. New York and London: W.W. Norton, 1963.

Frey, Albert Wesley. *Advertising*. New York: Roland Press, 1947.

Frost, A.B. *Stuff and Nonsense*. 2nd ed. New York: Charles Scribner's Sons, 1888.

Garland, Ken. *Mr. Beck's Underground Map*. London: Capital Transport, 1994.

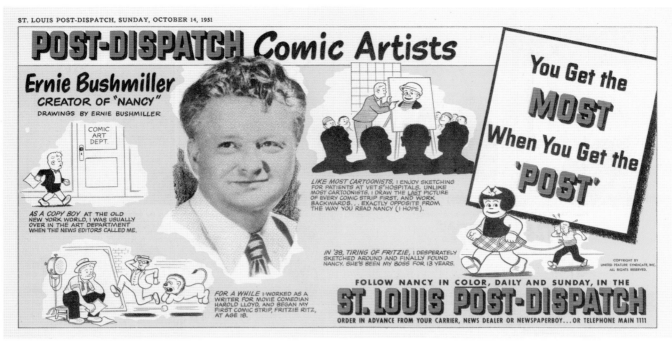

St. Louis Post-Dispatch, *October 14, 1951.*

Gauvreau, Emile. *My Last Million Readers*. New York: E.P. Dutton, 1941.

Gombrich, E.H. *Art and Illusion: A Study in the Psychology of Pictorial Representation*. New York: Pantheon Books, 1960.

Gregory, Richard. *Eye and Brain*. Princeton: Princeton University Press, 1997.

Heer, Jeet, and Kent Worchester. *A Comics Studies Reader*. Jackson: University of Mississippi Press, 2008.

Hemingway, Ernest. *Death in the Afternoon*. New York: Charles Scribner's Sons, 1932.

Holland, Norman N. *Laughing: A Psychology of Humor*. Ithaca and London: Cornell University Press, 1982.

Holtz, Allen. *American Newspaper Comics: An Encyclopedic Reference Guide*. Ann Arbor: University of Michigan Press, 2012.

Hubel, David H., and Torsten N. Wiesel. *Brain and Visual Perception*. New York: Oxford University Press, 2005.

Jenkins, Henry. *What Made Pistachio Nuts? Early Sound Comedy and the Vaudeville Aesthetic*. New York: Columbia University Press, 1992.

Josefsberg, Milt. *Comedy Writing for Television and Hollywood*. New York: Perennial Library, 1987.

Kahn, E.J., Jr. *The World of Swope*. New York: Simon and Shuster, 1965.

Kerr, Walter. *The Silent Clowns*. New York: Alfred A. Knopf, 1975.

Kleppner, Otto. *Advertising Procedure*. 4th ed. New York: Prentice-Hall, 1950.

Koenigsberg, Moses. *King News: An Autobiography*. New York: F.A. Stokes, 1941.

Kress, Gunther, and Theo van Leeuwen. *Reading Images*. New York and London: Routledge, 2006.

Kunzle, David. *The History of the Comic Strip: The Nineteenth Century*. Oakland, CA: University of California Press, 1990.

Laozi. *Tao Te Ching*. New York: Modern Library, 1993.

Leonardo da Vinci. *A Treatise on Painting*. Amherst: Prometheus Books, 2002.

Lindenblatt, Jeffrey, ed. *Frederick Burr Opper's Happy Hooligan*. Introduction by Allen Holtz. New York: Nantier Beall Minoustchine, 2008.

Livingstone, Margaret. *Vision and Art*. New York: Abrams, 2008.

Macfadden, Mary, and Emile Gauvreau. *Dumbbells and Carrot Strips: The Story of Bernarr Macfadden*. New York: Henry Holt, 1953.

Mallen, Frank. *Sauce for the Gander*. White Plains, NY: Baldwin Books, 1954.

Marschall, Rick. *America's Great Comic-Strip Artists*. New York: Abbeville Press, 1989.

Martin, Rod A. *The Psychology of Humor: An Integrative Approach*. Burlington, MA, London, & San Diego: Elsevier Academic Press, 2007.

McCloud, Scott. *Understanding Comics*. New York: Harper Perennial, 1993.

McShine, Kynaston. *Andy Warhol: A Retrospective*. New York: Museum of Modern Art, 1989.

Michaelis, David. *Schulz and Peanuts: A Biography*. New York: HarperCollins, 2007.

Monaco, James. *How to Read a Film: Movies, Media, Multimedia*. 3rd ed. New York and Oxford: Oxford University Press, 2000.

Nixon, H.K. *Principles of Advertising*. New York, Toronto, and London: McGraw-Hill, 1937.

Paulus, Tom, and Rob King, eds. *Slapstick Comedy* (AFI Film Readers Series). New York and London: Routledge, 2010.

Reilly, Adam. *Harold Lloyd: The King of Daredevil Comedy*. New York: Collier Books, 1977.

Ross, Nelson E. *How to Write Telegrams Properly*. Lancaster, PA: A Little Blue Book, Haldeman-Julius, c. 1928.

Rothkopf, Katherine, Richard R. Brettell, and Charles S. Moffett. *Impressionists on the Seine: A Celebration of Renoir's Luncheon of the Boating Party*. Washington, DC: Counterpoint, 1996.

Saunders, David. *H.J. Ward*. St. Louis: Illustrated Press, 2010.

Sheridan, Martin. *Comics and Their Creators*. Boston: Hale, Cushman & Flint, 1942.

Skutch, Ira, ed. *Five Directors: The Golden Years of Radio* (A Directors Guild of America Oral History, Series No. 15). Lanham, MD, and London: Scarecrow Press, 1998.

Smithson, Robert. *Robert Smithson: The Collected Writings*. Berkeley and Los Angeles: University of California Press, 1996.

Smolderen, Thierry. *The Origins of Comics: From William Hogarth to Winsor McCay*. Jackson, MS: The University of Mississippi Press, 2014.

The Snappy Thinking Cross Word Puzzle Book No. 1. New York: M.S. Publishing Company, 1924.

Sobey, Ed, and Woody Sobey. *The Way Toys Work*. Chicago: Chicago Review Press, 1998.

Stiff, Dean. *The Milk and Honey Route: A Handbook for Hoboes*. New York: Vanguard Press, 1931.

Strunk, William, Jr., and E.B. White. *The Elements of Style*. 3rd ed. New York: Macmillan, 1979.

Thorndike, Chuck. *The Business of Cartooning*. New York: House of Little Books, 1939.

Töpffer, Rodolphe. *Enter the Comics: Rodolphe Töpffer's Essay on Physiognomy and the True Story of Monsieur Crépin*. Translated and edited by E. Wiese. Lincoln: University of Nebraska Press, 1965.

Tufte, Edward R. *Envisioning Information*. Cheshire, CT: Graphics Press, 1990.

—. *The Visual Display of Quantitative Information*. Cheshire, CT: Graphics Press, 1997.

—. *Visual Explanations*. Cheshire, CT: Graphics Press, 1997.

Villard, Oswald Garrison. *Some Newspapers and Some Newspapermen*. New York: Alfred A. Knopf, 1926.

Walker, Brian. *The Best of Ernie Bushmiller's Nancy*. New York: Henry Holt, 1988.

Walker, Mort. *Lexicon of Comicana*. Port Chester, NY: Museum of Cartoon Art, 1980.

Weitenkampf, Frank. *American Graphic Art*. New York: Henry Holt, 1912. Rev. ed., 1924.

Who's Who in America: Supplement to Who's Who, A Current Biographical Reference Service, Volumes 17–20. Chicago: A.N. Marquis Company, 1959.

Who's Who on The World. New York: New York World, 1922.

Wilde, Larry. *The Great Comedians Talk About Comedy*. New York: Citadel Press, 1968.

ESSAYS

Almars, Joseph. "Photoengraving." *Illustration and Cartooning #14: Reproduction Processes*. Minneapolis: Art Instruction, 1947.

Baur, Edward F. "Ben Day Tints in Connection with Line Etchings." *Commercial Designing, Division 12*, edited by Joseph Almars. Minneapolis: Federal Schools, 1922.

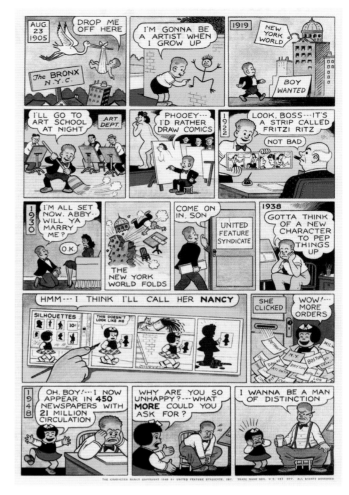

"Nancy and Me," Collier's, September 18, 1948.

Nancy, March 9, 1966 (partial metal plate).

—. "Mechanical Shading Medium." *Commercial Designing, Division 6*, edited by Joseph Almars. Minneapolis: Federal Schools, 1922.

Blackbeard, Bill. "Bushmiller, Ernest." *The World Encyclopedia of Comics*, edited by Maurice Horn. New York: Chelsea House, 1976.

—. "Nancy." *The World Encyclopedia of Comics*, edited by Maurice Horn. New York: Chelsea House. 1976.

Bushmiller, Ernie. "The Gag Strip." *Illustration and Cartooning #4: Beginning Cartooning and Illustration*. Minneapolis: Art Instruction, 1949.

Caniff, Milt. "Detour Guide for an Arm Chair Marco Polo." *The All American Art of Cartooning*. Brooklyn, NY: Higgins Ink, 1944.

Carrol, Noell. "Notes on the Sight Gag." *Comedy/Cinema/Theory*, edited by Andrew S. Horton. Berkeley: University of California Press, 1991.

Farber, Manny. "White Elephant Art vs. Termite Art." *Farber on Film*, edited by Robert Polito. New York: Library of America, 2009.

Gunning, Tom. "Crazy Machines in the Garden of Forking Paths: Mischief Gags and the Origins of Film Comedy." *Classical Hollywood Comedy*, edited by Henry Jenkins and Kristine Brunovska Karnick. London: Routledge, 1995.

Suls, Jerry M. "A Two-Stage Model for the Appreciation of Jokes and Cartoons: An Information-Processing Analysis." *The Psychology of Humor*, edited by Jeffrey H. Goldstein and Paul McGhee. New York and London: Academic Press, 1972.

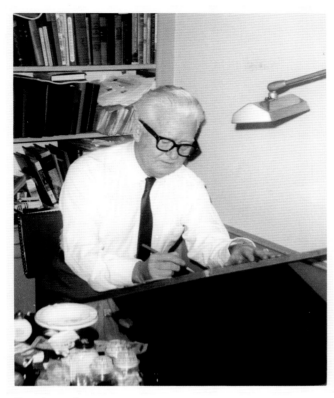

Publicity photograph, 1970s.

Wolter, John. "Art Staff Requirements." *Illustration and Cartooning #10: Cartoon Strips and Staff Work.* Minneapolis: Art Instruction, 1947.

INTERNET

Bergson, Henri. "Laughter: An Essay on the Meaning of the Comic." 1900, http://www.gutenberg.org/ebooks/4352.

"Bronx, New York: Plaque: Ernie Bushmiller Born Here." Roadside America, September 8, 2006, http://www.roadsideamerica.com/tip/13753.

"Ben Day Dots," parts 1–8, Legion of Andy (blog), first part located at http://legionofandy.com/2013/06/03/roy-lichtenstein-the-man-who-didnt-paint-benday-dots.

"Direct Gazes Enhances Face Perception." *Science Daily*, August 15, 2008, http://www.sciencedaily.com/releases/2008/08/080813095722.htm.

Dessem, Matthew. "The Gag Man." *The Dissolve*, April 24, 2014, http://thedissolve.com/features/movie-of-the-week/531-the-gag-man.

"In 'Reading' a Gaze, What We Believe Changes What We See." *Science Daily*, June 26, 2009, http://www.sciencedaily.com/releases/2009/06/090625133049.htm.

Johnson, Eric. "The Biology of Humor." *Discover*, May 1, 2002, http://discovermagazine.com/2002/may/featbiology#.UYBIUkRGCl1.

Langton, Stephen R.H. "Gaze Perception: Is Seeing Influenced by Believing?" *Current Biology*, August 11, 2009, http://www.sciencedirect.com/science/article/pii/S096098220901255X.

Sausverd, Antoine. *"Arrosers Arrosés."* Töpfferiana, October 27, 2010, http://topfferiana.free.fr/?p=2581.

Smuts, Aaron. "Humor." Internet Encyclopedia of Philosophy, http://www.iep.utm.edu/humor.

Trahair, Lisa. "The Narrative-Machine: Buster Keaton's Cinematic Comedy, Deleuze's Recursion Function and the Operational Aesthetic." *Senses of Cinema*, issue 33, October 2004, http://sensesofcinema.com/2004/33/keaton_deleuze.

The University of Chicago: Theories of Media: Keywords Glossary: Tableau Vivant, http://csmt.uchicago.edu/glossary2004/tableauvivant.htm.

Wollaston, William Hyde. "On the Apparent Direction of Eyes in a Portrait." *Philosophical Transactions of the Royal Society of London*, vol. 114, May 27, 1824, http://rstl.royalsocietypublishing.org/content/114/222.full.pdf+html.

INTERVIEWS

Bushmiller, Ernie. "An Interview with Milton Caniff and Ernie Bushmiller," by Fred Waring. Radio transcription, June 27, 1949.

Busino, Orlando. Telephone interview with authors, June 11, 2012.

Capp, Al. Filmed television interview, WTTV, Indianapolis, IN, 1956.

Carlsson, James. Personal and telephone interviews with authors, July 22, 2009; September 17, 2009; May 13, 2010; August 3, 2010; June 11, 2012; July 18, 2012; and August 12, 2012.

Cohn, Neil. Telephone interview with authors, March 27, 2010.

D'Angelo, Joe. Telephone interview with authors, August 24, 2010.

Doty, Roy. Telephone interview with authors, August 11, 2010.

Dumas, Jerry. Telephone interview with authors, August 26, 2010.

Ford, Georgia Lee. Telephone interview with authors, June 11, 2012.

Goulart, Ron. Telephone interviews with authors, January 28, 2010, and August 9, 2010.

Haenigsen, Harry. Video interview with Bill Janocha, Port Chester, NY, 1990.

Hasen, Irwin. Telephone interview with authors, August 15, 2011.

Hendin, David. Telephone interview with authors, July 15, 2010.

Hodgins, Dick. Telephone interview with authors, June 11, 2012.

Lazarus, Mell. Telephone interview with authors, August 8, 2010.

Lloyd, Harold. *Calendar* interview with Harry Reasoner. CBS TV, April 16, 1963.

Miller, Bobbie. Telephone interviews with authors, July 15, 2010, and July 26, 2010.

Plastino, Al. Telephone interviews with authors, September 7, 2009; April 7, 2010; July 11, 2011; and September 19, 2012.

Reinhardt, Ruth Alice. Personal interview with authors, September 10, 2010.

Schiller, Tom. Email interview with authors, August 31, 2012.

Weiss, Morris. Telephone interviews with authors, July, 30 2010, and August 8, 2010.

OTHER

Bushmiller, Ernie. 16mm Kodachrome home movies (James Carlsson collection), c. 1952.

—. Unpublished autobiographical manuscript (James Carlsson collection), c. 1970.

Comic book, United Feature Syndicate, 1953.

roadsideamerica.com/tip/13753.

"Ben Day Dots," parts 1–8, Legion of Andy (blog), first part located at http://legionofandy.com/2013/06/03/roy-lichtenstein-the-man-who-didnt-paint-benday-dots.

"Direct Gazes Enhances Face Perception." *Science Daily*, August 15, 2008, http://www.sciencedaily.com/releases/2008/08/080813095722.htm.

Dessem, Matthew. "The Gag Man." *The Dissolve*, April 24, 2014, http://thedissolve.com/features/movie-of-the-week/531-the-gag-man.

"In 'Reading' a Gaze, What We Believe Changes What We See." *Science Daily*, June 26, 2009, http://www.sciencedaily.com/releases/2009/06/090625133049.htm.

Johnson, Eric. "The Biology of Humor." *Discover*, May 1, 2002, http://discovermagazine.com/2002/may/featbiology#.UYBIUkRGCl1.

Langton, Stephen R.H. "Gaze Perception: Is Seeing Influenced by Believing?" *Current Biology*, August 11, 2009, http://www.sciencedirect.com/science/article/pii/S096098220901255X.

Sausverd, Antoine. *"Arrosers Arrosés."* Töpfferiana, October 27, 2010, http://topfferiana.free.fr/?p=2581.

Smuts, Aaron. "Humor." Internet Encyclopedia of Philosophy, http://www.iep.utm.edu/humor.

Trahair, Lisa. "The Narrative-Machine: Buster Keaton's Cinematic Comedy, Deleuze's Recursion Function and the Operational Aesthetic." *Senses of Cinema*, issue 33, October 2004, http://sensesofcinema.

com/2004/33/keaton_deleuze.

The University of Chicago: Theories of Media: Keywords Glossary: Tableau Vivant, http://csmt.uchicago.edu/glossary2004/tableauvivant.htm.

Wollaston, William Hyde. "On the Apparent Direction of Eyes in a Portrait." *Philosophical Transactions of the Royal Society of London*, vol. 114, May 27, 1824, http://rstl.royalsocietypublishing.org/content/114/222.full.pdf+html.

INTERVIEWS

Bushmiller, Ernie. "An Interview with Milton Caniff and Ernie Bushmiller," by Fred Waring. Radio transcription, June 27, 1949.

Busino, Orlando. Telephone interview with authors, June 11, 2012.

Capp, Al. Filmed television interview, WTTV, Indianapolis, IN, 1956.

Carlsson, James. Personal and telephone interviews with authors, July 22, 2009; September 17, 2009; May 13, 2010; August 3, 2010; June 11, 2012; July 18, 2012; and August 12, 2012.

Cohn, Neil. Telephone interview with authors, March 27, 2010.

D'Angelo, Joe. Telephone interview with authors, August 24, 2010.

Doty, Roy. Telephone interview with authors, August 11, 2010.

Dumas, Jerry. Telephone interview with authors, August 26, 2010.

Ford, Georgia Lee. Telephone interview with authors, June 11, 2012.

Goulart, Ron. Telephone interviews with authors, January 28, 2010, and August 9, 2010.

Haenigsen, Harry. Video interview with Bill Janocha, Port Chester, NY, 1990.

Hasen, Irwin. Telephone interview with authors, August 15, 2011.

Hendin, David. Telephone interview with authors, July 15, 2010.

Hodgins, Dick. Telephone interview with authors, June 11, 2012.

Lazarus, Mell. Telephone interview with authors, August 8, 2010.

Lloyd, Harold. *Calendar* interview with Harry Reasoner. CBS TV, April 16, 1963.

Miller, Bobbie. Telephone interviews with authors, July 15, 2010, and July 26, 2010.

Plastino, Al. Telephone interviews with authors, September 7, 2009; April 7, 2010; July 11, 2011; and September 19, 2012.

Reinhardt, Ruth Alice. Personal interview with authors, September 10, 2010.

Schiller, Tom. Email interview with authors, August 31, 2012.

Weiss, Morris. Telephone interviews with authors, July, 30 2010, and August 8, 2010.

OTHER

Bushmiller, Ernie. 16mm Kodachrome home movies (James Carlsson collection), c. 1952.

—. Unpublished autobiographical manuscript (James Carlsson collection), c. 1970.

Carlsson James. "I Remember Ernie" (unpublished personal reminiscences), 2010.

Cunningham, Steve, Steve Sweet, and Jesse Poimboeuf.

PICTURE CREDITS

Every reasonable effort has been made to acknowledge the ownership of copyright and provenance of the images included in *How to Read Nancy*. Any errors or omissions are inadvertent, and will be corrected in subsequent editions, provided the publisher is notified in writing.

Endpapers: photo by Walker Blackwell, courtesy James Carlsson. Page 3: photo courtesy Brian Walker. 5: *Nancy* daily, collection of Mark Newgarden. 7: art, collection of Mark Newgarden. 9: photo courtesy James Carlsson. 12: art courtesy Warren Bernard. 14: photography © The Art Institute of Chicago. 15: photos courtesy James Elkins. 16–18: maps © London Transport Museum and taken with permission from the book *Mr. Beck's Underground Map* by Ken Garland. 20: *Nancy* daily, collection of Dan Clowes. 22: dictionary page, collection of Paul Karasik. 25: art courtesy James Carlsson. 26: photo courtesy James Carlsson. 27: photo courtesy James Carlsson. 28: newspaper page courtesy The Rubenstein Library, Duke University. 29: *Puck* cover courtesy the Library of Congress. 29: comics panel, collection of Mark Newgarden. 30: photo courtesy James Carlsson. 31: Bushmiller photo courtesy James Carlsson. 31: *World* Building photo courtesy the Library of Congress. 32: photo courtesy James Carlsson. 32: art, collection of Mark Newgarden. 33: photo courtesy James Carlsson. 33: art, collection of The Center for Cartoon Studies. 35–36: puzzle and comic strip courtesy Will Shortz. 37: top two comic strips and "Trixie's

Tricks" courtesy Will Shortz. 37: *Judge* comics panel courtesy Warren Bernard. 38: comic strips courtesy *Hogan's Alley* magazine. 39: newspaper page courtesy Will Shortz. 40: photo courtesy James Carlsson. 41: art courtesy The Rubenstein Library, Duke University. 42: art, collection of Mark Newgarden. 43: comic strips, collection of Mark Newgarden. 44: puzzle courtesy Will Shortz. 45: art courtesy James Carlsson. 46: top two comic strips courtesy the Ohio State University Libraries, Billy Ireland Cartoon Library and Museum. 46: *Fritzi* daily, collection of Mark Newgarden. 47: all art courtesy James Carlsson. 48: art courtesy James Carlsson. 49: art courtesy James Carlsson. 50: memo and ad courtesy James Carlsson. 51: *Fritzi* dailies, top row, and right and left, bottom row, collection of Mark Newgarden. 52: art and photo courtesy James Carlsson. 53: photo, collection of Mark Newgarden. 54: art and newspaper clipping courtesy James Carlsson. 55: photo and *Fritzi* promotion courtesy James Carlsson. 56: cartoons, collection of Mark Newgarden. 57: art, top row, and dust jacket, collection of Mark Newgarden. 58: *Fritzi* daily courtesy Dolph Briscoe Center for American History, University of Texas, Austin. 58: *Nancy* ads courtesy Warren Bernard. 59: *Nancy* ads, collection of Rick Marschall. 60: photo courtesy James Carlsson. 61: *Nancy* movie poster courtesy the Hershenson/ Allen Archives. 61: Japanese *Nancy* comic book, *Nancy* board game, Shredded Wheat ad, collection of

Mark Newgarden. 61: Italian *Nancy* comic book courtesy Alfredo Castelli. 62: art, collection of Tom Gammill. 63: photo courtesy James Carlsson. 64: art and photos courtesy James Carlsson. 65: photo courtesy James Carlsson. 66: top and bottom *Nancy* dailies courtesy Denis Kitchen. 66: two middle *Nancy* dailies, collection of Mark Newgarden. 67: *Nancy* dailies, collection of Mark Newgarden. 68: photo courtesy James Carlsson. 68–69: *Nancy* dailies, collection of Mark Newgarden. 71: art courtesy James Carlsson. 160: comic book cover, collection of Mark Newgarden. 161: *Nancy* daily, collection of Dan Clowes. 161: catalog pages, collection of Mark Newgarden. 163: newspaper page, collection of Mark Newgarden. 164: paperback cover and interior page, collection of Mark Newgarden. 165: *Nancy* Saturday color daily courtesy St. Louis Mercantile Library. 166: *Fritzi Ritz* daily, collection of Mark Newgarden. 166: *Peanuts* daily original art © 2014 Peanuts Worldwide, courtesy Heritage Auctions. 167: movie still courtesy Photofest, Inc. 168: 1885 hose gag courtesy Andy Konkykru. 169: 1886 hose gag, collection of Thierry Smolderen. 169: 1886 hose gag courtesy the Biblioteca Nacional, Madrid Spain. 170: 1887 hose gag courtesy the Collection du Musée de la Bande Dessinée/Cité Internationale de la Bande Dessinée et L'image, Angoulême, France. 171: 1887 hose gag courtesy the Collection du Musée de la Bande Dessinée/Cité Internationale de la Bande Dessinée et L'image,

Promotional brochure, United Feature Syndicate, 1947.

Angoulême, France. 171: 1888 hose gag courtesy Pierre Chemartin. 172: 1884 hose gag, collection of Thierry Smolderen. 173: 1889 hose gag courtesy the Collection du Musée de la Bande Dessinée/Cité Internationale de la Bande Dessinée et L'image, Angoulême, France. 174: Lumière movie poster used by permission of the Bibliothèque national de France. 175: magazine page courtesy Joost Gielen. 176: 1904 hose gag, collection of Antoine Sausverd. 177: 1900 hose gag courtesy Diane Wanek. 178: May 24, 1900, hose gag courtesy Eckart Sackmann. 179: 1900 hose gag courtesy Collection Novanima. 180: 1905 hose gag, collection of Antoine Sausverd. 181: 1907 hose gag courtesy Pierre Chemartin. 182: 1920 hose gag, collection of Antoine Sausverd. 182: 1897 hose gag courtesy Cole Johnson. 183–185: *Nancy* Sundays, collection of Mark Newgarden. 185: *Fritzi Ritz* daily courtesy the Boston Public Library. 186: *Nancy* dailies, 5-4-1970 and 10-29-1964, and *Nancy* daily original, 9-22-1978, collection of Mark Newgarden. 186: *Nancy* daily, 2-7-1949 courtesy James Carlsson. 187: photo courtesy James Carlsson. 187: *Nancy* daily, collection of Mark Newgarden. 188–189: all artwork courtesy James Carlsson. 190: photo courtesy the KIT Tropenmuseum, Amsterdam. 191: *Nancy* daily courtesy Dolph Briscoe Center for American History, University of Texas, Austin. 191: *Fritzi Ritz* daily, collection of Mark Newgarden. 192: *Fritzi Ritz* Sunday, collection of Mark Newgarden. 193: *Fritzi Ritz* Sunday, collection of Mark Newgarden. 194: *Fritzi Ritz* daily 12-31-1930 courtesy Dave Johnson. 194: *Fritzi Ritz* dailies 6-29-1931, 7-1-31, and 7-3-31 courtesy Richard Michael Tususian. 195: *Fritzi Ritz* Sunday courtesy Peter Maresca. 197: *Nancy* Sunday original art, collection of Mark Newgarden. 198: *Nancy* Sunday page, *Chicago Sun*, collection of Mark Newgarden. 199: *Nancy* Sunday courtesy City of Sacramento Collection. 200: *Nancy* black-and-white Sunday page, *Laredo Times* courtesy City of Sacramento Collection. 200: *Nancy* comic book page, collection of Mark Newgarden. 200: *Nancy* Sunday page, *St. Louis Post-Dispatch* courtesy St. Louis Mercantile Library. 201: *Nancy* Sunday black-and-white, collection of Mark Newgarden. 202: paper mat, collection of Paul Karasik. 202: metal

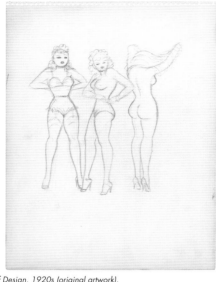

Sketches from the nude by Ernie Bushmiller, National Academy of Design, 1920s (original artwork).

plate courtesy Peter Huestis. 202: *Nancy* daily courtesy the Western Reserve Historical Society Library Research Center. 203: *Nancy* daily original courtesy James Carlsson. 203: *Nancy* daily, collection of Mark Newgarden. 204: *Nancy* unfinished original, collection of Mark Newgarden. 205: *Nancy* Sunday original, collection of Paul Karasik. 206: *Nancy* daily original, back and front courtesy Peter Huestis. 206: *Nancy* unfinished original courtesy James Carlsson. 207: comic book ad, collection of Mark Newgarden. 208: original art and comic book, collection of Mark Newgarden. 209: patent drawing courtesy U.S. Patent Office. 210: textbook image, collection of Mark Newgarden. 211: coloring book cover, collection of Mark Newgarden. 212: painting © The Andy Warhol Foundation for the Visual Arts, Inc., Private Collection, Courtesy Thomas Ammann Fine Art AG, Zurich. 213: *Nancy* Sunday courtesy *New York Post*. 214: magazine cover, front and back, collection of Mark Newgarden, used by permission of the Estate of Joe Brainard. 214: magazine page, collection of Mark Newgarden. 215: *Phil Fumble* Sunday original, collection of Mark Newgarden. 215: *Nancy* daily courtesy Heritage Museum, Big Springs, Texas. 216: lithograph, collection of Mark Newgarden. Photograph by Kristine Larsen. 217: magazine cover, collection of Mark Newgarden. 218: newspaper promo, collection of Mark Newgarden. 219: *Little Debbie* daily courtesy State Historical Society of Iowa. 219: *Nancy* daily, collection of Dan Clowes. 220: photo courtesy

James Carlsson. The strips on pages 220–262 are courtesy James Carlsson, Tom Gammill, Ward Harkavy, Eddie and Coco Goredetsky, Denis Kitchen, Paul Karasik, Patrick McDonnell, Mark Newgarden, Rob Stolzer, Wayno, and Jim Woodring. 263: product endorsement courtesy James Carlsson. 264: comic book cover collection of Mark Newgarden. 265: photo courtesy James Carlsson. 267: *St. Louis Post-Dispatch* ad courtesy James Carlsson. 268: *Collier*'s page collection of Mark Newgarden. 268: metal plate, collection of Mark Newgarden. 269: photo collection of Mark Newgarden. 270: comic book cover collection of Mark Newgarden. 271: promotional brochure, United Feature Syndicate, 1947, collection of Rick Marschall. 272: sketches courtesy James Carlsson. 273: photo courtesy James Carlsson.

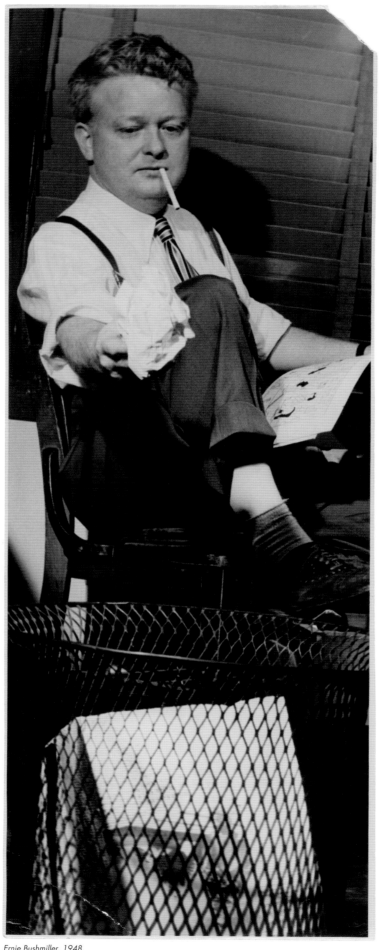

Ernie Bushmiller, 1948.